Correggio's Frescoes *in* Parma Cathedral

Correggio's Frescoes
in Parma Cathedral

CAROLYN SMYTH

Princeton University Press
PRINCETON, NEW JERSEY

Copyright © 1997 by Princeton University Press
Published by Princeton University Press, 41 William Street, Princeton, New Jersey 08540
In the United Kingdom: Princeton University Press, Chichester, West Sussex

Library of Congress Cataloging-in-Publication Data
Smyth, Carolyn.
 Correggio's frescoes in Parma Cathedral / Carolyn Smyth.
 p. cm.
 Includes bibliographical references and index.
 ISBN 0-691-03747-7 (cl : alk. paper)
 1. Correggio, 1489?–1534—Criticism and interpretation. 2. Mural painting and decoration,
Italian—Italy—Parma. 3. Christian art and symbolism—Modern period, 1500—Italy—Parma.
4. Duomo di Parma. I. Title.
ND623.C7S58 1997
759.5—dc21 96-45579
 CIP

This book has been composed in Adobe Jenson Multiple Master by The Composing Room
of Michigan, Inc.
Design by Diane Levy

Princeton University Press books are printed on acid-free paper and meet the guidelines for permanence
and durability of the Committee on Production Guidelines for Book Longevity of the Council on Library
Resources

Printed in the United States of America
10 9 8 7 6 5 4 3 2 1

To my parents,
Donald and Elisabeth Smyth

Contents

SIX

The View from the Stairs:
More Old Testament Figures Come into Sight

SEVEN

Christ Appears as the Viewer Ascends the Stairs to the Presbytery

EIGHT

The View from the Altar at the Middle of the Crossing:
The "Central View"

NINE

The View from the Eastern Apse:
The Western Face of the Cupola and Two More Squinches

Conclusion

List of Illustrations

Color Plates

Black-and-White Figures

FIGURES 1–10. VIEWS OF CORREGGIO'S FRESCO
FROM THE INTERIOR OF THE CATHEDRAL

Acknowledgments

IT IS MY GOOD FORTUNE to be able to offer my sincere thanks to many people. I express my gratitude to Paul Watson, with whom I first wrote on Correggio for my doctoral dissertation, and whose interest continued as the project took a new and (I hope) more mature form. Malcolm Campbell was instrumental in encouraging me to develop my ideas into a publishable book, as was John Scott, who read the first manuscript and saved me from many weak points by his thoughtful reading. The advice of Phoebe Lloyd, John McCoubrey, Philipp Fehl, Egon Verheyen, John Shearman, and Hellmut Hager have assisted this project at crucial moments. A special appreciation I extend to Leo Steinberg, teacher and friend, and an inspirational model of scholarly acumen and intellectual creativity. Work in Parma would indeed have been difficult without the generous help of Lucia Fornari Schianchi and Marina Gerra, as well as that of the staffs of the Soprintendenza, Fototeca (especially that of Chiara Burgio), Archivio di Stato, and Biblioteca Palatina. The *in situ* views, a photographic task made difficult by problems of light in the cathedral, were realized through the expertise of Ralph Lieberman. I am deeply indebted to Elizabeth Powers and Tim Wardell at Princeton University Press, who placed faith in my work and patience in awaiting the final manuscript, and to Elizabeth Johnson and Patricia Fidler, who edited the book with care and insight. During this project I have enjoyed the intellectual and emotional support of many friends, colleagues, students, and well-wishers, but I have been particularly blessed with that of Kevin Salatino and Stefano La Via. Special gratitude and affection are due Tony Apesos, the critic and coach who made me persist, and my parents, to whom I dedicate this book.

Correggio's Frescoes *in* Parma Cathedral

Introduction

THREE CRITICISMS have followed Correggio's frescoes in Parma Cathedral for more than a century. The first concerns the decorum of this riotously joyful, illusionistic image of the Assumption of the Virgin, attacking the behavior of the figures depicted and the propriety of the perspective. The second regards the simplicity of content of the cycle. Both appraisals are worthy of analysis, not only because they persist in even the most recent literature on the painting, but also because they reveal an outstanding and misunderstood feature of Correggio's work in the Cathedral: his ability to express a complex Christian message through a tactile persuasiveness of form. The third complaint regards the supposed illegibility of the fresco; this issue will be taken up after the first two have been investigated.

For Baroque, Neoclassical and Romantic writers, Correggio belonged to the divine quadrumvirate of artists that included Michelangelo, Raphael, and Titian, but from the middle of the nineteenth century, he fell out of favor. The frescoes in the Duomo, his most ambitious project, fell the hardest of all his work. In *Der Cicerone* (1855), for example, Jacob Burckhardt's opinion concerning Correggio's art as a whole is that the realism of his painting is almost immoral, and certainly antispiritual. At least, Burckhardt still places him beside the great Renaissance artists:

> *Inwardly as little under the influence of any ecclesiastical traditions as Michelangelo, Correggio never sees in his art anything but the means of making his representation of life as sensuously charming and sensuously real as possible. . . . There is an entire absence of any moral elevation: if these forms should come to life, what good would come out of them, what kind of expression of life would one expect from them? . . . But, if the subject is sensuously attractive, the charm is immensely increased, and affects us with a demoniac force.*[1]

Concerning the frescoes in the Cathedral, he is especially harsh and sees them as representative of all that is most objectionable in Correggio's painting. In the dome, the artist "gave himself up altogether, without any limit, to his special conception of the supernatural. He makes everything external, and desecrates it."[2] Cecil Gould's criticism in his monograph of 1976 is gentler but along similar lines; he believes that the actions of many of the figures do not belong in a sacred context. Recalling the pendentives of S. Giovanni Evangelista with a fond nostalgia, he notes that in comparison, the saints in the squinches of the Cathedral have "little solemnity left in them." And what

is more, "the incredible frivolity of the exquisite attendant angels . . . is only just within the limits of the decorum to be expected in a cathedral church."[3] Though Gould appreciates the formal excellence of Correggio's painting, he seems all the while to balk at the content. Elsewhere, he finds Correggio completely unfit to paint religious subjects:

> *Owing to the circumstances of Renaissance patronage it happened that Correggio, the painter of pleasure . . . spent most of his short career painting religious subjects. And though his achievements in that field proved immensely influential the works themselves, for all their brilliance, show a lack of solemnity, combined with a refined sensuality, which found a completely sympathetic response only in the eighteenth century.*

Lamenting that Correggio painted so few mythologies, the author continues: "As it was, two huge pieces of religious decoration [S. Giovanni and the Cathedral] fettered him to Parma for ten years."[4]

Gould's assessment of Correggio as an unthinking sensualist leads to the second criticism of the frescoes in the Cathedral. The opinion that the Cathedral fresco lacks all profundity of thought is more often implied than openly stated. The complete absence of any thorough iconographical study of the fresco confirms this prejudice.

The painting in the Duomo has usually been regarded as merely a picture of an event occurring in heaven and the very simplicity of the content due to the public nature of the Cathedral. Therefore, while the Camera di S. Paolo received Erwin Panofsky's scrupulous iconographical attention[5] and the frieze of S. Giovanni was investigated as a demonstration of Benedictine exegetic method,[6] the fresco in the Cathedral "parla al popolo."[7] Even John Shearman, in an essay deeply appreciative of the formal complexity of the painting, has called the fresco "the most perfect illustration I know of the *Assunta* as it is described in the *Golden Legend*," and his suggestion that it was conceived as a visual equivalent of popular religious spectacles—the *sacre rappresentazioni*—has been readily adopted in the literature.[8]

It has become customary on the part of many recent writers, such as Paola Ceschi Lavagetto and Eugenio Riccòmini, to set Correggio against the cultural ambiance of Parma;[9] the investigation of this culture, while informative, becomes a substitute for careful examination of the fresco itself, especially of its content.[10] Most troublesome is the tendency, when faced with the dramatic emotionalism of Correggio's painting, to find recourse in models of the next century. A lack of attention to specific iconographical aspects of the *Assumption*—as well as to the particulars of its visual form—has led critics to resort to the label "proto-Baroque," even while often acknowledging the evident historiographic entanglement such a term presents.[11]

Several authors have proposed a literary or philosophical basis for the cycle, but such attempts have been loose comparisons rather than exact definitions of the relationship of text to image. Lucia Fornari Schianchi sets the cupola alongside Dante's *Paradiso*, because of the presence of Adam and Eve in heaven and the strict hierarchy of the celestial ranks.[12] According to Ceschi Lavagetto, the composition, as a depiction of human aspiration to an illuminated vertiginous height, is a Neoplatonic image.[13] Otto von Simson, noting the originality of Correggio's choice of narrative moment, tries to show that the painter follows the pseudo-patristic portions of the *Golden Legend*. He

demonstrates that the artist heeds not the narrative of the *Legend*, with which Correggio's depiction is actually at variance, but the quotations from the Carolingian writings of Pseudo-Jerome and Pseudo-Augustine. In his search for a Christian source for specific aspects of Correggio's painting, von Simson is unique.[14] But no writer has tried to study the painting as a creative statement of Christian belief, precisely expressed in pictorial form with reference to a large body of theological writings and dogma. One of the tasks of this book will be to demonstrate the multilayered complexity of Correggio's Assumption iconography.

The second criticism returns to the first; if a painting is undecorous, then it cannot have deep Christian meaning. But Burckhardt, despite his animosity, understands the essence of Correggio's persuasive language when he remarks: "It is difficult to analyze exactly the sort of intoxication with which these figures fill the senses. I think that the divine and the very earthly are here closely combined."[15] Correggio seeks not only to convey the sheer rejoicing that the Virgin's ascent caused in heaven, but he wishes to draw us near the holy event. He perceives and paints the world of heaven as tangible and so close to us that it is subject to the same physical rules as the natural world which surrounds us and which is God's creation. The Assumption is about the proximity of the mortal and the divine, as the Virgin nears her place on Christ's throne. Correggio's style, which convinces us through perspective and light of the presence of angels and celestial clouds, could not be a better means for the representation of such a subject.

The third accusation, of illegibility, is largely the result of a habit of observing the cycle from the middle of the crossing (fig. 8). Among those who assumed the exclusivity of the central viewpoint was the canon quoted by Girolamo Tiraboschi in the late eighteenth century, who called the fresco a "guazzetto di rane," or frog stew.[16] This comment shows him to have been standing at midcrossing, directly below the apex of the dome. The understandable desire to see the maximum extent of frescoed surface results in the unreadability of much of the image—a sacrifice of quality for quantity.

A general view of Correggio's Cathedral fresco as seen from the center of the raised crossing and directly into the peak of the dome must illustrate any study of the painting, and a photographic reproduction of the cupola from this point in the church accompanies every modern essay on the work. Toschi's print (fig. 13), and the photographs of Anderson (fig. 14) and the Soprintendenza (fig. 8), all centralized views, became the standard records of the overall scheme of the decoration, and most twentieth-century scholars accept one or more of these reproductions as not just the most revealing and inclusive view, but as the only manner in which to analyze and to appreciate the painting in its entirety.[17] This universal habit of seeing arose in part from the urge to reproduce efficiently as much of the surface area of the dome as possible, but the preference for this view to the exclusion of all other *dal-sotto-in-su* points derives from a long-standing descriptive tradition that has determined written and copied reactions for more than two centuries.

From the moment the Cathedral frescoes gained their reputation as an important artistic monument, writers and copyists began to respect the center of the presbytery as the unique ground-level position from which to take in Correggio's perspectival complexities and the spiraling drama. But while this comprehensive view obliges the spectator's demand to examine the entire decoration, it also limits interpretive responses to the dome fresco. Without acknowledgment of the equally

important alternatives—the oblique views—the insistent dependence on a monopolizing view from below dispenses with the more leisurely pleasure and more liturgically correct experience of the gradual self-disclosure of the painting.

Anton Raphael Mengs, in his essay on Correggio's life and work ("Memorie sopra il Correggio" [1780]), is the first writer to describe the frescoes completely,[18] and he sets the pattern for the modern manner of viewing Correggio's painting. Beginning at the apex of the dome, he describes the paintings from the figure of Christ down to the squinches, dividing the cupola into a "superior" section (the figural wreath suspended in heaven) and an "inferior" segment (the fictive dado with the angels and apostles upon it) (fig. 8). This organization of the dome clearly centers the image and accounts for the composition as a series of descending rings. Mengs eliminates all sense of asymmetry, seeing the fresco only as a strict vertical hierarchy. This method of conceptual stratification reaches an extreme in the hands of Laudadeo Testi. In his book of 1923, he describes the fresco from the center of the crossing and marks off five horizontal "zones": the "anticupola" consists of (1) the six grisaille figures ("nel tempio") and (2) the squinches ("nel tempio" also); the "cupola" itself consists of (3) the apostles ("in terra"), (4) the attendant angels on the dado ("in terra, ma contro atmosfera"), and (5) the Assumption proper ("in cielo").[19] It is not very far from this kind of observation to Fornari Schianchi's comparison of the fresco with Dante's "rose" of the *Paradiso* or to Ceschi Lavagetto's Neoplatonic interpretation. Both these theories are determined by the custom of central viewing, which insists upon hierarchical concentricity.

The central view not only inhibited interpretation, it also inhibited seeing the figural composition at all. While the deterioration of the condition of the fresco no doubt has contributed to the confusion,[20] the observer's stubborn adherence to a point of view at the middle of the crossing has resulted in complaints regarding visibility. Corrado Ricci's response is typical, and indicative of the problem. To him, Correggio

> *failed to keep within due bounds in the execution of this work, and allowed the exuberance of his fancy and the mastery of his hand too unrestrained a license . . . the frescoes in the Cathedral are no doubt far superior to the earlier work [in S. Giovanni Evangelista]; but the multitudinous figures and the interlacement of so many human limbs in violent motion produces confusion. We are obliged to decipher rather than to contemplate, and are oppressed by the effort of disengaging the lines of any single body from those of others crowded about it.*[21]

Even now, tourists persist in charging blindly down the nave and up to the south transept in order to view the cupola, simply because, since the crossing itself is roped off, that station is closest to the favored central site.[22]

The viewer's experience of the painting begins upon entering the Cathedral through the west portal, with the initial glimpse of the eastern pendentives (figs. 1, 11). Led forward through the nave by the persuasive unfolding of Correggio's fresco scene, the spectator moves toward a succession of ever-larger wedges of painted dome and arrives at the foot of the raised presbytery (fig. 5). The first triumphal crossing arch and its piers delimit a series of selective, coherent compositions in accompaniment to the viewer's progress through the body of the church. In order to be privy to an en-

counter with the total interior of the cupola, the spectator must ascend to the level of the altar, though from the apse and arms of the upper Cathedral partial views continue to dominate the viewer's impression of the *Assumption*. In this fashion, the commonly favored total view is but one of a number of calculated disclosures intended to be read from various points in the church. The obscuring span of the crossing arch bounds and clarifies, setting apart the significant portions and isolating their most telling features. Correggio presents, by the use of these meaningful views, a series of deliberated "pictures," visible from certain predetermined stations. The asymmetry of the composition, the dynamic gestures of the figures, and the powerful massing of the celestial groups appear more purposeful with the recognition of the unraveling nature of Correggio's decorative plan. The painter's *dal-sotto-in-su* accomplishments, generally acknowledged as masterly displays of foreshortening, also include his selective engagement of viewers at specific positions below, with carefully designated arrangements that direct them to particular aspects of the iconographical program.

Several critics do observe that the asymmetry of the composition accommodates the nave viewer. Stefano Bottari reverses Mengs's descending order of description, commencing unusually with an analysis of the grisaille figures of the *sottarchi*; he also reproduces all six of them. Because this arrangement of description is more closely akin to the viewer's experience from west to east, Bottari may be credited as one of the earliest writers to attempt a divergence from the usual mode of description and manner of seeing. His account of the Virgin's sudden appearance as a "triumphal arrival" demonstrates that he begins in the nave of the Cathedral, though this is implied by his observation rather than openly stated and prescribed.[23] While Gould follows Mengs's lead by describing the elements of the fresco as a descending hierarchy of figures, he also notes that "the whole of the zone of the Duomo cupola containing the angels is tilted in the direction of the spectator advancing east from the nave."[24] His alliances are equally divided; when he describes the individual figures or kinds of figures, his location is below the apex, but occasionally he returns in his description to a point in the nave. That Gould claims the Virgin is both "seen from so far underneath that she must always have been difficult to discern" and "calculated so that she is framed by the nave arch as the spectator starts to mount the steps to the crossing" shows the author's confusion.[25] Though his last remark is not exactly accurate—the Virgin is first neatly framed from the western side of the last nave bay—Gould is part of the slow emergence from the opinion that holds the center of the crossing to be the sole and proper standpoint for observation.[26]

John Shearman was the first to note a deliberately planned nave vista defined by the occluding architecture; he explained Correggio's arrangement as an effort to resolve the purely formal problem that is faced by all dome painters of "the fundamental dichotomy between the directed center and the axially seen periphery."[27] Developing this observation in his most recent discussion of the principles of Renaissance dome painting, he sees the fresco in the Cathedral as a consummate example of "the transitive relationship between dome and viewer,"[28] remarking on the felicity of a view from the eastern edge of the last nave bay.[29] Shearman's treatment of Byzantine to Renaissance domes in terms of the "threshold instinct," which draws attention to the viability and frequently more satisfying compositional readability of an oblique and architecturally determined western viewpoint, illuminates an essential aspect of Correggio's thinking and moves subsequent analysis

away from the reigning exclusivity of the central view. Though Shearman's search continues to imply only one proper position from which to observe the fresco, overriding the multiplicity and flexibility of Correggio's serial program, and does not develop the iconographic possibilities suggested by this insight,[30] his insistence on the importance of looking from a position other than directly below the cupola points clearly in the direction of multiple viewpoints.

The most recent and perceptive contribution to the unstated problem of viewpoint is Riccòmini's essay of 1983. The author considers three different localities for viewing the fresco: the center of the crossing, the nave, and the eastern apse.[31] In the case of the latter, he even notes to whom the composition is visible—the bishop. Besides allowing more than one possible viewpoint, Riccòmini's suggestion that Correggio intended the fresco to show specific segments to particular viewers is a novel observation. Unfortunately, Riccòmini defines the nave vista chiefly in formal terms, as a precise geometric pattern of interlocking triangles.[32] The precise content of the nave view and the meaning of the composition in relation to the lay viewer still remain to be explored. Despite the implications of his formal analysis, Riccòmini reverts to the old centralizing habit, interpreting the dome as an image of Neoplatonic striving. In an important step toward an acceptance of more than one viewpoint, Riccòmini's book breaks with the custom of presenting in photographic reproduction only an illegibly inclusive centralized overview with supporting details. He is the first to offer a variety of oblique views photographed from the Cathedral floor.[33] These, however, are quite randomly taken; still lacking is a careful consideration of which viewpoints are viable iconographically and liturgically, and precisely where the architecture enframes views that are meaningful as well as formally pleasing. The purpose of the present study will be to define which views are significant and to provide a detailed investigation of each. By accepting the concealing and revealing nature of the *in situ* experience, we can better understand a program in which the placement and movement of viewers determine what they are given to see.

THE CANONS' ORIGINAL plan for the decoration of the Cathedral was ambitious and involved much more than Correggio's contribution. The decision to have the Assumption of the Virgin depicted in the great dome over the crossing was no doubt determined by the dedication of the Cathedral to Mary, patroness and protector of the city of Parma.[34] But while Correggio's commission was the first assigned—the largest, and iconographically the most essential—the project was originally to have extended beyond the cupola and into the transepts and nave. Included along with Correggio in this enterprise were Parmigianino, Michelangelo Anselmi, Francesco Maria Rondani, and Alessandro Araldi (fig. 12). Contracts survive for each of these commissions and reveal some idea of the project as it was conceived in November 1522.

In Correggio's case, the recorded dates and amounts of two payments and the contract for the plastering also survive.[35] It can be at least surmised from his payment on account in November 1526 that he probably began painting in the spring or summer of that year or the previous year, subsequent to the extensive technical preparation of the dome itself, and from the copy of a payment of 1530 that he left the project at that time in its present form.[36] In Correggio's contract of November 3, 1522, the supervising *fabbricieri* are the canons Pascasio Belliardi and Galeazzo Garumberti, and the artist's sponsor for the commission of the Camera di S. Paolo, Scipione dalla Rosa. Many writ-

ers have transcribed this famous document, and Correggio's autograph portion of the agreement has been reproduced.[37] The surfaces to be painted comprise

> *il coro, la cupulla con i suoi archi et pilli, senza le capelle laterali* [the transepts], *et diritto andando al sacramento* [the marble ciborium at the back of the apse], *fassa, crosera et nicchia con le sponde et ciò che di muro si vede il la capella insino al pavimento.*[38]

In other words, the canons asked Correggio to decorate, aside from the cupola and the squinches of the crossing which he did finish, the choir vault, pilasters and soffits, the semidome, and choir walls. Despite Gould's assertion to the contrary, the walls of the apse must be indicated as the "fassa" and section to be done "insino al pavimento."[39] The reduction of Correggio's total payment from an earlier sum (1100 or 1200 "ducati de oro," cancelled and barely legible) to the final amount of 1000 ducats has been noted by most writers, but the reason for this last-minute alteration remains unknown.

Because the painter agrees to cover these areas "con quelle istorie [che] mi saranno date," it is clear that the subjects were prescribed, but the degree to which Correggio was allowed to participate in the creation of the program is impossible to know. Certainly the final interpretation of the subject reflects many of the artist's own ideas, especially since the earliest surviving sketch for the project, in the Ashmolean Museum at Oxford, demonstrates that the precise subject of the lower segments of the cupola was not settled right away (figs. 15, 16). The underlying principle of the decorative scheme, that the fresco present a sequence of partial and significant views to the observer, had been in part conceived already by Correggio at S. Giovanni Evangelista.[40] It is perhaps safest to assume that besides the general subjects to be depicted, the more learned aspects of the program which, as we shall see, presents an Assumption quite unique in some of its particulars, were due to the theological recommendations of an advisor rather than to the painter himself.[41] Yet it remained for Correggio to bring this program to visual life, in fact, to a level of immediate persuasiveness that has allowed even scholars to conclude that its content, as well as its form, is purely sensual in nature. The final merging of the iconographical program and *in situ* spatial effects most likely testifies to some type of collaborative effort resulting from the patrons' demands, professional theological advice, and the painter's imaginative working of given material. The canons did determine that the paintings "imiteno il vivo, o il bronzo, o il marmoro, secondo rechiede ali suoj lochj et il dovere de la fabrica et la ragione et vagheza de epsa pictura. . . ." No doubt they had in mind Correggio's earlier fresco work for the Camera di S. Paolo and S. Giovanni, while Michelangelo's combination of fictive materials in the Sistine Ceiling provided the basis for Correggio's own more extravagantly illusionistic efforts.

Besides Correggio, whose work was left incomplete, other artists were to have participated in making the Cathedral decorations one of the grandest enterprises of the decade. On November 22, a few days after Correggio signed his contract, Parmigianino, Anselmi, and Rondani joined the project.[42] The entire eastern area and the transepts were to receive new wall paintings in the most modern style. Only the Montini Chapel was preserved, the south chapel of the south transept, which included Cima da Conegliano's altarpiece (now in the Galleria Nazionale, Parma) and

Cristoforo Caselli's frescoed lunette (fig. 17), both painted about fifteen years before. The fictive mosaic of Caselli's fresco not only met with the *fabbricieri's* approval, but even became a requested feature for the new decoration of the northern and eastern niches.[43] Both Parmigianino's and Anselmi's contracts mention the necessity for removal of earlier decoration, and a Quattrocento prophet (attributed to the early-fifteenth-century painter Bartolino de' Grassi), has been revealed under one of the soffits where it remains visible.[44] The 1522 project thus entailed the destruction of an earlier set of paintings, but the extent of this older fresco, and whether or not it included the cupola, cannot be determined.

The nineteen-year-old Parmigianino was engaged to paint the north chapel and vault of the north transept, which held a benefice referred to in the contract as "of the Women" ("de le done"). The canons' specific demand that Parmigianino's decoration in this niche imitate Caselli's fictive mosaic attests to the influence of one of the *fabbricieri*, Scipione dalla Rosa, Montini's nephew, as well as to the desire for a unity between parts of the project. This attention to the interrelationship between the paintings and the pre-existing arrangement of the Cathedral was to be crucial to the form of Correggio's cycle. Like all the other artists engaged in the project, Parmigianino never followed through with his promised work.

The largest commission after Correggio's was that of Michelangelo Anselmi, an honor he won as the second-most-talented mature painter in Parma. He was to paint the south transept, including the east niche, presumably the opposite wall, and the vault, omitting of course the south chapel. As in Parmigianino's agreement, the document of the commission mentions that earlier paintings are to be removed. In the contract, Anselmi promises to paint the transept "dove si dicie la messa del populo." The niche of this altar was dedicated to the Annunciation, a fact which will be of interest for Correggio's painting.[45] For this phase of the decorative campaign, Anselmi executed nothing. The lunette fresco in the east niche of the transept was not done until 1560–62 when Correggio's son Pomponio painted *Moses Receiving the Law*. Anselmi's activity of the 1520s and 1530s—several altarpieces, including two in the Cathedral, and the frescoes for the Oratorio della Concezione in Parma—kept him, too, from fulfilling his part of the agreement until 1548. In November of that year he drew up a new contract with the canons, resulting in his painting of the cross vault. Bresciani's replacement fresco of 1768 was meant to be a copy of Anselmi's ruined work, which the canons had specified was to have resembled his ornamental ribs for the nave of S. Giovanni.[46]

The other eastern niche of the north transept and the wall across from it were to be executed by Francesco Maria Rondani, whose contract is dated the same day as those of Parmigianino and Anselmi. Rondani, an artist who spent all of his career in Parma, is remembered primarily as Correggio's assistant in S. Giovanni Evangelista and Anselmi's dependent collaborator in the Oratorio della Concezione. In the 1520s, Rondani was involved in another project in the Duomo: after he completed his work on the nave frieze and Del Bono Chapel of S. Giovanni, he painted the walls of the Centoni Chapel (1527–31). His only other distraction seems to have been a number of mediocre altarpieces, and, though there is evidence that he may have acted in the role of assistant to Correggio also in the Cathedral,[47] he died in 1550 without laying a hand to the north transept. Unlike Parmigianino, he lived in Parma all his life, so that the only evident impediment to the fulfillment of his portion of the project would seem to be a limitation of talent; but the unanimous

nonparticipation of the other two artists and Correggio's inability to complete his commission indicate that something was gravely amiss in the Cathedral project.

A few days later, on December 10, 1522, the *fabbricieri* signed on yet another painter, Alessandro Araldi, to paint the vaults west of the cupola. The given subject is four prophets, one for each segment of the cross vault. The later date of this document hints that Araldi's part in the project may have been something of an afterthought. The contract itself betrays a fundamental lack of respect for Araldi, the senior artist of Parma, since the canons specify that the payment for the sixty-one-year-old painter must be proportionate to that accorded the nineteen-year-old Parmigianino. As if this weren't humiliating enough, the *fabbricieri* state

> that after the said vault will have been painted by Master Alessandro, it ought to be appraised by impartial experts, and if it will be judged to have been well painted and with good colors, then and in that case Master Alessandro ought and has so promised to paint all the other said vaults and arches of the said great nave, which are six in number.[48]

If Araldi's performance met with approval and he were allowed to continue, part of his payment would take the form of a plot of land chosen by the *fabbricieri*, the proceeds of which would pay for memorial masses in the Cathedral at his death. If not, the elderly painter would return his payment for the first vault. In other words, Araldi was painting to save not just his career but his soul, while the canons' interests were impersonally mercenary. Such a stingy, mistrustful attitude perhaps disrupted Correggio's own project.

Correggio left the Cathedral under circumstances that are unknown, but the legend that his work was unappreciated may have some foundation in real events. The story that the canons had intended to whitewash the paintings until Titian passed through and told them the worth of the frescoes—the capacity of the cupola in gold—was not related until the eighteenth century,[49] but another tale is told by an artist in a position to know why the frescoes were never completed. Bernardino Gatti, while working in the dome in the Steccata (fig. 18), alludes to an uncomfortable situation at the Cathedral when he writes from Cremona to Damiano Cocconi in 1559: "I do not want to be subject to so many opinions, and you know what was said to Correggio in the Duomo." Gatti's contract in the Steccata, like Araldi's in the Cathedral, stipulated that the commissioners were to sit in judgment on his work once it reached a certain stage—in his case, part of the dome from the apex to the windows—and they were then to decide if he should be allowed to continue.[50] Gatti's comparison between his own situation and Correggio's, as well as the nature of Araldi's commission, is evidence that Correggio's work may have been subjected to a similar appraisal and found wanting. The Parmesans' unpleasant habit of serving out commissions piecemeal did not allow for much confidence between painter and patron, nor did it permit the artist much creative freedom. Any work in progress in this circumstance became a trial rather than a creative endeavor given an artist in recognition of his achieved reputation.[51] Considering also that Gatti was an ardent admirer of Correggio (and in fact his cupola is a pastiche of Correggio's own), his words are reliable, if indistinct, and settle a dark cloud permanently over the events of the *Assumption* and the related commissions.

The project continued to be ill-fated after Correggio's death in 1534.[52] In the following year, the rest of Correggio's commission passed to the promising Parmesan artist Giorgio Gandini del Grano, who died in 1538 without beginning work. His commission does include specifications that he imitate mosaic in his semidome,[53] a stipulation which is in accord with Parmigianino's agreement, and which would have created matching fictive mosaics at the extremity of each of the north, south, and east arms of the church. The specific demand for fictive material also complements Correggio's imitation of marble and bronze. The reliable Girolamo Mazzola Bedoli, Parmigianino's cousin-in-law, received the commission in 1538, and completed the vault and semidome of the choir in 1544.[54] The image of the resurrected Christ with saints (without the fictive mosaic) rises over the ciborium (fig. 19). It insists upon the presence of the risen Christ, both in the "sacramento" and more generally to the viewer in the nave. Gandini was to have painted a Christ in Judgment; we cannot know what subject was given to Correggio. The paintings of the transepts and nave vaults dragged on through the sixteenth century and were finally completed in a rebirth of activity of the 1560s and 1570s. The result never achieved the impressive unity of design intended in the original commissions of 1522. Nor do these later frescoes distract the viewer from the dominating splendor of Correggio's dome.

The View from the Door:
Half of the Squinches
and the Decoration Between

THE MERE ACT of stepping through the west portal and into the great interior of Parma Cathedral initiates the viewer to the unveiling process of Correggio's program (figs. I, II). Beyond the dark, medieval nave arcade and vault, and glowing with light from the yet unseen oculi of the dome, the first glimpse of the inner halves of the squinches and of the interposing wall with its fictive relief commands attention. Here already we encounter a segment of the painting which, although distant and apparently fragmentary, offers a coherent, self-contained preface to the experience to come. From this westmost point in the church, the least of the fresco is visible, but if we heed from the first the directives of the architecture, our reward is a formally balanced arrangement of introductory emblems, neatly embraced by the overarching vault—a frontispiece to the subsequent nave views.

While the figures of the Baptist and St. Hilary are still concealed behind the nave vault, their attributes, the lamb and the bishop's crosier and miter, are visible within the arch and to either side of the fictive relief (fig. I). Silvery clouds of a palpably three-dimensional projection seem to spill into the church itself in defiance of the confines of the niches and the molding of the crossing arch, intriguing the viewer with a preliminary sample of Correggio's magical illusionism. Amid these clouds appear several angels, some of whom attend to the attributes with delight and reverence. For the viewer at the door, one prominent angel in the left half-squinch is annunciatory in purpose: leaning back as if into the space over the crossing, he turns to smile and to urge our attention to the lamb as soon as we enter. A corresponding angel in the right niche who holds St. Hilary's foot also looks to us intently and performs a similar communicative function. He shares the vertical axis of the crosier with another angel who gazes instead into the church below. This twinning of angelic functions also links a pair who partially emerge, left and right of the fictive relief, to gaze and to gesture in tandem. The Atlantean angels in the forefront of each squinch, each astride a ball of clouds and bearing another upon his back, also form a conspicuous parallel when seen as here without the saints. Even the clouds create a compact subcomposition of their own within the delineating bound-

ary of the crossing arch. But the particular placement of the attributes themselves, the focus of the grouping in the half-niches, especially accommodates the viewer at the door.

The idea of equating the patron saints' attributes and even of framing them in an architectural setting appears earlier in Parma in Cristoforo Caselli's impressive altarpiece of the *Madonna with the Baptist and St. Hilary*, painted in 1496–99 for the Cathedral chapel of the Consorzio dei Vivi e dei Morti (fig. 20). The verticality of the cross echoes that of the staff in Caselli's Belliniesque symmetry, and the scroll and book, too, are posed as equivalents. The saints stand like the piers of a church holding out their objects in front of the vaulted architectural setting that shelters the Madonna and Child. Correggio also projects the attributes of the saints of Parma forward, but in the architectural context they are first seen as independent symbols, only later as attributes held by their respective saints. The symbols are grouped directly across the choir from one another, and by so centering them, Correggio ensures their visibility as assuredly as do the mirthful and pointing angels.[1]

Because of the isolating action of the nave vault, the pair of attributes, held aloft by angels, are much like the proprietal statement of a coat of arms, and here work as emblems not yet of their saints but of the Cathedral into which we have entered. The lamb embodies the continuation of Christ's redemptive sacrifice as practiced in the Mass, especially at the altar in the crossing below. The crosier, similarly silhouetted against the ribs of the squinch, and the less visible miter remind the worshiper of the bishop's pastoral and administrative authority within the mother church of the diocese. The half-niches, here placed over the triumphal arch of the crossing, proclaim what the viewer will find within, for the church we have just entered is the realm of the rites of salvation and the bishop's seat. These motifs flank the fictive relief and sculpture around the window of the drum, which, as an integral part of this door view, deserve closer inspection.

The fictive reliefs (figs. 21, 22)—painted in imitation of bronze and made up entirely of classicizing elements—have always been treated as merely ornamental marginalia to the cycle and so have never received the attention their strategic placement warrants.[2] These must, however, have held some importance in the canons' conception of the program, since the inclusion of figured compositions painted to imitate bronze is specified in the contract ("istorie . . . che imiteno il vivo o il bronzo o il marmoro"). They are located to either side of each of the four windows between the squinches. Each fictive bronze panel, in a mirrored response across the window, pairs two variations on the same cartoon; in the north, south, and west, a putto plays with either a serpent or a cornucopia (fig. 21). The fresco for the east wall, however, because of its more public orientation, subtly violates that decorative ordering (fig. 22). Here both putti, including that of the panel on the right, entertain serpents. Due to an irregularity in the medieval structure, the east face is also wider than the other three, and therefore receives a more luxuriant acanthus ornament.

The small boys that play amid the coiled fronds hold cornucopias and fondle serpents. Gould compares the figures to the Hellenistic *Boy with Goose* in the Capitoline Museum,[3] but a closer prototype exists in the same collection. With one knee cocked before him, the other tucked beneath his chubby body, leaning back on one hand and with the other clutching the serpent close before his face, each of Correggio's snake-teasing putti recalls the Roman sculpture (second century A.D.) that perhaps depicts the infant Hercules performing his first feat of strength (fig. 23).[4] Correggio's infants are less grave, less wary than the antique child; their jollity recalls Theokritos' telling of the

tale of the infant Herakles who, after slaying the two serpents, "jumped up and down in childish pleasure, and laughed."[5]

In Christian terms, and specifically in the Marian context of the Cathedral, the serpents refer to the instigator of man's fall from grace and are emblems of original sin. God condemned the serpent in Genesis 3:15: "I will put enmity between you and the woman, and between your seed and her seed; he shall bruise your head, and you shall bruise his heel." From the Middle Ages, the conflict between the serpent and the Woman was absorbed into the counter-parallelism of Eve and Maria-Ecclesia. But while the medieval artist depicted the Woman herself treading upon the serpent,[6] Correggio signals the theme by means of Herculean putti, four of whom actually pinch the reptile's head. The bursting seed of the adjacent acanthus is a further reminder of the text of the Old Testament passage. The spirited antics of the putti, who make a plaything of the devilish temptor of the Garden of Eden, are a fitting overture to the Virgin's conquest of sin and death. They need not strain to suppress the reptiles, rather they demonstrate by their playful confidence the vicious animal's impotence in a happy mocking game. Eve obeyed the serpent, whose force is now spent since her virtuous counterpart, the Virgin Mary, will regain Paradise. We have but to step within the body of the church to see the emblem of evil already rendered innocuous.

The use of comical putti for serious themes is a common Renaissance convention, one favored especially by Mantegna and his school and employed by Correggio himself in the Camera di S. Paolo, where the children who dash behind arboreal portholes imitate, in an unstately fashion, a triumphal return from the hunt (fig. 24).[7] In the Cathedral, Correggio works the notion to a new level of significance. The lively activity of the putti in the Duomo, in fact the very frivolity of it, tells of the effectiveness of the Virgin's conquest of sin. It is reasonable, then, and typical of his awareness of *in situ* concerns, that Correggio should include not one but two snakes on the east face in order to make the reference to the implications of the Assumption even more emphatic.

The putti ride dolphins, which, as the swift bearers of souls and symbols of resurrection since ancient Greece, make further allusion to the Virgin's miraculous victory over death.[8] Exploding swags of fruit and gushing acanthus, heavy with regenerative growth, echo the fecundity of the cornucopias. Representative of life and abundance, the cornucopias spill upward, rising snakily against the windows like braces for the jambs and underscoring the vertical force of the design. They press forward in the pseudo-relief nearly as far as the fictive marble angels and sphinxes. The putti, snakes, cornucopias, and acanthus leaves are drawn from antiquity, but Correggio combines them into a fictive sculptural frontispiece that thematically introduces the illusionistic scene of the Assumption above, the celebration of Mary's redemptive role.

From the undamaged figures immediately over the north and south crossing arches (figs. 21, 25), the corresponding subjects of the east and west arches can be determined. Here, winged nudes would have similarly lounged on the curving console of the keystone. They, too, would have casually dangled in one hand the ends of the beaded and petaled garlands that fall from the sphinxes' hold. Of the surviving figures, one is male, the other female; both have large wings that drape gracefully over the molding of the arch. Correggio seems here to have invented a unique type of being, not subject to the gender exclusivity of angel or victory.[9] In fact, though they are depicted in imitation of marble, the texture of their feathery wings and the slenderness of the beaded thread con-

tradict the otherwise stony appearance of these figures.[10] It would be of some interest to know if these angels looked up to the Virgin, as the sphinxes do, or down to the viewer. The frescoed wall would have filled the lower portion of the window and has since fallen away.

The decorations that remain on the other faces also show that the formal culmination of this portion would have been the sphinx, as Toschi represented in his watercolor reconstruction (fig. 26).[11] From her central uppermost position on the cardinal wall, her extended head and upward gaze would have hinted toward the "real" figural activity that lies above the emblematic preface. Some art historians pass over this figure as an unusual whimsy (Gould gives it only a parenthetical mention),[12] and most fail to note it at all. According to Popham, "painted in chiaroscuro . . . there can be little doubt that [the sphinxes'] function here is purely ornamental."[13] But Correggio's employment of the sphinx is consistent with its proper place in Christian art and with the textual tradition from which Renaissance use derives. By capping the apex of the door view with a sphinx, the artist presages the revelatory nature of his design.

Popham, though he dismisses the sphinxes as decorative, refers to the apocryphal *Acts of Andrew and Matthew* in which a sculpture of a sphinx speaks at Christ's bidding and tells heathen priests that the man they question is indeed not only man but God.[14] The faith of the apostles wavers when the priests ask why they believe the son of Mary and Joseph is the son of God, but Christ restores their belief in his divinity by a miracle:

> *On the right and left of the temple Jesus saw two sphinxes carved, and turned to us and said: Behold the form of the heaven: these are like the cherubim and seraphim in heaven; and he said to the sphinx on the right: You semblance of that which is in heaven, made by craftsmen, come down and convince these priests whether I be God or man. It came down and spoke and said: O foolish sons of Israel. This is God who made man. . . . Tell me not that I am a stone image: better are the temples than your synagogue.*[15]

Such a tale might well interest an artist creating his own "semblance of heaven."

Not only in the apocryphal passage, but in Renaissance art, sphinxes are nearly always rendered in stone, either actually sculpted, as in Desiderio da Settignano's tomb for Marsuppini, in S. Croce, Florence, and Cristoforo Romano's monument for Gian Galeazzo Visconti in the Certosa at Pavia (figs. 27, 28); or represented as if sculpted, as in Castagno's fresco of the *Last Supper* in Sant'Apollonia, also in Florence (fig. 29).[16] The visual models available to the artist would have certainly been sculptural. Heemskerck's drawing (ca. 1532) of Jacopo Galli's outdoor antique collection shows two sphinxes, one in relief (Graeco-Roman) and another (Egyptian) in the round (fig. 30); but sculptural prototypes alone did not, as well proven by other examples, dictate exclusively sculptural treatment by Renaissance artists. Renaissance sphinxes often are living sculpture, ready to speak like those of the apocryphal acts, and their activity betrays their special insight. In Marco Meloni's altarpiece of 1504 (Modena, Galleria Estense; fig. 31),[17] prominent sphinxes decorate the corners of a pedestal for the Virgin, but these turn to one another in a manner that displays a mutual understanding and an intelligence that transcend their apparent substance. The inquisitive figures that surmount the window of Parma Cathedral follow this type, the sphinx of speaking stone.

Though it is not clear from Popham's discussion of two Correggio drawings on a sheet in the Ashmolean Museum, Oxford, the sphinxes in these earlier plans must be read as fictive sculpture (figs. 15, 16).[18] The sphinx is especially clearly developed at the lower right of the verso drawing, sketchily echoed in the opposite corner of the same sheet, and reappears (perhaps traced from the first) on the lower left edge of the recto. Like a hybrid of the two pieces in Galli's garden, and close in function to the armrests in Castagno's *Last Supper* or Donatello's bronze *Madonna* in the Santo in Padua, each of Correggio's drawn sphinxes faces forward in profile, forepaws neatly resting on a small stone block.[19] Such rigidity in a living being would be exceptional in the artist's oeuvre. In fact, the larger scale of the farther figure in the right verso group strikes a spatial anomaly until we accept that the smaller, strictly attentive foreground figure is the sculpted side of its throne. On the recto, the same creature attaches itself to a blocky chair parallel to the picture plane. Here the contrast between the rectilinear containment of the sphinx and the organic slouch of the seated figure behind it underscores the difference between furniture and "real" figure. Correggio suggests the texture of stone relief by using a lighter, more tentative touch of the red chalk than that employed for the robust and slouching figures nearby.[20] In the fresco, this area comes completely to life as the apostles invade it, and the sphinxes drop down to the level of the fictive relief and turn frontally. They keep their Egyptian earflaps but gain in feline tactility, psychological acuteness, and contextual pertinence.

To cite the chiaroscuro medium in which Correggio and other artists paint sphinxes as proof of their merely decorative value is to ignore the Renaissance perception that would not allow artists to paint them any other way. Moreover, since fifteenth- and sixteenth-century sphinxes occur often in a funereal context or as emblematic accessories to Mary as *Sedes Sapientiae* (figs. 27, 28, and 31),[21] their presence in the *Assumption* in Parma demonstrates Correggio's awareness of an iconological tradition. They are magical creatures, mysterious visionaries of pagan times, whose stoniness attests to their antiquity and "pauciloquence." Pico della Mirandola, in his *Commentary* on Benivieni's *Canzone d'Amore*, describes the sphinx as a sculpted harbinger of sacred truths:

> It was the opinion of the ancient theologians that one should not rashly make public the secret mysteries of theology except insofar as it was permitted to do so from above. . . . The only reason why the Egyptians had Sphinxes sculptured in all of their temples was to show that theological matters, when they are written at all, should be concealed under enigmatic veils or poetic fiction.[22]

Pico elaborates upon a passage in Plutarch's "Isis and Osiris" in the *Moralia*, the first reference to the sphinx in this capacity.[23] This concealment of cryptic knowledge contrasts with Christian revelation, for after Christ, truth is open to all through faith. In Renaissance painting, the juxtaposition of stone sphinxes with a pictorial portrayal of Christian personages may illustrate that while wisdom in the past was veiled, in the Christian era it is brought to life. The carved sphinxes of Castagno's *Last Supper*, for example, bear silent witness to the institution of the Eucharist. In the decoration in the Cathedral too, sphinxes are stony survivals of the past, like recollections of the striving for truth in an unilluminated time; they can only look on as the Christian event in the

cupola unfolds in a colorful simulation of real life. At the door of the Cathedral, where all we would have seen is the painted area headed by the sphinx, the *Assumption* is still "covered with enigmatic veils" under the vault (fig. 1). From a view of the fictive sculpture and the attributes of the two saints, visible in the doorway, the viewer proceeds toward the altar and the cupola uncovers itself, the revelation of a Christian belief.

The View from the Second Nave Bay: The Squinches Completely Revealed

THE PRINCIPLE of selected and meaningful views operates from the moment the churchgoer enters the Cathedral door and is greeted by the attributes of the two patron saints of Parma in the half visible squinches of the door view. Moving down the nave and into the second bay (fig. 11), the viewer sees the squinches revealed in their entirety (fig. 2). The saints and attendant angels are the first full-fleshed, animate figures in Correggio's cycle visible to the observer entering, as most observers do, from the west, and they form a preface to the still invisible celestial spectacle in the cupola. Like a piece of heaven detached for our benefit and installed before the niches over the piers, the squinch compositions relate to the crossing space and seem to project into it. These cloud-borne apparitions will relate to the *Assumption* in the dome, too. For Correggio, the intermediary architectural purpose of the squinch posed a metaphor for the subject of four saintly intercessors, intermediaries between heaven and earth.

No writer describing the cupola has fastened attention on the squinches and the individual saints for very long. Vasari, though his list is in some ways revealing, is merely the first of many scholars who simply enumerate the saints, and subsequent descriptions of the figural arrangements or the iconography of the niches have been very limited.[1] But Correggio's realization of the capability of one figure to communicate meaning is strikingly apparent in the figures of the saints. Whether confronted with the task of depicting a common saint like John the Baptist or a relatively rare and characterless one like Hilary, two considerations here shape his inventions: the associations these religious figures have for the Christian community of Parma and the relationship of each composition to the church space and to the viewer.

Even the conception of cloud-borne figures in niches, a decorative mainstay by the Baroque period, was novel in the 1520s. The invention of rapturous saints seated upon freely floating clouds was to prove as influential to later artists as the cupola proper,[2] but a tendency to concentrate on the dome has been at the expense of the supporting squinches; and recent writers too, perpetuating Mengs's bizonal perception, have treated them as separate from the upper cycle or have passed over them altogether. Commentators on the squinches focus again and again on two themes: the incredible illusionism of the pictures of cloud-filled niches with figures and the charming but surprisingly casual

angels. The angels await a discussion of the figural compositions of the individual squinches; but the issue of illusionism, which brings with it all related aspects of viewing, is so basic to this study that an analysis of the attitudes of earlier writers on the topic must be addressed immediately.

Mengs, one of the few observers to single out the squinches for special merit in a work done with "all the grace imaginable, and the greatest knowledge of chiaroscuro," notes Correggio's clever use of the real with simulated light to convince us of the presence of the figures in the four niches.[3] Still, it is essential that these four paintings be seen in an architectural context; this context organizes and enhances the meaning of the fresco for the viewer, and the lower placement of the squinches gives them particular status as the preliminary segment of the whole cycle. When recent scholars such as Gould treat the squinches as separate and ideally situated entities and illustrate their arguments with reproductions that do the same, the original sequence of viewing is violated.[4] The only acknowledgment of the interconnections between real events below and fictive ones above has concerned the gestural responses of the saints, which demonstrate, as Shearman notes, that they "assume our presence."[5] The conspicuous gesticulations of St. Hilary in the southeastern squinch especially call attention to the fact that the niche paintings are qualified by the observer,[6] and these directional movements and glances support the *in situ* effects of the squinch compositions.

The interpretation that the clouds are in movement deserves mention only because it occurs in standard monographs with some insistence. While Gronau, who seconds Mengs's admiration for the handling of light and shade in the niches, sees the clouds and figures with them as descending into the choir, Meyer believes the saints are depicted as ascending to heaven.[7] But there is no indication in the paintings of mobility in either direction—no wake of draperies, no trailing clouds—and the conflicting conclusions of these scholars underscore the absurdity of both assertions. Rather, the clouds appear in the squinches as self-sufficient chunks of celestial matter that firmly enthrone the saints, about whom the angels hover in ecstatic attendance. The relative permanence of the squinch compositions provides an element of contrast with the scene of the ascending Virgin.

Despite the fulsome praise with which the dramatic spatial intrusion of the squinch paintings has been described,[8] appreciation of the full extent of Correggio's determination to make a closer than usual relationship between painting and viewer is circumvented by the fragmentary and predominantly formal approach of previous criticism. In the case of a cupola on squinches preceded by a nave, lowest is not least but first. While the squinches have been treated as unimportant addenda to the scheme, recognition of the system of *in situ* views requires a readjustment of the usual scholarly emphasis.[9] This study will begin with an investigation of the eastern squinches, first analyzing the figures in the individual niches in greater depth, then presenting the squinches as *in situ* compositions. The remaining pair of squinches will be examined as they appear to the viewer in the church, that is, with the western part of the fresco that is seen from the presbytery. Such an unusual approach is demanded by contextual experience.

St. Hilary of Poitiers

In the southeast niche is the bishop saint and patron of Parma, St. Hilary of Poitiers (Pl. I; fig. 34). Each of the four angels that encircle the saint performs for him a special service, cooperatively taking

custody of an attribute that he may gesticulate the more freely. The foremost angel immediately below Hilary wedges himself spread-limbed between the clouds. He is the counterpart of the angel who supports St. John across the way, and he also assists Hilary directly by clasping hands with a friend to make an impromptu footstool. Looking up adoringly, perhaps to see the saint he serves, he reaches out and motions to the book. Another angel acts as lectern for this volume, while he imitates the saint's tilted, open-legged pose. The more northerly of the two footbearers is the only figure in the squinch to regard the viewer directly. He kicks up his legs, as if he had just arrived to grasp the hand of his companion and to embrace the bishop's miter. The fourth angel, who might support the crosier with his hidden hand, adds impetus to the trajectory of the saint's gesture both by drawing back one flap of the chasuble and by excitedly following Hilary's finger with his gaze. In the southeast squinch as in the northeast, more independent angels peek from behind clouds at the edges of the composition, their attention engaged by events below.

The saint himself falls back under the force of his own exclamation and reacts demonstratively to both the church below and to the scene above. Pointing with his right hand to the presbytery, his left hand opens above the book; his outspread arms part the embroidered cope to reveal a green lining and the narrow pleats of the surplice.[10] These rivulets of white drapery conceal the ungainliness of Hilary's pose. He sits astride a cloud, his right leg thrust forward and left bent under his body. Since he is bareheaded, we see the integral mark of his vows, his tonsure. The slight incline of the bishop's head, which contradicts the slanting axis of the figure, follows the direction of the pointing finger,[11] but he rolls his eyes ecstatically to the heavenly light painted in the center of the cupola. Even the concentric design of the large brooch that fastens his cope strains slightly upward, the eyelike glint in the jewel echoing Hilary's gaze.

The light to which St. Hilary looks illuminates the salient forms, catching on his hands and brow, the shimmering gold mantle, the white robe, and the cloud on which he sits. The light bathes each attribute as well: the crosier set against the shadowy depth of the conchiform niche, the miter's point (otherwise lost to view), the pale instep of the slipper, and the white leaves of the book. Correggio so distributes the clouds that, aside from the one on which the saint is enthroned, three silvery balls of vapor come forward and flash conspicuously in the light, each near one of these objects or pair of objects. The light source, which falls from the top of the cupola and from left of the squinch, necessitates that the most significant properties of the niche range forward and toward the left in order to be spotlit against the dark recess. This grouping not only answers requirements of illumination, but also, as we shall see later on, the demands of the architecturally determined context.

The particularized and unusual character Correggio creates for St. Hilary deserves investigation.[12] His blond windblown curls, boyish smile, and unconstrained demeanor assimilate him to the lively company of the frolicking angels. In Correggio's depiction, the young and beardless bishop wears the dignity of his station with an adolescent energy that thrusts aside, like his cope, the outward pomp of ecclesiastical office.

St. Hilary's attributes refer to his status as bishop and writer, but Correggio, instead of looking to any prototype for the saint's appearance, created for him a newly distinctive personality. St. Hilary had rarely been portrayed in Italian art. Even in France, where one would expect to find a developed iconography for the fourth-century bishop of Poitiers, recent scholars have pinpointed

very few images of the saint in painting, sculpture, or glass.[13] Though Hilary had been patron saint of the city at least as early as the thirteenth century,[14] surprisingly few depictions of him survive in Parmesan art. These, which tend to portray Hilary as aged, bearded, and blessing, seem not to have sparked Correggio's interest.[15]

Two works painted for the Cathedral itself provide successive examples of the vicissitudes of Hilarian imagery as it relates to Correggio's fresco: one, an altarpiece predating Correggio's painting by two decades, another contemporaneous with the artist's activity in the Duomo. In the large *pala* by Cristoforo Caselli, Hilary is lean and humorless (fig. 20). He displays his attributes, an elaborate pastoral crook and a book, and glances out at us. Michelangelo Anselmi's altarpiece for the Compagnia di S. Sebastiano, the *Madonna and Child with Saints Sebastian, Roche, Biagio, and Hilary*, still situated in the chapel in the Duomo for which it was painted, was executed during the years in which Correggio was engaged in the Cathedral project (fig. 35). It is the most dependent depiction of the saint, and the vitality of the characterization shows the influence of Correggio's conception. St. Hilary, in the left foreground, turns his back to us in three-quarter view. The surprised gesture of the right hand, the miter set down to reveal his tonsured head, and the open book are evidence of Anselmi's debt to Correggio.[16]

Useless too is the image of Hilary developed by the hagiographers. The *Golden Legend* includes fantastic accounts of the saint: God grants his prayers for the death of his daughter Apia that she may have no chance to forsake her virginity; and Hilary's prayer for vengeance on a proud pope takes the form of a fatal case of dysentery.[17] Correggio does not find these tales inspirational for his fresco. The spareness of Hilarian imagery in art and the stern, spiteful personality of popular legend deflected the artist along an independent and personal line of inquiry. He turned instead to another authority, the saint's name, and to Hilary's accomplishment in Latin and scripture.

Correggio's depiction of the saint deviates from all earlier and later representations by showing him not as a somber and bearded leader of the church but as a cheerful young man. The fresco of St. Hilary of Poitiers (Sant'Ilario or, in Latin, "Hilarius," and our Hilary) impresses us immediately by a happy and exuberant spirit that, like the supporting clouds and angels, threatens to spill into the church below. As the saint turns his gaze to the heavenly light painted in the center of the cupola, he smiles.

Ambrogio Calepino, the Milanese lexicographer of the sixteenth century, gives the Latin adjective "hilaris/hilare" the synonym "laetus" and the Italian meaning "allegoro, giocondo, lieto."[18] Peter Damian, in his sermon for the saint's feastday, draws upon the Latin meaning of Hilary's name: "For the very dignity of the remarkable name excites us, so that our own mind, moved with a spiritual joy, applaudingly rejoices (*hilarescat*)."[19] The "hilarity" of Hilary is etymologically sanctioned, too, in the *Golden Legend*, where Jacobus de Voragine states the derivation more simply: "Hilary comes from 'hilaris,' joyful; for he was indeed joyful in the service of God."[20]

The visual equivalent of etymological characterization occurs in a type of Renaissance portrait where name inspires image. For example, in Leonardo's *Ginevra de' Benci*, the juniper bush that acts as a dark backdrop for the sitter's pale features refers to her first name. Yet another type of visual wordplay, in which the artist plays upon his name to place himself as witness of a sacred event, oc-

curs in Taddeo di Bartolo's *Assumption* in Montepulciano. The inscription in the halo of one particularly individualized apostle, who is also the only disciple whose gaze directly meets the viewer's, identifies him as Thaddeus and confirms that the artist Taddeo has painted the saint of his own name in his own likeness (fig. 36).[21] Cecil Gould claims to have found a similar self-portrait by Correggio, in the altarpiece of 1514–15 painted for the church of S. Francesco in the artist's hometown of Correggio, and now in Dresden (fig. 37).[22] Indeed, St. Anthony of Padua does seem more specific in feature than his Peruginesque, Leonardesque, and Raphaelesque companions. The supporting evidence that the figure represents Correggio's name-saint, Anthony, puts him in the category of hagiohomonymic imagery.

In written documents, Correggio had already invented a name for himself that laid claim to good qualities and humanist wit; this is of considerable relevance to the fresco of St. Hilary. On October 14, 1522, in the contract for the altarpiece of the *Adoration of the Shepherds*, now in Dresden (fig. 38), the patron Alberto Pratonero called the painter "Antonio da Correggio Pittore," just as he is called in other documents from 1519 on. In an autograph addendum to the agreement, however, Correggio refers to himself as "Antonio Lieto da Correggio."[23] He translates his patronymic "Allegri" ("happy," "joyful") into the Latin "laetus" (also meaning "joyful"), arriving at a more Latinized version of his own name, the adopted name "Lieto." In a subsequent autograph note for the monks of S. Giovanni Evangelista the artist again indulges in this cheerful affectation, and on December 12, 1524, he baptizes his first-born daughter "Francisca Letitia."[24]

The characterization of Hilary as a joyful saint is a painted variation on the same theme. While the squinch figure is not a self-portrait, there may well be an element of self-identification that provokes Correggio to paint the eloquent Latin scholar and patron saint of Parma as good-humored. If Gould's identification of the artist's early self-portrait is correct, then Correggio had already presented an image of himself as smiling. This sequence of self-references, some admittedly speculative, at least calls into question Vasari's description of the artist as "nell'arte molto maninconico."[25] In any case, given the tradition of the etymological panegyric, the Renaissance interest in homonymic visualization, and Correggio's own fascination with happy Latin puns, it would have been natural for him to think Sant'Ilario into "hilarius," and then to endow the saint with suitable "hilarity."

The Latin basis of the portrayal is singularly appropriate for a saint renowned as a skillful Latin prose stylist. But in the early sixteenth century, the connotations of Hilary's name would have had a special meaning. The festivities for the popes, to celebrate the military and political deeds that they accomplished as sovereign rulers of the papal states, were officially called *hilaritates*. The imperial Roman source for these triumphal entries was apparent, for instance, in the *hilaritates* for Julius II of 1507. On Clement VII's less distinguished return to Rome from Bologna, in 1530, the Roman Council and Conservators decreed it the duty of the people to *hilaritatem ostendere* (show joy officially).[26] Considering that Correggio's commission for the Cathedral fell less than a year after the papal troops had ousted the French from Parma and claimed the city for the pope, this association may have also been inspirational for the artist's conception. The theme of the Cathedral fresco, the Assumption of the Virgin, alludes also to the Triumph of the Church in the guise of "Maria-Ecclesia." Correggio

emphasizes the patron saint's name in a cycle that is in effect a *hilaritates* in fresco. As Hilary looks up to the event in the cupola, his joy is part of the general rejoicing of the Assumption and in happy concert with Parma's newly won papal protection.

St. Hilary had a more serious side as well. The patron saint of Poitiers and Parma was of considerable importance in the early development of the church in the West. Born in the second decade of the fourth century of pagan parents and baptized, then made bishop in his native Poitiers, he was a politically astute and persuasive voice against the Arian heresy. After gathering all the Gallic bishops to his side to defend the Nicene Creed against the heretical tendencies of the court in Constantinople, he was exiled in the East, where he achieved a familiarity with Greek and scripture unrivaled at that time in the West. His writings, aside from the polemical attacks, include his Commentaries on Matthew (*In Evangelium Matthaei Commentarius*), the *De Trinitate*, and the *Tractatus super Psalmos*. These were respected as remarkable models of Latin prose and Christian exegesis by admirers from the next generation, like Jerome, and by scholars of Correggio's own era.[27]

St. Jerome, a late contemporary of the saint, testifies in his letters and in the *De Viris Illustribus* to St. Hilary's eloquence and names him "Hilarius latinae eloquentiae Rhodanus." On several occasions he measures rhetorical achievement—his own and others—against the saint's.[28] In his treatise on the Trinity, Hilary himself beseeches God to "bestow upon us . . . the meaning of words, the light of understanding, the nobility of diction, and the faith of the true nature."[29] In this way he prays that divinely inspired faith and eloquence may make him persuasive in the cause of true Christian belief. Hilary, unlike other Fathers of the Church, does not modestly apologize for the insufficiency of his ability to discourse on the Trinity, but thanks God for the "readiness of speech which you have granted me."[30]

Hilary's writings and reputation were known in the Renaissance. The early-Quattrocento patristic scholar Ambrogio Traversari appreciated Hilary's writings and owned twenty volumes of his work.[31] Closer to Correggio, the Parmesan humanist Taddeo da Ugoleto counted in the inventory of his library an edition of *De Trinitate* and the saint's commentary on the Psalms.[32] Hilary's rhetoric stimulated the interest of Pico, and Erasmus edited his *Opera* in 1523 with a prefatory dedication defending his contemporary value.[33] This attention indicates that in Correggio's time, attitudes toward the saint went beyond the medieval view of him as the miracle-worker presented by Venantius Fortunatus, Sulpicius Severus,[34] and the *Golden Legend*, and that Renaissance scholars regarded Hilary instead as an illustrious practitioner of high-flown Latin style, enlisted in defense of Christian dogma.

Correggio's inclusion of a book as one of Hilary's attributes alludes to the saint's renown as learned Latin theologian and as biblical scholar. Perhaps the Parmesan artist could have known an author portrait like the fifteenth-century French illumination that shows Hilary in his study before a lectern with several books, in a situation that emphasizes his scholarly pursuits.[35] But more important, Jerome had praised the content of Hilary's work as insurpassable for interpretation of the scripture.[36] Besides his purely scriptural defense of his position concerning the doctrine of the Trinity, Hilary's exegesis on Matthew was the first in Latin. The edition *princeps* of the *Opera* of Hilary, including the *Explanatio in evangelium Mattaei*, appeared in Paris in 1510. Erasmus's volume of 1523

was primarily a more rigorous edition of the Paris version; it included the scholar's letter to Jean de Carondelet attesting to Hilary's eloquence and scriptural knowledge and evoking Jerome's praise as his authority. The appearance of Erasmus's edition (as well as two reprints of 1526 and 1535 by the same publisher in Basel) supports the notion that Hilary's importance as biblical commentator was in circulation in the period contemporaneous with Correggio's depiction.[37] On the basis of this interest in Hilary, the book the saint indicates in the southeast squinch can most certainly be identified as biblical, and probably the book of Matthew.

In the Cathedral, Hilary's movements call attention to the authority of the scripture. While his left hand indicates the book, proudly held open and in turn indicated by two angels, his right hand commands the viewer to look to the presbytery. Although Hilary's youthful joy and the reference to his Latin and scriptural learning have gone unnoticed, we are on more recognized if misunderstood ground concerning his gestures. The writers who have described Hilary's movement observe correctly that he gestures to the choir below, but they differ as to the nature and destination of this motion. What Gronau refers to as a "blessing gesture" is to Ricci, Thode, and Shearman an indication of the altar.[38] Indeed, his right hand is carefully framed by the other attributes and set into conspicuous relief by the dark lining of his robe and the shadow of the shell. The insistent backward glance of the angel who holds open Hilary's cope reinforces the directed emphasis of the saint's movement, which is surely indicatory. But we need to observe that the gesture overshoots the center of the crossing where the altar is now and would have been in Correggio's time. Viewed in the Cathedral, it becomes clear that the angle of the saint's finger seeks a point well north of the altar. To what is Hilary pointing, then, if not the altar?

If we recall the appearance of the Cathedral in Correggio's time, the most notable feature to the north of the crossing would have been the pulpit. A. C. Quintavalle's examination of the architectural and documentary evidence for the medieval arrangement in the area between the nave and presbytery has demonstrated that an elaborate pulpit was located against the northwest pier of the crossing and projecting into the nave (figs. 11, 39). There, a large elevated platform accommodated a number of clerics and would have commanded the congregation's attention by its conspicuously asymmetrical intrusion upon the presbytery system as it fronted the nave.[39] Renaissance sources provide evidence of its formal prominence for viewers in the west and of its crucial function in the portions of the service addressed to the public. The sixteenth-century observer Da Erba, by describing the pulpit "in forma di teatro,"[40] attests to the visual impact of the celebration that took place in this area. In purpose, the pulpit was the express link between the sacred celebration in the presbytery and the laity in the body of the church, for from this focal point the sermon was preached and the Bible read to the people. Despite its asymmetrical placement, the pulpit was a liturgical center, where the deacon read the Gospel "ad Populi intelligentiam."[41]

Hilary's gesture takes on more meaning once the presence of the medieval pulpit and the events associated with it supply a motive for his action. Not only as a Latin rhetorician but as an example of Christian eloquence, orthodoxy, and dedication to the words of the Gospels, Hilary bids us to hear the reading of the Bible. He is bishop as well as saint, and he reminds the laity of the authority and leadership of that office, as is fitting in the seat of Parma's bishop, the Cathedral. Since the

primary task of that office is to instruct his flock, he acts as a bishop should, by pointing to the continuation of that instruction in the sermon.

St. John the Baptist

In the northeast squinch, John the Baptist embraces his symbol and regards the viewer from a cloudy perch amid excited and gesticulating angels (fig. 40). Although the effects of foreshortening and the gathered yardage of drapery hide much of his body, we can see that his muscular vigor is unravaged by asceticism, just as his round face is uncharacteristically youthful. This portrayal is far removed from the wild man Renaissance artists commonly identified with the Baptist. One art historian sees Correggio's St. John as being "as fierce as Correggio could make him, that is, hardly fierce at all,"[42] but the painter has deliberately chosen to depict a saint comparable in age and deportment to the bishop across the choir. The suggestion of a passionate temperament resides only in the affection with which he proffers the lamb. The unusually luxurious red cloth that accompanies the "garment of Camel's hair" (Matt. 3:4, Mark 1:6) is not the customary robe but an independent piece of fabric; only a tag of red behind the saint's right hip suggests that it offers any sort of covering. It alludes in color to the sacrifice that the lamb represents and enables the Baptist to bear respectfully the sign of the Passion just as the priest bears the sacrament. The use of the cloth is symbolically theophoric, allowing display and worship of the lamb,[43] while the actions of the angels reemphasize the exposition of the eucharistic symbol. The lamb, nestling in the saint's draped arms, refers to his recognition of Christ as the redeemer of man's sin, a concretization of the precursor's own words in John 1:29: "Behold the lamb of God, which taketh away the sin of the world."

So seemingly conventional is Correggio's portrayal of St. John that it comes as a surprise to find that, by presenting an adult saint who fondly holds the lamb, the artist has created an unprecedented image for the subject. Even in northern Europe, where the lamb is most likely to be the grown Baptist's accompanying attribute, a paten or book, held by the saint like a platform for the small symbolic creature,[44] keeps animal and man physically apart. John is frequently present in Italian *sacre conversazioni*, but he usually carries a cross, a scroll, and sometimes a baptismal cup, and often acts out his indicatory function in the Gospel. When Italian Renaissance painters do depict the Baptist with the lamb, they consistently represent the subject in one of two ways: the infant Baptist may hug the animal or it may remain at the feet of an indifferent adult saint. In Lombardy, the followers of Leonardo perpetuated the theme of the Giovannino at play with a lamb; for instance, in the *Vierge aux Balances* in the Louvre, once attributed to Cesare da Sesto, the infant precursor fondles a woolly playmate by the side of the Christ child and under the Virgin's supervision (fig. 41).[45] Venetian Baptists, old and young alike, commonly enjoy the company of the ovine attribute (perhaps in deference to a northern influence) but almost always accept the custom that associates age with reticent behavior, as in Titian's portrayal of the mature saint (fig. 42). The fresco in the Duomo in Parma is a synthesis of both iconographies into an effective illustration of the Baptist's relation to Christ as stated in the New Testament.[46]

The tender relationship between the saint and his attribute may embody more than mutual fondness, for the painter's portrayals of emotional attachment are frequently motivated by more than a

tendency toward the sentimental. The lamb, whose smile is eerily human and whose glance is know-
ing, behaves like no ordinary creature of his kind. Pressing his cheek to John's, he wraps the saint's
neck with his right foreleg in a hooved embrace, while the saint's left hand provides support. We have
seen that the arrangement is unlike any other depiction of the same subject, but the poses and the
psychological rapport of the two figures can be found often in images of the Virgin and Child. An
evocative parallel can be seen in the icons of the Virgin and Child *Eleousa*, the Byzantine formula for
intimate depiction of the Madonna and Christ child posed cheek to cheek.[47] Correggio's St. John
transforms the *Eleousa*, substituting new characters but preserving the delicate pathos. The anthro-
pomorphism that invests the lamb with unexpected emotion allows this attribute to act like the in-
fant Christ in a recognizable type of image.

Correggio's fresco in the Cathedral squinch represents a liberal and pointed use of a Byzantine
survival. While to Tassi the composition evokes a formal appreciation of the contrast of two be-
ings,[48] to an early-sixteenth-century audience the *Eleousa* form would have been familiar through
descendants of the icon type. Examples of its use by two artists admired by Correggio, Mantegna
(fig. 43), and Raphael, point out the continuance of the theme and the extra-thematic associations
of the fresco.[49]

By reference to known religious formulas like the Byzantine icon type and by a realistic portrayal
of human sentiment, Correggio extends the meaning of symbols beyond mere static iconography
into a naturalistic animation of Christian ideas. A comparison with Leonardo's use of the same sym-
bol in the *Madonna and Child with St. Anne* in the Louvre (fig. 44) points out Correggio's unusual vi-
sual language. Leonardo's lamb (though representative of Christ's sacrifice) is an element of nature,
passively drawn into the human exchanges. Correggio's lamb, however, is simultaneously an animal
of realistic form and texture and an emblem that has taken on the compassionate personality of the
sacrificial Christ it symbolizes.

From the eighteenth century on, the psychological warmth of Correggio's paintings was viewed
as issuing from the artist's temperament and as only marginally relevant at times to the religious
theme. Freedberg characterized this aspect of his art as outside even the development of classical
High Renaissance style, and traced, from Correggio's early works on, an individual accent which he
refers to as a "sfumato of emotion" and "shadowed sentiment."[50] But a closer consideration of the
theology depicted shows the intimacy between saint and animal is not just the whimsical result of
an overdeveloped sentimentalism or search for charm; the painter illustrates the significance of the
two figures in terms of active relationship rather than emblem. The subject of the northeast squinch
fresco is the love of the precursor for the sacrificial Christ and the affection of Christ, in his as-
sumed sacrificial form, for the Baptist and mankind. The response between saint and lamb, shown
in naturalistic and human psychological terms, is an image of human revelation and godly conde-
scension effected from divine grace. The spiritual love, which Correggio represents as recognizable
and experiential emotion, allows man to know and to believe in Christ's coming and his own sal-
vation; thus the painter depicts the Baptist's words in the Gospel of John.

Around the Baptist, as around the other three niche figures, move wingless angels. Reaction to
the angels is most often a mixture of begrudging amusement and reluctant censure, which, albeit
confused, is generally positive. Ricci specifies the activities of individual angels with unusual preci-

sion; for instance, he is the only scholar to note the praying angel behind the Baptist, and he rightly finds the angels of the southeast squinch "less smiling and joyous than the others." He chides them all effusively: "O roguish elves, can you not bear yourselves gravely, even in the mystic silence of the temple?"[51] Gould, like Ricci, is disturbed by their levity and a bit puzzled: "They are divinely beautiful and enchantingly naughty. What is more, they are aware of the presence of their fellows in the neighboring squinches, and glance across at them or wave."[52] The antics of these creatures are charming, even humorous, but thoroughly in keeping with the scenes they accompany. The Assumption of the Virgin and the presence of saints should indeed lift the spirits, particularly if those spirits are angelic and therefore especially sensible to events of the soul. Nor could their good humor be called inappropriately giddy or irresponsible, for each angel earnestly and purposively furthers the meaning of the scene or attracts our attention to its salient points. Some hold objects of symbolic importance, some support a saint physically, and some engage our attention downward into the church or upward to the saints in their niches—but each lithe figure actively contributes to the decorative program.

The angels that surround John are gleeful and helpful; no less than four of them are directly involved with the worship of the lamb. Painted light from the cupola illuminates a figure to the right, who, pointing to saint and attribute, looks over his shoulder to make certain we follow his indication. Another braces the cloud under the saint, but it is only playacting, for a cloud in turn supports him. To the left of this figure, another reverently touches one end of the theophoric red drapery which passes behind the saint and strains back in a graceful curve to better gaze upon the lamb. In the innermost reaches of the squinch, two angels pay tribute to John and his attribute: one, near the train of red cloth behind the Baptist, presses his hands together in prayer, and a second, near the saint's left knee, his head just visible in the clouds near the indicatory angel's hand, gazes in admiration. Finally, to either side of the entire composition, two angelic heads peer down into the church. These two have counterparts in each squinch. The gestures and glances of the whole group unite the scene with its ambience. The viewer sees in each squinch a holy figure equally well tended by its angels.

St. Hilary, St. John, and the Commune of Parma

The necessity to see more of the squinches and of the vision to which the sphinx has directed her gaze leads the viewer forward until in the midst of the second bay, the observer is arrested by the view of the two eastern squinches in their totality, surmounted by one oculus (fig. 2). Here we may incorporate the analyses of the individual saints within the program of significant views.

From the nave, the two east squinches and the saints within them inescapably form a pair that invites comparison. St. John hugs his symbol close to his body to conform to an acute triangle, and St. Hilary's expanding arms and farflung mantle make a triangle that is contrastingly oblique. In temperament, too, they are opposites, for the Baptist's seriousness is altogether different from the boyish excitement of his counterpart. John, barelimbed and muscular, looks out at us but retains a firmly settled stance; the bishop saint sways and motions in his heavy drapery, heedless of a tenuous equilibrium. While formally and psychologically the saints are contrasting and complementary

partners, they join forces to remind the onlooker, by their own active and symbolic participation, of the significant events below. The architecture enframes the paired niches and sets the resulting composition apart as an iconographical subprogram aimed at the lay viewer.

In the door view, the saints' attributes specified the very purpose of the Cathedral in the community to one entering its portals: the mystic lamb and the crosier identify it as the *locus* of the Mass and of the bishop's seat. Several steps forward, the patron saints, now completely visible, claim the attention of the lay populace. St. John and his attribute refer to the altar by allusion rather than physically, but his glance is to the visitor. St. Hilary, more demonstrative in his indication to the contemporary occurrences below, insists we heed the works read from the pulpit and provides an example by the book at his side. The two saints, precursor of Christ and guardian of the faithful, together allude to the continuity of Christian celebration that takes place beneath them. All four of the squinch figures are so arranged that this pattern, the pairing of New Testament character with medieval bishop, occurs from each side of the choir. But the choice of the Baptist and Hilary for the squinches of the congregational view is chiefly due to their identities as the patron saints of the Commune of Parma.

The primacy of St. John the Baptist and St. Hilary as civic intercessors over all other saints of Parma has historical basis, for both lay claim to special communal devotion long before any other saints receive such favor. Both were recognized as patron saints as early as the thirteenth century, and acknowledgment of their efficacy was given tangible form in the dedication of churches, chapels, oratories, and parishes.[53] Not only do St. Thomas and S. Bernardo degli Uberti assume the roles of patron saint at a later date, but the Parmesans continue to give preference to the Baptist and Hilary even after the official adoption of these co-intercessors.

Numismatic evidence demonstrates their predominance as well. In 1522, the year after the victory of the Parmesans over the French on St. Thomas's day, a coin was issued with the bust of the apostle. S. Bernardo degli Uberti never received such an honor. But since the opening of the mint in the late thirteenth century, the Baptist and St. Hilary appear on Parmesan coins, first singly only, and then from the mid-fifteenth-century Republic through the 1520s, together, sometimes on the verso of a coin fronted with an image of the Coronation of the Virgin. This combination of three major intercessory powers of the city—the Virgin *Coronata*, the precursor, and the bishop saint—is featured on coins of the early sixteenth century, including those of the papacy of Hadrian VI, the period during which the Duomo frescoes were commissioned (figs. 45a, b). The coin of 1522 shows the two saints standing side by side, sharing the communal standard.[54]

Hilary and the Baptist are the only saints to appear consistently at either side of the Virgin in the most conspicuous public images of the city. On the seal of the Commune, designed by G. F. Enzola in 1471, they accompany the *Coronata* along with the civic invocation to Mary's protection, "hostis turbetur quia Parmam Virgo tuetur" (her enemy is thrown to confusion because the Virgin defends Parma). A Parmesan citizen might have passed every day the image of the Virgin and the two saintly protectors which Bartolino de' Grassi had painted on the facade of the Palazzo dei Signori in 1448.[55] And when in 1520, the elders of the Commune of Parma commissioned a painting from Francesco Maria Rondani for the Commune's chapel or "chiesola," they clearly stipulated the standard civic iconography. Rondani was to paint the Madonna "regina del Cello" flanked by

Hilary and John the Baptist, and to either side, portraits of the twelve elders themselves, kneeling in veneration, with their coats of arms painted beneath and that of the city in the center. Thus Correggio was to paint in the eastern squinches and face of the cupola the same three holy figures that decorated the currency of Parma, the town seal, the facade of the civic palace, and the chapel of the communal council.[56]

The special value placed by the community on the two saints was made visible in the decoration of the Cathedral for the annual celebration of the Assumption. The *Ordinarium* of 1417 states that the *vexillum populi* must be hung from the central peak of the choir for three days for the vigil of the feast day.[57] With the completion of Correggio's fresco, the people of Parma, upon entering the church on the feast day of its dedicatory patroness, would see the standard hanging between the two foremost patron saints, and as they advance, the chief intercessor of the Cathedral and of the city, the Virgin herself. The inclusion of the *gonfalone*, which probably featured the arms of the city, would have introduced the image of a cross into the visual ensemble over the choir.[58] This helps explain Correggio's choice of the Baptist's attribute, for the lamb would amplify the civic emblem without repeating it. The fresco and decorations together would present to the lay visitor a compendium of religious images of particularly civic significance. A more complete popular view from further up the nave would thus on any day comprise what could properly be called "the three patron saints of Parma:" the Baptist, Hilary, and the Virgin rising to her coronation, assembled in one coherent decorative scheme.

The Grisaille Figures

Though they occur below the level of the squinches, the six graceful grisaille figures that stand at the lower interior faces of all but the eastern crossing arches (where Mazzola Bedoli later took up the theme) are not visible until the squinches can be seen in their entirety. There are three boys and three girls, each dressed in loose robes, who hold up or playfully drape themselves in long betasseled scarves of silky material (figs. 46, 47). The subject seems a fanciful one, but here, as elsewhere in Correggio's painting, even the most apparently ornamental passages have some significance. The tasseled garlands these figures hold—which Venturi calls "nastri e corolle di tulipani"—appear also in the hands of the deceased portrayed atop Roman sarcophagi.[59] Similar festoons occur in the sacrificial rites depicted on Roman reliefs, such as those with which maidens decorate ceremonial candelabra in the mate of the "*Borghese Dancers*" (fig. 48).[60] Such a scene is divergently translated in the fresco by both the pier figures and the angelic attendants with the candelabra who will soon appear on the fictive balustrade. The funerary associations of these objects are a prelude to the event in the cupola above, the Virgin's Assumption. The beautiful grisaille figures are not engaged in preparation for the funeral but are taking down the ornamental festoons, since the Virgin has already passed. We see them perform the conclusion of a solemn rite, but smilingly, since they know of Mary's triumph.

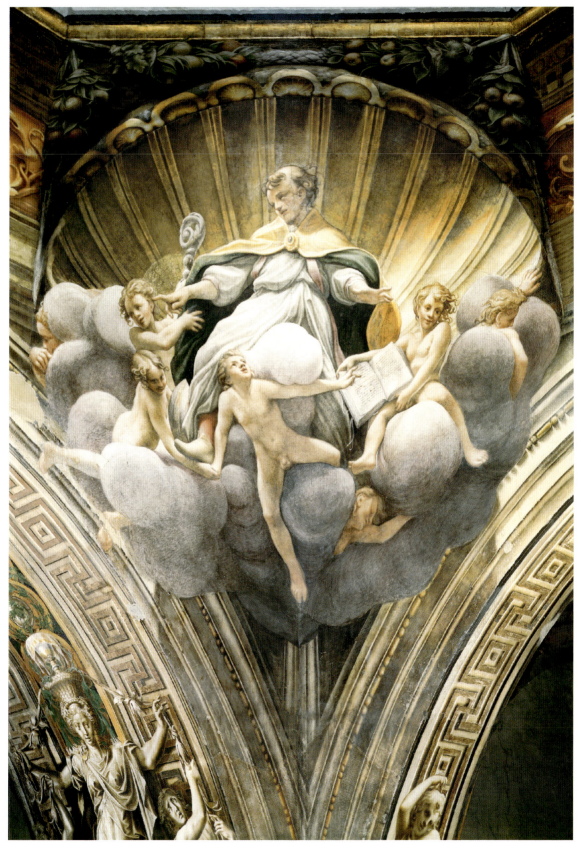

I. St. Hilary of Poitiers

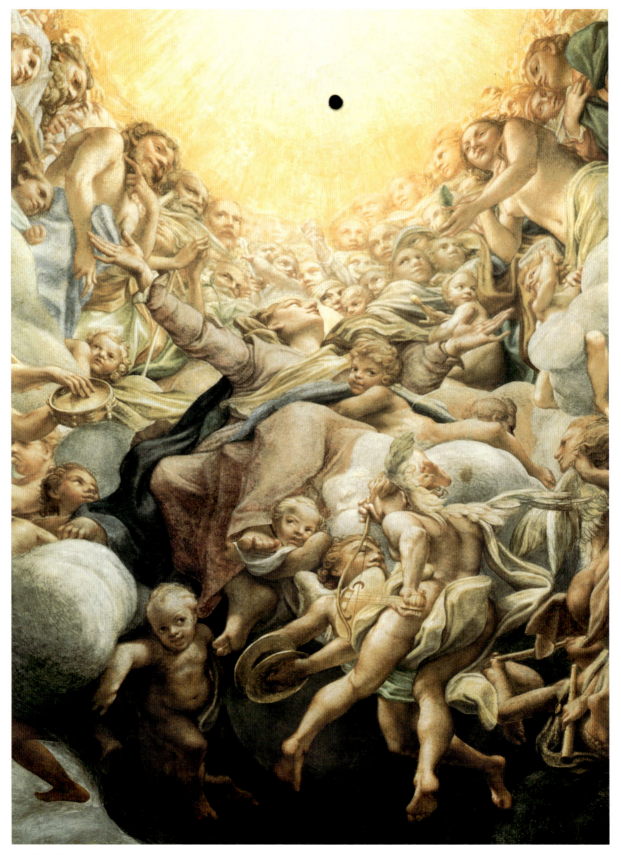

II. The Virgin and Adam and Eve

III. Old Testament figures; male figures to the Virgin's right

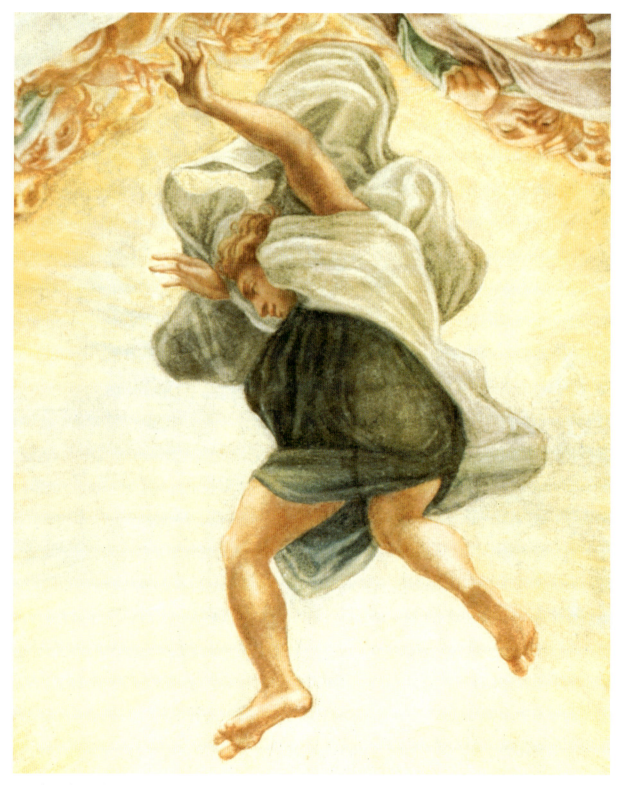

IV. Christ descending

THREE

The View from the Fourth Nave Bay: The Cornice, Two Apostles, the Dado, and Attendant Angels Appear

As THE VIEWER moves down the nave to the fourth bay, the visible surface of fresco expands to include a portion of the cupola proper (figs. 3, 11). The sphinx and the fictive relief with putti recede in prominence as the powerful simulated cornice and lively figures of the apostles and lower angels make their appearance. Three real windows necessitate the accommodating fiction of the architectural framework, which consists of a deep cornice and thick low wall. These form the setting for the figures that have now come into view. Against the marble backdrop and between the oculi, a pair of apostles shield their eyes from the intense glare of a yet undisclosed source of light. Flaming candelabra rise behind the gesticulating men, while boyish angels tend a censer or seem merely to frolic along the ledge and against the open blue of the sky. This crucial area of the fresco is unfortunately very damaged but legible with the assistance of prints and drawings such as Domenico Boniveri's engraving of 1697 after G. B. Vanni's drawn copy of 1642 (fig. 49).[1]

Above the real cornice that marks off the transitional squinch level rests, or seems to rest, a white marble cornice (fig. 3). With a few perspectival tricks and a masterful command of light and shade, Correggio gives the apostles a wide, projecting marble ledge. This cornice, which runs around the lower octagonal circumference of the dome, also signals the beginning of the Assumption scene proper, and with it a shift from architectural fiction to the illusion of open sky. The play of shadow below the upper, protruding rim of this molding creates the three-dimensional tactility of the illusionary form. With the filling of the lower rim of each oculus with a level layer of plaster, the *dal-sotto-in-su* effect is sustained, for the parapet floor thus seems to protrude from the wall to conceal a bit of window.[2] (Due to the poor state of preservation of this section of the eastern intrados, this is no longer as apparent as it is in the more western oculi.) Similarly, the feet and lower legs of the apostles are invisible. And it is the remarkable subtlety with which Correggio adjusts the tone and placement of shadow and reflected light to perfect consistency with the real and fictive radiance that makes the cornice a tour de force of illusion.[3]

The marvelous deceptiveness of the cornice produced an anecdotal aftermath. In 1652, Giovanni

Domenico Ottonelli and Pietro Berrettini (Pietro da Cortona) describe, to the exclusion of all else in Correggio's wonderful fresco, how

> he depicted a cornice all around [the cupola] with such exquisite artifice, that whoever gazes upon it, rais-ing their eyes from below, cannot believe that it is a painted thing; and this is something all say who come, and it is confirmed by many. The result is that, since it is really Painting, it gives everyone the desire to have it explained immediately, usually by the experience of touching it with a pole, to see whether it is done in relief and stucco, or is really a painted work.[4]

The authors further honor the verisimilitude of the cornice by a comparative account of how the clergy removed their hats for Titian's *Paul III* under the mistaken impression that the pope, not his portrait, was before them. Also in the mid-seventeenth century, the cornice began to earn its own apocrypha. It was not enough, for instance, for Ludovico Vedriani to merely borrow Correggio's fame for his fellow citizen Antonio Begarelli by claiming that the sculptor provided models for the Cathedral fresco; to enlarge upon the casual rumor dropped by Francesco Scannelli, he adds Be-garelli's authorship of the cornice, thereby crediting the Modenese artist with the model for the most astounding and consistently praised piece of trompe l'oeil in the whole cycle.[5] No less than the collector, connoisseur, and queen Christina of Sweden fell victim to the deception and had to see the fresco close-up from the windows between the squinches to be convinced it was only a pic-ture.[6] Ricci seems to recall both this story and Ottonelli and Berrettini's description in his own as-sessment: "Above the narrow cornice of gilded stone, Correggio has painted another and much deeper one, of simulated marble, in such bold and cunning relief to deceive the most practised eye. It is, in fact, only by ascending into the cupola and examining it closely that one discovers it to be a simulacrum."[7] Gould quite rightly feels the necessity of pointing out, in a parenthetical warning to his reader, the real and false projection[8]—a distinction that arouses to this day, in slide presenta-tions and even in the Cathedral itself, the compliment of stubborn disbelief.

FROM THE FOURTH bay, the arch supporting the cupola has lifted to also include a pair of apostles (figs. 50, 51). They stand within the marble structure and between the real windows, their gesticula-tions and drapery encompassing as much space as the setting will allow. These two massive, bearded men convey their feelings by the movements of their muscular limbs. The rippling of the hems and sleeves of each robe, and especially the turbulence of the great outer swathes of drapery, enlarge upon their grand efforts to protect themselves from the intensity of the light above. The source of the ra-diance is yet unseen, but the helpless writhing of the powerful figures is evidence of the strength of these beams. The eyes of the apostles, unlike the sphinx's eyes of stone, are sensitive to the celestial brilliance. Following upon and included with the saints in the squinches, sphinx and bronze putti below, the apostles presage the still-hidden Assumption; they introduce the reunion above and are an essential part of the narrative in the dome.

The apostles as a group are the most frequently criticized portion of the cycle in modern litera-ture on the cupola fresco, and several observers unite in denouncing the exuberance of their move-ments as inappropriate. What Gronau describes as their "exaggeration of increasing mobility" and

Testi as "unseemly and over-agitated attitudes,"⁹ is also disparaged at length by Ricci. To him, the apostles

> *seem to us the least successful part of the work, and we recall the vision of the Apostles in S. Giovanni Evangelista with a feeling of regret.... The nude forms are modeled with the master's accustomed sobriety, whereas the attitudes and draperies have become confused and extravagant. In some passages, indeed, repose and dignity are set at nought.*[10]

Ricci and others[11] add to these objections that of unreadability, which they attribute to the foreshortening, the drapery, and the restriction of the windows. To continue Ricci's observations: "The nude contours appear through the involved and tumultuous lines of the abundant draperies in portions too small to enable the eye of the spectator to grasp the attitude, which is further obscured by the exigencies of foreshortening...."[12] While certain protestations against the logic of these figures and their situation are well observed,[13] many of the criticisms can be countered by a comparison with other artists' depictions of the apostles and by an understanding of Renaissance conventions of rhetorical gesture as well as of the apostles' significance in the unofficial doctrine of the Assumption. Most important, the discussions of the legibility of these figures should be reconsidered according to an amended manner of looking, that is, from the oblique points of view in the Cathedral.

Apostles, the active witnesses of divine events, had expressed their reverent astonishment through spirited movement in much of Early Christian, Byzantine, and medieval art. In the central dome of the *Ascension* in S. Marco in Venice (and in a domical context), apostles adopt the conventional poses of wonderment—indicating, discussing, and shielding their eyes—that continue to be standard in later art (fig. 52).[14] The apostles in Parma Cathedral have Renaissance models for their behavior in the Assumption paintings of Correggio's predecessors, who perpetuated the medieval solution for expressive variety in their own styles. The clamorous agitation of the disciples in the *Assumption* by the usually placid Emilian painters Giacomo and Giulio Francia (ca. 1513, Galleria Estense, Modena; fig. 53) and these figures' particularly rhetorical appeal to the viewer communicate the miraculous significance of the Virgin's bodily ascent.[15] Not only are Mantegna's apostles in the Ovetari Chapel in Padua arranged in a circle, but one, in the back and to the right, raises a hand, palm up and protectively (fig. 54), much like the "blinded" apostle on the eastern face of the cupola. Titian finds that Mantegna's conception of the closeknit group around the tomb suits his own purposes and includes the light-sensitive disciple in his painting of the same subject (fig. 55). The variety and excitement of gestures in the Frari altarpiece, and even particular motifs such as the praying hands, the uplifted arms silhouetted against the sky, the carelessly tossed overcloaks, and the apparently reckless overlapping of bodies, all bring us closer to Correggio's fresco. The foreground figure of Titian's *Assunta*, who strains forward, his muscular arms outstretched in amazement, would not look out of place before Correggio's marble parapet. In all these examples, a developing Renaissance vocabulary of expressive gesticulation (which will culminate in Baroque *affetti*) emerges, naturalistically expanded, from the classical inheritance in medieval art of the pantomime of wonder.

The apostles' gesticulations would not have been at all excessive to viewers educated to High Renaissance expectations. As John Shearman has pointed out, the hyperbolic actions of Correggio's apostles can be likened to the eloquent motions found in Raphael's late paintings, or their proportions to the enlargement of arms and legs as well as gesture in Titian's romanizing *St. Peter Martyr* altarpiece. A comparison of the Parmesan apostles (figs. 50, 51, 56, 57, 73) with the expressive figures from Raphael's tapestry cartoons—Sherman cites the exclaiming figures that surround the dying Ananias—shows how Correggio's exaggeration of physical response for dramatic purpose nears Raphael's. This awareness of the rhetorical value of non-naturalistic grand gesture signals probably an engagement with contemporary theoretical issues of narrative style.[16] The same gestures, so irksome to nineteenth- and twentieth-century critics, endeared Correggio to the Baroque, and it is not surprising to hear Scaramuccia's (1674) compliment to the "majestic attitudes and decorum of these twelve Apostles,"[17] which isolates the apostles as particularly praiseworthy members of the cupola. These powerful figures fascinated artists such as Rubens and the Carracci, who copied them and inserted figures inspired by them into their own compositions.[18]

Commentators such as Ricci and Gronau betray that the probable location of their viewpoint is from the center of the crossing. From directly below the peak of the dome, the apostles painted on the nearly vertical surface of the lower cupola rise above the observer so steeply as to disallow an approximation of face-à-face visibility (fig. 8). For this reason, these viewers complain of the radical foreshortening, the confusion of drapery, and the "dizzying" movements of these twelve figures. But if the painting is considered from an oblique view, such difficulties subside, and the apostles become more easily decipherable (fig. 3). The view from the fourth bay, for instance, makes evident the corrective effect of the oblique approach. The voluminous and emotionally expressive drapery obscures what would be the more ungainly aspects of the foreshortening and produces an ambiguity that allows the figures illusionistic acceptability from more than one point of view as the viewer advances. The combination of figural perspective with the architectural perspective of the cornice and parapet yields an impressively persuasive vision to the viewer either in the nave or in the transepts and apse.

The meaning of the apostles' gestures relate to these noncentral views, too, as a comparison of the eastmost pair with their western counterparts proves (figs. 126, 127). Jumping ahead to what our accumulated experience in the Cathedral will later reveal, we see that all twelve figures are disposed to appear singly on the east and west faces of the dome, and in doubled pairs on the north and south (figs. 56, 57, 73). The similarity of type of the twelve figures in the Cathedral—all vigorous of limb, bearded, and anonymously draped—contrasts with the individualized apostles in S. Giovanni Evangelista (fig. 58). This sameness makes the difference in reaction to the Assumption all the more significant, as a return to our station in the fourth bay demonstrates. The two introductory apostles are unlike the others in one respect: their inability to bear the light from above.[19] The illuminated faces of the other ten apostles, like the shadows brought across the otherwise lit faces of the preparatory pair, inform us that undifferentiated light falls from the glowing center of Heaven in an even ring, its way to the parapet unobstructed. Why then, do two of the apostles cringe, when the other ten gaze openly toward the Virgin and central illumination?

The fundamental significance of this light and the subjective identification of the viewer with

the figures visible from below offer explanation. Light, from earliest Christian art, has served artists as a metaphor for divine revelation. Correggio uses this idea in the so-called *Notte* (*Adoration of the Shepherds*) in Dresden where the birth of Christ brings a glow into a world covered by night (fig. 38). A peasant girl grimaces painfully at the same godly light that the Virgin absorbs full-face; their acceptance of the light displays in natural terms the readiness of each for the earthly presence of the divinity incarnate.[20] Just as Correggio makes abstract subject matter concrete in other passages of the fresco—the Baptist's relationship with his savior, Hilary's devotion to scripture—the apostles' reactions are analogous to different stages of divine revelation. While further east the viewer shares in the apostles' vision of the Virgin, those viewers in the fourth bay do not yet have access to that image. Logically, the only two participants in the Assumption scene visible from the standpoint of the fourth bay likewise share the viewer's limited vision. The reaction of the two apostles provokes our curiosity, and we approach in order to discover from what they draw back in astonishment. As in the paintings of Mantegna and Titian, the differing responses of the apostles becomes a standard means of enlivening the scene of the twelve wondering men at the empty tomb. The reaction of these congregationally oriented apostles in the Cathedral points to the thoroughness with which Correggio considered every element of his program as it related to the particular viewer.

THE TROMPE L'OEIL cornice forms the base for a sort of classical parapet, also of simulated marble. This structure is background for the twelve disciples, platform for the youths and their torches, and setting for the eight windows that puncture the lower cupola. The surviving drawings for this portion of the fresco reflect Correggio's successive progression toward a simplification of form. The curvilinear moldings and voluptuous, candelabra-like column of the Haarlem drawing (fig. 32), and the fluted pilasters, ionic volutes, imposted capitals, and ribboned garlands of the Ashmolean sketches (figs. 15, 16) are all abandoned in favor of dramatically illuminated sheer surfaces. The final design of the parapet, though of uncluttered plainness, plays upon negative and positive spaces and volumes in a fictive context. We seem to have before us a heavy wall, interrupted by the square recesses that contain the oculi. A short cornice caps the whole. The windows, however, are real, and flush with the actual wall, for the false architecture is of course "built" in front of the surface of the dome by the perspective drawing and by the three-dimensionally suggestive chiaroscuro. The perspective implies a massive structure, as do the figures: the depth of the lower cornice exceeds the apostles' gestures, and the width of the upper ledge accommodates the breadth of the angels' activities.

This marble dado links two parts of the decoration, the squinches and the dome, but an architectural definition of this portion of the fresco illusion is elusive. Writers who attempt to specify the architectural function of this element are mostly divided between those who label it a "parapet," or concluding structure, and those who, by calling it a socle or plinth, see it as introductory.[21] Though it is conceived not entirely without reference to the forms of contemporary architecture, the dado answers primarily to the requirements of the depicted drama of the fresco illusion. As the final element of architectural pretense that is seen by the easterly moving viewer before the cycle breaks to the ethereal composition of clouds and figures, the marble dado belongs to the lower regions of real and painted architecture. At the same time, the simulated marble gives the viewer in

the fourth bay a motive to move on to see the upper cupola and the Assumption above. Not only does the white marble of the false wall contrast with the airy vista above it, but it also sets the scene for this illusion of open sky by accommodating the windows, by establishing the relative space, and by preparing an order of unreality that makes the vision of heaven believable.

Just as there exists no wholly satisfactory architectural term for what Correggio has constructed, there is also no real-life architectural parallel or source. A. C. Quintavalle whimsically suggests that the concept of a vault opened to the sky at drum level would have come to Correggio in Rome beneath the unfinished dome of Bramante's St. Peter's.[22] A search for a local equivalent leads to the exterior attic of the body of the Steccata, the primary building project of Parma in these years and one for which Correggio was even an advisor, but Zaccagni's architectural employment of the alternating flat frieze and oculus is less robust than Correggio's two-dimensional rendition. Made of base, dado, and cornice, Correggio's structure is more classical in spirit. The large full volumes have a grandeur and easy proportion comparable to the High Renaissance architecture of Rome, even to Michelangelo's much later apse design for St. Peter's, but are reminiscent of no particular monument of Correggio's time. There is evidence that even an aspect of the real architecture of the dado may be attributable to Correggio. Quintavalle's investigation of the fabric of the dome and Dall'Acqua's of the documents for the preparatory work on the cupola indicate that the oculi were an enlargement of the medieval windows, perhaps requested by the painter himself. The geometric purity of form appears to date from Correggio's Renaissance project, which would make the subsequent plaster filling of the lower rim an even more elaborate strategem.[23]

Precedents for this part of Correggio's fresco may be more easily found by looking at the simulated architecture of other painted vaults. The manner in which the architecture abruptly discloses a glimpse of sky comes most immediately from Mantegna's Camera degli Sposi (fig. 59), a concept also imitated by Araldi in 1514 in the room next to the Camera di S. Paolo (fig. 60). But whereas in Mantegna's and Araldi's ceilings an incidental oculus perforates a continuous expanse, Correggio annihilates the entire substance of the cupola, transforming it into a sky with flying figures while supplying a marble cornice that sustains the fiction.

John Shearman has proposed several possible sources for Correggio's illusionism, which merit attention since they constitute earlier attempts to transform a dome into an open-air vision introduced by a fictive architectural base.[24] In the frescoed dome (destroyed) once in the Cappella Acconci, S. Biagio, Forlì, ca. 1500, which represented the Vision of Augustus, Marco Palmezzano painted a solid paneled balustrade directly above the cornice of the drum (fig. 61). This seems to set back the surface of the dome itself since it retreats sufficiently to allow space for the emperor and the sibyl to stand on a platform before it and over the real oculus; it also possesses a certain three-dimensional volume, demonstrated by the rather wobbly angels who prance along its upper edge. The fictive solidity of the dado lends credence of a sort to the fictive emptiness of the space above, in which the vision of the Virgin and Child hover, surrounded by cherubim, in an iconic image that makes no pretense to perspective effect. Despite the tentativeness of the forms, this follower of Melozzo deals with concepts that Correggio will address as well: the expansion of the given shape of the real architecture into a deeper populated space, in which the impression of a heavenly void

becomes more real through the perspectival shaping of an introductory architectural illusion.[25] Still, the utter lack of monumentality of Palmezzano's style and the geographical distance from Parma intrude upon a formulation of artistic "influence."[26]

Another vault painting, also discussed by Shearman, brings us a little closer to the heavenly vision in Parma. Once again in Romagna, in the Sforza Chapel of the church of S. Francesco in Cotignola, Bernardino and Francesco Zaganelli repeat the Melozzan formula of foreshortened figures seated above the cornice and against a false dado (fig. 62).[27] Here, however, the celestial realm that breaks above the lower zone has a much more convincing quality, since the artists, not content to let the dado do all the perspectival work, have filled the air with naturalistic clouds. These give a newly material atmosphere to the painted sky, further defying the real surface of the chapel vault as well as establishing an ambience for the angels of each upper corner. In Cotignola, heaven is no longer represented as a lack of earthly form, a smooth sheet merely understood as space by means of the contrastingly vivid forms below it (a solution no different in principle from a Byzantine dome mosaic). Instead, the Zaganelli take a significant step in rendering heaven as an illusion of particular tactility, in which angelic beings have a foothold, and even cherubim some physical logic as they emerge from its vapor. Conversely, however, the dado itself appears less substantial. Again this example, rather than posing a compelling precedent, throws into relief Correggio's accomplishment. In Parma Cathedral, both dado and sky are convincing simulations. In contrast to the simulated architecture of these centralized Romagnese decorations, the three-dimensionality of Correggio's dado is required to set the stage as the first part of the dome proper seen by the advancing worshiper and a prefatory statement to the truth of the Assumption to come.

Though the frescoes of Romagna represent interesting stages in the history of ceiling illusion, they fall short, as Shearman also admits, of providing convincing sources for the pivotal illusion of Correggio's conceit. They lack entirely just the qualities that make Correggio's system work almost miraculously; they are without three-dimensional solidity and depth or forward projection, nor are they convincingly depicted with drawn perspective or handling of light, nor ambitious in scale or program.

Closer to Parma, the scattered remains of Lombard fresco decoration in and around Milan offer only a fragmentary notion of what was once, if we are to believe Lomazzo, a flourishing perspectival tradition.[28] In his *Trattato dell'arte* (1584), the Milanese painter and theorist cites as an example of marvelous *dal-sotto-in-su* illusion Bramante's depiction of four evangelists in S. Maria della Scala, Milan, already whitewashed in the writer's lifetime. When Lomazzo defines the difficult art of oblique perspective, in which forms on a curved surface are seen from below and ceilings seem open to heaven, he gives two examples: the first is the (lost) vault by "Agostino da Milano" in the Chapel of the Magdalen in the Milanese church of Sta. Maria del Carmine, depicting "many saints seated upon a cornice;" the second is Correggio's *Assumption*.[29] Franceso Prata da Caravaggio's fresco in the dome of the Cappella del Sacramento in SS. Fermo e Rustico, in Caravaggio (east of Milan), presents a truly curious formal comparison to the cupola in Parma (fig. 63). Along the base of the circular dome, where the artist has simulated a painted balustrade, twelve apostles enact gestures of wonderment against an open, angel-filled sky that rises to a celestial vision now filled by a sculpted holy dove. The most likely date for the fresco is 1525–26, though it has been placed earlier in the

decade. While the given elements recall strikingly those of Correggio's *Assumption*, the provincial solution, in which the painter has evaded almost all demands of foreshortening and adhered to a flat, symmetrically centralized scheme, belies any real connection with Correggio's consummate integration of architecture, figures, and open sky.[30]

If we consider the contextual aspect of Correggio's illusion, which shifts as the viewer advances from fictive sculpture and architecture to an increasing freedom of foreshortened figures in space, a conceptual stimulus might be found in Michelangelo's Sistine Ceiling. The *Genesis* histories of the central vault similarly become increasingly airborn as one advances through the chapel from the relief like compositions of the *Deluge* and the *Drunkenness*, dependent upon the depiction of firm ground, to the celestial images of God creating. These are flanked on all sides and bound by a heavy architecture that at the east and west edges of these narratives admits to the fictive openness of the vault.

Some have tried to identify the level of the apostles and dado as the tomb of the Virgin.[31] This concept equates the octagonal void around which the apostles stand with the abyss of the grave itself. By a literal extension of this idea, the simulated wall becomes the perimeter of the tomb, or even (according to Testi)[32] the polygonal sepulcher. The passage of the Virgin from the grave to heaven is indeed represented in the cycle, and real features of the church combined with the depicted narrative. It is unacceptable, however, that the apostles should stand within a windowed sarcophagus. (Correggio's proposals in the drawings in Haarlem and the Ashmolean [figs. 32, 15, 16] reveal a more elaborate and very untomb like architectural shaping of this element by means of projecting columns and pilasters, and a decorative emphasis of the windows.) The notion that places the grave over the choir, making subterranean the viewer, the clergy, and the altar of the Mass, is somewhat irrational. What we see are the twelve apostles gathered for the event; we have not yet reached the moment, though it has been intimated, in which the Virgin can be seen to have left her tomb. When Correggio calls into play the real structure of the Cathedral, he always respects the meaning of those portions of the church and the relationship of areas and objects to the viewer; it is unlikely he conceived of the space over the choir as literally the "tomb of the Virgin."

Such a theory leaves unexplained, anyway, the simulated architecture. The fresco evokes the illusion of a drum, an extension of the fabric of the church. The dado is a pictorial elaboration of the Cathedral walls, painted as if part of them, and yet, in its classical articulation, of an ideal and separate time. As a setting for the apostles, who themselves represent the many churches of the world and whose mission is the extension of the Word to the ends of the earth, the architectural fiction is appropriate. In the Assumption story of the *Golden Legend*, the apostles are interrupted in the midst of their preaching, swept magically on clouds to the Virgin's bed to witness her death and ascension. Jacobus de Voragine borrows an excerpt from the second homily on the Dormition by John of Damascus:

But a divine command, as if some food or cloud, brought together the apostles from the ends of the earth to Jerusalem, congregating and collecting from beyond any seas the apostles, who, scattered everywhere on the earth, were devoting themselves to the Word from the deep shadows to the heavenly table of the assembly or to the sacred celebration of the spiritual wedding of the celestial couple.[33]

They assemble in Jerusalem, "the eye-witnesses and the servants of the Word, to also serve his Mother. . . ." In the illusionistic scheme, the apostles are facets of the church, attendant upon the victory of Maria-Ecclesia; the marble socle reinforces their role. The artist does not simply illustrate the apostles' part in the *Golden Legend*, but accepting the given account of the Assumption, he draws from the narrative constituents to create a depiction of both apocryphal story and ecclesiological metaphor.

THE FIGURES UPON the dado—not quite children, not quite adolescent, and mostly of indeterminable sex—are wingless angels who tend the instruments of the Virgin's funeral (figs. 56, 57, 65–67, 73, 87, 129–31). All around the parapet, behind the apostles and between the eight immense candelabra of each corner of the polygonal lower dome, they pass bowls, polish candelabra, light incense, point and look out to the viewer, or simply strike poses on the balustrade. The costume of these figures is also ambiguous; the loose scarves of colored cloth float about them, sometimes adhering to their bodies, sometimes undulating upon the air. Although these activities involve a sacred ritual, the angels make a game of it. Some perform their duties with childlike intensity, while others lapse into happy irresponsibility. These figures, of character too ambiguous to be mortal, and so surely angelic, are utterly at ease with the celebration of the Virgin's death because they know she is received into heaven.

Any attempt to describe and to interpret the activities of the wingless angels of the parapet must begin with a search for an organizing system for this part of the composition. From a central vantage point, the angels can be read as a continuous frieze, a band of figures engaged in diverse but related activities, who weave around the massive candlesticks (fig. 8). Venturi, for instance, betrays his point of view when he describes this part of the program as a "ghirlanda" (a garland), in which "the movement speeds and slows in rhythmic waves."³⁴ The formal relationships of the figures resist an effort to isolate manageable groups within the frieze—between the apostles or around each of the candelabra. Again, *in situ* observation yields the most natural and graspable division of the composition and makes sense of the apparent disorder. The west crossing arch presents to the viewer in the fourth bay a group of angels compositionally separate from the rest who take part iconographically in the subprogram of this nave view (figs. 3, 65–67).

The arrangement of these seven angels must be described in some detail, not only because no earlier writer has set this group apart in accordance with the architectural context, and because the fragmentary state of the fresco warrants it, but also because the services the angels perform need clarification. Of the five angels once visible between the two eastern apostles, three are badly damaged and one totally destroyed. For an impression of this important portion of the fresco, we must refer to Boniveri's print from the earliest surviving series of copies of the fresco (fig. 49).

Just within the outer perimeter of this view (to the left and right, respectively, of the upswung arms of each of the two "blinded" apostles left and right of the eastern oculus) sit two unoccupied angels (figs. 65, 67). Their symmetrically contrasted diagonal poses, tucked within the confines of the arch, neatly conform to the architectural enframement of the fresco segment. The central pair over the eastern oculus likewise tilts as if toward a central vertical axis (figs. 49, 66). These four form a leisurely foreground for the real action that goes on behind them. In the center, between the apos-

tles, a pair of standing angels manages a censer. This central motif concerns the preparation of the thurible: while the figure to the right holds up the censer by its chain with his right hand, he lifts the pierced lid with his left, allowing his companion (now entirely lost in the fresco) to drop incense to the ready coals of the bowl. From the censer issues a smoky cloud.[35] An incense boat, passed behind the head of the lounging angel to the apostle's left (fig. 65), and the shiny side of a basin for holy water on the right (fig. 67) are included in this visible segment. The obscured youth to the censer-bearers' left reaches toward the incense boat, the contents of which will probably be used in the thurible (fig. 50). From behind the gigantic cascading sleeve of the left apostle, he turns his gaze up to the yet unseen object of the reverent activities, the Virgin.[36] Though the deterioration of much of the fresco in this area has destroyed the impact of the group, these carefully arranged figures would originally have been the first of their kind to be seen by the worshiper approaching from the door.

Pseudo-Jerome, in his letter on the Assumption, quotes from the Song of Solomon (3:6):"What is that coming up from the wilderness, like a column of smoke, perfumed with myrrh and frankincense, with all the fragrant powders of the merchants?"[37] The metaphor took a canonical place in the liturgical celebration of the feast day from an early period, for instance, in the *Liber Responsalis*, the eighth-century collection of antiphonal responses attributed to Gregory the Great.[38]

By depicting angels in attendance upon the censer, the artist heeds the ritual requirements of the Office of the Dead and alludes to the extraordinary participation of heaven in the funeral celebration for the Virgin. The smoke of the censer is itself symbolic of the relationship of the congregation to the assumptive Virgin. The wafting clouds of incense are likened in Old and New Testament to the prayers of the faithful,[39] as in Psalm 141:2–3:"Let my prayer be counted as incense before thee, and the lifting up of my hands as an evening sacrifice." As a result of the Assumption, the Virgin attains a place beside Christ and listens to the prayers of the people. It is appropriate, then, that the faithful who are assembled in the nave and who offer these prayers see a visual metaphor for their devotion.

Correggio's attention to the practical details that church ritual involves is remarkable, but the censer and basin are often accessories to the death of the Virgin imagery. Mantegna gives special emphasis to these objects in his *Death of the Virgin* in the Prado (fig. 68). In that picture, two enormous candlesticks are set at either end of the bier, and one apostle holds a metal pot. Another apostle steps apart from the orderly ranks of his fellow disciples and to our side of the Virgin to swing the censer vigorously over her body. The censer and basin are also present in both of Dürer's woodcuts of the death of the Virgin and of the Coronation (fig. 69). The purpose of the bowl (to hold holy water for the aspergillum) is made especially clear in the latter and illuminates the function of the object in the fresco in Parma. The tending of censers and lights, performed by apostles in these images, can likewise be carried out by angels. In a painting of the *Death of the Virgin* in Berlin from the school of Giotto (fig. 70), an angel holds up and puffs at the thurible. Throughout Trecento painting,[40] the censer-bearers' active concern in executing this task presages that of Correggio's angels. The symmetrically disposed, censer-tending angels isolated in the foreground of Baldassare d'Este's *Death of the Virgin* in Milan (Pinacoteca Ambrosiana; before 1502[?]) are an almost diagrammatic example (fig. 71).[41] In the foreground of this Ferrarese work and others like it, the pair

of angels with swinging censers create a transition between viewer and funerary bier. Correggio incorporates this tradition into his *Assumption*, for the two censer-bearers of the fresco are also in the "foreground" of the cycle by virtue of their placement on the east intrados, where, of all the angel-acolytes on the parapet, they are the first to be seen from the nave.

The censer, basin, and incense boat, as accessories usually belonging to scenes of Mary's death, do not conventionally appear in images of her Assumption.[42] By borrowing from imagery of the Virgin's death, Correggio, in the lower area of the fresco, extends his *Assumption* to include the events previous to it. The angels and their ritual activities imply the funeral preparations recently left behind by the heavenbound Virgin. As they celebrate her funeral, they are gladdened by her ascent. The apostles, who had gathered for her death, now witness the Assumption. The operations of the angel-acolytes, along with the garland-bearing youths of the piers and the putti, snakes, and dolphins of the fictive reliefs, present to the viewer a prologue to the Assumption that is laden with funerary motifs. The sequence offered the advancing congregation in this way takes on the chronological dynamism of a story. Not only is the meaning of the Assumption gradually revealed by the combined progress of the viewer and the disclosure of the cupola, but the observer moves through narrative time as a result of this programmatic relationship of viewer, architecture, and painting.

The view from the fourth bay has introduced yet another new element, the large brazen candelabra set upon the dado. Though partly obscured by the apostles' gestures, they punctuate the phrasing of the angelic groups and also serve to mask the corner joints of the octagonal dome. Elsewhere, as the views widen, these will gain in importance as the focus of figural action and, along with the smoke that rises from them, as the link between the lower fictive architecture and the skyborne wreath. In contrast with the portion of fresco isolated by the previous station, in which the angels tend censers of a plainly Christian sort, these great classical torches lend the program an antiquarian flavor. Both pagan and Christian significance has been claimed for them, and for the angels' activities around them,[43] but a closer look is necessary to explain the presence of these objects at the Assumption. An examination of the sources for the candelabra, both visual and textual, gives some insight into their possible meaning in the cupola.

Ricci first connected the candelabra with Mantegna's *Triumph of Caesar with Elephants*. Others have repeated this observation,[44] which has seemed to close the matter to further inquiry. It is entirely reasonable to assume the availability of the composition to Correggio, either in nearby Mantua or through drawn or engraved copies (such as Giovanni Antonio da Brescia's engraving of ca. 1500, fig. 72).[45] But how closely and to what purpose does Correggio resort to such a borrowing?

The objects on the corners of the parapet in the Duomo are indeed especially close to the central candelabrum tended by a young boy in Mantegna's *Triumph with Elephants*. In both *Triumph* and *Assumption*, the torches are composed of a base (with slightly concave faces that meet over supporting feet) and a long bulblike stem; they are attended by boys. Both candelabra are concluded not by a cup with a prong for a taper, but by a bowl for oil or incense, and so function as lamps or torches rather than as candlesticks. In Parma Cathedral, a wide flame and dense cloud of smoke erupts also directly from the bronze bowl, with no indication of a candle.

Though Martindale asserts that Mantegna's candelabra were rare in Roman antiquity and unprecedented in Renaissance art,[46] examples of each can be found. Women deck with garlands

similar objects in the companion relief to the "*Borghese Dancers*" (fig. 48), a Roman work now in the Louvre and in the piazza or atrium of Old St. Peter's in the fifteenth century.[47] And a stocky, classical candelabrum, which clearly functions as a torch, appears atop Desiderio da Settignano's Marsuppini tomb in S. Croce, Florence (fig. 27). By the 1520s, classicizing candelabra were common motifs in the Renaissance repertory of ornamental forms, appearing on tombs, architectural relief decoration, and especially in manuscripts.[48]

Correggio's arrangement for the unusual candelabra is also reminiscent of a less antique tradition. In scenes of the Virgin's death, candles are frequently placed at at each corner of the bier.[49] Turning again to Mantegna's *Death of the Virgin* in the Prado and to the Giottesque panel in Berlin (figs. 68, 70), we see that the two candlesticks next to the bier are a convention of Dormition iconography. Correggio follows this tradition part way, by encircling the lower zone with lights, but rejects Mantegna's Dormition candlesticks for Mantegna's Roman oil-lampstands; that is, he introduces triumphal candelabra, clearly pagan in derivation, into a Christian context. Just as the pomp of Mantegna's procession honors the victorious emperor, the ritual the angels perform celebrates the triumphal entrance of the Virgin into heaven. The "antique" putti with serpents showed the Virgin's erasure of the fear of sin and death; the angels on the dado use antique candelabra to celebrate a Christian triumph. Mantegna's *lychnuchi* become an appropriate accompaniment to the Christian apotheosis of Mary.

We will see that as the viewer moves down the nave, the vista opens to include more candelabra and angels who are now concerned with the lampstands. These figures clarify the Mantegnesque reference, showing by their activities the funerary importance of the triumphal candelabra. Of Mantegna's two elephant-riding boys, only one really attends the candelabrum.[50] Above the burning leaves of the cup, he prods the fire or lights a candle. Correggio read the action to his own purpose and split the activity of Mantegna's attendant between several angels on either side of the eastern half of the cupola. One angel, to the north of the group with the incense boat, sets a candle to the flame in imitation of the elephant-borne prototype (fig. 73). A partner cups his hands, probably to drop incense onto the fire. On a congruent segment of the dome to our right, an angel scents the lamp with boughs of cypress (fig. 56). The Parmesan humanist Grapaldus, in his elaborate Latin lexicon, reminds us of the funerary associations of cypress in antiquity, in which "the cypress is considered sacred to Pluto, and therefore the ancients attached it to the houses of the deceased as a sign of death."[51] A detailed description of a Roman funeral, and an unobscure one, is Virgil's account (*Aeneid*, Book VI) of the funeral of Miscenus.[52] Though the rite centers upon a cremation, the "funerary cypresses," the "hot water in cauldrons, to bathe and then anoint the body," and "the offerings of frankincense and meats and bowls of flowing oil . . . heaped together and burned" may be the background for the activities of some of the angel-acolytes.

Ricci, who calls the figures "nude genii" that "raise vast volumes of fragrant smoke to the glory of the ascending Virgin," signals the dual character of the angels with candelabra, without convincingly justifying their presence in a painting of the Assumption.[53] Correggio intermingles the antique and Christian customs of mourning and victory to evoke one of the earliest Christian funeral services. He imagines the event as existing in a time in which pagan and Christian culture intersected. The figures and objects on the parapet are not, however, a mere historical reconstruc-

tion; they participate in the symbolism of the Assumption. The angels celebrate Mary's triumphal death and ascent, and the rising perfumed clouds, matter earthly and pure at once, are a visual parallel for the ascending Virgin.

Like the rest of Correggio's program, the angels, so seemingly alike from the center of the crossing, are differentiated according to the place of the viewer. The group with the censer that first faces the nave viewer (figs. 65–67) recalls the Christian office of the dead, but to the viewer moving forward, the scene opens to disclose a more pagan funeral (figs. 56, 57, 73). The participation of the censer-bearers is quickly grasped as a part of Christian ceremony and prayer, which yet contributes to the narrative movement from death to victorious ascent. The triumphal implications of the candelabra and attending angels are reserved for the more informed viewer, for whom the purpose of this happy funeral is now evident. As we walk from the fourth bay to the sixth, before the stairs that lead to the presbytery, the Virgin herself appears.

FOUR

The View from
the Front of the Sixth Nave Bay:
The Ascending Virgin Appears

THE PROGRESS OF THE VIEWER toward the presbytery steps exposes the ascending Virgin and her angelic entourage (figs. 4, 11). As we move from the fourth bay toward the stairs, dangling legs emerge against the charcoal-colored underside of cloud, and then a throng of musical angels appears as a mass of entwined limbs and wings and swirling drapery. When we reach the middle of the sixth and last nave bay, at a point just at the latitude of the west jambs of the side doors, Mary herself appears (fig. 74). This view discloses more flying figures, and to either side below, more angels on the balustrade and four additional apostles. The celebratory rituals of the youths now visible on the parapet are symmetrically disposed and cooperant with the censer-tending group. To our left, the standing angel cups his hands to drop more scent on the candelabrum (fig. 73), while at the right, we now can see another make incense directly by setting cypress to flame (fig. 56). The newly apparent disciples, arranged in two pairs, now gaze up in unconcealed amazement. Once the crossing vault has risen over the two additional oculi, the source of their wonderment and of the angels' tribute is suddenly before us. Mary sits on a great ball of cloud, in a slice of heaven that teems with ecstatic youths who dance and play in concert with her rising. Light from above falls fully upon her face, upper body and left leg, while her gesture—which sums up the echoing parabola of the clouds, angels, and fictive balustrade—forms an opposing cup to the framing arch. To this luminous hub, all activity in this view seems to mount.

From the middle of the sixth bay, the opening lid of the nave vault widens to show the Virgin and her cloud at the eye of the composition. Because we are not yet distracted by the rest of the fresco, Mary's prominence is evident. Elsewhere, we have seen that an orderly, well-mannered approach to the fresco—beginning with the formal introduction of the squinches and leading, as we proceed down the nave, to further acquaintance with the dome—can yield insights denied to the overzealous viewer in the crossing. Perhaps no figure so clearly rewards our patience than the main character of the cycle. The reactions of art historians have depended, again, on their style of observation. Bottari, who chooses to organize his description in accordance with the unfolding *in situ* ex-

perience, enjoys the way in which the Virgin is suddenly revealed.[1] Gould, however, cannot extract the Virgin from a confusion he blames on foreshortening and on the condition of the fresco but which is really a problem of point of view.[2]

Against Gould's accusation, the viewer in the sixth bay notes how clearly Correggio has cast the ball of cloud upon which the Virgin rides at the summit and into the foreground of the scene. The brilliant light that illuminates the arched back of the viol-playing angel and shades the underbelly of the cloud makes this group seem to float before the surface of the real wall and into the midst of the very space of the dome. But the illusion depends also upon the defining action of the western crossing arch, which, by framing the scene, tells us where to look. The vertical striations of squinch ribs, the fictive balustrade pilasters, and the candelabra rush toward intersection and drive our attention, on their way, to the ascending figure of Mary. The Virgin is the apex of a figural pyramid that rises from the Baptist and Hilary at its base, through the towering apostles. The wide surfaces of her rose-colored robe and blue cloak and her broad gestures further distinguish her from the surrounding figures. Mary is amid the angels, yet not lost among them. The gestures of the figures, the chiaroscuro, the composition, and especially the architecture convince us that the Virgin indeed ascends before our eyes through the open vault of heaven. The revelation of the Virgin, mediator of our prayers, within the ever enlarging frame of the triumphal arch, realizes the antiphonal prayer of the Assumption feast day: "The doors to paradise are open for us through you, who today triumph in glory with the angels."[3]

Yet this image of the Virgin is unique among Renaissance *Assumptions*. Four aspects of the pose of Correggio's figure of Mary are unusual: her outspread arms, the torsion and foreshortening of her seated position, and her ascending movement. Each of these features relates her in a particular way to the viewer and to the figures around her, contributing to the effectiveness and meaning of the whole program.

The Virgin's open arms and upturned palms signify devotion, awe, and readiness to embrace her unseen recipient (fig. 74). It was usual in Renaissance depictions of the Assumption for Mary to press her hands demurely to her bosom, as in Andrea del Sarto's contemporary Passerini *Assumption* (Palazzo Pitti, commissioned 1526, ca. 1528; fig. 75).[4] The type that the Virgin in Parma Cathedral follows, however, the Virgin *orans*, is a distinct iconography that had been largely abandoned by the time Correggio took up the theme. The use of the *orans* pose as a sign of pious entreaty and total submission to God dates to the mid-third century, in figures such as those of the Roman catacombs.[5] Paintings such as the Umbrian *Assumption* from the thirteenth-century altarpiece panel, now in the Museum Mayer Van den Bergh in Antwerp (fig. 78), in which Mary holds her open palms at shoulder level like an early Christian devotee, show the tradition from which Correggio's Virgin evolved.[6]

Mantegna's *Assumption* in the Ovetari Chapel in Padua is the most notable exception to the Renaissance preference for a contained posture of worship for the ascending Virgin (fig. 54). The Ovetari Virgin raises her hands like a medieval *orans*, but the illusionistic context and the more naturalistic style give the old posture a new impulse. The exposure of the draped body, the unself-concious tilt of her head, and the parting of the lips convey the utter receptivity of her devotional feeling. Upward-directed gesture and glance help to link the *Assunta* with the image of God

the Father in the vault directly over the altar, a technique Correggio uses, as we shall see later, to suggest imminent reunion.[7] While the conception was sanctioned also by medieval example, Mantegna's Ovetari *Assumption* may be the closest inspiration for the pose of Correggio's Virgin. Titian's high altarpiece in the Frari is not a necessary precedent, but as a reinterpretation of Mantegna's *orante*, it offers a useful comparison of how another High Renaissance artist employs the gesture in this context (fig. 55). Titian softens the hieratic rigidity of the *orans* pose into a naturalistic expression of human emotion. Mary's lifted arms, which continue the foreground apostle's yearning gesture, accelerate the ascending current of spiritual desire. In both Titian's altarpiece and Correggio's fresco, the traditional pose is an opportunity to convey modesty and amazement in order to demonstrate that the Virgin's humility is so profound that she is in pious awe at her own celestial elevation.[8]

In Mantegna's, Titian's, and Correggio's paintings, the *orans* pose and upward glance move the continuum of devotional energy from the apostles still on earth, with whom we most closely identify, to the godhead who receives Mary. In each case, the pose signals the presence of a divine receptor above, but while Mantegna and Titian supply both Virgin and viewer with the vision of God the Father, Correggio reserves from us the appearance of Mary's destined host and uses the *orans* pose to suggest what we cannot yet see. This lack of resolution compels the viewer to seek the object of her worship by his own forward movement. Like the climbing smoke of the lamps, the Parmesan Virgin's pose evokes the ascent of prayer, alluding to our own worship, which is directed to God through the Virgin's mediation.[9]

Whether the Virgin stands or sits as she ascends, Renaissance artists nearly always arrange her body in strict frontal symmetry. Nanni di Banco's figure on the Porta della Mandorla (fig. 80) is the most notable exception to this rule. In a figural experiment that recalls the decorative opposition of the flat-pressed limbs of French Romanesque portals and anticipates the extreme *contrapposto* of the mannerist *figura serpentinata*, the *Maria della Mandorla* sits in one direction while gesturing in another. The divided movement of the two halves of the body is not simply an elegant solution for arranging the figure in the almond-shaped frame, but expresses and underscores the effort of the main action, the donation of the girdle. In the course of the long easy curve that sweeps up from her knees to her shoulders, there is a complete reversal of orientation. The passing of the girdle appears the more decisive as the hands and glance swing down to the left to St. Thomas and counter the direction of the legs.[10]

In Parma Cathedral, too, Mary's action tends in two directions: her sprawling legs and dangling feet move left, her chest, arms, and head move right. While the Virgin on the Porta della Mandorla is not necessarily a direct source for Correggio's Virgin, the contrapuntal pose functions similarly in both to clarify action and motive. Nanni's Virgin turns to let down the belt, and Correggio's turns and lifts her arms in prayer. Correggio uses the same principle to indicate that the involuntary nature of Mary's flight from earth and her desire for the heavenly reunion with her Son are both contrasting and simultaneous. But the contradiction in Correggio's figure is more extreme because the central portion of the body where the twist occurs is invisible due to the dramatic effect of *dal-sotto-in-su* illusion. The first and most celebrated instance in which such extra-

ordinary *contrapposto* is combined with such foreshortening in one figure is in the Sistine Chapel, in Michelangelo's *Jonah* (fig. 81).

Correggio incorporates in the Virgin Assunta the combination of torsion and foreshortening that made the *Jonah* the most advanced figural experiment of its time. Like the prophet, the figure of the Virgin is depicted on a concave surface high over the altar, and as falling back and gazing up. Mary's splayed knees and three-quarter turn of the head, but more especially the opposed movement of her arms and legs in extreme foreshortening, recall in more violent disjointed form the most innovative qualities of the Sistine figure. Unlike Michelangelo's prophet, however, the Virgin turns her head to complete the rotational movement of the rest of the figure. The greater height of the cupola in the Cathedral increases the demand for perspective drama so that the Virgin's knees are nearly to her chest. The disappearance of the waist, a rupture elided but not concealed by drapery, emphasizes the countermovement of upper and lower body. This divergent movement expresses the earthly and heavenly alliances of the Virgin in her corporeal ascent, while the foreshortening conveys, with ungainly grace, her mortal heft as the Lord's vessel and her spontaneous submission to divine will. It is as though Correggio began with a medieval Virgin *orans* of an ancient Romanesque Assumption fresco and modernized her on Michelangelo's model, making subtle changes to suit the physical context and meaning of the subject.

Alberti, Leonardo, Lomazzo, and other Renaissance theorists discussed the turning of the figure in *contrapposto* as a means of representing the vitality of the living body.[11] The foreshortened view from below, which emphasizes the lower and humbler limbs, instead came to be employed in the figural language of Renaissance painting to accentuate the effects of death or submission. Hubert Schrade, in an article of 1930, presents a case for this tradition by examining Renaissance and Baroque examples of such foreshortened figures. He argues that painters used the exaggeration of the lower part of the body consequent upon this foreshortening to express the ignoble aspect of mortality, for the body so displayed becomes literally "reduced" into inert matter.[12] Correggio, like Michelangelo in the *Jonah*, combines these seemingly conflicting figural devices, one conveying death, the other life. This formal alliance, invented for the Sistine depiction of the Old Testament prophet whose miraculous survival in the whale, a metaphor of death and resuscitation, was a symbol of the Resurrection of Christ, recurs in Parma in a figure similarly redolent of the promise of bodily resurrection.[13] Correggio does not just crib a formal motif from Michelangelo—in fact, we have noted specific differences between the figures. Instead, he utilizes the essential principle of this complex pose from the prophet who is a focal point of the Sistine Chapel, and who surmounted Perugino's *Assumption* altarpiece. Whether directly from contemplation of Michelangelo's *Jonah*—which I believe is likely—or from the shared heritage of Quattrocento art theory, Correggio's *Assunta* demonstrates an awareness of the potential for the human figure to express spiritual concepts in a specific and concrete fashion.[14]

The Virgin's pose, like the efforts of the music-making angels who strain upward to play and wave as she passes, expresses the upward impulse of her ascent. The instability of the extreme *contrapposto*, her dangling legs and upturned face, and the fluttering of her robes show her to be in transit. No more remarkable contrast to the strictly immobile Assumptions of the Quattrocento could

be imagined. While it is not unusual for Christ or angels to propel the soul of the Virgin between the death bier and heaven in the *Transito*,[15] the element of movement is extremely rare in Italian Renaissance depictions of the Assumption. Mantegna's and Titian's examples again depart somewhat from the static, diagrammatic symmetry of other Assumptions, but neither the Ovetari nor the Frari *Maria Assunta* moves with the dynamic rush of Correggio's Virgin in Parma Cathedral (figs. 54, 55). Mantegna's Virgin remains placid in a gliding ascent, while the Venetian figure spins more than she rises. For true motion, we must look north. In an *Assumption* by the Master of the Life of Mary, ca. 1465 (Munich; fig. 82), the trailing bulk of robe, which bends nearly at right angles from the axis of the body (a convention for upward flight peculiar to northern art), signals the ascent of the Virgin and of the two angels who accompany her.[16] The three-quarter or profile turn of the body and the upward orientation of face and praying hands are frequently combined in active German *Assumptions* and *Transitos*. Marco d'Oggiono, in the altarpiece of 1522–24 now in the Brera, certainly patterned his Assumption after a northern prototype (fig. 83).[17] Contact with the foreign tradition explains the agitated drapery and impetuous movement so exceptional for an Italian treatment of the subject. It can hardly be coincidental that the most active Italian *Assumptions*—Titian's, Marco d'Oggiono's, and Correggio's—are located in northern Italy, where the German variation would have been most accessible. Like the *orans* pose and the foreshortened *contrapposto*, the movement of Correggio's figure is central to the dynamism of the whole cycle and shows the Assumption as a crucial transition between Mary's life and death on earth and her eternal glory in heaven.

Analysis of Correggio's Virgin demonstrates that the artist was at pains to convey in one figure her significance in the Assumption as our mediator, resurrected. In a program of the complexity and sheer dimension such as that of the dome of the Cathedral, she is the midpoint of Correggio's strategy to balance the emphasis of significant incident with the unity of the whole, and she motivates and embodies the sequential thrust of the program. The unusual aspects of the Virgin's pose—the *orans* position, the foreshortened torsion, and the activity of her ascent—tell of her dual obligations to earth and heaven, which are the bases of her participation in the Christian scheme. Each expresses her miraculous movement from the world to Christ, her humility and elevation, her death and resurrection. Enframed by the architectural context, she is distinct as the pivotal subject of the cycle, before which we must pause. By her pose, she moves us forward to see her destination and the rest of the fresco.

IN THE CATHEDRAL fresco, Correggio paints a variety of angels who perform many functions. We have noted and examined already the angels near the patron saints and apostles. Of all the angels at the Assumption, these wingless adolescents are physically closest to us as they move against the fictive architecture of the squinches and dado. They operate among the things of the earth because they attend the saints, intercessors who share our human nature, and because they carry out the sacred but also social celebration of the funeral rite. From the middle of the sixth and last nave bay, where a complete view of the Virgin appears, two new kinds of angels are now visible with her (fig. 74). All the tall, musicmaking angels who exhalt the Virgin's ascent with their concert are nearly included here within the crossing arch. The attendant putti who are specially engaged with the Virgin (and later with some of the blessed) are distinguished from their musical fellows by their

diminutive size, apparent age, and winglessness. Though many writers have praised the angels in Parma Cathedral for their vivacity and grace, and many disparaged the confusion of the numerous overlapped and foreshortened bodies,[18] no critic has noted the specificity of Correggio's depiction of the angelic hierarchy surrounding the ascending Virgin, or described the narrative action, or interpreted it.[19] Before describing and analyzing individual angels within the two groups, it is necessary to examine first the reasons for Correggio's decision to differentiate between these seemingly ancillary figures. We may then proceed to an investigation of how the wingless putti, especially, declare by their actions the meaning of the Assumption of Mary while they participate in her ascent.

There exists no text on the Assumption which sets forth the same type of distinctions between the angels that Correggio makes in this fresco, though the presence of an angelic hierarchy is occasionally mentioned in a general sense. Pseudo-Jerome's military metaphor for Mary's angelic escort, repeated in the *Golden Legend*, implies hierarchical ranking: "on this day [of the Assumption] the army of heavenly beings came joyously with their troops to meet the bearer of God and poured around her a great light and led her up with praises and spiritual chants to the throne...."[20] Several passages further on, Jacobus de Voragine quotes also Gerardus, who gives the many angelic orders that participate in the Assumption; she is surrounded by

> the Angels rejoicing, the Archangels jubilating, the Thrones exhalting, the Dominations psalming, the Principalities making harmony, the Powers playing upon the harp, the Cherubim and Seraphim hymning and leading her to the supernal throne of the divine majesty.[21]

The list abbreviates yet depends on the nine angelic ranks defined and discussed by Pseudo-Dionysius, the late-fifth-century Neoplatonic theologian who provided the most thorough-going treatise on angels in his *Celestial Hierarchy*.[22] To Pseudo-Dionysius, the angels form a unifying bridge between God and man, along which divine intelligence can flow. He ranges the angels into three major orders, each with three subdivisions, according to their degree of participation in the light of God. These orders extend from the seraphim, cherubim, and thrones, who can see the full light of God and so dwell in divine understanding, to the principalities, archangels, and angels, who live in a light filtered by the ranks above them and who are tangent to the human sphere.

Most artists, Correggio included, found Pseudo-Dionysius's nine-part vision unwieldy and overmystical for pictorial interpretation.[23] Correggio and his contemporaries discarded the specifications and the Neoplatonic essence of the *Celestial Hierarchy*, but they sought means of indicating the idea of ranking, or at least of showing the differences between angelic beings. Usually, artists are content to distinguish seraphim from angels (properly speaking)—and sometimes an intervening subcategory—by means of size, age, corporeality, and color. Correggio himself considers the issue in the *Madonna della Scodella*, an altarpiece that occupied the artist during the years he was at work in the Cathedral (fig. 84). Of the four angels who bend the date palm to Joseph, three display for us their differing degrees of wingedness. The angel falling back on the right is entirely wingless, while the central angel of the group possesses tiny fledgling wings, and the leftmost sports wings of full feathers. Wing development, as well as size, becomes a determining factor for angelic status in the Cathedral cupola.

Correggio's distinction between the music-making angels who stand apart in their concert and the more privileged infants engaged with the Virgin's immediate presence conforms generally to the manner in which other artists handle the question of angelic hierarchy in the Assumption. Lorenzo Costa's *Assumption* in S. Martino Maggiore, Bologna, is only one example of the diagrammatic, tripartite solution for angelic representation common to many Renaissance depictions of the Virgin's heavenly ascent (fig. 77).[24] Titian, like Correggio, maintains a less obvious but still detectable hierarchy in his Frari *Assumption*, where in a lively throng, darting putti elbow the older robed children and the whole melts into a glowing magma of seraphim (fig. 55). In both Titian's and Correggio's paintings, the mandorla-bearing angels of earlier art, now unemployed, have vanished, but Correggio ousts as well the bodiless cherubim of his predecessors. The smallest, most elite angels are those closest to the Virgin. They are helpful, hearty infants, given a complete human form with which to perform their special duties on this extraordinary occasion.[25]

The musical angels, with their long limbs and playful, affectionate manner, resemble those in the squinches and on the balustrade, except that they are a little taller and winged (figs. 74, 85, and 86). More overtly rapturous as they hymn the Virgin, their affection is also more overtly expressed in their amorous entwinements. The radical foreshortening, which maintains the illusion that these figures truly hover above us, and the complexity of their postures and embraces make the discernment of individuals somewhat difficult but not impossible. No one angel predominates among the music-makers, but the viol player who turns his back to us, his legs dangling against the shaded cloud, is in the center and foreground of the entire group (fig. 74). He is dressed like his fellow musicians: the drapery that flickers about his body is not so much a costume to be worn as a free-flowing cloth that adheres to the body sometimes modestly, sometimes not, through a loose magnetic connection. Behind him, an angel crashes cymbals, while further down another tips on his back in an ecstasy of flute-playing. The pair to the right hug one another and nearly kiss in a complicated spinning dance (fig. 86). They are joined by the orange-robed figure to the right, who peeps out at us and clasps his friend's hand. The kicking legs and enraptured faces of the angels otherwise obscured from our view show they are just as joyful as their more visible companions.

A particularly complex figure leads into the tangled group on the left (fig. 85). As he flies away from us, rotating in space, he trails his right leg, bends his left, and flings both arms out before him. A flap of white drapery hides the immodest angle of the foreshortened pose. Perhaps he dances with a concealed partner, because from our viewpoint, some of the feet beneath this figure seem unclaimed, and he does not have an instrument. Next is an angel in green who plucks a lyre, and in silvery white, one who sings and shakes a tambourine. Another violist tucks his instrument under his chin and solemnly plays in the upper left of this crowd, while two flutists play farther back, one to the lyre and tambourine players. The other performs to a participant of a different rank, a small wingless putto on the other side of a cloud. This little angel, who holds Mary's shroud, looks back over his shoulder almost crossly, as if annoyed to be interrupted in the midst of so sacred a task.

The wingless putti who form the Virgin's immediate entourage are of interest for their important placement and for the intriguing specificity and purposefulness of their actions (fig. 74). Several angels attach themselves to Mary's blue-gray, green-lined cloak—one below the tambourine,

one at her waist, and perhaps a third behind the knee of the second. They gaze at their human charge admiringly and hug her around the middle. The bearers of this garment seem slightly older types than the rest of the wingless putti. Below the Virgin's right foot, a fat angel laughs, while the angel at her left foot grimaces. His task is more onerous, and more sacred. He holds the bare foot of the Virgin in a white cloth, in respect for the vessel of the Lord. By treating the lowest part of Mary's body as a priest would treat a sacramental object (and as the Baptist in the squinch treats the sacrificial lamb), he shows reverence for God's handmaiden; by scowling under the Virgin's weight, he demonstrates for us the doctrine that Mary ascended in body as well as in soul.[26] The physical elevation of the incorruptible body of Christ's mother is enjoyed by the one angel as it is executed by the other. These angels are among the most conspicuous of those visible to the viewer in the sixth nave bay.

One puzzling detail, only barely apparent in pre-restoration photographs, has become more evident (if no more easily explicable) since the cleaning of the fresco. The odd vaporous face that emerges from the cloud next to the foot-bearer recalls the nubiform features of Jupiter in Correggio's famous picture in Vienna. The identity of this figure is enigmatic, for he seems at first glance to be a malevolent being in heaven. Does he frown, like the foot-carrying putto, because he is the spirit of the moving cloud that supports Mary's ascent? This face is but one of the several mysterious passages that become more numerous as we progress into the dense crowd of celestial figures.

More small angels tend the white wrinkled cloth that passes over the Virgin's blue mantle and which can only be a shroud. The velocity of her ascent and the impetuous, pious outflinging of her arms cast aside the flimsy drapery; two angels help shed the Virgin of the trappings of the tomb that must no longer bind her. The little putto at Mary's right hand, who is startled by the flute player's song, collects one end of the winding sheet as it drops from Mary's body. Behind him, in significant coincidence, rises the Baptist's cross, for as the shroud cast aside represents her own death and resurrection, the cross reminds us of the Virgin's co-redemptive role in Christ's Passion. At her left hand, a putto holds the other end of the cloth and a small sword. The inclusion of the sword similarly points to the Virgin's part in the Passion by recalling the words of Simeon's prophecy to Mary at the Presentation: "And a sword shall pierce through your soul, also." Another angelic attendant of the shroud is visible near the Virgin's face, and an angel of the same diminutive order rears up behind Mary's head, holding what appears to be a handle or staff.

Those two angels at Mary's either hand make allusion to two of her Seven Sorrows: the first and most intimate, Simeon's prophecy (on her left and here the feminine side); and the most momentous and universal, the Crucifixion (on the side of the male saints above). These mementos, the sword and the cross, are placed near each of the Virgin's hands. They punctuate the gesture that both indicates her devotion to God and imitates the pose of her crucified son.

Even those angels most intimate with the Virgin turn to the viewer on earth in order to demonstrate the significance of the Assumption for humankind. Correggio portrays all three orders as those messengers of God's command that may operate in our world. Though they indeed cheerfully exhibit the foreknowledge of God's plan which Augustine first ascribes to them, Correggio's conception of the angels diverges from the epistemological concerns of the Fathers and is chiefly

soteriological.[27] The angels in the Cathedral are efficacious, intervening, and physically solid. Whether they laud the patron saints or carry the Virgin's robe, they perform deeds ordered by God and benefiting man. Impatient to serve, they gladly attend the steps of human redemption.

One portion of the composition presented to the viewer in the sixth bay remains, and it is perhaps the least frequently discussed section of the entire fresco. Under the crossing arch and embraced by the Virgin's prayer is an arc of illuminated figures (fig. 74). Those of the upper ranks disappear into the glowing distance, but those in the foreground are highly individual. These characters, bleached in the illusion of burning celestial light and obscured by overlapping, are usually assumed to be simply part of the same figural wreath that commences with Adam and Eve. In fact, these figures, the first of the blessed to be seen by the observer moving from the west, are very different in type from the yet-invisible Old Testament saints we will later encounter. Tassi's surmise that the white-bearded old man with a flower is Joseph and the speculation that the face looking out above this is Correggio's self-portrait have been the only attempts to identify members of this group.[28]

Beginning on the left, we can make out the Baptist just behind Mary's arm. His face is nearly hidden, but his praying hands are clear and encircle the cross mentioned above. This cross emerges from a curved shape that could be his baptismal bowl. Tassi's observation concerning the next figure is supported by the lily, the attribute of Joseph. On the south and female flank of blessed is a pyramid of three women. These, so deliberately conjoined in an intimate triad, must be the three Mary's variously mentioned in the Gospels as witnesses of the events that begin with the crucifixion and end with the morning after the resurrection. A veiled head peeks out near the Virgin's face. She is the Virgin's mother, because, as in Renaissance depictions of the Virgin and St. Anne, such as Leonardo's famous compositions, she sits directly behind Mary, and is here the only human figure to earn closer proximity to her than even Joseph. Several other figures beg identification, especially the two bearded men behind John and Joseph. Following the pattern set down by those who are identifiable, they must be New Testament figures whose deaths precede the Virgin's and whose deeds or character merit their place of importance. Whether they are Zachariah and Joachim, or (suitable near the cross) Joseph of Arimathea and (as a self-portrait) Nicodemus, or any other possibilities, we cannot know. The ranks behind these are anonymous, then merge into heaven's light.

Even such an incomplete attempt to describe this portion of the fresco serves to indicate its importance as a piece of the larger program. One iconographical strategem is to continue the program of the Seven Sorrows of the Virgin in the figures that appear above the Virgin's arms. In addition to the references to Simeon's prophecy and to the Crucifixion, the presence of Joseph could allude to the Flight, and the three Marys to the Deposition. The putto over the Virgin's head seems to rest his hand on a crosier, which could signify Christ's boyhood preeminence among the doctors in the temple; her son's first disappearance is the third of Mary's sorrows. The hand thrust forth from the crowd could hold the torch of the Betrayal. The last sorrow, Christ's Ascension, eludes us unless we accept the Assumption itself as the implied undoing of Mary's final separation from her son on earth.[29] Though a scheme of the Seven Sorrows would be consistent with Correggio's co-redemptive conception of Maria Assunta, the identifications of the attributes are too tentative to be proof for a conclusive argument. The figures not involved would still require explanation.

Such an interpretation begins to replace visual evidence with preconceived patterns of iconography. It may be that some of the clues have deteriorated, and misunderstood by subsequent restorers, were painted over and finally lost to us forever. The glowing fist just over Mary's head is the most obvious example of a central and prominent motif that is also oddly unreadable. Even in this congregational view, some of the imagery is undeniably private in nature, visible in detail only to the painter on the scaffold, or the devotee of art who can examine the dome surface from the windows that open in the walls between the squinches and below the frescoed sphinxes. This point of view—still accessible to those of hardy curiousity by means of a narrow spiral stair behind the crossing pier—must be added to the central and oblique views from the church floor.

The View from the Foot of the Old Stairs:
Mary Ascending, with Adam and Eve

IN THE FINAL NAVE VIEW, Correggio presents the most important of the enframed compositions in the Cathedral fresco. At this point, the last strictly congregational station before the stair and presbytery, the segments that have been progressively revealed to the advancing viewer unite, and with the added element of two more figures, form a fresco composition that emphatically proclaims the triumph of the Virgin and the remarkable efficacy of her part in the redemption of humankind (Pl. II; figs. 5, 11). While all writers isolate the central view in the crossing as the climax of the fresco, the asymmetrical slant of the entire figural wreath in the cupola and the adjustment of the saints within the dome composition make clear that Correggio intended this point at the foot of the steps to offer a view of at least equal significance. For the lay participant, who would not continue up the stairs,[1] the eastmost nave view concludes the process of revelation initiated at the west door and experienced in the nave. This spot corresponds as well to the site where the worshiper's participation in the Christian rite is most intense. Although in the Renaissance, lay communion was limited to major holidays, the Eucharist was taken by the members of the congregation at the foot of the stairs—precisely at this easterly nave station.[2] The positive conviction of the Christian message specifically presented here acknowledges the Catholic liturgy and is commensurate with the importance of the site.

Before Mazzola Bedoli's reorganization of the presbytery in 1566, the arrangement between the nave and the choir would have looked quite different to the viewer of Correggio's fresco. As we saw in chapter 2, the pulpit would have projected into the nave on the left or north side (figs. 11, 39). Moreover, according to Quintavalle's reconstruction of the medieval pulpit and ambo, the crypt would have opened onto the nave on either side of a central stair.[3] This stair projected a bit farther into the nave than the present one, beginning instead just about on line with the east jambs of the two side doors. Both Shearman and Riccòmini, the first scholars to suggest the validity of an oblique view of the cupola, have chosen a spot at the foot of the present stairs.[4] This modern viewpoint, however, which would include the second pair of Old Testament figures as well as Adam and Eve, would not have been as natural a stopping place for the early-sixteenth-century viewer as the spot just west of it, where the early steps once began. From this standpoint, Adam

and Eve are the only pair of the Old Testament blessed to be clearly enframed and presented with the rising Virgin.

The composition that emerges below the crossing vault has increased steadily in surface area, number of figures, and programmatic complexity. The fictive relief is still visible, but it has diminished in proportional significance. John the Baptist with the Lamb of God, and Hilary, the bishop who urges us to hear the Gospel, have become our ushers to the main event in the cupola; they function devotionally like the foreground saints of a *sacra conversazione*. The two pairs of apostles who take in the event are now clearly visible. From the sixth bay, those disciples who can withstand the divine vision are more numerous than those who cannot. To the enthusiastic incense- and candelabrum-tenders on the dado, Correggio has added a particularly confrontational angel (fig. 87). He looks down at us, laughs, and points from his place over the southern oculus. Of all the figures on the dado, this angel has the most direct relationship with the observer, and his appearance merrily signals the arrival of his audience at a point of special intimacy with the scene now visible above: the station for the sacrament of communion. From the eastmost nave viewpoint, the individual worshiper, the descendant of Adam and Eve, gazes upon the first parents (fig. 5). The assuming Virgin is here understood as the "new Eve," who, as instrument of the Incarnation and of our salvation, becomes the recourse from the consequence of the first Eve's sin. In this portion of the fresco, the viewer sees how the plan of heaven and the fate of mankind intersect.

The New Testament figures immediately above Mary have already been included by the delimiting crossing arch and are segregated into male and female sectors. Adam and Eve conform to this conventional pattern and by their conspicuous placement declare the division clearly for the viewer. Behind the Virgin's right hand sits the first man and at her left, the first woman (fig. 88). Within the orderly arrangement of this view, however, some slight asymmetry lends emphasis to the relationship between Mary and Eve. Though Adam sits taller than Eve, he is secondary in the couple's relationship to the Virgin. Mary turns her head and upper torso to Eve and seems in this view to respond to Eve's reverent attention. As she rises, the Virgin is set back very slightly to the left, but because of the orientation of her pose, the interval between the two women is charged with mutual response. As Mary passes, her outflung gesture seems directed now to Eve and embraces the space around Eve's apple. The mass of clouds and angels beneath the women are continuous also, but Adam rests over a separate group.

Both Adam and Eve await the ascending Mary with respectful gestures of acknowledgment. They are both nearly naked, except for the loose swathes of drapery that cover their loins. Adam secures his white covering with one hand while he looks to the Virgin. He rests his left hand upon his chest and points as if to the yet unseen figures who range behind him. Eve, similarly, gazes at Mary, placing her hand lightly and worshipfully upon her bosom, but the gesture is partly obscured by the more important action of her left hand. To the ascending Virgin, she extends her attribute and symbol of her sin, the apple. This gesture emphasizes the equivalent yet opposite roles of the two women, the mother of our fall and the mother of our redemption.

Martini, in 1865, was the first to mention Eve's presence and likewise to note the meaningful juxtaposition of the two female figures in Correggio's painting, "where the woman of the first sin must have appeared amid the great jubilation at the arrival of the woman of forgiveness."[5] Ricci, too, con-

tributed to the reading of Eve's gesture and attribute, and to him, Eve holds out the apple as if to say, 'O mystic dove! Thou hast atoned for me! Thou hast made reparation for the first sin!'"[6] Ernst Guldan, in his investigation of depictions of the antithetical pairing of Mary and Eve, is the only art historian since Ricci to probe more deeply into the significance of Eve's presence and behavior in the Duomo. He observes that Correggio's introduction of Eve into the paradise of the Assumption is a noteworthy innovation and that the two female figures in the cupola culminate a tradition that began with Dante.[7] Although the arrangement in the fresco is not directly based on Dante's passage in Canto 32 of the *Paradiso*, Correggio's imagery takes part in the same tradition that inspired the words of the poet: "The wound which Mary closed and anointed, that one who is so beautiful at her feet is she who opened it and pierced it."[8] Correggio's vision is even more intensely optimistic than Dante's since Eve does not lie at the feet of the Virgin like a remembrance of past sin, but, with Adam, enjoys a seat in heaven alongside the blessed. The first sinners greet the vessel of salvation as proudly and cheerfully as do the New Testament saints. In their individual ways, they pay tribute to the woman who undoes the universal consequence of their deed by her miraculous motherhood and later through her intercession.

This conception of a joyous reparation at the Assumption is a common theme in sermons for the feast day. Dante puts the description of the juxtaposition of Mary and Eve in St. Bernard's prayer to the Virgin, but St. Bernard himself discusses the connection in terms even more relevant to Correggio's fresco. In his sermon for the octave of the Assumption, Bernard draws a parallel between Mary and Eve much as Correggio paints it: "A man and a woman were the source of our unhappiness but thanks be to God, by a man and a woman, all is restored, and grace now abounds where once there was sin...."[9] God realized the Incarnation, and hence mankind's salvation, through Mary's agency, and this makes her the antitype to the authoress of the Fall. John of Damascus turns the parallel into drama, and the words from his homily on the Dormition might be the exclamations of Adam and Eve in the cupola:

> from their joyous lips: Adam and Eve, the ancestors of our race, exclaimed aloud, "You (Virgin) are happy, oh daughter, who have abolished for us the punishment of our transgression! ... You dissolved our pain and broke the ties of death. You restored us to our place of old; we had closed the doors to Paradise, you opened the path of the Wood of Life!"[10]

For the viewer stationed at the foot of the presbytery, the scene has opened to reveal Adam and Eve in Paradise. Between them the Virgin rises to remove the sin for which they are responsible and which they have passed on to us. Correggio has painted the first sinners rejoicing in order also to evoke the viewer's pious joy for this hope of salvation.

The contrast between Old and New Eve, an essential tenet of Mariology, had been presented in art as well as in Christian texts. An example of a type of image popular in the later fourteenth century is Giuliano di Simone da Lucca's painting in the National Gallery in Parma (fig. 89). Eve "who is so beautiful" sits at the feet of the enthroned Madonna, while the Virgin, larger in scale and in a position of compositional superiority, dominates her antipodal female attribute. The prostrate Eve takes the apple and covers her shame with an additional emblem of her vice, a goatskin.[11] Nor is

Correggio the first to paint Adam and Eve alongside the Virgin in heaven. In Fra Filippo Lippi's fresco in the Cathedral of Spoleto (fig. 90), the elderly first parents (clearly labeled so there can be no mistaking their identity) lead the ranks of the blessed at the Coronation in an arrangement similar to that in the Cathedral of Parma.[12] The theme took such hold in the Steccata in Parma that Adam and Eve appear three times with the Virgin in the frescoes there: in Parmigianino's monochromes and Anselmi's *Coronation* (after Giulio Romano's design) in the apsidal semidome, and in Gatti's *Assumption* in the dome (figs. 91, 18).[13]

In discussions of the Assumption, writers always allude to the Annunciation, because the Virgin's ascent, like the erasure of Eve's sin, follows from her crucial part in Christ's Incarnation. Just as Mary and Eve are figural antitypes, so are the events of the Annunciation and Fall. The notion is succinctly expressed in Pseudo-Jerome's influential treatise on the Assumption. At the Annunciation, the author reminds us, Gabriel tells the Virgin of her state of grace and that she is "more blessed than all women." "And through this, the blessing given Mary took completely away whatever of the curse was infused through Eve."[14] Fra Angelico, for instance, combines these themes in his famous *Annunciation* in Cortona (Museo Diocesano), where the Expulsion forms, quite literally, the background to Mary's conception of Christ (fig. 94). The Assumption is a necessity due the Virgin because of her co-redemptive action in bearing the savior. God chooses Mary as the means of man's salvation because of her humility and purity, and at her death, these virtues again earn her divine privilege, the reward of eternal celestial life.

By including Adam and Eve in this segment of his fresco, Correggio both sets the Assumption in a broad theological context and presents an interpretation appropriate specifically for the viewer at the foot of the stairs. Adam and Eve, and by implication all their progeny, regain access to heaven because Christ was born of a woman. The tripartite typology in which Mary's ascension is the apocryphal issuance of the Fall and the Annunciation would have been immediately comprehensible to the Renaissance worshiper familiar with the words of the Assumption Day sermon. The visual linkage of the first parents with Maria Assunta refers inescapably to the Incarnation—and precisely at the moment when the viewer shares in the sacrifice of Christ's flesh and blood. The Incarnation, symbolically present in the fresco, is actually present in the rite of the sacrament below. Thus, the fresco enlarges the worshiper's understanding of his experience at the foot of the stairs, since at the very spot where the reception of the Eucharist occurs, Correggio asserts the possibility of human redemption.

Adam and Eve's participation within the margins of this view also calls attention to the Virgin's capacity for more direct mediation. They appeal to the Virgin as do their descendants in the nave of the Cathedral. Mary's virtue has taken her to heaven, where she can continue to act on mankind's behalf. Once enthroned beside her son and our judge, she hears our prayers and intercedes for us in order to undo Eve's work and to win us grace once more. As Bernard expressed it: "Eve was the cause of prevarication, Mary gave birth to redemption. Why should human frailty be afraid to approach Mary?"[15] The theme of Mary's intercession complements the subject of her co-redemption. These two Mariological issues together inform a composition well suited to the devotional thoughts and actions of the congregation that sees it.

The first sin was committed when Eve took the apple and passed it to Adam; in the cupola, she

passes it again. Eve holds the apple out to Mary in order simultaneously to reenact and undo her action in the Garden of Eden. By introducing the gesture into a new context, the artist extends the meaning of the symbol. It is typical of Correggio to fasten not merely upon the attribute but upon the whole movement involving it, so that Eve is characterized by her gesture.

In the preceding chapter, we observed that most of the small wingless angels from the select order of celestial beings attend the Virgin directly. An exception to this rule is a putto who assists Eve rather than Mary. He strengthens the visual connection between the antitypes and also performs a task that elaborates upon the traditional contrast by means of concrete narrative action. The putto with the sword of Simeon's prophecy looks back to this angel, who moves just below Eve's extended arm. He tugs at Eve's robe with his left hand; the cloth creeps down and unfurls from her stomach as the angel makes a flourish with his right. The removal of the cloth is the removal of the shame put on after Adam and Eve succumbed to temptation. Fornari Schianchi misinterprets Eve's naked-ness here as indicative of her sin,[16] but in the book of Genesis, nudity signifies the contrary. Besides, it must be observed that she is not yet naked. The putto's action alludes with understated modesty to her imminent innocence. As professed in Pseudo-Augustine's sermon on the Assumption, Eve received the punishment of pain in childbirth. From this hardship, Mary was exempt but instead must endure "the sword of Christ's passion."[17] Correggio juxtaposes the sword and the cloth of shame, two emblems of suffering. Eve's shame is vanquished by the Virgin's sinlessness, and Mary's suffering ends at her heavenly reunion with her son.

Visually, the swath of drapery across Mary's chest seems continued in the cloth that falls over Eve's hips. Both Mary's shroud and Eve's drapery appear cut from the same crinkled, goldish white material. Simultaneously, Mary sheds her shroud and Eve her robe, because the Virgin's purity makes her immune from death's corruption and saves Eve and her descendants from certain damna-tion. The shroud of death is the garment of shame and sin. John of Damascus, in his Homily on the Dormition, explains how divine grace replaces the earthly clothes we put on at the Fall. On the day of the Assumption, we realize that after the Fall,

> we were not so much nude and lacking garments as much as we had been robbed of the splendor of the divine image, stripped of the most abundant grace of the Spirit. Not now will we say, deploring the old nakedness, "I had put off my tunic, how could I put it on?" (Song of Songs, 5:3).[18]

So too, here, the angel dresses Eve in the new nudity, made possible by the new Eve.

A drawing in the British Museum offers a record of the development of Correggio's thoughts on Eve's significance in the Assumption (fig. 95).[19] The artist's draughtsmanly instinct to suggest rather than to describe and the understated eroticism of the image make the drawing one of the finest of the surviving sketches for the cupola, but his subsequent reflection brings him to adjust the apple, putto, and Eve's state of dress (figs. 96–99). While he preserves the three-quarter position of the body, the graceful gesture of the farther hand, and the presence and location of the assisting angel, Correggio transforms Eve's pose and personality.

The angel of the drawing, Popham's "pomiferous putto,"[20] rests the apple on his knee, extends his left leg, and tilts his head to gaze at his mistress. While at first Eve eschews the apple "as if she

were ashamed,"[21] in the painting she confidently tosses back her head, takes the fruit herself, and holds it aloft unabashedly as the Virgin passes by. Eve's pose in the drawing is penitent, and her nudity might be taken for granted as merely an identifying characteristic. The complex foreshortening and passive function of the drawn angel changes in the cupola into the flamboyant and untraditional removal of Eve's garment. By changing the possesser of the apple and by adding the action with the cloth, the artist depicts the change in her state of grace as a transitional point in continued action.

The changes from drawing to fresco did not arise simply from formal considerations, as Popham asserts, but resulted from Correggio's reconsideration of Eve's significance in the context of the Assumption program. Whereas in the drawing Eve is a submissive figure on the celestial sidelines who quietly pays homage with her gaze, the Eve of the fresco belongs to a more positive, optimistic vision of the symbolic involvement of the first woman in the Assumption. This manipulation of figural relationship and movement for symbolic purpose, which recalls for instance the Baptist's affectionate embrace of the sacrificial lamb, is an essential element of Correggio's iconographic style. Looking up at this dramatic moment, the viewer sees at a glance that the purity that earned the Virgin's Assumption grants Eve, and by implication her descendants, spiritual renewal.

The youthful Adam, like Eve, is partly covered by a white cloth (fig. 100). Most artists represent a great disparity in age between the first parents in their afterlife (for example, Sodoma in his *Coronation*, Oratorio di S. Bernardino, Siena; fig. 93) and set the aged Adam beside a still girlish Eve. When Mary is shown in the youth symbolic of her purity, this physical resemblance serves to underscore the symbolic connection between Eve and Mary. Fra Filippo Lippi took exception to this custom by, more logically, assuming both of the original parents to have suffered the ravages of age, their lot from the Fall (fig. 90). Correggio too breaks with tradition by painting both Eve and Adam as vigorous young adults. In the heaven to which Christ's mortal mother ascends as a testament to his promise of forgiveness and eternal life for all mankind, even the authors of the Fall are granted again the radiant beauty in which they were created. Just as Eve is Mary's forebear, the "new Adam" is Christ. Later, in the presbytery, Christ will become visible, and we will see, in the symmetry of Correggio's program, which follows upon the symmetry of theological thought, that even as Christ descends to the Virgin, he turns his face to Adam. With his left hand, Adam touches his hand to his breast in reverent supplication to the Virgin, pointing with the finger to indicate the line of patriarchs and prophets that descend from his paternity. He forms an integral part of the composition seen from the foot of the steps because he tells of the benefits of the Virgin's reparation for his progeny, while he suggests the revelation to follow.

SIX

The View from the Stairs:
More Old Testament Figures
Come into Sight

To SEE THE NEXT SEGMENT of fresco, the viewer must leave the nave and ascend the stairs; as new figures appear, a new audience is assumed. Stepping from the nave up the stairs to the presbytery (figs. 6, 11), the observer enters upon territory that, during the ritual service, was used only by the clergy. The laity was prohibited from the steps as well as from the area around the altar during the liturgy. This ban, which is still maintained by the railing that links the last pair of piers before the crossing, is expressed in the *Ordinarium* of 1417:

> Tell the canons that never at any time, and especially not when the bishop is present either coming forth
> at the altar or in his throne, when the priest stands before the high altar, about to sacrifice, are the laity al-
> lowed to go up to the Sancta Sanctorum, lest it happen that the sacrifice be disturbed when the people are
> present in a crowd, moving to and fro in the church. . . .[1]

The separation of the laity and clergy was enforced liturgically and architecturally. The priest had access to the stair when he descended and then ascended for the purpose of the people's communion. The bishop used the stairs as part of his appearance to the congregation. A. C. Quintavalle cites the description of 1417 of the Ascension and Pentecostal processions, as well as archaeological evidence, for proof of the existence and form of the central stairs (fig. 39).[2] According to the *Ordinarium*, the bishop, after leading a procession to churches throughout the city, enters the Cathedral and begins the antiphonal "Beata Dei Genetrix." He then "stands at the top of the stairs by which one ascends to the choir" and bestows the pontifical blessing with which he is charged by his office.[3]

The steps to the altar are an obvious correlative to the climber's spiritual advancement.[4] The proscription against congregational trespassing in the presbytery is stated in symbolic and color- ful terms by Durandus, the thirteenth-century writer who gives mystic meaning to architectural substance:

For the Lord commanded Moses, that he should not number the Levites and the rest of the children of Is-
rael, but should set them over the tabernacle of the testimony to carry it and to keep it [Numbers 1:47;
18:6]. On account of (this) divine commandment, while the Holy Mysteries are in celebration, the clergy
should in the church stand apart from the laity.[5]

Durandus likens the steps between the nave and choir to the fifteen virtues and the fifteen steps of
Solomon's temple, asserting that "he is blessed who maketh ascents in his heart. This was the lad-
der that Jacob beheld: 'and his top reached to the heavens.' By these steps the ascent of virtue is suffi-
ciently made manifest, by which we go up to the altar, that is to Christ...."[6]

In Parma Cathedral, the fresco visible to the clerical viewer differs in intellectual and spiritual
tone from that visible to the lay audience. In contrast to the physically and iconographically more
accessible congregational view, the figures first appearing from the stairs are directed exclusively to-
ward a more learned viewer. The persons depicted are not always easy to identify, and the imagery
here operates on a more complex symbolic level. The observer on the stairs would have most likely
been initiated into the meaning of the figures, whose identities still challenge the modern viewer.
Moreover, the ascending clergyman or bishop attains a view of the holy inhabitants of the upper
realm of heaven. Near the top, he will be privy to the sight of the figure of Christ.

Very few of the figures that number among the ranks of the blessed behind Adam and Eve have
been identified. Abraham, Isaac, and the ram, who are adjacent to Adam, are clearly characterized
by relationship and attributes, and have been acknowledged by the more descriptive authors (Pl.
III; fig. 85).[7] The young Isaac, dressed in a slate gray toga, sits in the lap of the sternly noble father.
The patriarch gently touches his son's bare shoulder with one hand and with his left, holds what
appears (rather enigmatically) to be a knobbed stick. Isaac embraces the sacrificial animal of the
Genesis story, who is portrayed not as a ram but as a lamb, to emphasize the parallel with the com-
position in the squinch immediately below. To stress the connection further, Isaac points down-
ward, directly to St. John and the lamb in the squinch. The Old Testament figures, by their pres-
ence and connection with the "lamb of God," remind the viewer of God's sacrifice of his own son.
At the same time, they look forward to the Virgin, ascending to take a place beside them for her
part in bearing the Savior.

The next most conspicuous identifiable figure, for whom we must mount the stairs a bit farther,
sits a distance behind Abraham (fig. 101). The same raised arm that conceals his face reveals his at-
tribute, the head of Goliath. David, king, psalmist, and prophet, is also distinguished by the scroll
which unfurls on his lap. A putto embraces the giant's head with his whole body. By clutching it
around the brow, he turns the head so that the Philistine's gaze, whether seeing or unseeing, is to-
ward the merciful Virgin (fig. 85). The third recognizable group sits in the southern position across
from David and Goliath (fig. 86). The only male presence in this crowd of women is the head of
Holofernes, held by Judith's maidservant. He too looks to Mary for absolution, as the servant looks
to his heroic assassin. Judith herself, in open-toed sandals and a green dress with red and white
sleeves, holds the hilt of her sword and gestures to Mary.

Those critics who discuss the blessed at all have generally agreed on the identities of these three
groups. Identifications for other figures are more dubious. The helmeted warrior behind David

may well be Gideon, as Otto von Simson asserts,[8] but he has arrived in heaven without his fleece (fig. 101). The fierce and muscular elder behind Isaac could be, according to Tassi,[9] Jacob, but he is likewise devoid of attribute (fig. 85). Below "Jacob," an old man—perhaps Noah?—holds golden grapes and lets the tendrils escape down his robe. The object just below "Gideon" appears to be a jawbone (fig. 101) and is held by a strongly foreshortened figure in gray, who looks back and points, his foot protruding beneath the bone. This figure, whose attribute is particularly clear in Boniveri's print (fig. 102), must be Samson holding the ass's jaw with which he slayed the Philistines.

On the other side, the chorus of women are even more problematic, especially since the most prominent among them, the woman in green and red next to Eve, has not been convincingly identified (figs. 86, 96).[10] Nor has any compelling interpretation been proposed for the blessed, male and female, as a whole,[11] though von Simson, remarking that "these figures refer to the dignity of the Virgin, to her virginity or to her part in the redemption effected by Christ,"[12] at least attempts to draw the figures together and to explain their presence next to the ascending Virgin. An important feminine figure still begs identification, and the painting an interpretation that takes into consideration the whole program of the Assumption, including Adam and Eve.

Beginning from what we can assert concerning these figures, we can discern a pattern that allows for a newly synthetic, if tentative, iconographical hypothesis. Adam and Eve are the first of the blessed characters in heaven to appear. Adam initiates an entirely male choir and Eve an all-female group.[13] All the identifiable figures are drawn from the Old Testament.[14] We are safe in assuming that Correggio has distinguished the New Testament blessed from the Old, just as he separates the sexes in a consistent arrangement. (The delimiting elements for these divisions are the vertical path of the Virgin and the western crossing arch.) Obvious parallels exist between the known figures. David and Judith, Jewish heroes who behead an enemy and save their people, pair off as naturally as Adam and Eve; thus formal counterparts also match in type. Abraham and Isaac, by their position behind Adam, demand comparison with the two women behind Eve. As the priestly viewer sets foot on the stairs, the architecture simultaneously reveals both couples, and the architectural enframement insists on the correspondence.

We have already seen that Correggio compares Adam and Eve to their New Testament partners, the new Adam and the new Eve. In art and theological literature, the patriarch Abraham and his son are commonly presented as types for God the Father and Christ. Augustine, in *City of God*, alludes to the typology:

the Apostle says: "Who did not spare his own son, but delivered him up for us all" (Rom. 8:32). For this reason, even as the Lord carried his own cross, so Isaac himself also carried to the place of sacrifice the wood on which he too was to have been placed.[15]

Isaac holds the lamb and points to the Baptist. John predicts by his prophecy the coming of the Lamb of God just as Isaac does in his person.

Though no art historian has satisfactorily identified this feminine group (figs. 86, 96), they must in some way be associated with Abraham and Isaac. Like Eve, the female counterpart to Abraham

must be a type for Mary. Though Bonaventura, Bernard, the *Biblia Pauperum*, and Fra Filippo Lippi in the Duomo in Spoleto (fig. 90) compare Sheba and Esther to the Queen of Heaven,[16] this figure has no crown, nor indeed does she possess any identifying object or accessories. For narrative and symbolic reasons, however, Rebecca makes perfect sense. Not only is she Isaac's bride, but Augustine describes her as the church, a title usually conferred upon Mary herself.[17] According to the Early Christian writer, Abraham sent his servant to search for a bride for Isaac

> *because God the Father sent the prophetic word to the earthly universe, so that God might seek out the bride, the Catholic Church, for his only begotten son . . . thus through the prophetic word the Church of the Gentiles is summoned to the true bride-groom Christ from a distant land.*

Rebecca agrees to go to Isaac just as the community of the faithful, or the church, goes willingly to Christ. Ambrose, in his "Isaac, or the Soul," a discourse on the symbolic levels of the Song of Songs, poetically extends the metaphor that presents Isaac and Rebecca as the spiritual union of the soul with Christ.[18] He describes how she goes to the well to draw water, "and so the church or the soul went down to the fountain of wisdom to fill its own vessel and draw up the teachings of pure wisdom." As *typus ecclesiae* and the soul, Rebecca is the perfect match for Maria Assunta. Bonaventura, too, discourses on Rebecca's resemblance to Mary, because by giving Eliezar drink at the well, she is, like the Virgin, a fountain of mercy.[19] In Dante's celestial vision of the Mystic Rose, Rebecca, with Eve, Sarah, and Judith, accompanies the enthroned Virgin.[20]

It is admittedly a problem that this figure has no attributes, and her identity must remain uncertain.[21] Yet Correggio's frequent employment of pose as meaning instructs the viewer to read her stance and gesture carefully. Her upright bearing, the slight lift of the head, and the delicate gesture with which she places one hand reverently on her breast, the other triumphantly at her hip, expresses the quality of dignified submission which Clement of Alexandria attaches to Rebecca. Like Rebecca, he continues, the Church "has been given the reassuring name 'submissive endurance,' either because her endurance continues for all eternity in unending joy, or because she is formed of the submission of those who believe."[22]

Moreover, it is possible that Correggio dresses Rebecca in a subtle attribute, after all. Ambrose compares the mantle Rebecca dons when first meeting her betrothed to the mantle stripped by the watchmen from the bride or soul in the Song of Songs (5:7):

> *They took the mantle from her, for they were searching whether she bore the true beauty of naked virtue, or else because everyone ought to enter the celestial kingdom without clothing and not bring any covering of deceit with him.*[23]

Perhaps the heavy green cloth that falls abundantly about Rebecca's shoulder is just such a mantle. Correggio would then be illustrating Ambrose's metaphor, making Rebecca's bared head consistent with the nudity of Eve.

For lack of any more telling attributes, the primary evidence for identifying Rebecca remains her placement across from Isaac. To complete the puzzle conveniently, the other woman just visible between Eve and Rebecca could be called Sarah; by some details of her appearance as well as her sta-

tion across from Abraham she fits the part. She is here in the white headdress that commonly indicates old age. Unlike her daughter-in-law, she smiles, and unlike Eve, even parts her lips as if to laugh. In Genesis, Sarah is rebuked for laughing when the Lord announces the birth of Isaac (whose name means "laughter"). Correggio has elsewhere demonstrated his interest in depicting, always appropriately, significant mirth. As Augustine, in the *City of God*, interprets her reaction, "her laughter, though inspired by joy, was still not inspired by complete faith." But when Isaac was born Sarah's laughter was "the celebration of joy; for, as we see, she said, 'The Lord has created laughter for me, for whoever hears shall rejoice with me.' "[24] Here she praises Mary with her smile, and others, like Judith's handmaid, smile with her. Her secondary placement to Rebecca—which is in contrast to her husband's dominance behind Isaac—also has a theological basis, again in scripture and in Augustine's explanation. Isaac puts his wife in his mother's place. To Augustine, this prefigures Christ, who receives the Church and substitutes it for the Synagogue.[25] Correggio rejects the negative interpretation of Sarah's death as the spiritual infidelity of the unconverted Jews and gives her a place in Heaven.[26] By giving miraculous birth to the *typus Christi* Isaac, Sarah, like Eve and Rebecca, is a figure for Mary.

Like Adam and Isaac, David is a type for Christ as well as being his direct ancestor (fig. 101). With the head of Goliath, who represents the devil, he is a savior of his people and offers a prefiguration of Christ on the cross. David, "who bears the figure of Christ," carries his sling into battle and with it slays Goliath. In the words of Augustine, "Christ, indeed the true David, comes, who will battle against the spiritual Goliath, that is the devil, and while carrying his own cross."[27]

David is matched in the feminine precinct by Judith, a militant heroine who also annihilates an enemy of the Jews (fig. 86). She too defends her people by beheading her victim with his own sword. Various interpreters have read in Judith images also conventionally associated with the Virgin. In a text traditionally attributed to Hugh of St. Victor, Holofernes is the Beast of Revelations 13:4, who receives his authority from Nebuchadnezzar, who is the dragon.[28] Since the woman of Revelations 12 is usually a type for Mary, Judith is by implication compared by Hugh not only to the woman clothed with the sun who opposes the satanic force, but to the Virgin herself. He declares that Judith is a type for the church and that Holofernes represents the rival of Christianity. Just as Nebuchadnezzar's general lusted for Judith,

> the persecutors of the Church eagerly desire to corrupt her integrity. Judith, in the tent of Holofernes, is not defiled . . . and the holy Church amid the pagans is not corrupted by their filthy idols. "With his sword, Judith cut off Holofernes' head," as the holy Church annihilates her enemy by means of its own ill-will. Judith, after her victory, celebrated joyously with her people, and the holy Church, overcoming the enemy and its vices, celebrates joyously even with the angels.[29]

While Rebecca is patient submission, Hugh makes Judith *confitens*—confession of Christian belief—or *laudans*, praise.[30] Of the two female figures in the fresco, Judith is the more aggressive. She points triumphantly to the mother of the Lord, gripping her sword in her lap. Like Rebecca, Judith is a *typus ecclesiae*, but she conquers sin through action rather than by spiritual essence. Both mirror the virtues of the Virgin in type and accomplishment.

The three most conspicuous pairs of male and female figures each correspond to Mary and Christ in three different ways (fig. 6). Adam and Eve are their moral opposites, and by committing the first sin they begin the history of human salvation. Isaac and Rebecca are spiritually likened to the bond between Christ and the human soul or the community of faithful souls, the Church. This second pair reinforces the concept of the Assumption as a fulfillment, *sub gratia*, of the promise of the Song of Songs. David and Judith are successful victors over evil and vanquish the enemy of good before Christ's coming. These last four stand midway in man's moral history between the Fall and Salvation.

No written source provides such a program, nor do any visual precedents exist for Correggio's unique imagery. There does exist, however, a Sienese tradition for the inclusion of Old Testament figures in the scene of Mary's ascent. In this type of image, which first occurs in the Trecento, small, symmetrical groups of male figures appear in the clouds to either side of the Virgin. Most often they are individually unidentifiable, but they are usually recognizable, often by scrolls, as prophets, and on occasion even labelled (as in Matteo di Giovanni's *Assumption* in the National Gallery, London, of 1474, fig. 76; also fig. 92).[31] Correggio's corona of Old Testament figures is not exactly in keeping with these Sienese *Assumptions*, since in Parma David is the only true prophet perceptible in the great mass of figures that accompanies the Virgin's ascent. Instead, while the Tuscan inclusion of Hebraic figures alludes to the prophetic promise of the Messiah's virgin birth, Correggio's scheme in this fresco passage is ecclesiological. The ranks of pre-Christian figures lead from Adam and Eve, through the great Jewish heroes and heroines who prefigure Christ and the Virgin—a divinely ordained history that will culminate in God's union with his faithful within the Church, which is symbolized by the Virgin Mother and spiritually maintained by its servants, the clerical viewers below.

For sheer quantity of participants, the painter draws from another body of imagery: the Coronation set amid the Court of Heaven. The myriad of figures that mount, rank upon rank, in such paintings of the Coronation as Fra Angelico's in the Louvre or Antonio Vivarini's and Giovanni d'Alemagna's altarpiece for S. Pantaleone, Venice (fig. 104), are part of an iconographical current particularly popular in the generations preceding Correggio's.[32] In these Renaissance *Coronations*—more properly Late Gothic in their meticulous, lavish depiction of celestial royal splendor—figures from Old and New Testaments, martyrs, confessors, and saints are witnesses to the sublime wedding. The crowd is often arranged as in Parma in separate male and female sectors. Correggio's Virgin ascends to her Coronation in a compositional syntax that reminds the viewer of the inevitable consequence of the scene before us. Viewing the event to which this compositional structure alludes, the simultaneous appearance of Mary and Christ moving toward the royal reunion, will be the privilege of only those in the eastern portion of the Cathedral.

By using an arrangement that includes those who await the Coronation, Correggio places the Virgin's Assumption in a chronological continuum. In Quattrocento *Coronations*, Christ crowns Mary, who will sit on his couch beside him for all eternity, in symbolic time, and so the blessed number those long in heaven and some not yet born at Mary's death. In contrast, Correggio's representation of time is as impeccably naturalistic as it is symbolic, because those figures present passed on to heaven before Mary's own ascension. Thus all the figures are present at the Assumption by virtue

of narrative logic as well as programmatic consistency. In the changing proportions of the ever expanding composition, the ascending Mary leaves behind the apostles, witnesses of her death, and the angels who triumphantly celebrate her funeral. The viewer progresses forward in space and forward in the Virgin's posthumous history, moving from her death to her Assumption and to an allusion to her imminent Coronation. The priest or bishop moving up from the bottom of the stairs has an intimation of what he will see at the top: Christ descending to meet and to crown his mother.

SEVEN

Christ Appears as the Viewer
Ascends the Stairs to the Presbytery

BETWEEN THE LAST NAVE PIERS and the western piers supporting the crossing vault, and nearly to the top of the medieval steps (midway up the present stairs), the clerical observer sees Christ come completely into view (figs. 7, 11). Although, as we are now aware, the arrangement between the nave and the presbytery would have been different in Correggio's time, it is safe to assume that the viewer privy to the stairs would have had a similar experience to the observer on the present-day steps. It is also reasonable, considering the regularity of interval between the stations examined so far, that this significant new figure would have been first entirely apparent directly below the center of the groin vault (i.e., midbay), wherever that point might have fallen on the stair. As the priest or bishop advanced up the steps, at this point in his ascent he would have been able to look up and see the remarkable—and problematic—image of the Savior, descending to welcome Mary into heaven.

A similar view is experienced by the choir located in the area of the presbytery between the stairs and the altar. Seated here was the *chorus superior* or *chorus primus*. According to the *Ordinarium* of 1417, this group included the master of the choir, several prebendary canons, a deacon, and a sub-deacon.[1] The figures in the western squinches and on the west side of the cupola would have been behind these viewers, but visible to them would have been a larger segment of the figural crescent, now nearly a ring, in which Christ descends to meet his Virgin mother.

Christ turns so vigorously at the waist that his limbs form a spinning cross (Pl. IV; fig. 105). The outstretched left leg and arm are the axis of this unusual pose, and the right arm and leg, bent at a more acute angle, fly out in opposite directions. As he turns he bends forward, draws up his knees, and looks upon his destination. The extreme foreshortening of the *dal-sotto-in-su* view contributes to the complexity of the figure. As he falls, the green shift hitches up to reveal a good deal of his muscular legs.[2] The white overdrapery billows loosely around his body and floats above his head, partly obscuring the foreshortened turns of his body in the same manner that the apostles' drapery conceals the awkwardness of their foreshortened forms. By High Renaissance standards, Correggio's figure of Christ is unusually heroic and vigorous.

Many writers insist that the figure does not represent Christ at all, but an archangel, who pre-

sumably descends to escort the Virgin to her son's divine throne. Opinion as to the identity of this figure has been divided from the middle of the nineteenth century to the present day,[3] but strangely, no author has discussed this issue. Yet an investigation as to whether Correggio depicts a divine messenger or Christ himself in the center of the cupola is essential for even a cursory analysis of the entire program. An assessment of the history of criticism concerning this figure will demonstrate that this tacit dispute arises out of an uneasiness with Correggio's unique vision of the appearance of Christ at the Assumption. Analysis of this controversy sheds light on what may have been a problem for Correggio himself, the reconciliation of his vision with Renaissance decorum.

The earliest authors, from Vasari through the seventeenth century, are not inclined to dwell on visual detail.[4] Consequently no mention is made of the figure at all until Mengs offers the succinct observation that in place of a lantern "is painted with violent foreshortening, Jesus Christ who comes to meet his mother."[5] The figure of Christ in the Cathedral cupola began to be called an angel about the time when accusations that Correggio's fresco lacked propriety became more insistent. In the middle of the nineteenth century, a change in perception took place; Burckhardt, critical of the fresco as a whole, does recognize, in 1855, the descending character to be Christ, but Martini and Meyer, writing in 1865 and 1871, respectively, call the figure Gabriel.[6] Influential writers on Correggio such as Ricci, Gronau, Thode, and Popham perpetrated the notion that the artist depicted an angel descending to the Virgin.[7] With Gould, who recognizes the figure as Christ, the trend changes.[8] Though most later observers follow his lead, there remain some dedicated to the nineteenth-century appraisal.[9] Even Gould seems reluctant to admit to Christ's identity, remarking that it was "at least understandable" that some would see him as an angel.

Criticism of the figure, which made the angel theory popular, is based on several objections. A review of the complaints set forth by both factions underscores the peculiarity of Correggio's image and establishes the points of controversy. Testi, for instance, is offended that observers had ever seen the figure as the Savior, to him a judgment "manifestly in error." His reasons are the apparent youthfulness of the figure's proportions—he refers here no doubt to its athletic vigor—and its lack of resemblance to Christ as Correggio represented him in S. Giovanni Evangelista and elsewhere.[10] The beardlessness of Christ is also perceived as a problem. Gould refers to this difficulty, as well as to another seeming indignity, the awkwardness of the pose and foreshortening, when he begrudgingly acknowledges the identity of the central figure. According to Gould, Christ "is so distorted" that he would naturally be read as an angel, "till the beginnings of his beard were revealed by detail photography."[11] This observation is wishful thinking on Gould's part, for even the best photographs show Christ's cheek to be darkened only by the shadow from the flying drapery near his face.[12] The extremely foreshortened, actively turning pose has received the most disapproval. Mengs makes deferential reference to the "violent foreshortening" of Christ, but later critics are not so generous. Correggio's depiction of the hurtling figure seen from below is the opposite of iconic; even in the dome of S. Giovanni Evangelista, he had met a compromise between naturalism and formality (fig. 58). Gronau censures the "divine messenger," while comparing it to the figure of Christ in Correggio's earlier dome. Echoing Burckhardt's stricture against the artist's excessive realism, he remarks that as the angel comes to meet Mary,

one could say he is suspended, but his hasty movement, shown by the arrangement of his arms and legs, is as much a plunging fall as a soaring flight . . . thus the impression is painful, embarrassing and disagreeable, because the mania for an ever bolder reality has taken every aspect of sublimity from this figure.[13]

A final objection that has not appeared in the published literature is the omission of the stigmata on the body of the risen Christ.[14]

Each of these objections is based on an inadequate view of Correggio's pictorial and literary sources. The subject of the Assumption together with the context of the Cathedral cupola offer a distinct iconographical occasion, and the artist meets these specific needs with an innovative interpretation of the figure of Christ that resembles no other in his work. Christ looks no less like any other Christ in Correggio's oeuvre than the Virgin resembles another of Correggio's portrayals of Mary. The figure can be best understood as part of the dramatic narrative of the whole story of the Virgin's posthumous existence, as well as a fitting illustration of the theological significance of the Assumption doctrine.

The portrayal of Christ without a beard, while customary in Early Christian art, had become unusual by the fifteenth century. Nevertheless, Christ appears beardless on several occasions in the Renaissance. Andrea del Castagno, who shows Christ bearded at the Last Supper, portrays him clean-shaven at the Resurrection (fig. 106). While it is possible the painter refers to Early Christian prototypes, the contrast of bearded and beardless Christ in one cycle points to a more meaningful purpose. In Andrea's painting, the beardlessness of Christ, as one means of illustrating the youth of the depicted individual, demonstrates the ageless integrity of the resurrected body and shows Christ to be the embodiment of the promise of eternal life. The quality of youth refers to his early life and ministry on earth, and symbolically connects Christ's divine and human existences.[15] Similarly, Christ appears bearded at some events, bare-cheeked at others in a group of *predelle* by the Renaissance painter Bartolomeo di Tommaso da Foligno. He is specifically unbearded in the *Lamentation* and *Entombment* (a panel in the Metropolitan Museum, New York; fig. 107), where Mary kisses him passionately. Here the affection between mother and son goes beyond familial devotion and recalls the Song of Songs. Christ is the youthful lover in the Virgin's embrace, the "bridegroom."[16]

It is precisely this youthful type—the beardless bridegroom—that artists frequently employ in Coronations. In a *Coronation* in Cleveland from the circle of Arcangelo di Cola da Camerino a beardless Christ bends to crown the demurely kneeling and nubile Virgin (fig. 108).[17] A painter from the circle of Bembo, in the *Assumption* in Bergamo, represents Christ young and clean shaven (fig. 103). To these artists and to their Christian audience, the Coronation of the Virgin was also a marriage, and their paintings recall that Christ is both son and bridegroom to Mary. The painters invoke the Song of Songs, as do writers of the church. Jacobus de Voragine describes how "she came forth glorious from the tomb, and was assumed into the heavenly bride chamber. . . ."[18] In sermons, treatises, and liturgical texts on the Assumption, the Son summons his mother to "come from Lebanon,"[19] while St. Bernard, exhorting the Virgin to meet the embrace of her bridegroom Christ, has her exclaim, "Let him kiss me with the kisses of his mouth."[20] Where the more erotic content from the Song of Songs is only implied in the *Golden Legend*, Bernard emphasizes it. This association of the

amorous language of Solomon with the heavenly reunion of Christ and the Virgin survived into the Marian texts of the Renaissance. When Antonio Cornazzano, a Parmesan poet of the later Quattrocento, combines the narrative of the *Golden Legend* with the literary model of Petrarch, he is only extending the medieval metaphor of Maria-Ecclesia-Sponsa. In the *Vita della gloriosa Vergine Maria*, Christ comes to his mother (whose pallor on her deathbed is as white as the snow that Petrarch evoked for the dying Laura), opens his arms, and sings the words of the Bridegroom, "Veni eletta mia, vien sposa mia." Mary flies longingly to heaven, where he closes her eyes and kisses her tenderly upon the mouth.[21]

We have seen that on Assumption Day, St. Bernard rhetorically embroiders upon the Virgin's happy embrace of her bridegroom, Christ. The parallel of the Coronation and Song of Songs compares erotic desire with the passionate longing between Mary and Jesus and between the soul and God.[22] For the evocation of the biblical epithalamium, these Renaissance painters show the lovers, mother and son, in the bloom of youth. The Song of Songs, the Mariological exegesis of which would have been commonly understood in the sixteenth century, is perhaps the foremost textual background for the intense emotionalism of Correggio's image.

In the cupola in Parma, the Virgin ascends to heaven a young woman, and Christ descends as a man in his early adulthood. Testi's and Gould's disapprobation is proven groundless by the many depictions of the beardless Christ. That the Son's youthful beauty is a feature of Coronations in particular emphasizes again that Correggio conceives of the Assumption in a larger narrative context: at this point in the Cathedral, as a Coronation-in-the-making.

Christ may also appear after the Passion without his wounds, as numerous examples from medieval and Renaissance art demonstrate. The wounds of the Passion were originally absent in a work Correggio would have surely known from his trip to Rome, Michelangelo's *Risen Christ* in the church of S. Maria sopra Minerva.[23] Especially in depictions of the Coronation, such as Correggio's own in S. Giovanni Evangelista, we find the stigmata can be omitted (fig. 110), and indeed, from the Trecento on, Christ at this moment appears frequently woundless.[24] A twelfth-century illumination which forms the title page to a manuscript of the *Commentaries* of Honorius of Autun on the Song of Songs provides an exegesis of how a medieval artist contemplates this problem (fig. 111). To illustrate Honorius's text—fundamental in the formation of the equation Maria-Ecclesia-Sponsa—the painter depicts and labels the *Sponsa* and *Sponsus*, who enact the Coronation. The hand with which the Bridegroom/Christ crowns his consort is intact; the other, which blesses a figure of "man redeemed," bears the stigmata. Here Christ is simultaneously the suffering Redeemer and, at the heavenly reception of Mary, the beautiful Spouse.[25] The woundlessness of the figure in the apex of the cupola of the Cathedral therefore does not argue against the identification as Christ.

Christ's extremely active pose in the Cathedral, the violence of which is emphasized by the flying drapery, goes beyond a Renaissance fascination with complex exercises in contrapposto. In this case, Correggio's conception defies any search for pictorial precedent. Here the artist drew upon Christian textual tradition rather than upon visual example. Christ is again the lover in the Song of Songs, and the Virgin is his beloved. Not only is he beautiful and amorous, but he moves swiftly and gracefully, "like a gazelle, or a young stag"(Sg 2:9). Correggio creates his image around these

words, much as Ambrose weaves his description of the Savior's alacrity upon the verse. Ambrose's text on the Song of Songs 2:8 might serve as a caption for the frescoed figure:

> *when he is sought, he not only comes, but he comes leaping, "leaping over the mountains and bounding across the hills." He leaps over souls which have more grace, bounds over those which have less. Or it may be taken this way: How did he come leaping? He came into this world in a kind of leap. He was with the Father, he came into a virgin, and from a virgin he bounded into a manger. He was in a manger and he shone in heaven, he went down into the Jordan and up onto the cross, he went down to the tomb, rose up from the tomb, and sits at the right hand of the Father. Like the hart who longs for the fountains of water (Ps. 41:2), he went down to Paul and shone around him and leapt up over his church, which is Bethel, that is, the house of God.*[26]

Correggio rejects the static and symmetrical formal character usually used to express Christ's dignity, choosing instead to enliven his figure with a turbulent energy closer to the biblical text most frequently associated with the Assumption and Coronation.

The foreshortening of the figure of Christ, at once its most eccentric and essential feature, is noted even by those who identify it as Christ. It is hardly surprising that by subjecting an image of the Son of God to the distorting effects of *dal-sotto-in-su* foreshortening Correggio provoked comment. If the foreshortening of the apostles seemed objectionable to some, how much more so the similar treatment of Christ himself? Christ and God the Father may be foreshortened to project headfirst toward the viewer, as in Caselli's *Madonna with Saints* (fig. 20), or Pordenone's *God the Father* in the central dome of the Madonna di Campagna, Piacenza, ca. 1530–32 (fig. 112), because the ensuing enlargement of the head is not demeaning. Francesco di Giorgio's enigmatic *Coronation* of 1471 is an unusual example in which a member of the triune divinity is seen from the feet up; Michelangelo's *Creation of the Moon* is a remarkable special case. Correggio himself was previously reluctant to perform such a feat of figural perspective on the form of Christ in the dome of S. Giovanni Evangelista and settled for a compromise between an iconic and a natural view of the figure (fig. 58). Even keeping in mind the demonstration in chapter 4 that the *dal-sotto-in-su* foreshortening of an active figure may refer, as in the instance of Correggio's ascending Virgin, to bodily resurrection (a notion surely appropriate for the depiction of Christ in Heaven), Christ's naked legs require explanation. By depicting Christ as falling feet first, and by lifting his robe above his knees, the artist accentuates just that most vulnerable and ignoble half of the human body which he is careful to conceal when he paints the Virgin. But what seems at first the painter's unnecessary impudence fits neatly into and concludes the iconological program in the Cathedral. Correggio emphasizes the lower part of Christ's body to allude to his manly form, his human nature, and consequently to his Incarnation. The relation of Christ's sexuality to Incarnation theology has been amply demonstrated by Leo Steinberg's important study.[27] The figure at the apex of the dome, then, is flesh as well as divinity.

To the worshiper at the foot of the stairs, who saw Adam and Eve from the spot where the Eucharist was administered, Correggio already presented the Assumption as the natural consequence of the Incarnation. The foreshortened, bare-legged, descending Christ can be seen during Mass

only by the clerical viewer or bishop on the stair or in the upper church, who would be prepared to understand the implications of such an original artistic treatment of the Savior. Here it becomes more clear, even, that the Assumption of the Virgin to heaven, her necessary reward for bearing Christ, is the fruit of her conception at the Annunciation. The occasion Correggio depicts is Christ's second descent to the Virgin, which this time takes place in heaven. She ascends in body, as she received him before, and he descends also in bodily form as in his first union with her. The idea of the reciprocity of the Annunciation and the Assumption fills the theological literature. As John of Damascus says:

> And as he had descended to her, thus she herself, object of his love, had to be transported to "the greatest and most perfect tabernacle," heaven itself. It was proper that she who gave asylum to the Word of God in her womb was placed in the tabernacle of her Son.[28]

Bernard, telling of the miracle of Christ's condescension, emphasizes how Christ assumed a lowly form: "Why are they surprised that the Virgin ascends, abounding with charms, from the barren earth? Let them be surprised rather at Christ coming down from the abundance of the heavenly kingdom as a pauper."[29] On a more popular, narrative level, the story of Mary's death as told in the *Golden Legend* borrows the pattern of the Annunciation: the angel arrives, hails Mary, and gives God's blessing. He brings the announcement of her death, that is, of her coming union with Christ.[30]

In legendary accounts of the Virgin's bodily ascent to heaven, it is Christ who comes to meet the Virgin. The *Revelations* of Elizabeth of Schongau, recounted in the *Golden Legend*, declares that when the Virgin rose from the tomb, "there came from Heaven to meet her a man admirable and glorious, bearing in his right hand the banner of the Cross, and with him uncounted thousands of angels."[31] Jacobus de Voragine quotes, too, Pseudo-Jerome, who specifies that the mother of God was honored in her death and that "Christ himself went forth in all gladness to meet her, and with joy placed her beside himself on the throne. Else he would not have fulfilled what He Himself commanded in the law: 'Honor thy father and thy mother.'"[32] There is no account in which the heavenly reception of her body and soul takes place by angelic proxy. In Correggio's fresco, angels take the Virgin up to heaven at her Assumption, but only Christ comes to greet her corporeal ascent to his throne. Although Correggio's representation of Christ at the Assumption may be unusual, von Simson certainly overstates the rarity of the inclusion of the Redeemer in an Assumption context.[33] We have already encountered several Renaissance *Assumptions* in which Christ receives his mother (figs. 76, 103, 109). The depiction of the reception of the Virgin's body in heaven by an intermediary of an absent godhead would be unprecedented. Surely Correggio has not created the dramatic process that unfolds in the Cathedral in order finally to reveal at the uppermost height the figure of a mere angel.

The selectivity of the visibility of Christ, who appears to the clergy but not to the congregation, has precedents in Parmesan decoration. In the chapel of S. Francesco al Prato in Parma, a fifteenth-century artist places Christ in the Gothic vault in such a way that only a viewer within the chapel can see him (fig. 113). Even nearer to Correggio's fresco is a similar situation in the Cappella Rava-

caldi in the Cathedral crypt, where a Quattrocento fresco of Christ in the vault is again right-side up and readable only from the altar.[34]

Perhaps the earliest criticism of Correggio's Christ is in Bernardino Gatti's fresco of the Assumption in the dome of S. Maria della Steccata in Parma, painted in 1560–72 (figs. 18, 114). Nothing in Gatti's oeuvre so justly earns him the unflattering nickname "la scimmia di Correggio" as the Steccata *Assumption*,[35] yet every part of the fresco is a Counter-Reformatory recanting of the earlier artist's innovations. The bearded, draped figure in the center of the dome of the Steccata is indeed Christ, and the similarities furnish additional proof of the godly identity of the figure in the dome of the Cathedral. While Gatti admires Correggio enough to copy its context and general action, he suffered evidently from the same qualms concerning the beardlessness, foreshortening, and masculine vigor of the Cathedral figure as did later generations of art historians. The Steccata Christ, too, is youthful, open-armed, and bathed in the luminous splendor of the golden light of heaven. He is woundless, and as the triumphant bridegroom, opens his arms to receive the Virgin. But Gatti, opting for a more usual bearded portrayal of Christ, also amends the radical foreshortening of the figure.[36] The figure moves headlong toward the Virgin, enabling the artist to eliminate much of the foreshortening; the action of the arms is no longer Michelangelo's commanding gesture, nor Correggio's expression of eager readiness to embrace, but a more formulaic pose of worship. In the Cathedral, Christ's feet-first descent makes the drapery flutter up to reveal his sturdy legs, but in the Steccata, the more seemly sideways pose allows the body to be fully clothed. The dazzling depicted light in the Cathedral dome sets Christ in a vivid relief; he will receive his mother with a corporeal hug. The later figure is of a piece with the gold aureole, partly dissolved by the light, like a mystical vision whose curving lineaments even fit the circumference of the angelic ring around him. The mid-Cinquecento interpretation emphasizes spiritual feeling at the expense of natural emotion and concrete form. We may recall that Gatti was eager to avoid the negative criticism Correggio had apparently received following the unveiling of the Cathedral fresco.[37] This variation on Correggio's figure is a valuable early document of the same tradition of resistance that eventually would have him an angel.

The relationship between Christ and Adam is now visible and echoes the response between Mary and Eve (fig. 7). Christ descends to Mary, but he turns his head and body to face Adam on our left. The viewer nearing the top of the stairs at this point sees the whole fabric of interrelationships between the first parents and the Madonna and her son. All four are likened by their miraculous youth. Adam's age—he appears to be a christological thirty-three—likens him to Christ, whom Correggio paints as an unusually masculine figure, because Christ is in a certain sense Adam's descendant. "The exceeding wise Creator did not discard what was broken, but remade a new Adam from the old, and substituted Mary for Eve," said Bernard in his sermon on the Assumption.[38] The resemblance between Adam and Christ, the new Adam, occurs elsewhere in Renaissance art; Raphael's *Disputa* is one notable example.[39]

Because of the complexity of Christ's pose, the remarkable similarity between his stance and his mother's has gone unnoticed.[40] Both Mary and Christ turn in extreme *contrapposto* (fig. 115), with knees bent and twisted to the right. The left foot protrudes slightly in front of the right foot. Both turn the upper halves of their bodies to their left, lifting their arms simultaneously. (Christ, as if

from the rush of his fall, lifts his hands over his head, while the rising Virgin's are at eye level.) Meder conducted an interesting experiment to show that several of the music-making angels below the Virgin could have been drawn from one lay figure or model in a single pose, arranged to be seen from several different points of view.[41] While he discovers a principle of Correggio's working process, he does not extend it to apply to the protagonists. For these figures, the insistence on resemblance has meaning. A blurring of the individuality of angels is understandable, but such likeness between Mary and Christ has a long tradition. Through the resemblance of pose, as well as the emphasis on his human form, Correggio illustrates that Christ took his human nature from the Virgin.[42] Just as her ascent mirrors his descent in the parallel between Annunciation and Assumption, his pose echoes hers, too. Pseudo-Augustine, in the Assumption Day sermon, says: "For the flesh of Jesus is the flesh of Mary. . . . If therefore he is the son of his mother by nature, it is fitting that she be the mother of the son by nature . . . not to the unity of the persona, but to the unity of material nature and substance."[43] Even Christ's specific qualities are borrowed at his conception on earth from his mother: "from her he took his nature, not his origin . . . taking on the holy nature of humility from her sanctified body, and taking on the immaculate from the immaculate."[44] One of the three reasons Pseudo-Augustine gives for belief in the Virgin's corporeal Assumption is the unity of the Virgin's flesh with the flesh of Christ, and this passage is repeated in the *Golden Legend*. The exchange is reciprocal because Mary also takes her appearance from the godhead. Her devotion makes her a mirror of divine qualities. "Is she not beautiful, reflecting, unveiled, the face of the Lord, and being transformed to his image, going from clarity to clarity under the illumination of the spirit of God?"[45] The resemblance of poses shows that Christ and Mary may collide in joyous embrace. Like the cymbals the angel beneath them strikes together, their like bodies will meet in perfect harmony.

EIGHT

The View from the Altar at the Middle of the Crossing: The "Central View"

BECAUSE OF ITS CENTRAL POSITION, most art historians have singled out the next clerical view as the primary and most complete view (figs. 8, 11). But while the experience of the fresco from directly below the apex of the dome is satisfying in terms of general symmetry and design, the central viewpoint is not a station meant for every observer, nor is the central view the most comprehensive experience of the painting.

In Correggio's time, the altar would probably have stood where it stands today, at precisely the middle of the crossing.[1] The officiating priest who stands in this spot would be the only observer with access to the exact central view. Far from being the most normal place from which to see the painting, the center of the crossing would have been a highly specialized viewpoint. It seems natural that the priest who celebrates the Mass at the altar has the clearest view of the celestial events at the top of the cupola. In taking the host for his congregation, he partakes in the merging of divine and human worlds, just as he takes in the Virgin's heavenly union with Christ depicted in the dome. In each case, the priest is witness to the reenactment of Christ's redemptive union with this world.

Only Riccòmini has remarked that access to the central standpoint would be the exclusive right of the priest at the altar. As he notes, "In this position, the total view of the cupola in its centrality is the privilege of the priest, who, in raising the host, fixes his gaze on the real center of the cupola— a spot exactly between the head of the Virgin and that of her son who comes to meet her."[2] Riccòmini's isolation of this view as a special rather than a general one is a crucial contribution to the understanding of Correggio's cycle. We may go further, however, and dispense with the notion that this view is "total," since instead the composition is here, also, visually specific because intended for a particular spectator. The main feature of this vista is not, as Riccòmini asserts, an empty space between two figures, for the visible composition hinges upon the dominating figure of Christ and his relationship to the viewer's space. Finally, it is necessary here to qualify the idea of "view," which in this case is ideal rather than actual. It is more accurate to say the priest and altar are overshadowed

by the form of Christ incarnate than that the priest, who would naturally be concerned with the host and ritual surrounding its elevation, actually gazes upon the fresco. His looking up at the painting is not the same kind of looking as the faithful observer's gaze, for example, upon the emergent shape of the Virgin appearing from the last bay of the nave.

Although it has become the site from which the fresco is most frequently copied and photographed, the central view has, like all other views in the Cathedral, inherent visual limitations. As in the oblique views, the architectural context—the dome on four piers—prohibits any absolutely inclusive view. From the altar, what were important scenes from the nave have become the outer perimeter of the octagonal composition. These lower figures make up a rhythmic, ornamental pattern which radiates toward the main celestial action. The oculi, alternating with the dark smoky shapes of the apostles, punctuate a decorative margin edged by the pastel ruffle of attendant angels. The only link between the lower zone and the upper knot of cloud and figures is the smoke rising from the eight funereal candelabra. The scene readable from the altar, then, is an entirely skyborne ring of angels and saintly figures which contrasts with the surrounding architecturally dependent composition.

While the observer at the center of the crossing can perceive the general scheme of the decoration around the oculi, individual figures are very hard to make out. The apostles, because of the steep incline of the lower walls of the cupola, have become impossible coagulations of undulating drapery; the paired individuals are especially difficult to separate. Complaints such as those concerning the ill-conceived design of these figures (as noted in chapter 3) appear justified from below the peak of the dome. Here the viewer can glimpse now and again a bit of a leg or an upraised hand but cannot comprehend the underlying structure of the figure or discern the foreshortened heads. In fact, the decoration of the entire lower part of the dome, including the fictive bronzes between the squinches, the sphinxes, and the figures against and on the fictive balustrade, is functionally illegible.

Iconographically, the lower, now decorative section around the oculi possesses a unity of content distinct from the upper ring of clouds and figures. As the first part of the dome to be seen by the approaching viewer, it presents the earliest portion of the narrative, the symbols and figures concerned with the Virgin's death and funeral. From the altar, this part of the program gives way entirely to the culminating reunion. The angel-decked clouds of Riccòmini's "gigantic optical whirlwind"[3] form a figural corona that is a setting for the Coronation-to-be.

The central point of view allows the limbs and actions of the many angels to coalesce into the seething confusion that gave rise to the criticism of legibility—namely, the "stew of frogs." Even from the center of the crossing, however, the viewer can discern separate groups and major divisions in the figural wreath. We see the asymmetrical arrangement of the palpable cloudy form, the angle of which has accommodated the congregation, particularly, and which here suggests to other points of view besides the central station. The cone of heaven is tilted with respect to the actual cupola, so that the figures above the Virgin fan out for viewing and the clouds west of Christ block our view. This creates Shearman's "inverted flower-pot,"[4] cloudy without and populated within. The figural wreath is in turn set within a larger shell of clouds that rise up the cupola wall and seem to pass behind the "befigured" formation. The heavy ball of angels that accompany the Virgin is set like an

enormous jewel in the cloudy ring. In the middle of the ring, piled vertically up an infinite well, are the blessed. Across from the Virgin, emerging from the less populated cloud formation, moves Christ. Banks of puffy clouds hang down as if obscuring the more inhabited ranks of heaven (fig. 116). A few tumbling angels dot this lower stratum, including an angel with fiery red wings, an angel who peeps back through the clouds to earth, and a putto seen directly and provocatively from below. The central feature of this central view, against which the Virgin and Christ will fly into one another's arms, is the blazing yellow light at heaven's peak. The protagonists will converge within the tall shaft of the blessed, against the brilliant burning light of the very eye of heaven, whence Christ comes and where he will return with his mother.

The imminent union of Christ and the Virgin, which has been perceptible from the top of the stairs, is now fully framed in the figural wreath. The newly visible angels in the west side celebrate even more giddily than their music-making counterparts, as Christ flies to greet Mary. No longer does the enframing architecture set Mary apart from the confusion of surrounding figures as it does in the oblique views. We have already noted the objections of many writers, such as Gronau, that "every time one steps beneath the cupola" an impression of arms and legs obscures Mary's presence.[5] The figure of Christ now, rather than that of the Virgin, is at the heart of the composition. The Virgin's role here is of secondary importance as Christ, detached from the figural wreath, becomes the focus of the dramatic action.

Such an unusual emphasis in a depiction of the Assumption is unprecedented, for in Assumptions of all periods, the Virgin is the primary subject of the composition. A typical example is Matteo di Giovanni's, where Mary, seated in the middle of the composition and in exaggerated scale, rises to a much smaller Savior, who hovers discretely below the upper edge of the panel (fig. 76); it is also legitimate, even more usual, for the godhead to be excluded entirely (figs. 53, 77, 83). This emphasis is the case in the views from the nave in Parma Cathedral; from a more eastern station, however, the figure of Christ takes center stage. To explain his remarkable prominence, we must turn to Renaissance *Coronations*. There, in works such as Raphael's Monteluce altarpiece, is found parity between mother and son; Correggio's own fresco in the apse of S. Giovanni Evangelista is just such an example (fig. 110). The Virgin may in some cases take an entirely submissive place with regard to the divinity, as in Fra Filippo Lippi's *Coronation* (fig. 90) or Sodoma's (fig. 93).[6] Because Correggio interprets the Assumption as preliminary to the Coronation, Christ's conspicuousness in the eastern views is entirely appropriate.

Since it is the central view of the fresco that all writers discuss, it is here that their varying conclusions may be addressed. Until fairly recently, most critics would have agreed with Tassi, who notes that Correggio's frescoed dome has eluded learned interpretation, "since here iconographic rules are respected with utmost simplicity."[7] These writers assume that Correggio paints a simple presentation of the Assumption in a manner that requires no analysis because the content is so apparent. And in part, they are right—the brilliance of Correggio's accomplishment is that the content is, on one plane, immediately graspable. This is especially true of the congregational vistas, but as we have seen, even these operate on a number of levels of meaning. Shearman was the first to suggest a textual source for Correggio's interpretation of his subject, proposing that the painting depended directly on the *Golden Legend*. In retrospect (1992), he intimates some discomfort with

such an appraisal, seeing in Parma Cathedral "the most complete statement possible of the *mystery of the Virgin's bodily Assumption into Heaven*."[8]

Von Simson dedicates his article of 1983 to a kind of "intellectual rescue attempt" for the fresco.[9] He agrees that the source is to be found in the *Golden Legend* but qualifies Shearman's earlier statement, which, he argues, is much too vague. Recognizing the uniqueness of Correggio's choice of specific subject matter, von Simson notes that the scene in Parma Cathedral is completely different from the scenes preferred by most earlier Renaissance artists. In Quattrocento art, he asserts, God the Father rather than Christ usually receives the Virgin. Correggio's decision to portray the Assumption otherwise rests, according to von Simson, on the non-narrative portions of the *Golden Legend*, especially the section in which Jacobus de Voragine selects passages from various theologians and arranges from these a defense of the truth of the bodily Assumption of Mary. Most relevant, he insists, are Jacobus's quotations from Pseudo-Jerome and Gerardus describing the reunion of mother and son, especially the former's assertion that "the Savior himself went forth in all gladness to meet her."[10] Von Simson's article is the first serious attempt to deal with the relationship of Correggio's painted interpretation of the Assumption to theological texts on the subject. This effort is limited, however, since we have already seen that the *Golden Legend* is but one of a great body of writing that treats the legend and justifies belief in the Virgin's corporeal ascent to heaven. Other texts can illuminate the meaning of Correggio's painting and his choice of emphasis.

For several of the major themes visualized in the Assumption fresco, one has to turn elsewhere than the *Golden Legend*. One such idea is the understanding of the Assumption as a divinely sanctioned consequence of the Incarnation.[11] In one variant account of the Death and Assumption of the Virgin not followed by Jacobus, the angel and St. John hail Mary with the same words employed by Gabriel at the Annunciation, thereby demonstrating that the Annunciation of both the Incarnation and of the Death of the Virgin will bring Mary closer to the Son of God.[12] Reference to the Incarnation as the primary condition of the Virgin's bodily ascent is minimal in the *Golden Legend*, but both Pseudo-Jerome and Bernard commence their writings on the Assumption by reminding us that the glory of the Virgin's ascent is intimately connected to her part in Christ's descent to earth. Bernard dwells on the theme so frequently that he even feels compelled to explain this emphasis:

> *Why do we read today in church this passage of the Evangelist where it is told that a woman blessed among all women received the Savior? It is in order that the reception (of the Virgin into heaven), the object of today's solemnity, by comparison with that one (the Annunciation) will appear to us incomparable in its glory, and above all human appreciation.*[13]

The concept of the causal interdependence of the Assumption and the Incarnation is crucial for Correggio's fresco, where we have seen (in chap. 7) that the Redeemer meets his rising mother in bodily form reminiscent of their first convergence on earth. In Bernard's words, these are "both happy receptions."[14] St. Bernardino, in a sermon delivered in Siena on the feast of the Assumption of 1427, describes the Annunciation in order to explain and justify to his audience the immense rejoicing that greets the Virgin's arrival in heaven.[15] The tone and content of the sermon are truly

simple—far more "popular" in nature than Correggio's painting!—and demonstrate that the association of the Annunciation with the Assumption would have reached all segments of Christian society in the Renaissance.

These examples demonstrate, as have the analyses in the previous chapters, that the *Golden Legend* has no particular priority as a source for the program in the Cathedral. In a program of the depth and complexity of Correggio's, there is no reason to assume that one source alone contributed to the content of the fresco. Nor need that source be a strictly popular one, since the program accommodates clerical viewers as well as laymen. Correggio himself would have been familiar with a wider range of discussion than merely Jacobus de Voragine's, but he would no doubt have been counseled by the canons who commissioned and supervised the project. The contract itself indicates that the canons—whether as a group or represented by an individual—must have played a significant part in the organization of the program, since Correggio agrees to paint "those *istorie* given to him." Unfortunately, we know too little about the individuals who signed this document to identify any likely candidate as theological advisor.[16] As Krautheimer says, in reference to Ghiberti's Baptistery doors, "Our impression is more and more that exegetical writing starting with the Church Fathers and elaborated in ever new variants, by the fifteenth century was instantaneously and permanently present in countless variations to the mind of any good theologian; and that in formulating a program . . . any number of variants would strike his mind, like the numberless notes . . . vibrating when a tuning fork is struck."[17] What is the case in Florence in the early Quattrocento would certainly apply to any Italian city in the Cinquecento.

Several libraries in Parma were available in those years for any reader seeking written authority for interpretation of the given subject matter, but the most extensive by far would have been that of the cathedral Chapter.[18] The book collection of Taddeo Ugoleto, a Parmesan humanist of the previous generation, passed into the hands of three of the *fabbricieri* who signed Correggio's contract and from there, probably to the library at the Cathedral. The inventory of Ugoleto's holdings includes, besides the *Golden Legend*, Jerome's letters and Augustine's sermons, Bonaventura's, Bernard's and Antoninus's sermons, Jerome's and Hilary of Poitiers's treatises on the Trinity, and, on a less elevated level, several editions of anthologies of the Miracles of the Virgin.[19] Commissions for seats (in 1500) and then for a new and larger structure (in 1514) for the Chapter's library, located near the Cathedral, demonstrate that the collection was expanding in the decade before Correggio's work on the cupola of the Duomo.[20] Nor need the canons have been limited to local sources, since several participated in the numerous ambassadorial trips between Parma and Rome necessitated by the political events of the period. The artist, whose own intellectual accomplishment must have flavored his imaginative visualization of the material given him, would probably have had access, as a friend of and painter for the Benedictines, to the library at S. Giovanni Evangelista.

While the writings of theologians, the Song of Songs, and the context of the Coronation-to-come may explain why it is Christ who greets Mary in Correggio's *Assumption*, only the relationship of the fresco to the events that take place below at the altar can account for the exceptional focus of the central view. The informative experience of the western views encourages the viewer to seek out Mary, but Christ, foreshortened and silhouetted against the yellow aureole of heaven, seems to descend at this point with equal convincingness toward another destination in the crossing itself. Unlike the

hovering figure in the cupola in S. Giovanni Evangelista, who to the viewer directly below lies flat against the surface of the dome, Christ in the Duomo appears suspended into our space (figs. 58, 105). The corporeal form of Christ, expressed by his athletic appearance and foreshortening, seems to dangle his naked legs into the crossing as the banks of the blessed rise over his head and into the distant source of light. Christ flies into the arms of Mary, herself representative of the Church; he also makes this descent over the most spiritually charged spot in the Cathedral. Like a vessel of the host hanging from the apex of the vault of a medieval ciborium, the bodily form of Christ hangs over the altar.[21] The image of the Son of God is the most salient feature of the fresco from the site where the host becomes his body in the moment of transubstantiation. Just as Christ's bodily descent to the Virgin also refers to the Incarnation, at the altar the image also represents the repeated descent of the divine presence in the sacrament of the Mass.

Christ is the son of Mary and redeemer of all humankind, for whom he enters the host as a reenactment of his sacrifice. In the Assumption the promise of eternal life is given specifically to the Virgin, but the fresco illustrates the more general belief that Christ offers salvation to all the faithful. In the central view, Correggio incorporates the meaning of the Christian rite that takes place below into a program that is at once specific and inclusive.

NINE

The View from the Eastern Apse: The Western Face of the Cupola and Two More Squinches

THE ONLY MEANINGFUL VIEWS remaining to be discussed, those from the apse, take in the western section of the dome (figs. 9–11). The two western squinches, which were first visible from the center of the crossing, now form the substructure of the composition. From the squinches rises the great semibowl of the cupola, completing the composition hidden from the congregation. It shares some features with the nave view, such as apostles, attendant angels, and the fictive marble balustrade; above this, clouds and more tumbling angels fill the frescoed sky. For the observer in the middle of the east arm of the church (figs. 9, 11), Christ flies at the apex of the slice of dome, while from the back of the apse (fig. 10), a putto, foreshortened in a revealing spread-eagle pose, is uppermost. The Virgin is present only from beneath the eastern crossing arch and at the front of the apse, but because she is seen upside-down in a disorder of angels, she is functionally as invisible there as she is from further east in the apse. Riccòmini, the one art historian to consider this view, remarks, "The fresco cannot be understood (from the apse) because obviously the Virgin cannot be discerned. . . ."[1] But this view, like the central and western ones, offers a specific and unified message for the audience who sees it.

From the *Ordinarium* of 1417, we know precisely the persons in the apse to whom this view would have been visible. It may be safely assumed that through the fifteenth and first half of the sixteenth century the arrangement went substantially unchanged. The choir stalls and the bishop's throne remain in place today. Cristoforo Lendinara's wooden choir stalls (1469–73) wrap around the north, south, and east perimeters of the apse and meet at the Romanesque *cathedra* in the eastmost location. Above the bishop's throne rose, and still rises, the ciborium of 1486–88 (the "sacramento" of Correggio's contract).[2] This area was designated in the Renaissance as the lower choir (*chorus inferior* or *secundus*, as distinct from the *chorus primus*), and seated the major clergy.[3] Though an eastern position is plainly a sign of clerical status, the designation "lower choir" shows this part of the Cathedral was conceived quite otherwise. According to Durandus, the chief clergy must sit in the lower choir as a demonstration of their humility. Since "the highest sit last,"[4] the bishop takes the first

place of dignified humility in the eastern extremity of the church. The *Ordinarium* supplies a detailed list of the others present during the Mass,[5] the most eminent of whom are the archpresbyter and archdeacon. Here also sat a deacon, a subdeacon, and a variety of canons and prebendary clergymen. In the first half of the sixteenth century, as in the fifteenth, the bishop would usually not be present, and the vicar would sit at the back of the apse in his absence. The bishop in Correggio's time was Alessandro Farnese, the future Pope Paul III (bishop of Parma 1509–34); since he was usually not in Parma but occupied in Rome,[6] episcopal matters were turned over to his representatives the vicars, the Parmesan Pompeo Musacchi, bishop of Lidda, and Bartolommeo Guidiccioni of Lucca.

The major clergy, then, including the bishop or his proxy, saw the two squinches and the lunette of fresco above them. In the southwest squinch, Correggio painted a saint identified by nearly all writers as the apostle Thomas, and in the northwest, S. Bernardo degli Uberti (figs. 117, 118). A discussion of the western squinches that face the presbytery must address two fundamental errors that have persisted in the literature on the fresco. That Correggio depicts not Thomas but Joseph and that S. Bernardo is not a patron saint of the city until well after the frescoing of the dome argue against the standard perception that the four squinches represent "the four patron saints of Parma." The usual assertion that the squinches together constitute a radially symmetrical sub-program is an interpretation supported by the habit of observing the cycle from the middle of the crossing and by the assumed exclusivity of the central viewpoint. We have already seen that the squinches visible from the nave depict two patron saints, St. John the Baptist and St. Hilary of Poitiers. Their ancient civic status earned them a place in the view offered to the worshiping citizens of the town. The western squinches, on the contrary, unite with the figures in the cupola above them to create a set of views entirely adapted to the clerical audience.

St. Joseph

Clemente Ruta, in his *Guida ed essatta notizia à Forastieri delle più eccellenti Pitture che sono in molte chiese della città di Parma* (Parma, 1739), is the first to name the southwest figure as Thomas, an identification that was seconded and made more popular by Mengs (fig. 117).[7] This identification is not on first consideration without some reason. Thomas was in 1522 the newest addition to the roll of Parma's patron saints, elected to the honor the year following the Parmesan expulsion of the French on his feast day, December 21, 1521. A. E. Popham notes the timely felicity of the Parmesans' adoption of St. Thomas as the fourth patron saint of the city so soon before Correggio received the commission that included the four architectural niches.[8] Riccòmini sees the connection between political and artistic events as more than coincidental and remarks: "It is more than likely that the first and most immediate occasion which induced the canons to have the dome painted and to have depicted there the theme of the five patron saints of the city (that is, the four saints and the Virgin) was the unexpected victory on the day of St. Thomas."[9] Accordingly, the fresco, commissioned as a commemorative thanksgiving to both the Virgin and Thomas, would have of course included their images. Since the eighteenth century, the identification of the occupant of the southwest squinch seemed confirmed, and St. Thomas easily took a place among the saintly protectors.

Vasari, however, who referred to the theme of the squinches in Parma Cathedral as the "quattro

santi protettori de quella città," called the figure under discussion "San Joseffo sposo della Nostra Donna" ("Saint Joseph, husband of Our Lady").[10] More recently, David Ekserdjian has presented evidence to support Vasari's naming of the saint. In a document from the *Libro degli Ordinazioni* (1526–30) from the Archivio del Comune of March 19, 1528, the Town Council of Parma adopts St. Joseph as a patron saint and moves to dedicate the right transept of the Steccata to him as well as an altarpiece.[11] Vasari's long-ignored assertion can be sustained by an examination of the figure's physical appearance, dress and attributes, as well as comparison of depictions of the saint by Correggio and other artists. A closer look at the history of Joseph's theological connotations and his devotional status in Parma indicates the artist's intention from the beginning of the project to include the guardian of the Holy Family as an integral part of the *in situ* program.

Among Renaissance artists, Correggio has the distinction of painting the saint with unusual frequency. Joseph appears in the painter's undisputed oeuvre nearly a dozen times.[12] Throughout his career, he consistently depicts Joseph as an elderly but vigorous man with gray hair receding from his brow, gray beard, and the traditional red overmantle that may vary in hue from flame to crimson.[13] The squinch figure resembles Joseph in Correggio's *Madonna della Scodella*, contemporary with the Cathedral frescoes, and now in the National Gallery of Parma (fig. 84). In this painting, Joseph is paternal guardian of the Holy Family in Egypt and pulls down the palm branch to enable the Virgin and Christ child to partake of the nourishing fruit. The physiognomy of the bony forehead and sharp cheekbones, the flaring nostrils, the dark eyes shaded by the straight brow, and even the cut of his mantle make him seem a portrait of the same man as we see in the squinch.

In the squinch, the old bearded saint, outfitted as a traveler with red cloak and heavy boots, holds a staff in his hand. Angels to our right attend his rope-bound pack and water cask (fig. 119). On the left, an angel carries a palm and cluster of dates and nearby, another motions with a lily (fig. 120). While the accessories of travel refer to Joseph as the protector of the Holy Family in Egypt, the lily attests to his role as perfect spouse. As we will see, these two aspects of Joseph are of special relevance to his placement in the Cathedral.

The character and attributes of travel of Correggio's figure correspond as well to depictions of Joseph by other Renaissance artists.[14] An example is Andrea Solario's painting in the Poldi-Pezzoli, Milan (signed and dated 1515), in which, kneeling in delighted reverence to the Virgin and Child, Joseph passes each the nourishing palm dates, without benefit of angelic intervention (fig. 121). At his side is a virtual still-life of his attributes in his capacity as traveler—the canteen, baton, and sack of figs.[15] North of the Alps, where the Rest on the Flight is a more common subject than in Italy, artists are particularly careful to delineate the objects Joseph carries. In a woodcut by Albrecht Altdorfer, Joseph has flung the staff and canteen over his shoulder; his hat, coat, and heavy boots all show him to be Joseph the traveler.[16] Dürer's Joseph, in the *Flight* from the woodcut *Life of the Virgin* series, watchfully leads the Virgin and her donkey through a dark forest (fig. 122). Equipped with his cape, walking stick, and large pouch, he strides past an enormous palm tree, luxuriant with clearly described dates, that rises to overarch the composition with its fruitful branches much like the tree in Correggio's *Madonna della Scodella*. Baroque artists, not yet misled by the later identification of the figure in the southwest niche of the Cathedral, borrowed Correggio's conception of the saint. For example, in Francesco Solimena's altarpiece for the Church of the Theresians

in nearby Piacenza (done ca. 1700), St. Theresa enjoys a vision of the cloaked Joseph that corresponds to our view of the composition in Parma Cathedral (fig. 123).

The lily appears rarely with Joseph until the early seventeenth century. The association between saint and flower is drawn from another apocryphal story, that of the betrothal of the Virgin. Though Joseph, an old man of many years, felt himself unworthy to number among the suitors for Mary's hand, divine providence had deemed otherwise, and when all the men had gathered in the temple with branches signifying their hope for marriage, Joseph's bloomed spontaneously. Some Renaissance artists such as Fra Angelico and Rosso Fiorentino, in their depictions of the Marriage of the Virgin, presage Correggio by specifically depicting the flower as a lily. As the flower of chastity and of the Annunciation, the lily in the squinch indicates Joseph's role as celibate protector of Mary's virginity and guardian of the mystery of the Incarnation. To Augustine, the joining of Joseph with Mary is a conjugal and spiritual bond, "a marriage free from all corruption."[17] St. Bernard of Clairvaux defines Joseph's importance in his pure union with Mary. According to Bernard: "Joseph by betrothing Mary to himself, and by carefully watching and approving her demeanor during the whole time she was in his custody, became the most faithful witness of her purity."[18] The placement and gesture of the angel with the lily emphasizes the significance of this attribute. He points toward the east chapel of the south transept. As we know from fifteenth- and sixteenth-century sources, the chapel on the spot to which the angel gestures was once dedicated to the Annunciation.[19]

Not only does the iconography of Joseph argue against the conventional identification of the figure as Thomas, but the iconography of Thomas resists it also. In countless Italian pictures, and not only in Tuscan ones,[20] artists follow the apocryphal account in which Thomas is granted a token of Mary's corporeal Assumption in the form of her girdle dropped from heaven. It is nearly inconceivable that in a cycle of the Assumption of the Virgin, in which the artist is at pains to supply the attending saints with appropriate attributes, Thomas should appear without Mary's girdle. This lack of reference to the apostle's traditional participation in the event painted in the dome fresco confirms the necessity for a reconsideration of the figure in the squinch. The object in the figure's left hand has been called a T-square, an attribute of Thomas, but without a crossbar, and in the company of so many Josephine attributes, it is certainly a traveler's staff, neatly hewn by the carpenter who holds it.[21] The objects in the squinch have always troubled observers constrained to misidentify the saint they accompany, as in Perfetti's attempt to render the dates in his late-eighteenth-century drawing after the painting (fig. 124);[22] but once we recognize the saint as Joseph, the attributes become recognizable and wonderfully suitable.

If the figure in the southwest squinch is Joseph, not Thomas, then how did he win his place in the Cathedral program? Inquiry into the history of devotion to the saint in Parma shows that Joseph enjoyed a local regard more time-honored than that of the apostle. Parma claims one of the oldest sanctuaries dedicated to Joseph in Europe, an oratory that may have existed as early as 1074 near the Cathedral.[23] Because the cult of Joseph was widespread but by no means universal in the Renaissance,[24] the frequent invocation of the saint in Parma is noteworthy.[25] Correggio's fresco is part of an increased interest in the saint expressed in the devotional practices of the region around Parma, in contemporary religious writing, and in visual art. Jean Gerson, the chief pro-Josephist of the early fifteenth century, notes that the Augustinians of Milan were already celebrating his feast

day, and a church was dedicated to him in that city.[26] Bologna boasted an oratory of antiquity nearly equal to that of Parma, as well as the possession of two relics of his clothing.[27]

Joseph appears with particular emphasis in paintings of Emilia-Romagna in the first decades of the century. Some notable instances include: Costa's *Adoration of the Christ Child* (ca. 1490, Lyons), where Mary and Joseph share equal prominence in the symmetrical arrangement around the sleeping child; Aspertini's *Sacra Conversazione* (St. Nicholas des Champs, Paris), where Joseph, not the Virgin, slides the child protectively from the infant Baptist's menacing little cross;[28] and, in perhaps the most exceptional image, the *Holy Family and the Four Crowned Martyrs* in the Worcester Art Museum, Mass., attributed to Niccolò Pisano, in which the Virgin stands apart and blesses the Christ child, who, waving a lily, rests in the arms of his kneeling earthly father (fig. 125). The conflation in the Worcester painting of the lily of the Annunciation with the flowering rod of Joseph's betrothal implies the saint's guardianship of Mary's purity and is of interest to the floral attribute in the southwest niche.

On Joseph's day, March 19, 1528, while Correggio was at work in the Cathedral, the Parmesans enlisted Joseph's intercession against the plague spreading that year through northern Italy, and the saint's special status in Parma was confirmed. As a special mark of their devotion, we read in the document published in full by Ekserdjian, the Commune also on this date dedicated a chapel and altarpiece to the saint for the Steccata.[29] At the beginning of the previous century, in 1406, Joseph had been elected "co-protettore di Parma." Though his feast day is not mentioned in the section of the *Ordinarium* of 1417 that tells of saints' holidays regularly celebrated in Parma Cathedral, he appears in the "libro d'oro" of 1426 again as patron saint of the city.[30] These notices indicate that, at least in the Renaissance, Joseph's protection was called upon only selectively as occasion demanded.

Comparison with other Renaissance images of the Flight into Egypt such as Dürer's woodcut, identify the subject in the cupola and also demonstrate how Correggio's isolation of the saint is remarkable. In the squinch, Joseph is extracted from the narrative context of the Holy Family's sojourn in Egypt, but retains the theological meaning of his guardianship and pilgrimage by preserving the attributes that refer to the Flight. The document for the Steccata of 1528 invokes Joseph in just this capacity, as "Il glorioso santto Joseph Nutritio del nostro Redemptore." We may also recall the inscription on the original frame of 1530 for Correggio's altarpiece for the Josephine confraternity at S. Sepolcro in Parma, which names the saint "most faithful guardian of the mother of God."[31] As one who safeguards the Virgin Mother and keeps the incarnate Christ from harm, Joseph on the Flight is a model for the priest, who ensures the sanctity of the Church and the preservation of the host. According to Ambrose, for instance, it follows that as the Virgin is a *typus ecclesiae*, then her husband is a *typus apostolorum* and represents the priest or bishop married to the church in order to spread and to strengthen the faith. St. Ambrose writes: "The most holy Mary to one [Joseph] is a wife, but is made fertile by Another, just as the individual churches are indeed inseminated by the spirit and by divine grace, even while visibly tied to the bishop who temporarily governs them."[32] The parallel is developed by Bede, who compares the expulsion and mission of the Apostles to the Flight of the Holy Family from Herod. Based on such analogies, the saint, in the guise of the traveler into Egypt, represents a priestly figure.[33] In Parma Cathedral, his protective action on the Flight is an example to the clergy of the right relationship of bishop and Church and a definition of pastoral duty.

Correggio's imagery is not only part of the increasing respect for Joseph fostered in the early sixteenth century, but it has a place in the *in situ* program of the Cathedral project. The southwest squinch is visible to those canons, deacons, and other officers of the church, including the bishop or his vicar, in the upper and lower choir of the crossing and apse. These constitute just the persons for whom the image of Joseph, married in celibacy to the Church and earthly parent and custodian of Christ's bodily existence on earth, would be most pertinent.

St. Bernardo degli Uberti

Joining Joseph with his specifically priestly associations is S. Bernardo degli Uberti in the northwest squinch (fig. 118); together they form a significant pair visible to the clergy in the choir. From the northwest squinch spills a cloud that supports this saint and seven angels. He is dressed in a plum-colored cassock, with a cape of slightly bluer hue. The reddish color of this robe refers to his office of cardinal, while the purple mozzetta demonstrates that he is bishop. A crumpled white surplice runs around his hips, the curving hem of which continues into the pages of the book. As one leg trails behind, the other, with knee bent high, props up his book. His gestures are of supplication, and his stance forms a yearning diagonal. The noble bearded head turns to the unseen object of his devotion, and, as he clasps his right hand to his breast, he points to us with his left. The foreshortening of the left hand makes the pointing finger inescapable for the viewer in the presbytery. The destination of his gaze does not belong to the fresco but far away beyond the confines of the painted world and beyond the Cathedral itself. He pleads to God on behalf of the viewers in the east of the church.[34]

As in the other three squinches, the angels' movements and attentions are various, but their mood is united in joy. They have but one attribute, the silver crosier, to attend. An angel grips it respectfully in a white cloth and motions above, looking to the Virgin. To the left, another figure parts the clouds to see below, and, on the right of the squinch, two laughing figures also stick their heads out from the mist. Below the saint are three beautiful angels, who slide among the clouds in languorous poses. The foremost angel kicks his heels and laughs as his green robe and hair fly up with the velocity of his movement. Another sits carelessly as if in a cloudy throne; the third, of a genderless angelic beauty,[35] hovers beneath S. Bernardo.

Bernardo degli Uberti (ca. 1050–1133), born of a noble Tuscan family, was the abbot and seventh General of the Order of the Vallombrosians at the monastery of S. Salvi. In 1099, Urban II made him a cardinal, and he acted under his successor Pope Pascal II as the papal vicar of northern Italy. Around 1104 he became bishop of Parma, replacing the schismatic bishop Wido. The citizenry and bishop of Parma had been until this time united behind the antipope, siding with the German emperor rather than with the Roman pontiff. Bernardo, backed by Countess Mathilde of Canossa, instead supported the pope of Rome. As a result, in 1104 a group of citizens seized Bernardo as he said Mass and cast him into prison where he remained for two years. He was released—through the machinations of Mathilde and what seemed a miraculous change of popular opinion. Pascal II, to whom S. Bernardo was the apostolic legate of Lombardy, visited Parma in 1106 and dedicated the Cathedral. The subsequent history of his life concerns his further entanglement in the dispute between imperial and papal factions.[36] S. Bernardo's presence in Parma left a vivid legacy, not only in

the surviving accounts of his saintly activities, but in his contribution to the fabric of the Cathedral itself, much of which dated from the period of his bishopric.[37] His relics, preserved in the Cathedral crypt, were a continual reminder of his contribution.

Images of S. Bernardo, though common in Tuscany and especially Vallombrosian convents, occur with infrequency in Parma before Correggio's painting.[38] Several altarpieces postdating the squinch include the saint, but the only surviving Renaissance image in the city painted before Correggio's in which the saint can be identified is Araldi's altarpiece of 1516 in the Cappella Centoni (the fifth chapel on the right in the Cathedral). In each of these, and to some extent in Correggio's portrayal, Bernardo is the generic cardinal/bishop, bearded or clean-shaven, with cap, miter, or bare head. But it is not so much how Correggio painted the bishop of Parma that is of interest, as the fact that by depicting him in the squinch, the artist elevated him to a new place of importance, in the company of three patron saints.

Almost all authors describing the squinch call Bernardo a patron saint, in keeping with the supposed program of the "four patron saints of Parma." But as with the southwest squinch, the case is not so clear. Ireneo Affò notes that the saint had long been revered in Parma, but according to del Prato, he was not considered one of the official protectors of the city until 1548, the year in which his relics were moved to a new tomb in the crypt.[39] Though S. Bernardo was venerated from the thirteenth century in Parma, he had no special status there, at least, in the early fifteenth century, for the *Ordinarium* of 1417, while giving careful instructions for the celebration of his day on December 4, does not refer to him as "advocatus," as it does St. Hilary.[40] Nor was a coin ever minted in Parma with his image, though the civic patron saints John the Baptist, Hilary, and Thomas were so honored. And during the years after Correggio's project, in 1533–39, the Virgin, Joseph, the Baptist, and St. Hilary are called upon as special intercessors in the *Libri degli Ordinazioni*, but S. Bernardo is not.[41] With the translation of S. Bernardo's relics in 1548 to the tomb completed in that year by the Reggian sculptor Prospero Clemente, S. Bernardo finally won respect as patron saint. It may be that Bernardo enjoyed an on-again, off-again status as patron saint similar to the pattern that characterized Parmesan devotion to Joseph, but as a saint of considerably narrower, specifically ecclesiastical associations, his position was more uncertain. S. Bernardo's fortune may well have reflected the political climate of the time, and especially the influence and aspirations of the bishop, Alessandro Farnese. In 1519, the year that the bishop held a synod in Parma and made one of his rare appearances in his diocese, the sculptor Gian' Francesco d'Agrate was commissioned to sculpt a new tomb for Bernardo's remains.[42] Nothing came of the idea until 1544, when Clemente was finally commissioned to execute the tomb in the crypt. In 1548, he completed the monument that has housed the relics since their translation of that year. Enthusiasm for the tomb project, then, was sponsored in the years when Farnese power was strong in Parma; first, during the synod, then in the same period as the Farnese acquisition of temporal power of the city in 1545. Like S. Bernardo, Alessandro was also made cardinal, then bishop of Parma during a troubled time for the city. Also like Bernardo, Alessandro was determined to reform the churches and monasteries of Parma through the constitutions of his synods of 1516 and 1519. The Farnese claim to Parma was founded upon Alessandro's bishopric, and having perhaps identified himself with the medieval bishop of Parma, the revival of S. Bernardo's cult was connected with the assertion of Farnese power.

Correggio's inclusion of S. Bernardo in his fresco cycle is part of this history. If we recall that the entire decoration was conceived as an artistic celebration of the papal victory of December 1521, it is no surprise that the pro-papal Bernardo should appear in the squinch. The canons of Parma saw Bernardo's story as particularly relevant in a time when Italy was attempting to cast out the northern imperial troops and the church was struggling to maintain its spiritual and secular hold in Europe. While the inclusion of the pro-papal Bernardo was appropriate for the program in its initial stages, it would have become even more relevant as the project progressed. The second *Vita* describes the situation in terms that would have recalled the Sack of Rome of 1527: "At that time Henry, the wicked emperor, entered Rome, and forgetting the honor of God, despoiled the clergy and imprisoned the Pope with many cardinals, bishops and prelates."[43] Bernardo, too, had rejected the imperial cause in favor of papal domination from Rome. His opposition to the heretical support of an antipope could also have been seen as a prefiguration of the Catholic resistance to the northern and internal movements for religious reform. Because he had even been patron of the construction of the Cathedral, he fittingly took his place in a program dedicated in part to showing the power of the church.

When he was present upon his throne in the most eastern point in the Cathedral, Bishop Farnese (or his representative) thus had set before him the image of his noble predecessor and a model for the successive bishops of Parma. Not only was Bernardo an example to the bishop by virtue of his office, but by his part in the history of the Cathedral and the city, he was an example to the clergy in general. S. Bernardo had endured hardship and persecution for the unity of the church and could be invoked to remind the clergy to defend the Roman faith with similar devotion. The figure of S. Bernardo was also a reminder to the clergy of the authority of their bishop, the head of their diocese, and their spiritual leader and teacher.

The second of the *Vite* of S. Bernardo, an account that is part history, part legend, was written in the twelfth century and existed in a sixteenth-century copy in the library of S. Giovanni Evangelista.[44] In this manuscript, the bishop saint is depicted much as Correggio portrays him. The biographer describes how when Pope Urban II wants to make the modest Bernardo a cardinal, he succeeds only by ordering him to Rome by papal command.[45] Correggio shows his awareness of the humility of S. Bernardo, stressed frequently in the *Vita*, by rendering him bareheaded and in simple dress, with the crosier of his pastoral duty and the holy book open on his knee his only attributes. The biography relates how, at every turn of events, Bernardo prays on the behalf of evildoers. Whether beset by marauding thieves or cast into prison by the faction of the antipope, Bernardo turns to God in supplication.[46] In the squinch, he prays also for the prelates and canons assembled below, to whom he points. The image of S. Bernardo degli Uberti reminds the observers of their imperfection and dependence on God's mercy. By depicting the saint in this way, Correggio recalls not the high estate of his viewers but their continual need for humility. In contrast to St. Hilary, whose miter is conspicuous to the masses in the nave, Bernardo appears to the clergy without his cardinal's hat, one of the few consistent attributes of his iconography. Its absence makes him all the more a figure of humility, a virtue that links him with the Virgin. Furthermore, the men in the upper and lower choirs looked at an image of the saint whose remains lay below in the crypt and whose soul was assuredly in heaven; his person therefore provided a link between this world and the next. Bernardo could plead on the clergy's behalf, as Correggio depicts him, just as their

participation in the Mass in turn benefited the souls under their charge in the ongoing chain of spiritual responsibility.

Correggio pairs Joseph the *typus apostolorum* with Bernardo the medieval bishop of Parma to provide inspirational models for the clergy and bishop that see them. Joseph, by his intimacy with the Holy Family, shows the priests gathered below that they are the guardians of the church and of Christ's body on earth. S. Bernardo, by his office and by his role in the actual history of the Cathedral, presents an example to the present bishop. To the clergy, he is a representation of ideal episcopal authority, of right behavior in the face of heretical adversity, and of humble supplication to God.

The Western Face of the Cupola

Together, the two western squinches are part of a larger clerically oriented composition visible to those in the presbytery (fig. 9). As in the nave, the first figures that appear above the squinches are the apostles (figs. 126, 127). We have seen that those disciples visible from the nave shield their eyes, not only from the Virgin but also from the dazzling light of the descending Christ. Correggio's interest in the accessibility of views applies to the apostles as well as to his audience. It becomes apparent at least from the front of the apse that the apostles can see the Virgin, to whom they gesture, but not her son. The low mass of cloud that drops near the parapet obstructs the western disciples' path of sight. The two apostles to either side of the west oculus tip toward one another with their bodies but gesture away from the central axes in a symmetry that synchronizes with the movement of the saints in the squinches. The paired apostles on the south and north sides of the cupola continue this pattern. They urge one another to behold the Virgin's miraculous resurrection by pointing up and by catching one another's attention. In every case, these eight individuals move toward the east in order to face Mary. The asymmetrical arrangment of the clouds, then, not only permits the Virgin to ascend within sight of observers in the nave and the western apostles, but it also prevents the apostles from any view of the figure of Christ.

Renaissance artists disagreed on whether or not the apostles saw the Virgin and one of the Trinity at the Assumption. Taddeo di Bartolo, in the Palazzo Pubblico in Siena, makes the invisibility of the event a part of the miracle (fig. 109). Titian, on the other hand, gives the apostles a glimpse of both the Virgin and God (fig. 55). Most painters, such as Titian, allow that the apostles could look upon the Assunta, but only with difficulty. Correggio agrees with this tradition, but since it is not always the rule for Christ to appear at the Assumption, the painter must make his own decision on this point. The apocryphal narratives are also divided. In the *Golden Legend* and in one related Latin version, Christ appears to the apostles at Mary's tomb.[47] A long conversation ensues between the disciples and the apparently visible Christ. In another Latin version, the divine workings are secret, for as they wait with Mary's sarcophagus, "suddenly there shone around them a light from heaven, and they fell to the ground, and the body was taken up by angels into heaven."[48] The problem is analogous to that of illustrating the Transfiguration. The Bible (Luke 9:28ff.) permits the apostles a view of Christ in his radiant robes and with Moses and Elijah at his side, but painters such as Bellini and Raphael prefer, in order to show the brilliance of Christ's appearance, that the apostles are nearly blinded in their attempt to set eyes on their Lord (fig. 128). In both the *Transfig-*

uration and in Correggio's *Assumption*, vision and blindness are relative with regard to a hierarchy of divinity. When God the Father speaks at the Transfiguration, he comes in an "overshadowing" cloud, just as Correggio overshadows the western apostles but lets them see Mary. Though the apostles are twelve similar and rather anonymous men, Correggio has carefully conceived their responses according to a logical understanding of the nature of divine events and our access to such events when they enter the human world.

The angels behind the apostles, like their eastern counterparts, carry out the funeral rites of the Virgin, but an examination of the individual figures visible from the apse shows their activities are also specifically appropriate for the clerical audience. Over the western oculus, two angels tend a bowl, perhaps of incense, while another turns his back to us (figs. 129, 126). The two figures nearest the candelabra in this group wear robes of exceptional richness, edged with golden fringe. The seated angel holds up the silver basin, and his partner lifts the substance from the bowl, probably to restoke the candelabrum. The third angel occupies himself with something on the other side of the marble dado. An analysis of the actions of all the funeral-attending angels who appear from the apse shows that while a few pass bowls and polish candelabra within our range of sight, many of them peer over the balustrade to a place invisible to us. The two rather similarly posed angels who stand at the two western candelabra each look away from us to an unseen point beyond the dado, and the figure over the northwest oculus, as he points up to heaven, looks down to an unseen interlocutor (fig. 130). Likewise distracted, a pair over the southwest oculus fix their gaze over the balustrade and seem to communicate with an invisible audience (fig. 131). The effect is similar to the separation of the presbytery and nave, once made more decisive by the medieval parapet (fig. 39). To the clergy seated in the apse, the congregation is hidden from view since the altar would have obstructed their view of the worshipers standing in the body of the church. The angels bid the clergy to remember their charges in the nave—to recall that these faithful attend the ascent of the Virgin as well, if from a different station, and partake in the reenactment of Christ's descent, in the Mass, under their supervision.

From the nave, we identified three different kinds of angels near or beneath the Virgin: the wingless funeral attendants, the long-winged music-making angels, and the putti. These types appear on the west wall of the cupola, too, but the angels near Christ are more various, as if subject to a greater range of celestial mutations, and the different kinds readily intermingle (fig. 116). Here a winged adolescent in a yellow cloth peeks down at us as he cavorts with a wingless friend. At the same level and to the south, an angel with fiery red wings presents his back. The angels are more sparsely scattered through the clouds than those surrounding the Virgin, so that frequently the viewer catches only a glimpse of a leg or wing or peeping face. From a gap in the clouds, one angel over the southwest window looks down toward the funeral attendants (fig. 132). Such a psychological link between the two angelic realms of balustrade and sky is exceptional. The angel seems to direct his gaze behind the dado, to the same spot as that to which the attendant below him motions. Followed through to the floor of the church, the angel's gaze leads to the pulpit. When the sermon was read, it must have seemed to those in the choir that this angel turned to listen to the preacher's words. In this detail, Correggio again arranges a figure in the cupola with respect to the events below in a manner that unifies and gives life to the frescoed illusion.

One figure in particular deserves comment. Though critics of the cupola have striven to over-

look this angel, his placement and posture make him inescapable. Directly below Christ is a putto one tactful writer described as having "his head in the clouds" (fig. 133).[49] We view the male putto directly from below, so that as his drapery flies up and legs splay apart, even his genitals are open to the observer's gaze. Tassi takes refuge in formalism by praising the light and warm color of the western angels.[50] Ricci describes the western angels together, but when he observes that "they seem to rise and cleave the clouds in vertical flight . . . ,"[51] he can only mean this individual. Nor can this figure be merely an exercise in foreshortening, though the placement of the figure assists our perception of space and volume, thereby locating the cloud bank below Christ. Gronau is one of the only writers to confess any reaction to the angel, and his response is censorial. He describes the figure, "just over (Christ) in the clouds, where, since there is no merciful shred of drapery to cover him, we have an embarrassing *sotto-in-su* view from below a man's body."[52]

Though several of the angels on the eastern face of the cupola fly in potentially immodest positions, Correggio takes care to cover the loins of each with a scarf of fabric, or to so arrange the figures (like the laughing putto below the Virgin's foot) that no excessive nudity will occur before the congregation. Certainly Correggio was aware of which observers would see the putto "with its head in the clouds." The putto is especially prominent and in fact surmounts the picture (Christ being entirely absent) for viewers seated in the eastmost choir stalls at the back of the apse (fig. 10). Riccòmini, in the only interpretation offered to date, suggests that not only was the audience of the figure preconsidered, but that Correggio planned this passage as a joke to spite the bishop. Riccòmini proposes that perhaps

> one can imagine . . . finally that Correggio reserved . . . a point of view destined for the Chapter, or better for its most important members, since in those years the bishop was never there. To prove this (and to be certain that the thing was planned and does not occur by accident), one need only sit at the center of the hemicircle of the choir, just where the choirstalls are interrupted by the bishop's throne. This point is exactly symmetrical to the spot in the nave at the foot of the stairs where one contemplates the rising Virgin. . . . To whom this joke was personally intended, if joke it is, we can't know, but it lightens the "high tone" of the fresco.[53]

Riccòmini thus assumes the figure is meant to be humorous in a slightly malicious way. But though the fresco has many passages of nearly comic ecstasy, the artist's light touch is always in the service of the Christian theme, better to express the joy and mirth of the heavenly event. The angels that cavort in paroxysms of delight are devised to bring a smile to the viewer, but hardly a schoolboy's smirk. In fact, the entire tenor of the fresco, its very "proto-Baroqueness," lies in a conservative assurance and enthusiastic seconding of the precepts of the Church as institution; it is unlikely that Correggio should wish to subvert the overall mood of pious triumph with one passage of willful impudence. The critical silence on the subject is proof that the tumbling angel has shocked many modern eyes, but it would be better to accept the centuries between us and it as obscuring, and to conclude that the figure is, to a twentieth-century viewer, puzzling, rather than to assume that Correggio's standards of morality and humor were the same as our own.

Two possibilities, neither conclusive, can be offered with regard to the troublesome putto, and

each depends on a slightly different viewpoint. If these arguments do not explain the presence of the putto, at least they acknowledge his existence and conspicuous placement.

Purely in terms of the formal effect of the figure, the complete foreshortening creates a dramatic perspectival impression, especially for those in the east end of the apse. By painting the putto in isolation at the very center of what we are to believe is the lowest part of the figural wreath, Correggio produces the convincing illusion that the clouds drop down toward us to a point nearly level with the marble balustrade. No side view could produce this effect so persuasively. The clouds enter into our space, and the viewer in the lower choir feels as a result closer to the celestial events. The major clergy catch a glimpse of the "lowliest" parts of the male angel but are privileged to the sensational illusion of proximity with the heavenly scene. This contradictory combination is reminiscent of Durandus's insistence that the highest clergy be brought low by their seats in the *chorus inferior*. We must also recall that though the angel flies in undignified fashion to those below, his (imagined) view of the Virgin and Christ is exceptionally clear, and his appearance to the other angels of impeccable right-side-upness.

To the clergy nearer the eastern crossing arch, Christ is still visible. The closeness of Christ, also seen *dal-sotto-in-su*, with this even more exposed angel is peculiarly suggestive, as if the artist alluded to a kinship between the two. Keeping in mind how carefully Correggio considered the functions, actions, and appearances of the angels, we must accept that this unusual angel is the result of the same deliberation and possesses a meaning in the context of the Assumption. As the most assiduous of angel painters, Correggio may have known of the tradition that Christ is the *princeps angelorum*, prince of the angels.[54] The angel-like shape in which the painter cast Christ, which made some observers even mistake him for an archangel, is perhaps due to this idea. According to Origen and Lactantius, Christ after the Resurrection is not of pure spirit as is God but of a stuff cosubstantial with the subtle and invisible material of the angels.[55] In the cycle in the Cathedral, the figure at the apex of the dome is not only the Christ of the Assumption but also Christ after the Resurrection. Because the corporeality of Christ exists also in heaven and distinguishes him in the Trinity from God and the Holy Spirit, he is shown moving, joyous, and foreshortened, as a man. Correggio's emphasis, as we have seen, is upon the incarnate aspect of the Savior as Mary's son, just as he includes the first parents to call upon her role as the "new Eve." The angel, near Christ physically and formally, is a sort of reference to the corporeal body of the heavenly Christ. By means of this equivalence, Correggio paints the angel as he does not dare paint Christ—with his full corporeality, complete even to his genitals, in plain view. The angel is a tangible symbol for the carnal aspect of Christ in heaven. To guard against possible misunderstanding, the congregation in the nave cannot see the remarkably angel-like descending Christ, which the clergy in the crossing and apse enjoys and understands. But the clergy also sees the putto, who appears childlike, like the boy Christ became at the Incarnation, the event which merited the Virgin her ascent. What even the clergy cannot see, because Correggio could not entrust even them with his insight, is what Christ too must have even in heaven at the Assumption. As in the rest of the fresco, Correggio asserts that the events of heaven, the protagonists and the angels, too, are not visions, but real and true, and he paints them with all the immediacy and physicality at his artistic command.[56]

As we have seen, the squinch figures and angels of the balustrade remind the clergy of its charges

and responsibilities. Moreover, from the apse, Christ himself seems to plummet not to the Virgin, who is from this viewpoint illegible, but into the church to the congregation. The view of the linkage between the image of the descending Christ and the worshiping body of the church graphically expresses the symbolic meaning of the Assumption and Coronation. The special privilege of the eastern view is an enactment of the union of Christ the Bridegroom with his bride, the Church— that is to say, with the faithful laymen in the nave as well as with those more privileged participants in the eastern *sanctum*.

As WE HAVE MOVED from the congregational view at the foot of the stair to the clerical view, the scene in the dome is reversed, and the meaning consistently adapted to impress upon each body of observers the significance of the Virgin's Assumption as the promise of human union with Christ. Correggio turned the lack of simultaneity of our experience in the Cathedral into an opportunity to create, within one cycle, separate and related pictures, each appropriate to the place and status of the observer to which it is visible. In organizing the fresco as a series of multiple overlapping compositions, the artist conceives the painting as a symbolic and vivid depiction of the story of the Assumption, with shifting emphases in accordance with the station and spiritual needs of each viewer.

Conclusion

For all the stations from which we have examined Correggio's fresco, we have identified two general audiences: the congregation in the nave and the clergy in the presbytery. In retrospect, the iconographical nature of these two general views can be discussed and compared.

From the western entrance and to the site at the foot of the old presbytery stairs, the congregation sees a slice of the cupola which culminates in a depiction of the ascending Virgin. The identification and investigation of the content of these scenes revealed an iconography specially designed for the Parmesan citizens. The paired patron saints set the civic tone of this sequence and allude through their intercessory function to the redemptive powers of the Virgin, who is also a patron of the city. As the Virgin rises, victorious over death, an angel holds the sword of the prophecy of Simeon, the allusion to her Passion. When Adam and Eve appear, we see that what is celebrated is not only Mary's miraculous flight, but the coredemptive effects of her virginal motherhood. Elements of the surrounding architecture would have once made the meaning of this vista for the lay spectator even more vivid: the pulpit, rising to the left, would have clarified St. Hilary's gesture, and the altar at the center, the Baptist's demonstrative relationship with the sacrificial lamb. The isolated central stair, originally narrower and more formally striking as it projected forward from the dark open arches of the crypt, would have formed a distinct feature between the nave and the sanctuary area, a physical link by which the clergy administered the Eucharist and blessing to the congregation. An understanding of this part of the fresco program requires no recondite knowledge; the meaning of the scenes becomes evident as the narrative expands.

The clergy, however, gathered in various parts of the presbytery, see a message related, but different from that seen by the congregation. They see the figure of Christ, descending as if into the space of the church, just as they witness the rite of the Eucharist, the means by which Christ enters their lives daily. The angels excitedly point back to the laity in the nave, and the saints portrayed in the western squinches remind the clergy of their charges. Both saints are examples of clerical duty: Joseph, by his guardianship of the Holy Family, is a model of priestly behavior, and S. Bernardo degli Uberti, by his presence and pious stance, intervenes for the clergy as he provides an ideal for the bishop. The Old Testament figures, with their more complex allusions to Christ and Mary, have come into sight. This half of the fresco departs from the simple telling of the Assumption story and presents more challenging material in images that bear directly on the function of

the clergy, underscoring their responsibilities toward the instruction and salvation of the laity according to the strictures of their ecclesiastical offices.

These contrasting but interlinked programs, east and west, operate also within the larger context of the politics of power and faith. The program presented to the faithful in the nave depends upon a metaphorical meaning traditionally associated with the Assumption. From the twelfth century on, the Virgin was regarded as a symbol of the Church. As Honorius of Autun put it:

> *The glorious Virgin Mary stands for the church, who is also both virgin and mother. She is mother because every day she presents God with new sons in Baptism, being made fruitful by the Holy Spirit. At the same time she is virgin because she does not allow herself to be in any way corrupted by the defilement of heresy, preserving inviolate the integrity of the faith. In the same way Mary was mother in bringing forth Jesus and virgin in remaining intact after bearing Him.*[1]

And likewise, "Everything that is said of the Church can also be understood as being said of the Virgin herself, the bride and mother of the Bridegroom."[2] The Assumption, as the triumph of the Virgin over death and sin, is representative of the triumph of the Church. Seen in a historical context, this message to the congregation had political as well as theological implications. The contracts for the entire project in the Cathedral, including Correggio's and those of the other three artists, were signed less than a year after the city of Parma had been won back by the papacy and become, in effect, subject to both the temporal and spiritual rule of the Church. The choice of theme was especially appropriate—a commemoration of the papal triumph. The Virgin, rising over the blazing torches of victory, embodies the community of the faithful who see her but also the actual victory of the Church as a political state. The presence in the squinches of the most publically revered patron saints of the city underscores the civic tone of the program. In this way, the scenes visible to the congregation are spiritually inspiring, but they also, through the incorporation of traditional communal images, celebrate the recent political events in Parma.

Yet this triumphant declaration was also defensive, for in this period, in Parma and elsewhere, the power of the Church was by no means free of opposition. Politically, the papal victory was the most recent stage of two decades of uncertainty, in which Parma had been tossed from one state to another. Even as Correggio worked in the Cathedral, the Sack of Rome would bring into question throughout Europe the very "triumph" he was painting. Moreover, the fundamental Catholic ideology promoted by the Marian program, which implied the necessity of Church mediation for salvation, was increasingly under assault. By giving visual form to the belief in the Virgin's corporeal Assumption and its attendant doctrine of coredemption, Correggio and his advisors were making a timely assertion. Luther was to reject the Mariological interpretation of the Song of Songs, and so the scriptural basis of the legend and theology of the Assumption. More importantly, he repudiated the notion that any man or woman could effect the plan of salvation, since salvation, like all things, is due "by no human work but entirely by the grace of God and the activity of the Holy Spirit."[3] Italian Catholic reformers, too, in these years, sought by more moderate means to return to a purified Church more in keeping with apostolic ideals and to a more direct devotional relationship with Christ. Correggio's fresco is in pointed defiance of such thinking, since the depiction

of the Assumption here, by content and context, speaks of ecclesiastically mediated redemption. The reinforcement of the division between lay and clergy and of the distinction between members of the clerical hierarchy by means of the *in situ* organization of the fresco takes on a special significance in light of the new ideas that would threaten the entire intervening structure of the Church.

But what evidence do contemporary sources offer to support the theory that the canons and Correggio consorted to devise a painting so specifically directed toward congregation on the one hand, clergy on the other? Turning to the contracts, and to Vasari and Lomazzo, several passages supply some clues.

One early document indicates that this contrast was conceived at the time. The subject of the apse fresco, which Correggio did not commence, was described quite specifically in the contract of his successors, Giorgio Gandini and later, after Gandini's death, Mazzola Bedoli. On June 30, 1535, and then May 19, 1536, the *fabbricieri* drew up contracts with Gandini to complete the frescoes of the apse.[4] The subject of the painting was described in some detail: Gandini was to paint Christ in Judgment ("in atto di judicare"), accompanied by angels, the Virgin, the Baptist, and Saints Peter and Paul. These figures were to be depicted "supplicating for the clergy and people of Parma" ("in atto di suplicare per il chlero et populo de Parma"). The same specifications appear in Mazzola Bedoli's contract of April 5, 1538. As Mazzola Bedoli finally executed the apse fresco, many particulars of the contract were overlooked (fig. 19). The background was supposed at first to be painted as if it were gold mosaic, in imitation—still—of the Montini chapel at the end of the south transept (fig. 17). Besides being consistent with the plan for pseudo-mosaic in the semi-domes of the transepts, this conceivably was to indicate that the scene in the apse was to operate on a different level of reality than the painting in the cupola and squinches. This would allow for repetition of some of the figures of the dome painting, without narrative overlap. But Mazzola Bedoli rejected this conception to create a fresco more consistent with the illusionism of Correggio's dome. In fact, the final semicircular, cloud-borne composition refers overtly to Correggio's apse fresco in S. Giovanni Evangelista, and Christ's pose is borrowed from Correggio's Christ in the cupola there.[5] It is not clear from the contract whether the "chlero et populo" were to be actually represented or not; the former seems likely, but no such personages were included. At any rate, the beneficiaries of the saints' entreaties were understood to be represented by two groups of viewers, exactly the same groups for which Correggio designed his fresco.

Other sixteenth-century evidence exists to support the assertion that the fresco in the dome is to be seen from more than one point of view, and obliquely. In both editions of the *Vite*, Vasari refers to the views of the fresco in the plural: he describes in the Duomo "a very great multitude of figures . . . in which the *views* are foreshortened from below."[6] Lomazzo demonstrates his awareness of centralized versus oblique views by making a useful distinction between types of decorated vaults. In the fifth book of the *Trattato*, which concerns the issue of perspective, he cites Pordenone's dome in the church of the Madonna di Campagna in Piacenza as an example "della prima vista mentita suprema perpendicolare," that is, as a painting seen from directly below. Correggio's dome, though, to Lomazzo is another kind of painting, and depends upon "la seconda vista mentita obliqua" ("the second type of illusion, seen obliquely"), "that is, those that can be made in the vaults of chapels, not in square pictures, but in semicircular and similar forms, like domes and apses."[7] Clearly, Lomazzo understood the importance of architectural context for decorative painting. In the Greek-planned

church in Piacenza (figs. 112, 134), the viewer is drawn into the very heart of the building and takes in the frescoed dome, including *God the Father* in the lantern, in its entirety. In Parma Cathedral, however, the viewer stands at some distance from the crossing and sees the dome obliquely, as a semidome. Similarly, the words of Correggio's contract, in which he promises to paint the eastern vault and apse "andando al Sacramento,"[8] indicate an active conception of the space in the church as well as a programmatic consideration of the sacred area near the ciborium in the east.

From these early sources, the division of the painting into several views for "chlero et populo" becomes a clear postulate for interpretation. The scanty sixteenth-century literature and documentation thus provide at least a few hints to lead the interpreter away from the neck-craning position of midcrossing. Other considerations allow a further insight into the manner in which physical placement, especially for those among the clergy, was a sign of individual distinction and most likely an essential mark of status of utmost concern to the Cathedral canons.

While lay worshipers in the nave were most likely individually undistinguished until they approached the presbytery steps at the moment of communion, in which these devoted members of the church would realize their participation in the body of Christ and thus achieve personal salvation, the clergy were carefully organized and arranged in their eastern space according to traditional rights. The care with which this hierarchy was followed is apparent in the *Ordinarium*; though we cannot be certain as to the exact location of, for instance, the canons who signed Correggio's contract in 1522, we can be sure that their places were specifically orchestrated. Though for Parma, the fifteenth-century *Ordinarium* remains the most tangible evidence for a long-standing protocol of seating, in other Cathedrals in northern Italy documented incidents of the 1520s and 1530s provide more colorful evidence to indicate the fierceness with which clerical and canon members defended their physical placement within the local clerical hierarchies.

One example from Cremona pictures the nearly comical pride which the canons attendant on Cathedral matters could attach to their rightful place in the Cathedral or other liturgical sites, showing how physical placement assumed significance as an essential indication of status among peers. From a letter written in 1531 from Rome by the bishop of Cremona to the Chapter of his Cathedral,[9] it is apparent that considerable discord had arisen among the Cremonese canons because of the claims of one of the cantors—not incidentally an intimate of the bishop himself—to his place in relation to the other members of the *capitolo*. The argument, which had persisted for over a decade, had finally to be resolved by vescovial mandate. A certain Traiano de Laude, cantor and more especially steward and "commensuale" of the bishop Cardinal Benedetto Accolti, must "obtain the place suitable for his dignity in the choir, chapter, processions and other events of the chapter, which is immediately after Monsignor Augustino Pinzone." One can almost hear in this letter the cardinal's sigh of resignation, having for at least eleven years invoked even papal declarations to satisfy the petty arguments of his "tablemate," a man who must have ruined many a delightful dinner with his whispered demands for a more prestigious location with respect to his resentful colleagues. Such a mentality would be consonant with the carefully constructed views Correggio creates in the same years in Parma.

ONCE THE SPATIAL character of Correggio's dome—the multiplicity and variety of views—is defined, its particular place in the development of decorative painting in the Renaissance can be more

precisely assessed. Some of the usual prototypes can be excluded or qualified, and some new connections proposed.

The influence of Michelangelo and Raphael that was so evident in S. Giovanni Evangelista is more thoroughly assimilated into Correggio's now authoritative style. The canons' decision to specify that the artist paint decorative images "che imiteno il vivo, o il bronzo o il marmoro" ("that imitate life, bronze or marble") is clearly inspired by the Sistine Ceiling.[10] We have noted already the similarity of pose and meaning in Michelangelo's *Jonah* and Correggio's resurrected *Assunta*. Correggio's debt to Michelangelo is plainer in the drawings (figs. 15, 16, 32) for the earlier phases of the project than in the final fresco. The figures (prophets and sibyls?) in the Ashmolean designs, so thoughtful in their sphinx-decorated chairs, resemble Michelangelo's pondering seers. Like the Sistine *ignudi* they flank a roundel, here an oculus rather than a fictive medallion.[11] Michelangelo's *ignudi* are surely the inspiration behind Correggio's wingless angels on the dado, but the Parmesan painter resists borrowing any specific poses.[12] Correggio's figures here resemble those in the Sistine Chapel in the variety and animation of their poses, but the similarity goes not much further. The happy temperament of these figures suits the theme of celebration as appropriately as the complicated languor of Michelangelo's complements the Sistine epic of creation and human salvation.

In terms of illusionistic conceit, Correggio's design far surpasses Michelangelo's ceiling in the integration of part to part, and to a degree this is due to the different shapes of the host architecture. The successive nave scenes in Parma Cathedral can be compared to what happens with Michelangelo's Old Testament narrative: these, beginning with the pictures of the *Deluge* and ending with the nearly anamorphic *Separation of Light and Darkness*, become increasingly illusionistic. The idea of a sequential experience, and of different kinds of illusions appearing to viewers at different sites, occurs in both the Sistine Chapel and at Parma.

Correggio has absorbed Raphael, too, with a new thoroughness. In comparison with his earlier, more open dependency in the apse of S. Giovanni, his debt to this artist is founded in the Cathedral on indwelling principle rather than surface appearance. Shearman (followed by Riccòmini) has signaled a relevant precedent for Correggio's dome in Raphael's obliquely constructed composition in the Chigi Chapel in S. Maria del Popolo, Rome (fig. 135).[13] There, Raphael painted the vault as though it were open to the sky, and oriented the figure of God the Father to the viewer. This situation, Shearman contends, must have inspired Correggio in the Cathedral. Both artists develop the "fundamental dichotomy between the directed center and the axially-seen periphery," because in both monuments, Shearman argues, the upper area is oriented toward the viewer just at the entrance of the chapel or crossing while the lower zone is to be seen in its symmetry from the center. But Correggio's arrangement exceeds Raphael's in unity, both because of the extent of trompe l'oeil features and because the lower zone is also, in Parma Cathedral, meant to be seen obliquely, or foreshortened into invisibility to a central viewer.[14] An earlier intimation of this effect in traditional, semidome form in the Cathedral itself can be seen in Caselli's fresco lunette in the Montini Chapel, where the vertical striations of grotesque work exaggerate the concavity of the surface, and the half-length Pantocrator can be read as a partly concealed disk, creating a semidome that pretends to be an occluded dome (fig. 17).

In chapter 3, in the discussion of prototypes for Correggio's contrast of fictive architecture and

sky, we have noted Shearman's proposal of several domed chapels as precedents for the decorative ideas in Parma.[15] In terms of perspectival illusion, these frescoed domes lack the organic coherence of Correggio's decorative system, but more importantly, none exhibits a multiplicity of views. Each is intended (with the possible exception of the still very simple design of the Cappella Acconci, fig. 61) to be surveyed from within the centralized space as a radially balanced design.

For works preceding Correggio's that simulate the oblique, occluded experience of the dome in Parma Cathedral, and which also deal with the problem of uniting the vision of the Assumption with its architectural context, several non-dome decorations prove suggestive. Mantegna's *Assumption* on the wall of the Ovetari Chapel in the Eremitani in Padua is close in subject and form to Correggio's (fig. 54). The *orans* pose of the Ovetari Virgin has been noted, but the entire spatial conception of the fresco also presages the structure of Correggio's fresco. The apostles are not just clustered but stand in a circle, so that the foreground disciples obscure several in the background. The Paduan Virgin's movement is implied by her upward glance, and as she glides behind the archway the upper tip of her mandorla is already obscured. In this way, the fictive arch enframes her passage much as the western crossing vault will enframe Correggio's *Assunta*. Mantegna repeated this idea in a different scale and medium and with a related subject in his panel of the *Death of the Virgin*. As Roberto Longhi demonstrated convincingly, the painting has been cut in two, and the picture in the Prado (fig. 68) was once surmounted by a fragment now in a private Ferrarese collection. This fragment would have completed the scene in which Christ, seated within a cloudy mandorla and holding the tiny soul of the Virgin on his lap, passes behind an archway in the same manner as in the Ovetari *Assunta* (fig. 54).[16] Correggio's decorative program gives three-dimensional form to the arrangement Mantegna depicts in two.

The conception of the Virgin Assunta as rising behind an arched enframement occurs elsewhere in Renaissance settings of the subject. David Rosand has demonstrated that Titian took the choir screen into account when he painted his *Assumption* in the Frari in Venice.[17] From the nave, the altarpiece is then perfectly set within the arch of the screen (fig. 136). A similar situation may have existed in one of the most important of Assumption chapels, the Cappella Sistina. Shearman, refining a reconstruction initiated by Wilde, notes that Pintoricchio's frescoed altarpiece of the Assumption (known from a drawn copy and now replaced by Michelangelo's *Last Judgment*) would have also been visible through the archway of the choir screen. From the entrance of the Sistine Chapel, then, the viewer would have seen the painting of the Assumption neatly enframed by the arched door of the *cancellata*.[18] These instances—the Ovetari Chapel, Titian's Frari *Assumption*, and the Sistine Chapel—form the tradition from which Correggio created his own enframed Assumption over the altar for the worshiper in the nave in Parma Cathedral. He develops the idea further, however, for in the Duomo at Parma the architecture not only enframes the image of the ascending Virgin, but it is used variously, as we have seen, to delimit meaningful segments of the composition to a range of viewpoints below.

Correggio's cycle belongs to a family of monuments painted in the same decade in northern Italy. Pordenone's handling of site and subject is consistent with the shape of the given architectural environment, and three major surviving fresco projects demonstrate the spatial rules to which he adhered.[19] In the Malchiostro Chapel in the cathedral of Treviso (1519–20; fig. 137) and later in the

Pallavicino Chapel in the Franciscan church of Cortemaggiore (1529–30; fig. 138), there is a precise relationship between the figures in the cupola and the viewer below. The dome in Treviso is now destroyed, but old photos, examined carefully, show that Pordenone gathered the figures rather surprisingly into the north side of the dome.[20] The vision of God the Father, plunging as if into the space of the chapel, though for the attendant members of the confraternity below and within the chapel, sets a pattern for later work. In the Franciscan church in Cortemaggiore, a similar celestial throng seems to descend into the chapel, directly over the altarpiece of the Immaculate Conception. Though the altarpiece (a copy of the original, which is in the Capodimonte, Naples) is set in a spatially interruptive Baroque frame, the illusion Pordenone sought is still effective, and St. Anne in the painting at our level really does seem to react to the heavenly group in the dome. In Cortemaggiore, where a small nave precedes the chapel, a section of the dome is visible beneath the architectural vault, in a vision akin to and perhaps inspired by the nave view in Parma. The different requirements of the Greek-cross plan of the church of the Madonna di Campagna in Piacenza (1530–32; fig. 134) result in the lack of vivid illusionism in Pordenone's third and final decorated dome. At Piacenza (and as Lomazzo observed), one does not approach the central space from a longitudinal corridor; instead, the central dome caps the central intersecting space of the chapel, from which four equal arms radiate. While Freedberg attributes the more self-contained painting in the main cupola at Piacenza to a classical phase in Pordenone's stylistic development, the centralized arrangement of the architecture is surely more responsible for the centralized composition.[21] Like Lomazzo, we must distinguish the dome seen obliquely from the dome seen from directly below. Finally, about the same period, ca. 1525, Lorenzo Lotto painted a dome similar in principle to Pordenone's in Cortemaggiore, at S. Michele al Pozzo Bianco in Bergamo (fig. 139).[22] In the oval vault, a celestial group accompanies God the Father at the lower back edge of the vault. This part of the decoration is visible to the viewer outside the chapel, together with the scenes of the life of Mary lower down on the chapel wall. Lotto's chapel differs from Correggio's cycle in that it is only to be seen from outside, like a diorama, and not to be experienced by means of the spectator's movement.

Correggio himself had already explored the technique of different viewpoints, establishing in the cupola of S. Giovanni Evangelista the foundation for the more complex system of the Cathedral. In the earlier painting, the principle of the later cycle is initiated, since Christ appears correctly foreshortened and hovering when seen from west of the cupola, in the nave (fig. 140). But only those privileged observers in the east of the church can see the Evangelist himself, crouched down just above the wide cornice of the cupola (fig. 141). Within the more restricted ambience of the Benedictine church—an ex-novo architectural work in which he painted extensively for the monastic group with which he was closely affiliated—the artist first experimented with a strict dualism of viewpoints, contrasting but overlapping views for the visiting worshiper and the monastic practitioner.

The relationship among the three artists—Correggio, Pordenone, and Lotto—remains problematic, but some exchange of ideas seems probably to have taken place. The most likely route of exchange would have been through the contemporary Parmesan bishop of Treviso, Bernardo de' Rossi, who surely encouraged the selection of Pordenone for the Malchiostro Chapel, and who was portrayed by Lotto in a portrait now in the Capodimonte, in Naples.[23] More informal cross-

fertilization, such as Lotto's Bergamesque experience or the problematic contribution of a "missing link" of Lombard perspectival decoration, can only be surmised.

Comparison with these related works puts Correggio's achievement in an art historical context. It demonstrates that the *in situ* effects of the fresco are indeed a part of a Renaissance tradition. The viewer is a participant in a specific sense. The fresco, as we have seen, is a sequence of pictures, defined by the location of the viewer and the architecture of the setting. In this way, the painting enlivens and gives new meaning to the lay worshiper's progress in the nave or the clergy's meditative experience in their seats. In the west, viewers advance to see the Virgin and finally Adam and Eve revealed, and so their devotion is active, accompanied by the enlarging vista of fresco. The meaning of the western views is readily graspable to the faithful observer. In the east, from the presbytery, the possibility of a progression of views for a single viewer as occurs in the runway of the nave is excluded, both by the architecture and by the more sedentary role of the viewers. While the unusually prolonged form of the Romanesque apse accommodates some plurality of vistas, the movements of the clergy are limited, and their places and visual experiences of the fresco individually prescribed, as we have seen already in chapters 7, 8, and 9, whether in the upper or lower choir. The content of their frescoes is therefore more symbolic than narrative, as appropriate for their situation, both spiritual and physical.

While figures in the Parmesan dome may seem to extend their movements or gaze into our space, their existence in another artful world is never forsaken. For instance, one of the most convincing areas of illusion is found in the apostles on the cornice. Yet, from each viewpoint below one glimpses an apostle's toe overshooting the cornice (fig. 126). By this figural overlap, Correggio demonstrates the cornice to be fictive like the apostle himself.[24] No one really falls for the illusion; we are ready to be convinced and therefore easily persuaded. The artist is commended for his approximation of reality—ever the criteria for excellence for Vasari and classical art literature—and the viewer for his perception and appreciation.

The subtle mechanics of Correggio's program ensure that the proper things are seen in their proper places, and this emphasis on propriety is itself typical of High Renaissance culture. The faithful layman and the cleric receive the message due their status. This division of the audience into popular and privileged sectors as determined by their status and spiritual condition is undemocratic and pluralistic. In the culture from which it arises—not just Parma in the 1520s but Italy in a time of change and emergency—the chaos of heresy, plague, and military defeat must constantly be suppressed by new or revived forces. Correggio himself lived a life representative of the experience of this generation. He grew up under the aristocratic rule of the local count of Correggio, who controlled the small town and its court by medieval privilege. He died painting his *Loves of Jupiter*, mythologies destined to become gifts from the duke of Mantua to the emperor Charles V; this after seeing Parma and the courts of northern Italy succumb to the papacy and the French, then to the papacy again. The developing situation in Italy and in Europe as a whole was toward centralized power, and the *in situ* demands of Correggio's fresco duly make an autocratic claim. Correggio's fresco reveals to the viewer, looking from his proper place at Mary's ascent through the cosmic hierarchy, that the viewer's place is itself a part of that hierarchy.

Notes

Introduction

1. Jacob Burckhardt, *The Cicerone: An Art Guide to Painting in Italy* (London, 1918), repr. New York and London, 1979, 177–78. "Innerlich so frei von allen kirchlichen Prämissen, wie Michelangelo, hat Correggio in seiner Kunst nie etwas andres als das Mittel gesehen, Leben so sinnlich reizend und so sinnlich überzeugend als möglich darzustellen. . . . Vollständig fehlt das sittlich Erhebende; wenn diese Gestalten lebendig würden, was hätte man an ihnen vorzugsweise zutrauen würde? . . . Handelt es sich aber um das sinnlich Reizende, so erhöht sich dieser Zauber unendlich und berührt uns dämonisch" (*Der Cicerone: Eine Anleitung zum Genuss der Kunstwerke italiens* 2; *Gesammelte Werke* 10, Basel, 1955, 305).

2. Ibid., 181. Correggio "gab sich dabei seiner Art von Auffassung des Übersinnlichen in ganz unbedingtem Masse hin. Er veräusserlicht und entweiht alles" (1955, 310). See also Vincenzo Golzio, "Il Correggio nella critica d'arte del secolo XIX," in *Manifestazioni parmensi nel IV centenario della morte del Correggio* (April-October 1935), Parma, 1936, 255–60. The German perception is discussed in C. G. Herzog zu Mecklenburg, *Correggio in der deutschen Kunstanschauung, in der Zeit von 1750–1850*, Baden-Baden and Strasbourg, 1970. Ruskin, in 1845, is even more ferocious in his reaction to the "rank blasphemy" of Correggio's *Assumption*, while a decade later in France, where Romantic critics had been especially indulgent toward the sensuality of the painter's religious work, Hippolyte Taine likewise demotes him below Central Italian virtue. See Giuliano Ercoli, *Arte e fortuna del Correggio*, Modena, 1982, 68 and H. Jacoubet et al., "Le Corrège vu par quelques Français," *Etudes italiennes* 4, 1934, 211–46.

3. Cecil Gould, *The Paintings of Correggio*, Ithaca, New York, 1976, 114.

4. Cecil Gould, *The "School of Love" and Correggio's Mythologies*, London, 1970, 5.

5. Erwin Panofsky, *The Iconography of Correggio's Camera di San Paolo*, London, 1961.

6. Geraldine Wind, "The Benedictine Program of S. Giovanni Evangelista in Parma," *Art Bulletin* 58, 1976, 121–27.

7. Lucia Fornari Schianchi, "Come si fabbrica un paradiso," in *Rivedendo Correggio: L'Assunzione del Duomo di Parma*, eds. L. Fornari Schianchi and Eugenio Battisti, Milan, 1981, 10. Fornari Schianchi follows Shearman ("Correggio's Illusionism," in *La prospettiva rinascimentale, codificazioni e trasgressioni*, ed. M. Dalai Emiliani, Florence, 1980, 291) in contrasting the "popular" program of the Duomo to Correggio's "patristic" approach in S. Giovanni.

8. Shearman 1980, 291. It should be noted that Shearman modifies his assessment of the content of Correggio's painting in his most recent discussion of the *Assumption*, where he refers to the fresco as "the most complete statement possible of the *mystery* of the Virgin's bodily Assumption into Heaven" (*Only Connect: Art and the Spectator in the Italian Renaissance*, Princeton, 1992, 190; see chapter 8 in this volume, 78 and n. 8).

9. Paola Ceschi Lavagetto, "La cupola del Duomo: tracci per una ricerca storica e iconografica," in *Correggio; gli affreschi nella cupola del Duomo di Parma*, Parma, 1980, 22–33 and Eugenio Riccòmini, "La più bella di tutte," in *"La più bella di tutte": La cupola del Correggio nel Duomo di Parma*, ed. E. Riccòmini, Parma, 1983, 9–139.

10. Because there is more known concerning intellectual enterprises in Parma in the 1510s than in the chaotic 1520s, the cupola is frequently contextualized in too early a moment. While a type of humanism similar to that found in the

later Quattrocento in Florence was evident in Parma, the commission in the Cathedral has little to do with the Neoplatonic, scholarly pursuits of the previous generation. Even Riccòmini (1983, 64–68), who carefully notes some aspects of the philosophical and religious climate of the Po Valley in the 1520s, seeks a Neoplatonic basis for the painting.

11. For example, Fornari Schianchi (1981, 9): "la sua religiosità è di tipo retorico e persuasivo, ben adatta ad anticipare la pittura barocca controriformata." Shearman (1992) provides the most explicit discussion of possible Renaissance prototypes for the illusionistic effects of the Cathedral fresco, but in a brief investigation of the iconographical program refers forward to the Asam brothers' late Baroque altar ensemble at Rohr (188). The first formulation of Correggio's anticipatory role in the development of the Baroque can be credited to Josef Strzygowski (*Des Werden des Barock bei Raphael und Correggio*, Strasbourg, 1898, 87–114).

12. Fornari Schianchi 1981, 8.

13. Ceschi Lavagetto 1980, 26.

14. Otto von Simson, "Correggios *Assunta* in der Domkuppel zu Parma," *Römisches Jahrbuch für Kunstgeschichte* 20, 1983, 336–38.

15. Burckhardt 1979, 182. "Es ist schwer, sich genau zu sagen, welcher Art die Berauschung ist, womit diese Gestalten den Sinn erfüllen. Ich glaube, dass hier Göttliches und sehr Irdisches durcheinander rinnen" (1955, 310).

16. Girolamo Tiraboschi, *Notizie de' pittori, scultori, incisori e architetti natii degli stati del Serenissimo Duca di Modena*, Modena, 1786, 265.

17. Since the restoration, some new photographs of a view from the nave have begun to accompany the literature, but the centralized impression maintains priority. See also, for instance, even the most recent edition of Frederick Hartt's (revised, David Wilkins) *History of Italian Renaissance Art: Painting, Sculpture, Architecture* (New York and Englewood Cliffs, N.J., 1994, 562, fig. 593), in which an old, pre-restoration centralized view illustrates the text on Correggio's dome. Even when updated with a reproduction of the restored fresco, commentary in general textbooks still perpetuates the notion of centrality; see F. Hartt, *Art: A History of Painting, Sculpture, Architecture*, with N. Rosenthal (4th ed.), New York, 1993, vol. 2, 709–10, fig. 21: 19, where an updated, post-restoration reproduction (essentially identical to the segment selected by Toschi) is described: "one seems to be looking directly upward into the clouds at the Virgin. . . . It is as if Correggio had turned Titian's *Assumption of the Virgin* into a cylindrical rather than a flat composition and placed the observer below it, looking up."

18. *Opere di Antonio Raffaello Mengs* (Parma, 1780), eds. Giuseppe Niccola D'Azara and Carlo Fea, Rome, 1787, 176–77.

19. Laudadeo Testi, *La cupola del Duomo di Parma* (published in incomplete form before the author's death the following year), Rome, 1923, 39–42; the same scheme is proposed in his (posthumously published) *La Cattedrale di Parma*, Bergamo, 1934, 83–87.

20. The restoration of the fresco, conducted by Renato Pasqui under the supervision of the Soprintendenza, was completed in 1980. A report of the restoration is supplied by Riccòmini and Fornari Schianchi, "La vicenda della conservazione," in Riccòmini 1983, 189–212. For criticism of the restoration, see Alessandro Conti, "Diario correggesco," *Ricerche di Storia dell'arte* 13–14, 1981, 105–10.

21. Corrado Ricci, *Antonio Allegri da Correggio: His Life, His Friends and His Time*, trans. Florence Simmonds, New York, 1896, 265–66; but in *Correggio*, London and New York, 1930, 109–10, Ricci compares the *Assumption* more favorably to the cupola of S. Giovanni; Ricci's treatment of the Cathedral frescoes is less critical in the second edition.

22. Complaints such as Gronau's of "all dies Uebermass gewaltsamer" and the dizzying effect of the painting (Georg Gronau, *Correggio*, Stuttgart and Leipzig, 1907, xxviii) are likewise the result of his viewpoint at the middle of the Cathedral, where the apostles exist on a nearly vertical surface with relation to the view. See chap. 3 of this volume, on the apostles.

23. Stefano Bottari, *Correggio*, Milan, 1961, 36; *Il Correggio* (republished with updated catalogue), Novara, 1990, 29; "il trionfale arrivo della Vergine in cielo che si dischiude improvviso."

24. Gould 1976, 109.

25. Ibid., 110, 111.

26. Sidney J. Freedberg (*Painting in Italy: 1500–1600*, Harmondsworth, Middlesex [1971], 1975, 286) describes the crucial displacement of the figural wreath: "Towards the forward and lower part of this rotating form [the figural wreath], where it will take the eye of the spectator as he approaches from the nave, there is a concentration of the heavenly host,

among whom the Virgin is borne upward by a jubilation of angels. The perspective of these figures, like that of the whole form within which they are gathered, is not strictly central but inclined slightly towards the oncoming spectator." Yet like Gould, his method of description and specific observations are centrally inspired. Roberto Tassi (*La cupola del Correggio nel Duomo di Parma*, Milan, 1968, 116) presents a central view of the cupola divided into two halves, in the fashion of Mengs's "inferior" and "superior" zones or Testi's "cupola" and "anticupola." These comprise the squinches and related material, and the dome proper. Because he insists on the primacy of the central view, Tassi sees the effects of perspective, light and volume as Correggio's communicating means, but he does not mention the compositional asymmetry.

27. Shearman 1980, 290. Shearman proposes Raphael's design for the cupola in the Chigi Chapel, S. Maria del Popolo, Rome, as the Renaissance prototype for this solution.

28. Shearman 1992, 188.

29. The position Shearman identifies is too far to the east; Christ is not visible from the nave, as is evident either from observation in the Cathedral or from comparison of a cross-section diagram of the structure (Shearman 1992, 187) with a photograph of the dome seen from directly below. Fornari Schianchi (1981, 7) follows Shearman (1980). Philippe Morel ("Morfologia delle cupole dipinte da Correggio a Lanfranco," *Bollettino d'arte*, ser. 6, 23, 1984, 10) correctly notes the misobserved view, but in forcing the *Assumption* into his definition of a characteristic Renaissance dome decoration, he protests that the asymmetry of the composition is insignificant. His Neoplatonic interpretation follows from the segmental perception that can be traced directly back to Mengs.

30. Shearman's second analysis of the Cathedral fresco, though omitting his formalistic observation (1980, 290) that the oblique view presents "a separate colour-composition," does not attempt an examination of the Christian meaning of the program. In his investigation of Correggio's earlier decoration of the dome of S. Giovanni Evangelista, however, he reveals two contrasting points of view, and with them, two contrasting iconographical programs—a principle that the artist elaborated even more extensively, as we shall see, in the Cathedral.

31. Riccòmini 1983, 106–9. For a more detailed discussion of Riccòmini's approach, see my review, *Art Bulletin* 70, March 1988, 151–52. The existence of oblique views as signaled by Shearman and Riccòmini is also acknowledged by Joseph Manca, "Stylistic Intentions in Correggio's *Assunta*," *Source: Notes in the History of Art* 7, 1987.

32. His preferred western site of observation, even east of Shearman's, places the Virgin in the center of the composition, with several pairs of the blessed just visible under the crossing arch. Both authors maintain that the stairs reached into the nave at the same point they do now; however, according to A. C. Quintavalle's examination of the Romanesque fabric of this part of the Cathedral (*La Cattedrale di Parma e il romanico europeo*, Parma, 1974, 293–94 and fig. xxxviii; see fig. 11), they would have projected in Correggio's time a bit further west, limiting the visible figures more precisely. This issue will be taken up in chap. 5.

33. Riccòmini 1983, figs. 6, 7, and 8.

34. The dedication of the Cathedral to the Virgin is first documented in the 9th century; the more specific dedication to Maria Assunta dates at least as early as Pope Pascal II's consecration of the church, at which S. Bernardo degli Uberti was ordained bishop, in 1106 (Testi 1934, 15 and 149, n. 31; Giovanni M. Allodi, *Serie cronologica dei vescovi di Parma*, Parma, 1856, I, 126, 262; A. Vignali, *La Basilica Cattedrale di Parma ed il XVII cinquantenario della sua consacrazione*, Fidenza, 1956, 5–7).

35. Transcriptions of the first and last recorded payments, and of the document for plastering, were first published by Luigi Pungileoni, *Memorie istoriche di Antonio Allegri detto il Correggio*, Parma, 1817–21, vol. 2, 186, 201, 233, and 228–29 (but see Testi 1923, 67–68 for a correction of the amount of the second payment); these documents are also transcribed by Tassi (1968, 157–58, nn. 12, 13, and 15) and Gould (1976, 185), who relies on Pungileoni and Tassi. The first payment and contract for plastering are still extant in the Archivio Notarile, Parma, but for the last payment of 1530, which is lost, we depend on a seventeenth-century memorandum from an index in the Archivio della Fabbriceria. Marzio Dall'Acqua corrects and completes Gould's version of the first payment in his catalogue for the Archivio di Stato di Parma (*Correggio e il suo tempo*, Parma, 1984, 50, 52). Dall'Acqua's volume presents the most reliable transcriptions of most of the documents relevant to the Cathedral project, including newly published copies of the notarial agreements for the structural preparation of the cupola and its inner surface prior to Correggio's work (56–63). In addition, he brings to light new material on the inner mechanisms of the constituency of the *fabbriceria* itself, which indicates that the canons were often at

pains during the first half of the 1520s to maintain consistency in the membership of the supervisory body of the project through substitutions and reconfirmations of the *fabbricieri* (65–70).

36. Gould 1976, 106–7. Correggio would have still been occupied at S. Giovanni Evangelista well into the 1520s. Jorio da Erba agrees to plaster the surfaces for Correggio's fresco in November 1523, but the artist surely began work in the Duomo rather later; the chronology for preparation and designs is even more problematic.

37. The document is in the Archivio di Stato in Parma, under the notary Stefano Dodi. Ireneo Affò was the first to publish Correggio's autograph portion (*Vita del Graziosissimo Pittore Francesco Mazzola detto il Parmigianino*, Parma, 1784 [2d ed.], 30, n. 1). A handwritten but conveniently legible transcription of the complete contract by Carlo Callegari, including the other contracts between artists and *fabbricieri*, remains in the Archivio in Parma, and is the indubitable source for all subsequent published transcriptions except Testi's (1923, Docs. I and II) and Dall'Acqua's: *Istrumenti in copia autentica delle convenzioni fatte nel secolo tra la congregazione della fabbrica della Cattedrale di Parma e li celebratissimi pittori Antonio Allegri . . . ,* 1803, Manoscritto della Biblioteca no. 45, Archivio di Stato, Parma, 1–5. For a brief history of the transcriptions of 1803, see Dall'Acqua 1984, 71. Correggio's agreement is transcribed by Pungileoni 1817–21, vol. 2, 183–84, with errors; by Pietro Martini, *Studi intorno il Correggio*, Parma, 1865, 170–71, who offers a more accurate version; Tassi 1968, 12; and Fornari Schianchi, "Dal umano al celeste: le tre cupole del Correggio a Parma," in *Correggio: gli affreschi nella cupola del Duomo di Parma,* Parma, 1980, 21, who follows Martini. Ricci (1896, 251–53; 1930, 65), Silvia de Vito Battaglia (*Correggio bibliografia*, Rome, 1934, 128), and Dall'Acqua (1984, 49, tav. VII) reproduce Correggio's autograph part of the contract. Gould (1976, 183–84) transcribes the autograph agreement from reproductions and uses Pungileoni for the canons' portion. The most precise version can be found in Dall'Acqua 1984, 48–50.

38. The transcription used here is from Correggio's autograph portion of the agreement (see Dall'Acqua 1984, 49–50); note correction of Martini's (1865, 171: "muro," not "nuovo").

39. Gould 1976, 106. Ricci (1896, 251–53 and 1930, 100–101) translates the document vaguely; Tassi (1968, 8) also interprets the commission as including "entrambe le pareti sino al pavimento." See note 53 below, on Giorgio Gandini's commission of 1535, for further evidence of the extent of the original project, as well as an indication of the possible subjects of the walls.

40. There, Christ hovers in convincing perspective to the viewer just west of the dome, while St. John is visible only to the monks in the choir—as Shearman was first to observe. See Conclusion in this volume for a discussion of how Correggio's ideas for the frescoes in S. Giovanni are developed in the Cathedral.

41. The contracts for the other artists commissioned in November 1522 specify that drawings must at some point be submitted for approval by the *fabbricieri*; Anselmi, for instance, promises to paint "picturas benepictas ac bonas et laudabiles et secundum mappam seu designationem quam ordinabunt et declarabunt predicti domini fabriceri et cum illis figuris quibus et prout videbitur ipsis dominis fabriceriis" (Dall'Acqua 1984, 75).

42. The contracts for Parmigianino, Anselmi, and Rondani, as well as Araldi's contract of the next month, are in the Archivio Notarile, Archivio di Stato, Parma (notary Galeazzo Piazza). They were first completely published by Martini, (1865, 171–80) and more recently by Dall'Acqua (1984, 74–84). Again, Callegari (see note 37 above) provides a handwritten copy of these contracts (9–41).

43. For the chapel, see Testi 1934, 73–75. The canons' respect for Caselli's by then old-fashioned grotesques *all'antica* appears less mysterious in light of Peter Humphey's discovery of documentation that proves the patron, Bartolomeo Montini, was alive as late as 1524, and hence when the contracts for new decoration in the Cathedral were being written. Montini, a prominent and influential Parmesan citizen, was canon of the Cathedral, *protonotario apostolico*, and an active supporter and financer of the building of S. Maria della Steccata. The chapel, conceded to Bartolomeo in 1505, contains his tomb, dated and executed in 1507, and was probably decorated in those years (see Peter Humphrey, "Cima da Conegliano a Parma," *Saggi e memorie di storia dell'arte* 13, 1982, 35–46). The Cathedral canons were naturally unlikely to destroy the funeral chapel of one of their most venerable colleagues before he had even used it.

44. Fornari Schianchi 1981, 6. A. C. Quintavalle (1974, 299 and 303, n. 26) conjectures that this fragment constituted part of a cycle that indeed comprised the cupola.

45. For Anselmi's contract of 1522, see Martini 1865, 176 and Dall'Acqua 1984, 74–76. Testi (1934, 76–77) includes several Renaissance references to the dedication.

46. Anselmi's second contract of 1548 is transcribed by Martini 1865, 183–85 and Dall'Acqua 1984, 92–93; Testi (1934, 75–76), discusses the subsequent history of the decoration of the south transept.

47. In his contract for the completion of Correggio's work in the Cathedral choir, Mazzola Bedoli is instructed to "reponer nella Cupola quell'oro ch'è già posto da Rondani e da Magistro Antonio da Corezo" (Tassi 1968, 157, n. 9; the date of the contract should read 1538, not 1539).

48. Dall'Acqua 1984, 83:

> *Item quod postquam erit picta dicta volta per ipsum magistrum Alexandrum debeat colaudari per peritos partibus non suspectos et si judicata fuerit esse bene picta et bonis coloribus tunc et eo casu debeat ipse magister Alexander et ita promissit pingere dictas omnes alias voltas et fornices dictae navis magne quae sunt numero sex ultra dictam primam voltam. . . .*"

There is an inconsistency in the contract: the commissioners indicate Araldi is to start by painting only one of the vaults west of the crossing, while Araldi, in his own handwritten portion of the document, promises "a depinzere due volte de la nave granda de mezo le quali due volte sono la prima sopra lorgano et laltra quela che ge segue dreto . . ." (ibid., 84), that is, two of the eastern nave vaults.

49. Tiraboschi 1786, 265.

50. Ireneo Affò (*Il Parmigiano, Servitor di Piazza* [Parma, 1794], repr. 1972, 25) transcribes the letter:

> *Or circa degli Capitoli iò trovato chel septimo dice che quando sarà fatto dalla cima delle finestre in susa abbia da fare vedere la dita Opera a li Signori de la Compagnia de la Madona, e se a lor piacerà la dita opera che io abbia da seguitare, ma se non li piace non abbia da seguitare più avante. De questo io sono molto contento, ma con questo pato che se l'opera starà a paragone de quella che iò facto in la Steccata, che lor sabino da contentare, ma se io mancherò da questo, che lor possano procedere contra di me come lor vogliano che sarò molto contento, ma non contentandose de questo non ne voglio far nulla perchè non voglio stare alla descrecione de tanti cervelli, e sapete quello che fu dito al Coregio in nel Domo. . . .*

51. While studies have been done on the nature of artists' contracts in fifteenth-century central Italy (especially Martin Wackernagel, trans. A. Luchs, *The World of the Florentine Renaissance Artist: Projects and Patrons, Workshop and Art Market*, Princeton, 1981 [1st ed., Leipzig, 1934], similar research into the types and stipulations of northern Italian commissions and sixteenth-century practice might clarify the situation in Parma. Payments in the early Renaissance were frequently determined by arbitration after completion of a work (Hannelore Glasser, *Artists' Contracts of the Early Renaissance* [Ph.D. diss., Columbia University, 1965], New York and London, 1977, 41–42), but a case such as Araldi's in which such judgment interrupts completion is unusual. Gandini's contract for the choir paintings in the Cathedral left undone by Correggio demonstrates an escalation of this self-protective tendency. The *fabbricieri* reserve the right, after the painter begins, to determine whether or not he is to execute the walls of the Cappella Maggiore, and they add a postscript describing a final arbitration which will determine whether Gandini's painting merits the price. Mazzola Bedoli, in 1538, was required to include a preparatory sketch for the choir vault design, attached to the contract itself (the drawing is now lost but a copy survives). While these precautions would perhaps not be exceptional in the 15th century, by the 1520s and '30s such an attitude toward the creative process seems outmoded.

One other contemporary contract, also for a large northern Italian cathedral cycle, stipulates that the artist may continue only after the commissioners' mid-project approval: Pordenone's agreement of 1520 to finish the decoration of the nave of Cremona Cathedral (Caterina Furlan, *Il Pordenone*, Milan, 1988, 357). There, however, Romanino had been suddenly removed from the job and replaced by Pordenone due to a change in the membership of the presiding *fabbricieri*. The outcome for Pordenone anyway was very positive.

52. Correggio's heirs returned payment to the Cathedral in 1551 (Tassi 1968, 157, n. 4).

53. Gandini's and Mazzola Bedoli's contracts were notarized by Benedetto Del Bono. There are two contracts for Gandini: June 30, 1535 and May 19, 1536. The second, in the Archivio Notarile in Parma, has been most frequently cited and is transcribed by Callegari (45–55), Martini (1865, 180–83), and Dall'Acqua (1984, 86–89). The first contract, in the Archivio della Fabbriceria, was partially transcribed by Pungileoni (1817–21, vol. 3, 29–30), E. Scarabelli-Zunti (*Documenti e memorie di Belle Arti parmigiane*, ms., second half of the 19th century, Soprintendenza, Parma, vol. 3), Ann Rebecca Milstein (*The Paintings of Girolamo Mazzola Bedoli* [Ph.D. diss., Harvard University, 1977], New York and London, 1978,

278, n. 178), and most recently and completely by Gabriella Guarisco (*Il Duomo di Parma: Materiali per un'altra storia*, Florence, 1992, 48, no. 5). While the document of 1536 incorporates much of the first contract, it is not, as Testi asserts (1934, 104–5) identical. Indeed, in 1535, one year after Correggio's death, the commissioners not only include the walls of the eastern chapel (which become optional pending judgment in the second contract), but they specify the subject matter to be represented: "Le faccie d'essa capella da man dritta, e da man stanca, siano ornate de pittura non manco convenente sia quella de la capella cioè da man drita la missione del spiritus [santo] con la Vergine Maria, li apostoli e a[ltri] discipuli non manco de 12 oltre li apostoli. L'altra da man sinistra gli sia la morte e la sepoltura de la Madona cum li apostoli e altre figure necessarie al compimento del'istoria" (Guarisco, 48). The rest of the contract is substantially the same as that of 1536. That Gandini became the artistic heir to the earlier artist's incomplete assignment would suggest that Correggio, who was indeed to have painted the walls "insino al pavimento," may have likewise been given these subjects— a Death of the Virgin on the left, and, on the right, a Pentecost. Such compositions would round out very nicely an Assumption and would complete a cycle devoted to the later events in the life of the Virgin. Gandini's first contract has never been connected with Correggio's original project, but its implications are at least suggestive.

54. Milstein 1978, 169–73; document, 269–73, n. 174.

Chapter One

1. Also positioned for comparison are the only visible portions of the saints, their feet. The Baptist's bare leg attests to his ascetic simplicity, while the bishop rests his shod foot in the hands of angels, as if they were the pedestal of a throne. We are forced to revere, as we enter the church of the bishop's seat, the lowest member of the representative of the episcopal office. The prominence of Hilary's slipper might also recall early Parmesan folk customs: on the saint's day, practical tricks were played with shoes, perhaps because Sant'Ilario was the particular patron of shoemakers, and offerings of clothing, especially shoes, were given to the illegitimate children who were wards of the hospital dedicated in his name (Carlo Malaspina, *Vocabulario Parmigiano-Italiano* [Parma, 1859], Bologna, 1970, vol. 4, 55: "Scarpetta"). Such a playful reference, which does not cancel the more serious significance, might not be out of place with this saint, as we shall see in chapter 2.

2. The fullest description is supplied by Ricci (1896, 258), who is the only writer to notice the dolphins in the fictive bronze design and to compare the putti to "infant Hercules." A. O. Quintavalle (*Mostra del Correggio* [exh. cat., Palazzo della Pilotta, Parma], Parma, 1935, 242), attempts to connect the motifs of the fictive frieze with the festoons painted over the squinches: "fra i rami che reggono i pomi fatali, s'avvolgono serpenti che vengono vinti da alcuni putti, simbolo d'innocenza e d'amore"; but the two areas of fresco are conceived on different orders of illusion and not meant to be read so strictly together.

3. Gould 1976, 113.

4. Phyllis Pray Bober and Ruth Rubenstein (*Renaissance Artists and Antique Sculpture*, Oxford, 1986) do not offer any versions of the subject. The theme appears frequently on ancient Greek coins (H. Stuart Jones, *A Catalogue of the Ancient Sculptures Preserved in the Municipal Collections of Rome*, vol. 1, *The Sculptures of the Museo Capitolino*, Oxford, 1912, 128, no. 54b), as well as sculptures in Florence (the Uffizi), Naples, Turin, and Paris (the Louvre). For an introduction to the subject in antique art, see Dorothy Kent Hill, "Ancient Representations of Herakles as a Baby," *Gazette des Beaux-Arts*, ser. 6, 33, 1948, 193–96. Guglielmo della Porta's bronze *Infant with Serpent* in the Museo del Capodimonte, Naples, is a later Renaissance treatment of the theme. The subject is rare in earlier Renaissance art. Fifteenth-century examples of the infant Hercules strangling the serpent appear as initials in book illustrations by the Master of the Putti and the London Pliny Master (see Lilian Armstrong, *Renaissance Miniature Painters: The Master of the Putti and His Venetian Workshop*, London, 1981, figs. 47, 111); though visually unlike Correggio's, they attest to Renaissance familiarity with the myth.

5. Theokritos, *The Idylls*, trans. Barriss Mills, West Lafayette, Ind., 1968, Idyll 24, 90. Perhaps the allusion to the infant Hercules offers a punning reference to the original dedication of the church to S. Ercolano, whose relics have been preserved in the main altar since the early Middle Ages. Correggio and his patrons would have been familiar with the early history of the Cathedral. Barbieri notes a reference in the chronicle of the fourteenth-century preacher Giovanni Cornazzano, which was added to by other writers up to 1527 and copied in the later 16th century, which

calls the Cathedral "Ecclesia major … antiquitas consecrata fuerat ad honorem b. martyris Herculiani …" (*Ordinarium Ecclesiae Parmensis* [1417], ed. Luigi Barbieri, in *Monumenta historica ad provincias parmensem et placentinam pertinentia*, Parma, 1866, 2, n. 5; on the manuscript Chronicle, see A. C. Quintavalle 1974, 271). An epitaph in the Cathedral, dating probably to the 16th century, commemorated Pope Pascal II's consecration of the church in the early 12th century (though giving the wrong date) and referred to the Duomo as "olim divi Herculano dicatum" (Allodi 1856, vol. 1, 126, 262). In this way, the fictive basement would record not only the early spiritual history of mankind, but the pre-Marian history of the Cathedral itself, both to be surpassed as the viewer advances to witness the Virgin's Assumption.

6. The medieval tradition is discussed by Gertrude Schiller, *Ikonographie der christlichen Kunst*, vol 4, pt. 1, Gütersloh, 1976, 89, 92. Luini creates another variant on the theme in his painting now in Chantilly (Musée Condé), in which a dead serpent hangs from the Tree of Knowledge behind the infant Redeemer, who, with a bitten apple at his feet, points to the cross (Luca Beltrami, *Luini: 1512–1532*, Milan, 1911, 557).

7. John Scott has pointed out (in conversation) that the putti in the oculus of the Camera degli Sposi carry the accessories of an imperial triumph (a baton, a laurel crown), in imitative reference to the portraits of Roman emperors on the surrounding vault.

8. See Eunice Burr Stebbins, *The Dolphin in the Literature and Art of Greece and Rome* (Ph.D. diss., Johns Hopkins University, 1927), Menasha, Wis., 1929, 64. The motif of the putto riding a dolphin, which can be traced to a particular antique sarcophagus in Rome in the late Quattrocento, became a trademark in the Venetian manuscript illuminations of the Masters of the Putti and of the London Pliny (Armstrong 1981, 14–15, 53–54), though Correggio's putto is unlike either the Renaissance or Roman depictions.

9. The sex of Correggio's angels elsewhere in the cupola—especially in the squinches, where Gould (1976, 114) and Gronau (1907, xxviii) see some as female—is often ambiguous. Though traditionally, indeed biblically, angels must be male, the slightly rounded breasts of some of the figures cavorting on the dado or in the clouds of the squinches make them appear, at the very least, androgynous. Perhaps Correggio takes license from Michelangelo, who in the *ignudi* of the Sistine Chapel had created angelic beings of a revolutionary character.

10. Correggio also brings his sculpture to life in the Camera di S. Paolo, where the rams of the bucrania smile at one another and the viewer, and the fictive sculptures in the lunettes have unsculptural floating hair and dresses. The sphinxes, a special case of this phenomenon, will be discussed below.

11. Toschi's enterprise to copy the rapidly deteriorating frescoes, a project announced in a manifesto of 1844 and continued by his students after his death in 1853, is discussed by Fornari Schianchi, "La cupola del Duomo nella grafica di reproduzione," in Riccòmini 1983, 157, 162, and 176, n. 48. The watercolor is by Toschi with L. Bigola and C. Raimondi and is in the National Gallery of Parma. It is clear that Toschi represents the east face of the lower cupola because both putti hold snakes. He does not replace the keystone angel.

12. Gould 1976, 113–14.

13. A. E. Popham, *Correggio's Drawings*, London, 1957, 68.

14. Ibid., 68; Popham refers to R. Holland, "A Note on ' La Vierge aux Rochers,'" *Burlington Magazine* 94, 1952, 285–86.

15. *The Apocryphal New Testament*, ed. M. R. James (1924), Oxford, 1953, 455–56.

16. Popham (1957, 67, nn. 5 and 6) also cites a drawing from the school of Mantegna, in the British Museum, which depicts a fountain with sculpted sphinxes. The sphinxes that appear in Mantegna's drawing of *Virtu Combusta* (British Museum) may be understood instead as negative impediments to wisdom; see André Chastel, "Note sur le sphinx à la Renaissance," in *Umanesimo e Simbolismo, Atti del IV convegno internazionale di studi umanistica* (Venice, 1958), Padua, 1959, 182; and J. M. Massing, *Du texte à l'image: La calomnie d'Apelle et son iconographie*, Strasbourg, 1990, 179. Andrea Solario's *Salome* in the National Gallery in London (Bernard Berenson, *Italian Pictures of the Renaissance: Central Italian and North Italian Schools*, London, 1968, vol. 3, 1436) offers another example in this pejorative vein. Chastel eloquently examines the double-edged visual tradition of the sphinx as guardian of esoteric knowledge, which he traces (perhaps too exclusively) to Pico (see below, n. 22). Mantegna's monochrome media of drawing and especially engraving, with its chiseled technique, satisfy the Renaissance requirement that sphinxes be stony. For a general history of sphinx imagery, including a brief section on their appearance in Renaissance art, see Heinz Demisch, *Die Sphinx: Geschichte ihrer Darstellung von den Anfängen bis zur Gegenwart*, Stuttgart, 1977.

17. Also noted by Popham 1957, 168. The altarpiece was painted for the Confraternity of S. Bernardino in the church of that saint in Carpi (near Modena).

18. Ibid., 167–68.

19. The closest visual parallel may be found in a first-century sardonyx cameo in Vienna (illustrated in Demisch 1977, fig. 319; also Fritz Eichler and Ernst Kris, *Die Kameen im Kunsthistorischen Museum*, Vienna, 1927, 51, n. 6, pl. 3) on which an easily lounging figure is supported by a rigid armrest composed of a sphinx. It would remain to be determined if such an image could have been available to Correggio.

20. Popham ventures no chronological relationship between the two sides of the sheet in the Ashmolean. The more exacting delineation of the architecture in the verso sketch, as well as the simpler spatial conformity of the figures to parallel planes, indicates, I suggest, a chronological primacy. In the recto, the seated figures gain in personality and spatial command, tipping forward and backward along opposed diagonal vectors. They also here bear a striking resemblance to the similarly sphinx-ensconced figure of the first-century sardonyx cameo in Vienna. The drawing in Haarlem (fig. 32), in which the thrones are more elaborate and seem to be flanked by decorative putti, is most dependent on Michelangelo and might precede both of the ideas preserved at Oxford. Popham's and Gould's identification of the seated figures as prophets and perhaps sibyls is sensible. If this is the case, the drawings could even precede Araldi's contract of December 1522, in which the elder artist's directive to paint prophets in the nave vaults would have made Correggio's inclusion of them redundant. Such an early dating for the drawings may seem reckless, but there is no reason why Correggio might not have started formulating ideas for the decoration immediately upon receiving the commission.

21. A funereal instance, in addition to the representative examples by Desiderio and Cristoforo Romano, is Riccio's Torriani tomb, before 1532, in S. Fermo Maggiore, Verona (fig. 33), where four bronze sphinxes similarly crane their necks and act as living architecture. H. W. Janson (*The Sculpture of Donatello*, Princeton, 1957, vol. 2, 184–85), discusses the meaning and possible sources of the sphinxes that support Donatello's bronze *Madonna* in the Santo.

22. Reference from Chastel 1959, 180, and E. Wind, *Pagan Mysteries of the Renaissance* (1958), New York, 1968, 17, to Pico's *Commentary*; see Pico della Mirandola, *Commentary on "Canzone" of Benivieni*, trans. Sears Jayne, American University Studies Series, 2, Romance Languages and Literature, vol. 19, New York, 1985, 169–70. This interpretation had already entered Christian literature by the third century. Clement of Alexandria speaks too of the necessity for the concealment of sacred truths, understood by the Egyptians, Hebrews, Greeks, and the apostles, and notes: "Therefore also the Egyptians place sphinxes before their temples, to signify that the doctrine respecting God is enigmatical and obscure" (in the *Stromata*, trans. William Wilson, *Clement of Alexandria*, vol. 4 [2], The Ante-Nicene Christian Library, Edinburgh, 1869, 239).

23. Plutarch, *Diatriba Isiaca e Dialoghi Delfici*, ed. Vincenzo Cilento, Classici della storia antica, Florence, 1962, 20, 21: "Questa (the philosophy of the priests) è, in massima parte, celata in miti e in formule che hanno solo oscuri accenni e adombramenti della verità, come, senza dubbio, essi stessi significano, collocando dinanzi ai templi, opportunamente, le sfinge a indicare che la loro teologia serba il carattere di una sapienza riposta."

Chapter Two

1. Giorgio Vasari (*Le vite de' più eccellenti architetti, pittori, et scultori* [1568], ed. Gaetano Milanesi, Florence, 1880, vol. 6, 472), speaking of the saints in the squinches, calls them "quattro santi protettori di quella città che sono nelle nicchie; San Giovanni Battista, che ha un agnello in mano; San Ioseffo, sposo della Nostra Donna; San Bernardo degli Uberti fiorentino, cardinale e vescovo di quella città, ed un altro vescovo." Though the biographer provides no more than a list, and this merely to indicate the works Girolamo da Carpi copied, he arranges the four figures according to recognizability from a Tuscan point of view. St. John the Baptist with his lamb is clear to anyone, but as patron saint of Florence as well as of Parma wins pride of place; Joseph, too, diagonally across the choir from the Baptist, was easy to point out for Vasari, if not for subsequent writers (see chap. 9); S. Bernardo degli Uberti, medieval bishop of Parma, is first and foremost "fiorentino"; and Hilary, a French saint and exotic to any non-Parmesan of the time, is quite naturally unknown to the writer.

Most recently, the worthy studies by Fornari Schianchi ("Dal umano al celeste: le tre cupole del Correggio a Parma,"

in *Correggio: gli affreschi nella cupola del Duomo di Parma*, Parma 1980, 7–21, and 1981, 5–13) and Riccòmini (1983, 39–42, 56–82), which place the Duomo frescoes alongside contemporary historical and cultural developments, also bypass any analysis of the squinches. Ricci (1896, 256–57; 1930, 104–5) and Henry Thode (*Correggio*, Künstler Monographien, no. 30, Bielefeld and Leipzig, 1898, 71–72) are sensitive to the connection between figures and viewer established by glances and gestures but dwell on the surrounding angels rather than their charges. Nor does Tassi (1968, 128), who presents the most discursive passage on the squinch subjects, venture into interpretation. That these discussions, though so brief, remain the most extensive treatments of the imagery in the squinches testifies to the present level of inquiry into this portion of the Cathedral cycle.

2. The Parmesan painter Lanfranco's frescoes in the pendentives in the Gesù Nuovo, Naples, are but one of many examples. Riccòmini's essay "I nipotini del Correggio" (in *Correggio: gli affreschi nella cupola del Duomo di Parma*, Parma, 1980, 34–53) treats only the cupola, but a study could be done on the Baroque descendants of the squinches as well. John Shearman, in his study, "Raphael's Clouds, and Correggio's" (in *Studi su Raffaello: Atti del congresso internazionale di studi* [Urbino and Florence, 1984], ed. Micaela Sambucco Hamoud and Maria Letizia Strocchi, Urbino, 1987, 657), states: "Within a period of about twenty years Raphael and Correggio, between them, have invented what amounts to the whole complex apparatus and repertoire of the Baroque cloud."

3. Mengs (1780) 1787, 177: "In tutta quest'opera, e particolarmente ne' quattro pieducci, vi è tutta la grazia immaginabile, e la maggior intelligenza del chiaroscuro."

4. For example, the little book published by the Soprintendenza in 1980, *Correggio: gli affreschi nella cupola del Duomo di Parma*, 30–31, includes illustrations of the two eastern squinch figures, St. John and St. Hilary, in color and full-page format, perversely arranged in reverse to the situation in the Cathedral. Gould sees the squinches as wholly distinct "both from each other and from all the rest," and, postulating that even their design occurred at a later date than the cupola's, duly leaves description of them for the end of his chapter (1976, 107, 114). Julius Meyer (*Correggio*, Leipzig, 1871, 182), also lists them "endlich" in his general account of the decorative components.

5. 1980, 289.

6. Heinrich Bodmer, *Correggio e i Emiliani*, Novara, 1943, viii, remarks: "La folla dei fedeli riunita nella navata centrale può scorgere Sant'Ilario … che guarda in giù (he actually looks up to the cupola) con lieta commozione verso i devoti, aprendo le braccia sotto il mantello ondeggiante e accennando verso il basso con le dita." Ricci (1896, 256) and Thode (1898, 72) must be credited with similar observations, but Bodmer best accounts for St. Hilary's concern with the faithful.

7. Gronau 1907, xxvii: "Vor die vier Zwickel haben sich auch hier die leichten Wolkenballen herabgesenkt; frei schweben sie vor den grossen Muscheln, die jene dekorieren, ein bewegliches Element, das der nächste Augenblick wieder entführen mag." To Meyer (1871, 182), the four patron saints "ebenfalls auf Wolken von Genien aufwärts getragen, nur in leiserer Bewegung wie wenn sie langsam dem Himmel zuzögen." Ricci's conviction (1896, 256) that the clouds in the squinches "rise like the smoke of incense" embellishes this notion, but he omits the observation in the 1930 edition.

8. For example, Freedberg (1975, 286), states: "In the pendentives below the drum the four patron saints of Parma are given the appearance of entire projection forward from the surface of the wall, carried on clouds borne by angels that float within the spectator's space. Grand form and power of action command belief in the presence they assert."

9. Modern writers such as Gould and Shearman who emphasize the process of fresco painting tend toward this attitude. The squinches were probably painted last as the scaffolding was lowered, but they form an integral part of the decoration as a whole, as we shall see. Gould's reasoning (1976, 107) that the squinches may have even been designed after 1528–29 is based on his observation that the squinch frescoes are painted with a "softer and more subtle" chromatic range, and therefore belong to a later phase in Correggio's stylistic development. This difference can just as reasonably be explained in terms of decorative requirements; Correggio can tone down the colors in the squinches simply because they are closer to the viewer than those in the cupola proper.

10. Hilary wears yellow, the color for unmartyred confessors or doctors and symbolic of divine wisdom, according to the *Ordinarium Ecclesiae Parmensis* (1417), 114 and n. 2. Yellow hangings are put up in the Cathedral on his feast day, January 13.

11. The tilt of the saint's head has confused some writers, who have misread the direction of his gaze. Ricci (1896,

256), for example, says: "[W]ith outstretched arms he gazes below and points to the high altar"; Bodmer (1943, xviii) makes the same mistake when he observes that Hilary looks down (see above, n. 6).

12. Tassi (1968, 128) describes the figure as "sottile d'estasi e di digiuni," but the saint is robust enough to express his spiritual agitation and diminished rather by foreshortening.

13. R. Gazeau, "Contribution a l'étude de l'histoire de la diffusion du culte de St. Hilaire," in *Hilaire et son temps: Actes du Colloque de Poitiers, XVI Centenaire de la mort du saint*, Paris, 1969, 126.

14. There is some confusion as to when St. Hilary was adopted by the citizens of Parma as protector of the city. Testi (1923, 40, n. 1), without citing sources, puts the date of his election to patron saint as early as 1147 (probably following Gaetano Negri and Antonio Barbieri, *Cenni intorno la vita di S. Ilario*, Parma, 1846), but Affò (*Storia della città di Parma*, Parma, 1793, vol. 3, 278), L. Barbieri (1866, 114, n. 3), and del Prato (*I santi prottetori di Parma*, Parma, 1903, 15) cite 1266 as the earliest invocation of both Hilary and the Baptist as protectors of the city, giving responsibility to the Società dei Crociati and the Guelf supporters of Charles of Anjou. Luigi Grazzi (*Parma romana*, Parma, 1972, 269) hypothesizes that the saint was appropriated by the town in order to attain devotional parity with Milan and Bologna, which had the relics of important martyrs (Gervasio and Protasio, Vitale and Agricola, respectively), and because the Parmesans believed that St. Hilary had passed through the town and stayed there in the fourth century after being exiled by Constantius II. The medieval Parmesans may have mistaken the bishop saint of Poitiers (who was not martyred) for another Hilary. The relics of S. Ilario Martire, a Frenchman martyred in Rome under Julian the Apostate, were once in the church of SS. Giuliano e Maria in Borgo Taschieri and are still preserved in the Jesuit Mission.

15. The earliest image of St. Hilary in Parma of which I am aware is the depiction of an enthroned and blessing saint that appears on a Parmesan coin minted from 1269 to 1299 (*Corpus Nummorum Italicorum*, vol. 9, *Emilia* [part 1], Reale Accademia dei Lincei, Rome, 1910, 400, pl. 26, n. 36). A complete investigation of Hilarian iconography in Parma would ideally include a study of local manuscript illumination; Testi (1934, 23) reproduces a depiction of the saint (stern and bearded) from a Gradual from the Cathedral (with no specific reference to his source). A fifteenth-century sculpture of St. Hilary with a small kneeling donor, now in the Ospedale Riuniti, Parma, portrays the saint with a solemn bearded face, mitred, and blessing and holding his crosier with rigid severity. Though an unattractive piece, its original placement in the hospital chapel of S. Ilario would have given it key importance in the Parmesan cult and iconography of the saint (Maria Ortensia Banzola, *L'Ospedale Vecchio di Parma*, Parma, 1980, fig. 51). A fresco of St. Hilary, bearded but smiling, decorates one of the inner faces of the arches to the Borri chapel in S. Giovanni Evangelista. For disattribution to Parmigianino, see S. J. Freedberg, *Parmigianino: His Works in Painting*, Cambridge, Mass., 1950, figs. 223–24; though more recently Eugenio Battisti has optimistically given the fresco back to him ("Il Correggio e il Parmigianino," in *L'abbazia benedettina di S. Giovanni Evangelista a Parma*, ed. Bruno Adorni, Parma, 1979, 139–40; illustration, 133). Copertini ("Quesiti e precisazioni sul Parmigianino," *Archivio storico per le province parmensi*, ser. 3, 5, 1940, 17–27), gives the fresco to a follower of Parmigianino, perhaps Rondini or Mazzola Bedoli; for most authors, the image postdates that of Correggio.

16. St. Hilary is clearly the figure in the left foreground, not right foreground, as A. G. Quintavalle maintains (*Michelangelo Anselmi*, Parma, 1960, 39 and caption, fig. 62). Quintavalle quite reasonably equates the completion date of the altarpiece with that documented for the completion of the frame, 1526 (102); this, however, poses problems of influence and chronology and certainly undermines Gould's placement of the squinch designs late in the period of the Cathedral project of 1526–30. The possibility that Anselmi influenced Correggio can be overruled by the multiple instances in which Correggio's conceptions appear in Anselmi's altarpiece. St. Hilary aside, St. Blaise's pose is that of St. Gemignano in Correggio's *St. Sebastian* altarpiece in Modena, and the motif of the Madonna forming the Christ child's fingers into a blessing as she puts on his jacket has its source in Correggio's small painting in the National Gallery in London. Unfortunately none of these works by Correggio may be dated securely, but all are agreed to be from the mid-1520s. Anselmi's dependence on Correggio for his characterization of Hilary thus challenges Gould's chronology of the squinches and intimates an earlier dating for their design. Correggio's artistic authority would have been at work on Anselmi especially during the period in which the Sienese artist was connected to the Cathedral by four projects: in addition to the altarpiece for the Compagnia di S. Sebastiano, his work for the Confraternità di S. Agnese, still in the crypt chapel; the *Madonna and Child with Saints Sebastian and Roche*, once in the Cathedral and now in the National Gallery in Parma; and his own contract with the canons to execute the vault and east apse of the south transept, left undone until

the contract was resumed in 1548. Anselmi, operating at mid-decade within this circle of patronage, would have most likely had ready access to Correggio's drawings for the cupola decoration.

About 1538–39, in his fresco on the wall of the chapel of the Immaculata in the Chiesa Collegiata, Busseto (near Parma), Anselmi reverts to depicting an elderly and somber St. Hilary that is closer to Caselli's, but the beseeching gesture and open book have become established characteristics (reproduced in A. G. Quintavalle 1960, fig. 112).

17. Jacobus de Voragine, *Legenda Aurea* (*Vulgo Historia Lombardica Dicta*), ed. Johann G. T. Graesse, Dresden and Leipzig, 1876, 98–100 and *The Golden Legend*, trans. and adapted by G. Ryan and H. Ripperger, New York and London, 1969, 90–92.

18. Ambrogio Calepino, *Dictionarium linguarum septem* (Reggio, 1502), Basel, 1575.

19. Peter Damian, Sermo II, "De Translatione S. Hilarii Episcopi Pictaviensis Confessoris (XIV Jan.)," *PL*, CXLIV, 514: "Ipse quippe nos insignis vocabuli dignitas provocat, ut mens nostra spirituali laetitia affecta plausibiliter hilarescat."

20. Jacobus de Voragine, ed. Ryan and Ripperger, 90 and ed. Graesse, 98: "Hilarius dictus est quasi hilaris, quia in servitute Dei valde hilaris fuit. . . ." Similarly, in 396, Paulinus of Nola wrote a personal dedication to his patron saint Felix, whose name bears a synonymic disposition to Hilary's. His poem begins: "Felix, happy in your deserts as in your name and in your name as in your deserts . . . the time is ripe to pour out our gratitude to you in bounteous prayers" (Paulinus of Nola, *The Poems*, trans. and ed. P. G. Walsh, Ancient Christian Writers: The Works of the Fathers in Translation, no. 40, New York and Ramsay, N.J., 1975, 75, Poem 13).

21. First pointed out by Christian Wolters, "Ein Selbstbildnis des Taddeo di Bartolo," *Mitteilungen des Kunsthistorischen Institutes in Florenz* 7, 1953, 70–72. Gail Solberg ("Taddeo di Bartolo: His Life and Work," Ph.D. diss., New York University, 1991, 519) sees an "association" established by Taddeo with his apostolic namesake rather than a self-portrait in the modern sense; this is even more the case with Correggio's identification.

22. Gould 1976, 22; seconded by John Shearman, "Correggio and the Connoisseurs" (review of Gould, *Correggio*), *Times Literary Supplement*, London, March 18, 1977, 302.

23. Gould 1976, 183; see ibid., 181, also for the document for his payment from S. Giovanni Evangelista of January 23, 1524.

24. Ibid., 190; Dall'Acqua 1984, 43.

25. Vasari-Milanesi, vol. 4, 111.

26. Pio Pecchiai et al., *Roma Cristiana*, vol. 12, *Riti, ceremonie, feste e vita di popolo nella Roma dei Papi*, Bologna, 1970, 141–43.

27. For a short biography of St. Hilary and also citations of appraisals of his literary contribution, see Le Bachelet, "Hilaire," *Dictionnaire de Théologie Catholique*, vol. 6, Paris, 1920, col. 2401; also see Sister Mary Frances Buttell, *The Rhetoric of St. Hilary of Poitiers*, Catholic University of America, Patristic Studies, vol. 38, Washington, D.C., 1933. The *Tractatus mysteriorum* was cited by Jerome but unknown until the recovery of a manuscript in 1887, and so it is not relevant to the study of Correggio's conception of Hilary; see Le Bachelet, col. 2401; and Hilary of Poitiers, *Traité des mystères*, ed. and trans. Jean-Paul Brisson, *Sources chrétiennes*, vol. 19, Paris, 1947, 61.

28. Buttell 1933, 16; for references to Hilary's eloquence, 14–17.

29. Hilary of Poitiers, *The Trinity*, trans. Stephen McKenna, Fathers of the Church, vol. 25, New York, 1954, 34.

30. Hilary, *The Trinity*, 33. On the uniqueness of Hilary's claim, see Eduard Norden, *Die Antike Kunstprosa vom VI Jahrhundert vor Christ bis in die Zeit der Renaissance*, Stuttgart, 1958, vol. 2, 583–84.

31. Richard Krautheimer and Trude Krautheimer-Hess, *Lorenzo Ghiberti*, Princeton (1956), 1982, 178.

32. Alberto del Prato, "Librai e biblioteche parmensi del secolo XV," *Archivio storico per le province parmense*, n.s. 4, 1904, 42, n. 88.

33. Pico discusses Hilary's *De Trinitate* in the seventh book of *De rerum praenotione libri novem, pro veritate religionis, contra superstitiosas vanitates*, Florence, 1506–1507. For Erasmus, see John C. Olin, *Six Essays on Erasmus and a Translation of Erasmus' Letter to Carondelet, 1523*, New York, 1979, 93–120.

34. Venantius Fortunatus, "Vita Sancti Hilarii," in *Monumenta Germaniae Historica*, ed. B. Krusch, Berlin, 1885, vol. 4 (1); Sulpicius Severus, "Chronica II," ed. C. Halm, in *Corpus Scriptorum Ecclesiasticorum Latinorum*, Vienna, 1866, vol. 1.

35. The image of St. Hilary studying the Bible comes from the 15th-century pontifical of Luçon, in the Bibliothèque

Nationale, Paris; reproduction in Hilary of Poitiers, *Sur Matthieu*, ed. and trans. Jean Doignon, Sources chrétiennes, vol. 254, Paris, 1979, vol. 1, frontispiece.

36. For a discussion of Hilary's knowledge of scripture and scriptural commentary as well as his grasp of Greek, see Buttell 1933, 12–13. Hilary requests the right to defend by purely scriptural argument his position against the Arian sympathizers in his first letter to the emperor in *Liber ad Constantium Augustum*, Book II (Buttell, 5). In the *Trinity*, the saint gratefully acknowledges that his understanding of the Trinity is based on both the Old and the New Testament (*Trinity*, 187–89). By his own account (in *De Trinitate* 6:19–20 and *Ad Psalmos* 61:2), Hilary's inspiration for conversion to Christianity came from the Gospel of John.

37. Hilary of Poitiers, *Sur Matthieu*, vol. 1, 57–58. The edition *princeps* was entitled *Opera complura sancti Hilarii episcopi* and the editor was Badius Ascensius (Josse Bade). Erasmus's *Divi Hilarii . . . Lucubrationes* of 1523 was published by Jean Froben and dedicated to Jean de Carondelet, a Burgundian official at the Hapsburg court (Olin 1979, 93).

38. Gronau 1907, xxvii: "segnender Gebarde." Ricci 1896, 256 and 1930, 104; Thode 1898, 72; and Shearman, "Correggio's Pendentives and Travels," lecture, Institute of Fine Arts, New York University, December 1982.

39. A. C. Quintavalle 1974, 268, n. 24, and especially 345–52; his reconstructions in plan and elevation of the appearance of the medieval arrangement are demonstrated in figs. xxxvii and xxxviii (here, the bases for figs. 11, 40). Cristoforo della Torre provides evidence for Quintavalle's hypothesis: "Anno 1566, quando Chorus apertus fuit et scalae ad magnitudinem totius ecclesiae ampliatae fuerunt, Evangelistae [the four Renaissance bronze sculptures of the Evangelists] fuerunt amoti et evangelistarium [the Romanesque pulpit] destructum fuit" (276). From the first years of the sixteenth century, Gonzate's four bronze sculptures of the Evangelists would have surmounted the medieval structure (Testi 1934, 102). The 16th-century texts by Angelo Maria Edoardi da Erba and della Torre crucial for Quintavalle's reconstruction are transcribed in his volume of 1974 (270–73, 273–76).

40. Ibid., 272–73, 347: da Erba describes Antelami's pulpit: "minutissimo intaglio in tre tavole di marmo bianco di Carrara, scolpì tutti li misteri della Passione di Nostro Signore, e l'eresse in forma di teatro sopra quattro colonne, dove dal Choro si leggono al popolo in giorni festivi nella Chiesa Cattolica gli Evangelii."

41. Ibid., 274.

42. Tassi 1968, 128: "selvaggio quanto più riusciva al Correggio di fare, cioè quasi niente. . . ."

43. For the use of cloths and veils in liturgical practice, see R. Hatfield, *Botticelli's Uffizi "Adoration": A Study in Pictorial Content*, Princeton, 1976, 35–41, and accompanying notes.

The Baptist's use of a cloth to hold reverently the sacrificial lamb is derived from the early Christian practice, itself of pagan origin, in which the bearer carries an offering in the long sleeves of his robe as a sign of tribute. The best local instance related to this practice can be found in Antelami's relief lunette over the west door of the Baptistery in Parma, where angels carry instruments of the Passion in their extended sleeves. In the most general terms, the cloth came to signify respect for the sacredness of the object held, which usually is connected with the body of Christ. The Baptist's cloth functions in this case rather like the corporal with which the priest bears the host; see Joseph Braun, *Die liturgischen Paramente in Gegenwart und Vergangenheit*, Freiburg, 1924, 205–209.

44. As for instance on the north portal of Chartres, or in the von Werl altarpiece in the Prado by a follower of Rogier van der Weyden (illustrated in Charles Cuttler, *Northern Painting from Pucelle to Breugel*, New York, 1968, fig. 97).

45. Though attributed to Cesare by Morelli and Berenson, the most recent literature gives the painting merely to "a Lombard artist of the sixteenth century;" see Marco Carminati, *Cesare da Sesto, 1477–1523*, Milan, 1994, 18 and 22.

46. A schematic overview of depictions of John the Baptist with the lamb in Italian Renaissance art demonstrates the uniqueness of Correggio's squinch painting. Leonardo seems to have invented the motif of the lamb as a plaything for the infant Christ, with the result that the subject is common in Lombardy. The involvement of the infant Baptist with the sacrificial symbol, however, survives in no extant painting or drawing by the master himself, yet the motif is frequently employed by his followers. In numerous examples from the Lombard orbit of Leonardo (besides fig. 41, see Luini's painting in the Baron E. de Rothschild Coll., Paris [Berenson, *Central Italian and North Italian Schools*, vol. 3, 1490]), John, in the presence of the Virgin and Child, maneuvers a fleecy pet, and the childish play between infants and lamb prefigures Christ's redemptive acceptance of death. The theme enters Tuscan and Venetian art, as in Andrea del Sarto's *Mystic Marriage of St. Catherine* in Dresden, ca. 1512–13, or a drawing by Palma Vecchio in the British Museum, 1515–16,

most likely as a consequence of Leonardo's influence (S. J. Freedberg, *Andrea del Sarto*, Cambridge, Mass, 1963, figs. 38–39; Philip Rylands, *Palma Vecchio*, Cambridge, 1992, 250, cat. D2).

Usually artists from the Veneto prefer to depict John as a stalwart adult saint with the attribute at his feet, as in fig. 42, or, for examples contemporary with Correggio's, Palma Vecchio's painting in Vienna (1527–28; Rylands 1992, 245, cat. 100) or Giovanni Cariani's *Resurrection with Saints* (ca. 1520; Berenson, *Italian Pictures of the Renaissance: Venetian School*, London, 1957, vol. 2, 729). In the characteristically Venetian religious pictures of horizontal format, the relationship between saint and attribute may be on occasion somewhat closer, yet the physical proximity consistently lacks emotional intimacy. Palma Vecchio's Baptist ignores the lamb or restrains it, as in the pictures in Lugano and Vienna (Rylands 1992, 180, cat. 39 and 192, cat. 50). The prototype for this type of depiction may be a painting in Edinburgh, attributed to the young Titian (*Holy Family and Baptist*, Earl of Ellesmere Loan, National Gallery of Scotland, ca. 1507–8; Rylands 1992, 70). In each of these examples, this lamb is clearly only an animal, incapable of the superbestial psychological state Correggio's creature exhibits. This is the case in even the few exceptional examples in which the grown saint holds his attribute with unusual care: Pordenone, in his altarpiece *St. Lorenzo Giustiniani and Saints*, ca. 1532–35, for the church of S. Maria dell'Orto and now in the Accademia, Venice (Berenson, *Venetian School*, vol. 2, 875); or Lotto's Baptist in the polyptych of Ponteranico, near Bergamo, ca. 1527 (Flavio Caroli, *Lorenzo Lotto e la nascita della psicologia moderna*, Milan, 1980, 177), which is so similar as to reflect in all probability knowledge of Correggio's invention. By the middle of the century, artists like Veronese and Lanino begin to experiment with more flexible relationships between saint and attribute, but Correggio's painting remains a significant violation of the custom established by his predecessors and followed by his contemporaries.

47. For numerous Byzantine and medieval examples as well as a discussion of the origins and history of the *Eleousa* image, see Victor Lasareff, "Studies in the Iconography of the Virgin," *Art Bulletin* 20, 1938, 36–42.

48. Tassi 1968, 128: "La scena vive tutta sul contrasto bellissimo tra la bruna accensione della testa del Santo e il bianco pallore dell'animale, tra l'occhio vivo dell'uno e quello appena vellato dell'altro, tra le labbra carnose e tumide e il muso liscio e sottile; se ne fa un fulcro luminoso."

49. Mantegna's infant Christ in the small painting in the Accademia Carrara, Bergamo, is safely steadied at waist and seat by the Virgin's delicate hands (fig. 43). He hugs his mother around the neck and puts his head close to hers, snuggling at right angles to her bosom. Correggio translates the pose of this Christ child as closely as the lamb's anatomy will allow. Another northern Italian example of the "tender" Madonna is Vincenzo Foppa's in the Museo Civico, Castello Sforzesco, Milan (*La Pittura Bresciana del Rinascimento*, exh. cat., Pinacoteca Comunale Tosio-Martinengo, Brescia, 1939, Bergamo, 36–37, pl. 6). Raphael's *Tempi Madonna* and *Small Cowper Madonna* are High Renaissance variations on the Byzantine type; even more to the point are his sketches such as those in the Musée Wicar in Lille and in the British Museum (E. Knab, E. Mitsch, and K. Oberhuber, *Raphael: Die Zeichnungen*, Stuttgart, 1983, 23, pl. 384).

50. Freedberg 1975, 268, 269.

51. Ricci 1896, 257.

52. Gould 1976, 11.

53. See n. 14 above and Felice da Mareto, *Chiese e conventi di Parma*, Parma, 1978.

54. *Corpus Nummorum Italicorum*, vol. 9, Emilia (I), Pls. 27–28 and corresponding commentary. The coins that depict Saints John and Hilary sharing the communal standard occur during the papacy of Julius II and of Hadrian VI; during the papacy of Clement VII, the standard disappears, and each saint receives his own properties, resulting in individual portrayals of the saints which more closely resemble Correggio's.

55. A. del Prato, 1903, 9–10. The Parmesan motto can be traced back to 1248 (Affò, *Storia della Città di Parma*, 1792–95, 212–13); del Prato derives evidence for the fifteenth-century facade painting from da Erba's chronicle and communal documents of payment.

56. Umberto Benassi, *Storia di Parma*, Bologna, 1899–1906, III, 125.

57. *Ordinarium Ecclesiae Parmensis* (1417), 183.

58. Ibid., 183–84: "*Vexillum Populi*, funi annexum, in medio pinnaculi supra chorum attrahatur, ut ibi pendeat." L. Barbieri (1866, 184, n. 4), in his notes for the *Ordinarium*, speaks of the Assumption day tradition of "la mostra poi del confalone del popolo (ora sostituito da un drappo collo stemma del Comune, cioè croce azzurra in campo d'oro) valeva a

provare che Maria assunta in cielo era il titolo proprio e speciale della chiesa parmense." The cross was the communal coat of arms long before Correggio's time, as a survey of medieval and Renaissance Parmesan coins again show. Popham (1957, 112) connects Anselmi's drawing in Lille of putti bearing a shield with the Parmesan cross with the payment of November 1531 that the artist received for painting a new communal standard. The document is also cited by A. G. Quintavalle (1960, 78–79), but she does not associate it with the drawing.

59. Adolfo Venturi, *Storia dell'arte italiana: La pittura del Cinquecento*, Milan, 1926, vol. 9 (2), 561. A good example of such a tomb is illustrated by Guntram Koch and Helmut Sichtermann, *Römische Sarkophage*, Munich, 1982, fig. 64, a sarcophagus in the Museo Nazionale, Rome.

60. This relief, now in the Louvre, was in the courtyard or piazza of St. Peter's and was known in the Renaissance. See Bober and Rubenstein 1986, 95, pl. 59B.

Chapter Three

1. This print, in the Biblioteca Palatina, Parma, is the earliest and probably most useful copy after this group of censer-tending angels. See Fornari Schianchi (1983) who, aside from Boniveri's, reproduces several other prints of the same damaged fresco passage: S. F. Ravenet's of 1785, also in the Biblioteca Palatina (fig. 186); an anonymous late-eighteenth-century pencil drawing (fig. 194, in the Palazzo Vescovile, Parma); and a watercolor done after the above drawing (fig. 201, also in the Palazzo Vescovile).

2. Ricci (1896, 258 and 1930, 106) and Shearman (1980, 291) also have noted this. See A. C. Quintavalle 1974, 239 and 299, for evidence that Correggio had the windows enlarged or redesigned for his decorative purposes. Dall'Acqua's publication of the documentation relating to the technical preparation of the dome and surface (1984, 53–63) indicates that much work was done before Correggio commenced painting, though no specific mention is made of the oculi.

3. The only admission of two-dimensionality is given by the shadows of the extended toes of two of the apostles, one above and to the left of St. John the Baptist—who can be seen from the next station in the sixth bay—the other, visible from the apse, to the left of the most westerly oculus. Since these human figures are obviously illusion, so must be the shadows they cast, and by this inference, the cornice, though as a purely architectural form it truly fools the eye. The possible implications of this will be discussed in the Conclusion.

4. G. D. Ottonelli and P. Berrettini (Pietro da Cortona), *Trattato della pittura e scultura, uso et abuso loro* (Florence, 1652), ed. Vittorio Casale, Treviso, 1973, in the chapter "Della forza che ha pittura nel rappresentare," 23: "egli figurò una cornice intorno intorno con tale, e tanto esquisito artificio, che chi, da basso alzando gli occhi, la rimira non può credere, che sia cosa dipinta; tutto che, esser tale, detto gli venga, e confermato da molti: e quindi segue, che essendo veramente Pittura, porge ad ogn'uno occasione di volersene chiarire presentialmente con la solita esperienza di toccarla con un'hasta, per vedere evidentemente, e provare se sia lavoro di rilievo, e di stucco, ò pure d'opere dipinta."

5. L. Vedriani, *Raccolta de' pittori, scultori, et architetti modenesi più celebri* (Modena, 1662), Bologna, 1970, 50: "e quel sempre maraviglioso Cornice, che fa stupire il mondo, fu formato prima di rilievo dal Begarelli"; and F. Scannelli, *Il microcosmo della pittura* (Cesena, 1657), ed. A. Ottina della Chiesa and B. della Chiesa, Milan, 1966, 275. Meyer (1871, 188–90), notes Vedriani's development—more patriotic than accurate—of Scannelli's already dubious story. For a thorough discussion of the Begarelli-Correggio legend, see R. W. Lightbown, "Correggio and Begarelli: A Study in Correggio Criticism," *Art Bulletin* 46, 1964, 7–21.

6. Gould 1976, 111. Cosimo III had a similar experience but a less adventurous reaction (*Viaggi di Cosimo III*, July 3, 1664); quoted by F. Razzetti, "Antologia di viaggiatori e di scrittori antichi," in *Correggio; Gli affreschi nella cupola del Duomo di Parma*, Parma, 1980, p. 61: "Di lì (Cosimo III) stette al Duomo chiesa tutta dipinta dal Correggio nella cupola della quale è una cornice tanto bene in prospettiva che da basso pare di rilievo, cosa che inganna ognuno, perchè oltre l'essere bene intesa, è aiutata di più per di sotto da un cordoncino di legno dorato che sporta in fuori tre dita, in che consiste l'artificio. Il sig. Principe fece salire uno dei suoi per vederne il lavoro, e la regina di Svezia, quando vi passò, non credendo fosse dipinta salì centoventi scalini per accertarsi del fatto."

7. Ricci 1896, 258.

8. Gould 1976, 111; and Riccòmini 1983, 82: "ancor oggi . . . dopo il restauro, la gente ancora non riesce a convincersi che quel cornicione a gola in finto marmo sia solo dipinto."

9. Gronau 1907, xxviii: "in diesen zwölf Gestalten beginnt jene ins Uebertriebene gesteigerte Beweglichkeit, die die Spätzeit Correggios recht eigentlich charakterisiert;" and Testi 1923, 40: "atteggiamenti incomposti e troppo agitati."

10. Ricci 1896, 259; in the later edition (1930, 106–7), Ricci omits this particular criticism. Similar negative comments are put forward by Meyer (1871, 186): "Zudem ging in dieser Malerei Correggio, soweit es möglich war, noch weiter in der Bewegtheit der einzelnen Gruppen und Gestalten. Das zeigt sich auch in den Aposteln und Genien an dem unteren Umlauf der Kuppel, deren Theilnahme an dem Vorgange der Himmelfahrt doch nur ein festliches und begeistertes Beiwohnen sein soll."

11. For instance, Gronau 1907, xxviii: "All dies Uebermass gewaltsamer, die Leiber hierhin und dorthin reissender Bewegung ermüdet nicht nur das Auge; in der Höhe, auf so schmalem Raum, der den Gestalten engeräumt ist, erregt es fast Schwindel."

12. Ricci 1896, 259–60. And he continues: "This defect is more especially noticeable in the single figures. Distributing the twelve figures in eight compartments, the painter was compelled to place eight in groups of two, leaving the remaining four to appear separately; and this, indeed, explains the more confused and involved treatment of the latter: the space they occupy being filled in the former case by two figures, the artist had less scope for energetic movement, and a certain reticence in pose and drapery was enforced by this limitation of the field."

13. For instance, Burckhardt's (1955, vol. X [II], 310): "In den Aposteln ist Correggio inkonsequent; wer so aufgeregt ist wie sie, bleibt nicht in seiner Ecke stehen; auch ihre vermeintliche Grossartigkeit hat etwas merwürdig Unwahres."

14. Otto Demus, *The Mosaics of S. Marco in Venice*, Chicago and London, 1984, vol. 2, color plate 5, pls. 234, 249–60. Though the identification of Correggio's specific prototypes remains tied to the problem of his travels, the widespread use of a very limited range of gestures for the apostles throughout Christian iconography suggests that this repertory would have been inescapable through a variety of medieval images. For a number of examples that demonstrate the almost formulaic postures assumed by Christ's disciples at his Ascension, from the sixth-century Rabula codex to twelfth-century manuscript illustrations, see Gertrud Schiller, *Ikonographie der christlichen Kunst*, vol. 3, *Die Auferstehung und Erhöhung Christi*, Gütersloh, 1971, figs. 489–501. Just as the ninth-century *Ascension* fresco in the lower church of S. Clemente in Rome, where apostles assume the standardized postures of wonderment, has been taken for an *Assumption* by many modern viewers, similar images could have been of interest for Assumption painters in the Renaissance. For a summary of the controversy concerning the subject of the painting, see John Osborne, *Early Mediaeval Wall-Paintings in the Lower Church of San Clemente, Rome* (Ph.D. diss., Courtauld Institute of Art, 1979), New York and London, 1984, 43–53.

15. Rodolfo Pallucchini, *I Dipinti della Galleria Estense*, Rome, 1945, cat. 257, fig. 84. The painting, perhaps commissioned in 1513, was in S. Maria Maggiore in Mirandola in the nineteenth century. The two artists were also responsible for the *Nativity* in S. Giovanni Evangelista, in Parma (see also Marco d'Oggiono's *Assumption*, fig. 83). The alternative solution, in which apostles accept the miracle with pious quietude, is more characteristic of the work of Pinturicchio, Perugino, and their followers; see, for instance, Lorenzo Costa's *Assumption*, fig. 77.

16. Thus Burckhardt's negative criticism is understandable (see n. 13 above). But in applying the criteria of strict realism to Correggio's apostles (which would make much of Renaissance art absurd), he does not recognize that the deliberate artifice and drama of Correggio's statement is a visual language meant to clarify the depicted event.

Shearman (*Raphael's Cartoons in the Collection of Her Majesty the Queen and the Tapestries for the Sistine Chapel*, London, 1972, 130) equates this type of depicted action with the discourse concerning figural movement in Dolce (especially the emphatic movement of *energeia*), and points out that it parallels the treatment of rhetoric in literary theory. An analysis of Correggio's attitude toward contemporary art theory might indeed prove fruitful, but such an investigation lies outside the scope of this study.

17. Luigi P. Scaramuccia, *Le finezze de' pennelli italiani ammirate e studiate da Girupeno sotto la scorta e disciplina del genio di Raffaello d'Urbino* (1674), ed. Guido Giubbini, Milan, 1965, 172: "[le] maestose attitudini, e'l decoro di que' dodici Apostoli." Even still, his praise has the ring of apology, as if it were a counterresponse to unrecorded detractors.

18. Rubens's drawing is reproduced by Eugenio Busmanti, "Alcune trascrizioni della cupola del Duomo," in Riccòmini 1983, fig. 229, 179. The red chalk figure in the Albertina, long attributed to Correggio but now given to Annibale Carracci, combines the self-protective action of an eastern apostle with the pose of a western one (illustrated by D. De-

Grazia, ed., *Correggio and His Legacy; Sixteenth-Century Emilian Drawings*, exh. cat., National Gallery of Art, Washington, D.C., 1984, 132, cat. 33). Ludovico Carracci paints an apostle modeled specifically on one of Correggio's into his *Transfiguration* for the main altar of S. Pietro Martire, 1596–97, in the Pinacoteca Nazionale, Bologna (illustrated in Andrea Emiliani, ed., *Ludovico Carracci*, exh. cat. Pinacoteca Nazionale, Bologna, and Kimbell Art Museum, Fort Worth, Texas, Bologna, 1993, 92–93, cat. 42). The many drawings of the apostles once attributed to Correggio and disattributed by Popham attest to the popularity of this part of the Cathedral fresco; see, for instance, Ricci 1930, figs. CCLXXa, CCLXXI, CCLXXIIa and b, CCLXXIIIa and b.

Some of the earliest imitations of this section of Correggio's decoration are found in Parma: Gatti's apostles in the drum of the central dome of the Steccata of 1560–66 (illustrated in *Sta. Maria della Steccata a Parma*, ed. Bruno Adorni, Parma, 1982, 190–91) and those in Lattanzio Gambara's *Ascension* on the west wall of the Cathedral, completed in 1573 (P. V. Begni Redona and Giovanni Vezzoli, *Lattanzio Gambara, pittore*, Brescia, 1978, 194–95). In the *Assumption* fresco in Verona Cathedral (1534), executed by Francesco Torbido on designs created by Giulio Romano probably ca. 1532, the disciples are primed by Raphael's late style but also reflect an early and direct response to Correggio (see Frederick Hartt, *Giulio Romano*, 1958, 203–4, fig. 429) and were primed by Raphael's late style, but they also reflect an early and direct response to Correggio.

19. There is no textual tradition that accounts for some apostles to be less ready than others for the full force of theophany. Nor can any of the individual disciples in the Duomo be identified specifically on the basis of behavior or location. It might be tempting to assume that the apostles foremost from the nave could be the denying Peter, rock of the Church itself, and the doubting Thomas, the newest Parmesan saint—but how much easier it would have been for the artist to have handed a key to one and a girdle to the other. Efforts to identify them by color associations become merely frustrating, too. Such attempts are misleading with regard to the *in situ* program, for the apostles are not meant to represent identifiable individuals—especially since different ones are seen from different viewpoints. Correggio has taken some care to render them anonymous.

20. To some, the light from the center of the cupola is the key to the entire meaning of the work. Morel (1984, 12–13) refers to the fusion of the figures in the upper part of the dome, which occurs by virtue of the brilliant supernatural light. The light and the hierarchical ranking of the figures seem to him to be a reflection of the Neoplatonic thought of Ficino. Morel's observations follow those of Ceschi Lavagetto (1980, 26). The latter, who proposes Ficino as a source for Correggio's frescoes in the Cathedral, also admits the more general meaning of the light: "Anche il concetto della luce è neoplatonico, ma comune fin dalle origini all'iconografia religiosa: spesso i misteri cristiani sono presentati con metafore luminose."

21. Among the former are Burckhardt and Shearman ("brustwehr," 1955, vol. 10 (2), 310; and "a painted parapet," 1980, 289–90); while the terms of Mengs ("una specie di zoccolo" [1780], 1787, 177) and especially of Martini ("plinto," "zoccolo," and "quasi un atrio del paradiso istesso," 1865, 161) correspond to the second perception. The preferred use of the word "balustrade" or "balaustra" (by Thode 1898, 74; and Bodmer 1943, xviii) indicates at least perhaps a subliminal awareness of the problem; though while a balustrade can be found at either the bottom or top of an elevation, the proper meaning of the word as "a row of balusters joined by the rail" disqualifies it for Correggio's situation. Gould (1976, 129), also perhaps detecting a semantic confusion, characteristically opts for the inoffensive and undescriptive "simulated architecture" (with a precedent in Gronau's "tauschende Architekturmalerei," 1907, xxviii).

22. A. C. Quintavalle, "Correggio: Le Scelte Critiche," in *Arte come comunicazione visiva, Quaderni di storia dell'arte*, vol. 5, Parma, 1969, 237.

23. See n. 2 above.

24. Shearman 1980, 288, and 1993, 176–78.

25. In addition, the problem of viewing, both the observer's and that of the depicted characters—which Shearman finds suggestive for Correggio's two church frescoes—is proposed in Forlì in a manner not addressed in earlier, strictly centralized dome decorations, including Melozzo's.

26. Palmezzano's dome is discussed by Rezio Buscaroli, "Opere inedite di influsso melozziano in Romagna," *Melozzo da Forlì* 6, 1939, 292–93. A related example of this type of dome fresco can be found in the church of S. Fortunato in Rimini (ex-S. Maria di Scolca); ca. 1512. Perhaps attributable at least in part to Girolamo Marchesi da Cotignola, it depicts four Evangelists on a parapet, surmounted by an image of God the Father set against an illusion of open sky. The sty-

listic disparity between the lower and upper parts of the painting makes the monument problematic, but the symmetry of the resulting composition remains in any case aligned with Quattrocento tradition; see R. Buscaroli, *La pittura romagnola nella seconda metà del quattrocento*, Faenza, 1931, 173–75, and also *Carlo Francesco Marcheselli, Pitture delle chiese di Rimini (1754)*, ed. Pier Giorgio Pasini, Fonti e studi per la storia di Bologna e delle province emiliane e romagnole, no. 4, Bologna, 1972, 125–127.

27. Shearman 1980, 288; R. Buscaroli, *Melozzo e melozzismo*, Forlì, 1955, 120–22; Raffaella Zama, *Vecchie e nuove conoscenze nella Cappella Sforzesca restaurata*, Cotignola, 1990.

28. Two extant fresco decorations demonstrate the Lombard impulse of the fifteenth and the early sixteenth centuries to adjust material surfaces to imaginative purposes by pictorial means. A fresco of the *Resurrection of Christ* by an anonymous Lombard painter in the vault of the Cappella di S. Donato in the Castello Sforzesco demonstrates an early if awkward attempt to turn vault into sky, with figures oriented toward the viewer and a mountainous edge surrounding the whole airy illusion. This painting appears to be a cruder version of the more ornamental Bembesque vault in the adjacent Cappella Ducale, both dating from the period of Galeazzo Maria Sforza; see Gian Guido Belloni, *Il Castello Sforzesco di Milano*, Milan, 1966, 20–21, 28. Another anonymous artist "rebuilds" the late Gothic ogives of the chapel dedicated to the Virgin in the Benedictine church of S. Pietro in Gessate, Milan, updating them into a rounded arcade in order to house the saintly figures in comfortable Renaissance fashion. The Quattrocento chapel decorations are discussed by Andriano Frattini, "Documenti per la committenza nella chiesa di S. Pietro in Gessate," *Arte Lombarda*, n.s. 65, 1983, 27–48.

29. G. P. Lomazzo, *Trattato dell'arte della pittura, scoltura, et architettura* (Milan, 1584) in *Scritti sulle arti*, ed. R. P. Ciardi, Florence, 1973, vol. 2, 235–36. With so little surviving evidence, we can only hypothesize tentatively that works like the Sforza chapel in Cotignola represent a vestige of Milanese-sponsored illusionism.

30. The most recent reference to the subject of the fresco as "apostoli e angeli musicanti" indicates some iconographical trouble as well. Without the Virgin, the painting can hardly represent a Pentecost, and indeed, it is tempting to imagine the dove substituted by an image of the Assunta. This clumsy but historically intriguing work has no surviving parallel in Lombard art; Marco Tanzi's remark, "è quindi altamente probabile che il caravaggino si rifacesse a qualche prestigioso archetipo perduto, bresciano o cremonese" ("Francesco Prata da Caravaggio: aggiunte e verifiche," *Bollettino d'Arte* 72, 1987, 148), proposes what would be untraceable implications for the investigation of Correggio's own possible sources.

Yet nearer to Parma, Bernardino Zacchetti, in the dome of the first nave bay in S. Sisto, Piacenza, wedges Michelangelesque prophets into a bulky drumlike loggia that gives way, within the upper ring of the vault, to a glimpse of Christ in heaven amid angels (fig. 64). Even at so late a date as Zacchetti's decoration, 1517, and with the conspicuous advantage of direct Roman inspiration, the dome in Piacenza is of an earlier mentality than Zaganelli's (discussed and illustrated in Raffaella Arisi, *La chiesa e il monastero di S. Sisto a Piacenza*, Piacenza, 1977, 58–59).

31. This idea, first stated in the last years of the seventeenth century by Padre Sebastiano Resta (*Correggio in Roma*, ed. A. E. Popham, *Archivio storico per le province parmensi*, no. 9, supplement, Parma, 1958, 46–47), is followed by Testi 1923, 40–42; Gould 1976, 129; Shearman 1980, 291; and Morel 1984, 10.

32. Testi 1923, 42. Venturi calls it "zuccolo o grande altare marmoreo" (1926, vol. 9 [2], 567).

33. In Jacobus de Voragine, ed. Graesse, 523: "verum apostolos, qui ubique terrarum dispersi hominum piscationi vacabant, sagina verbi homines de profundis tenebris ad coelestem mensam curiae vel sollemnes patris nuptias educentes, divinum praeceptum, quasi sagina quaedam vel nubes, e finibus terrae Jerusalem contulit, ultra quasdam aquas congregans et colligens."

34. Venturi 1926, vol. 9 (2), 572: "il movimento si affretta e si smorza in ritmiche onde; folgorano e si spengon le luci."

35. In Boniveri's print, the composition of the fresco is of course reversed. A comparison of Boniveri's print with the same scene as it appears in S. F. Ravenet's etching of 1785 shows this later copyist to have misconstrued the censer as another lampstand, while the eighteenth-century copyist also exaggerated the action by depicting lumps of incense. For Ravenet's print, see Fornari Schianchi 1983, 157, fig. 186.

36. He is ready to receive the boat, which is being relayed on the left. This object is a common type of boat-shaped incense holder, generally set on a stand. A flat cover, hinged at the center, opens on one side. The same figure that holds

the base of the boat holds open this cover, while his partner picks up the incense with one hand to drop it into his other. The incredible obscurity of this activity seems quite deliberate on the artist's part. (illustrated under the entry for "navicula," *Liturgische Gerate der Christlichen Kirchen*, Strasbourg, 1972, fig. 24).

37. Pseudo-Jerome, "Epistola IX ad Paulam et Eustochium," *PL*, XXX, col. 133; the author continues: "Et bene quasi virgula fumi, quia gracilis et delicata, quia divinis extenuata disciplinis, et concremata intus in holocaustum incendio pii amoris, et desiderio charitatis . . . manans ex ea fragrabat suavissimus odor etiam spiritibus angelicis."

38. "Responsoria sive Antiphonae de Assumptione sanctae Mariae," *PL*, LXXVIII, col. 798.

39. E. Pax, "Weihrauch," *Lexikon für Theologie und Kirche*, Freiburg, 1965, vol. 10, cols. 990–92. In *Revelations* 5:8, the 24 elders have "golden bowls full of incense, which are the prayers of the saints."

40. For example, in Niccolò di Pietro Gerini's *Death of the Virgin* in S. Maria, Impruneta (illustrated in Miklòs Boskovits, *La pittura fiorentina alla vigilia del Rinascimento*, Florence, 1975, fig. 165). Instances of censer-tending angels on Trecento tombs are numerous, such as the angelic attendants with censers and basins from the Aliotti tomb, 1336, in S. Maria Novella, Florence (reproduced, and attributed to Maso di Banco, in Gert Kreytenburg, *Andrea Pisano und der toskanische Skulptur des 14 Jahrhunderts*, Munich, 1984, 77, pl. 389); see Henriette s'Jacob, *Idealism and Realism: A Study of Sepulchral Symbolism*, Leiden, 1954, 74–81, for a discussion of the antique and medieval tradition of funereal incense burning.

41. Such angels are likewise prominent in Bartolo di Fredi's *Death of the Virgin*, from a polyptych in the Pinacoteca, Siena, signed and dated 1388 (Berenson, *Central Italian and North Italian Schools*, vol. 2, fig. 413); and in a fifteenth-century Venetian example, Michele Giambono's canvas in the Museo di Castelvecchio, Verona, where an angel kneels before the Virgin's bier and flicks a thurible (Mauro Lucco et. al., *La pittura del Veneto: Il Quattrocento*, Milan, 1989, vol. 1, 185, fig. 245). The picture attributed to Baldassare d'Este was probably done for the nuns of Mortara (southwest of Milan); see *Catalogo della Esposizione della pittura Ferrarese del Rinascimento*, Ferrara, 1933, 119, no. 144.

42. Dürer's woodcut of the Coronation however, does include the basin and aspergillum at the side of the empty tomb, and an apostle holds a censer. Dürer's image makes an interesting comparison with Correggio's, as we will see in chap. 6 , as a conflation of various scenes of Mary's death and postmortem existence.

43. Gould (1976, 112), who concentrates on the prototypes for the torch-tending figures rather than their function, believes their action is "a pagan funeral rite for the Virgin . . . and pagan, in the best sense, is what they are"; while Testi (1923, 41, n. 1), sees the attendance of *ceroferarii* and *turiferarii* as part of a medieval religious ceremony.

44. Ricci 1896, 61; for instance, Gould 1976, 111; Popham 1957, 70.

45. For a chronology and discussion of engravings after the *Triumphs*, see A. Mezzetti, in *Andrea Mantegna*, ed. G. Paccagnini, exh. cat., Palazzo Ducale, Mantua, Venice, 1961, 188–92. Paintings, drawings, and engravings after the composition with elephants, as well as the painting in Hampton Court, are reproduced in Andrew Martindale, *"The Triumphs of Caesar" by Andrea Mantegna*, London, 1979, 97–100, figs. 52, 59, 63, 82. Charles Hope notes the incontestable fame of the *Triumphs* in the sixteenth century; (*Andrea Mantegna*, ed. Jane Martineau, exh. cat., Royal Academy of Arts, London, and Metropolitan Museum of Art, New York, London and New York, 1992, 349; also see entries by Susan Boorsch, ibid., nos. 117–19).

46. Martindale (1979, 148–49), identifies the source for Mantegna's peculiar creation as textual, specifically a reference to *lychnuchi* in Suetonius's *Vita*.

47. See chap. 2, n. 60. Winged victories attend a burning candelabrum also on a second-century relief from the Basilica Ulpia (Munich); this sculpture was in the Palazzo della Valle in the sixteenth century. Bober and Rubenstein (1986, 202, pl. 171), call this object a *thymiaterion*.

48. Again in a funerary context, and alongside sphinxes, another antique candelabrum surmounts Gian Cristoforo Romano's monument for Gian Galeazzo Visconti in the Certosa of Pavia (fig. 28). Commemorative monuments with candelabra-torches are numerous from the later fifteenth and early sixteenth centuries. A prominent Roman example is the pair of tombs by Andrea Sansovino for Ascanio Sforza and Giuliano Basso della Rovere (ca. 1505–7) in S. Maria del Popolo; each features a pair of angels who joyfully carry classical candelabra (illustrated in John Pope-Hennessy, *Italian High Renaissance and Baroque Sculpture*, London, 1963, vol. 1, figs. 57, 58). A candelabrum appears as a decorative feature in the frontispiece of a Venetian edition (1470) of Eusebius's *De Evangelica Praeparatione*, illuminated by the London Pliny Master (reproduced in Armstrong 1981, fig. 110), and a minutely described object close to Mantegna's *lychnuchi* ornaments a parchment of 1477 of Gian Galeazzo Maria Sforza (Giulia Bologna, *Il Castello di Milano*, Milan, 1986, 85). Jacopo Bellini experiments

with inventive classicizing torches even earlier in his sketchbooks. Direct derivations from Mantegna's *Triumphs* continue to lend impetus to the candelabra in an antiquarian context, as in Giolfino's *Triumph of Pompey* (Museo Civico, Verona), who includes elephants as well as specifically Mantegnesque candelabra (illustrated in Martindale 1979, fig. 118).

49. For instance, in Fra Angelico's predella of the *Dormition*, Museo S. Marco, Florence, and in Jacopo Bellini's treatment of the same theme in the Louvre sketchbook.

50. The illegibility of his activity in the painting in Hampton Court, at least partly the result of the erosion of the painted surface, is only somewhat explained by a drawing in a private collection in Paris (Martindale 1979, fig. 52).

51. Francesco Maria Grapaldi, *De partibus aedium; Lexicon utilissimum* (1494), Basel, 1533, 61: "Plutoi sacra habetur, et ideo funebri signo ad domos defunctorum illum posuere maiores." Correggio probably would have been acquainted with this book, written by a scholar of the previous generation who was well connected with the canons of the Cathedral.

52. Virgil, *The Aeneid*, trans. Allen Mandelbaum, New York, 1972, Book VI, 285f.

53. Ricci 1896, 260–61, and 1930, 107.

Chapter Four

1. Bottari, 36 (1990, 29): "si dischiude improvviso."

2. Gould 1976, 111; see Introduction. Bodmer (1943, xix), seems to see Mary both obliquely from the nave and centrally from the crossing: "Emergendo dallo strato di vapori, cosicchè il corpo non è visibile, con lo sguardo volto verso l'alto e le braccia aperte in un'estasi di beatitudine, la Vergine si libra nell'aria, possente figura dalle forme giunoniche." Philippe Morel (1984, 12) founds a formal principle for the whole cycle upon what he perceives to be the invisibility of the Virgin: "una dinamica di fusione che l'informerebbe l'opera."

3. *Liber Responsalis, PL*, LXXVIII, col. 798: "Paradisi portae per te nobis apertae sunt: quas [quae] hodie gloriosa cum angelis triumphas."

4. The type is common from the fourteenth century and throughout Italy. Another example is Matteo di Giovanni's altarpiece of 1474 in the National Gallery in London (fig. 76). Lorenzo Costa's *Assumption* in the church of S. Martino Maggiore in Bologna, commissioned in 1506, constitutes an Emilian example (fig. 77).

5. As in the fresco of a female *orans*, mid-third century, in the Chamber of the "Velatio," Catacomb of Priscilla, or the bust of the Virgin, an early fourth-century fresco in the arcosolium lunette of Chamber V in the Coemeterium Maius, both in Rome (illustrated in André Grabar, *Early Christian Art*, trans. S. Gilbert and J. Emmons, New York, 1968, pls. 96, 115, 232).

6. Or, the panel by a Tuscan painter ca. 1270–80, in S. Maria delle Vertighe, Monte San Savino; Schiller 1980, vol. 4 (2), fig. 711; also see Millard Meiss, "A Dugento Altarpiece at Antwerp," *Burlington Magazine* 71, 1937, 24–25. In two Romanesque examples more local to Parma, the Virgin is depicted ascending to heaven in the *orans* pose: on a capital of the nave of Parma Cathedral (A. C. Quintavalle 1974, fig. 424) and in a twelfth-century manuscript illumination in the Archivio Capitolare in Piacenza Cathedral (*Il Duomo di Piacenza* [1120–1972]: *Atti del convegno di studi storici in occasione dell' 8500 anniversario della fondazione della Cattedrale di Piacenza*, Piacenza, 1975, frontispiece). A panel from Pietro Lorenzetti's altarpiece in the Pieve, Arezzo, and a fresco of a follower of Giotto over the entrance to the Cosinghi Chapel in S. Croce in Florence mark the period, ca. 1320, when the subject of the Assumption gains significant popularity, but in these *Assumptions*, the Virgin worships in the palm-to-palm manner that becomes customary in the Renaissance until the sixteenth century; see James H. Stubblebine, "Cimabue's Frescoes of the Virgin at Assisi," *Art Bulletin* 49, 1967, figs. 7, 8. This change is noted and discussed again by Stubblebine, *Duccio di Buoninsegna and his School*, Princeton, 1979, vol. 1, 13–14, 48, and by Meiss, 24–25. A panel from the school of Fra Angelico in the Isabella Stewart Gardner Museum in Boston of ca. 1430–34 (John Pope-Hennessy, *Fra Angelico*, London [1952], 1974, 224–25, fig. 72) is the earliest Renaissance revival of the *Assunta orante* tradition; but Mantegna's *Assumption* in the Ovetari Chapel (see below) is the earliest on a monumental scale.

Finally, we might conjecture whether or not Correggio could have had a more immediate precedent. Some writers have mused upon the possibility that the Renaissance frescoes may have replaced earlier paintings. Perhaps the dome or the semidome, as well as the soffits, was painted; the soffits once bore fifteenth-century prophets, one of which is still visible. Cited as evidence for this intriguing hypothesis are the contracts for Parmigianino and Anselmi that specify the removal of paintings from the small lunettes in the transepts (Martini 1865, 171–72, 175; Dall'Acqua 1984, 74–77).

If a painting of the Assumption existed at the time of the commissions of 1522, it is very likely to have been medieval in form.

7. See the reconstruction by Giuseppe Fiocco, *The Frescoes of Mantegna in the Eremitani Church, Padua*, Oxford and New York (1947) 1978, 27, 38. The image of God the Father was probably painted by Niccolò Pizzolo.

8. Annibale Carracci certainly understood the early Christian associations of the *orans* pose when in his altarpiece for the Cerasi Chapel he painted the Virgin ascending to heaven with outspread arms. The confidence of her radiant expression is characteristic of a later, post-Trentine attitude toward the Assumption, for which the theme represented the glorification of the Church. Seen against this background, the drawing in the British Museum in London (fig. 79) assumes a clearer relationship to Correggio's fresco—the knowing expression of the Virgin in this drawing is entirely at odds with the more passive humility of the *Assunta* in Parma Cathedral. As seen in chap. 2, Correggio's figures do not smile randomly. To Popham's argument that this drawing is a forgery of the Carracci school can be added the iconographical evidence. Popham's later inclusion of the drawing in Correggio's graphic oeuvre should be challenged and his first identification restored. See Popham, "On a Drawing Attributed to Correggio," *Critica d'arte* 8, 1949, 286–88, and Popham 1957, 71.

9. Another group of works demonstrates that artists working in central Italy in the 1510s had also experimented with the *Assunta orante*. Raphael, in a composition sketch for an *Assumption* in the Ashmolean, Oxford, lends the Virgin a buoyant posture, in which he invests the archaic *orans* pose with naturalistic movement—as Correggio does also, later. A drawing in Stockholm shows a retreat from this idea to a more contained and traditional arrangement (illustrated in K. Knab, E. Mitsch, and K. Oberhuber, *Raffaello, I Disegni*, Florence, 1984, 327, 331). If Shearman is correct in identifying this unexecuted project with the altarpiece for the Chigi Chapel—and his convincing arguments have been seconded by other writers (Shearman, "The Chigi Chapel in Sta. Maria del Popolo," *Journal of the Warburg and Courtauld Institute* 24, 1961, 143–57; and Fabrizio Mancinelli, "La Trasfigurazione e la Pala di Monteluce," in *The Princeton Raphael Symposium*, Princeton, 1990, 153–60)—a revival of the early Christian approach to the subject of the Assumption might conceivably be located in Rome ca. 1513–14, in Raphael's studio and for the very important commission in S. Maria del Popolo. Similarly, a series of drawings by Fra Bartolommeo show the painter entertaining but then discarding the concept of a Virgin *orans*. We can observe his clear statement of this pose in a drawing in Munich, reconsidered in a variant in Rotterdam (Chris Fischer, *Fra Bartolommeo, Master Draughtsman of the High Renaissance*, exh. cat., Museum Boymans-van Beuningen, Rotterdam, 1990, 327, fig. 215, and 286, no. 77), in which the *pentimenti* of the arms move toward successive closure. The final pose as executed in the resultant altarpiece of the *Assumption* in Naples of late 1516 (for S. Maria in Castello, Prato) reverts to the palm-to-palm scheme favored from the early Trecento (ibid., 327, fig. 213). Shearman has hypothesized Fra Bartolommeo's dependence on Raphael's composition, considering his presence in Rome in 1514; but it is possible that Fra Bartolommeo's idea is earlier, growing out of rejected ideas for another *Assumption* altarpiece of 1508. Creighton Gilbert ("Some Findings on the Early Works of Titian," *Art Bulletin* 52, 1980, 52–62) has suggested that Titian may have been privy to Fra Bartolommeo's *Assumption* scheme by means of the Ferrarese intersection of the two painters' careers; this is in contrast to Debra Pincus, who suggests that Titian's Virgin *orans* is a deliberate assertion of Venetian identity, evoking the many Byzantine prototypes at S. Marco ("The Venetian Ducal Tomb: Issues of Methodology and a Note on Titian's *Assumption*," in *Verrocchio and Late Quattrocento Italian Sculpture*, ed. S. Bule, Florence, 1992, 352). With the exception of a clumsy rendering of the Assumption in a pala in Bibbiena, in which Fra Paolino actualizes the Munich version of the Virgin's stance, none of the central Italian *Assunte oranti* ever came to fruition in painted form. The same is the case with Sebastiano's modello in the Rijksmuseum, Amsterdam, of ca. 1526, featuring the Virgin ascending to heaven quietly but with extended arms, and which Michael Hirst has also proposed to be an idea for the Chigi Chapel altarpiece, intermediary between Raphael's and Sebastiano's eventual *Nativity of the Virgin* (Sebastiano del Piombo, Oxford, 1981, 88; but he gives the precedent for the pose to Mantegna, not to Raphael). Hence the moment is ripe for an *Assunta orante*, monumentalized as in Parma, though whether the developments in Rome were decisive for the form of Correggio's depiction of Mary remains open to debate.

10. A gold-ornamented *cintola* was commissioned for the relief in a document of 1422; see Mary Ellen Bergstein, "The Sculpture of Nanni di Banco," Ph.D. diss., Columbia University, New York, 1987, 358, 488.

11. "Therefore the painter, wishing to express life in things, will make every part in motion—but in motion he will keep loveliness and grace. The most graceful movements and the most lively are those which move upwards into the air"

(*Leon Battista Alberti: "On Painting,"* ed. John R. Spencer, London and New Haven, 1966, 74). David Summers discusses this issue in "Maniera and Movement: The 'Figura Serpentinata'," *Art Quarterly* 35, 1972, 269–301.

12. Hubert Schrade, "Über Mantegnas 'Cristo in scurto' und verwandte Darstellungen: Ein Beitrag zur Symbolik der Perspektive," *Neue Heidelberger Jahrbücher*, 1930, 75–111. The author explores the connotations of feet-foremost foreshortening in Mantegna's *Dead Christ* by comparing it with other examples such as Bellini's drawings of the death of the Virgin and Pordenone's *Lamentation* in Cremona Cathedral.

13. The argument concerning Michelangelo's *Jonah* is an extreme condensation of an unpublished paper, written by the author at the University of Pennsylvania for a seminar with Dr. Leo Steinberg and delivered as a lecture ("Foreshortening as Meaning in Michelangelo's *Jonah*") at the 37th Annual Central Renaissance Conference, University of Missouri, Columbia, April 1991.

14. The combination of foreshortening and thoroughgoing contrapposto in the depiction of the Virgin of the Assumption was rarely attempted again. A nearby example of imitation and rejection is Camillo Procaccini's *Assumption* in the Cathedral of Piacenza, ca. 1600, where both effects are much moderated. See Nancy Ward Neilson, *Camillo Procaccini; Paintings and Drawings*, New York and London, 1979, figs. 147, 149, 150; an *in situ* view of Procaccini's *Assumption* and *Coronation* is reproduced in Francesco Arisi, "La pala apsidale del Duomo," in *Il Duomo di Piacenza: Atti*, 1975, 108.

15. Schiller 1980, vol. 4 (2), fig. 607, provides an example of the active *transito* in a Romanesque antiphon in the Bibliothèque Nationale, Paris. The Virgin's soul is portrayed twice to demonstrate the movement of her spirit from her body to heaven. In the first stage, Christ passes it to an angel, who in the second, passes it to God. Procaccini's ensemble in Piacenza (see previous note; Arisi 1975, 119) also creates a sequential impression, from the enormous altarpiece of the *Transito* to the frescoed *Assumption* and *Coronation* overhead in the apse and crossing vault, respectively.

16. Hans Martin Schmidt, *Der Meister des Marienlebens und sein Kreis*, Dusseldorf, 1978, fig. 17, and Schiller 1980, vol. 4 (2), 725. Another example, also reproduced in Schiller 1980, vol. 4 (2), fig. 726, is an *Assumption* by Rueland Frueauf of 1490, in Vienna.

17. Domenico Sedini, *Marco d'Oggiono: Tradizione e rinnovamento in Lombardia tra Quattrocento e Cinquecento*, Milan and Rome, 1989, 147, cat. 55. The altarpiece was commissioned for the Bagarotti Chapel, in S. Maria della Pace in Milan. Malaguzzi Valeri's hypothesis that the composition reflects a lost portal lunette at S. Maria della Grazie which had a legendary attribution to Leonardo has no basis (*La corte di Lodovico il Moro*, vol. 2, *Bramante e Leonardo*, Milan, 1915, 558); the late-sixteenth-century replacement for the earlier *Assumption* most probably instead relies on Marco d'Oggiono.

18. Though Ricci (1896, 261) finds that "some of the figures [angels] are of incomparable grace and beauty," Dickens's condemnation of the "labyrinth of arms and legs" that "no operative surgeon gone mad could imagine in his wildest delirium" rests on the music-making angels (Charles Dickens, *Pictures from Italy* [1846], New York, 1973, 105–6); Morel (1984, 12) is similarly baffled by these tangled limbs and finds recourse in quoting Burckhardt.

19. Mengs, ([1780] 1787, 177) as usual states the case most simply and accurately: set apart from the other figures in the dome "è il gruppo principale della Madonna, che viene assunta da molti angeli, che le sostengono i panni, e da ambe le parti ve ne sono altri, che suonano vari strumenti." Ricci (1896, 261), like him, notes the "angels and cherubs" (or, 1930, 108, "angels and putti"), but neither writer observes that the type of service is associated with physical type.

20. Jacobus de Voragine, ed. Graesse, 512: "hodierna die credendum est militiam coelorum festive genitrici Dei obviam advenisse eamque ingenti lumine circumfulsisse et usque ad Dei thronum cum laudibus et canticis spiritualibus perduxisse, coelestem quoque Jerusalem militiam tunc ineffabili laetitia exsultasse et jucundam tau ineffabili curitate et omni gratulatione jubilasse." Similarly, in Pseudo-Jerome, "Epistola IX ad Paulam et Eustochium," col. 134: "hodierna die militiam coelorum cum suis agminibus festive obviam venisse Genitrici Dei, eamque ingenti lumine circumfulsisse, et usque ad thronum cum laudibus et canticis spiritualibus perduxisse."

21. Jacobus de Voragine, ed. Ryan and Rippinger, 457; ed. Graesse, 512: Gerardus in suis homeliis dicens: solus dominus Jesus Christus potest hanc magnificare, quemadmodum fecit, ut ab ipsa majestate laudem continue accipiat et honorem, angelicis stipata choris, archangelicis vallata turmis, thronorum hinc inde possessa jubilationibus, dominationum circumcincta tripudiis, principatuum circumsepta obsequiis, potestatum amplexata plausibus, virtutum girata honoribus, cherubin circumstantiata hymnificationibus, seraphin undique possessa ineffabilibus cantationibus." The heavenly guest list is also used by John of Damascus. Evidence for its Renaissance currency survives in a popular devotional

book composed in the late Quattrocento, in which Antonio Cornazzano retells the *Golden Legend* fable—here, the *Transito*—in familiar terms (see chap. 7, n. 21):"Gli cherubin gli tron tutti in brigata/ Le podesta e le dominationi/ Circondaven la donna accompagniata" (*Vita della Gloriosa Vergine Maria*, Venice, 1517, 27r).

22. Pseudo-Dionysius the Areopagite,"La Hierarchie Céleste," *Oeuvres Complètes*, ed. Maurice de Gandillac, Paris, 1943, 185–244; *PG* III, cols. 119–370.

23. Giovanni di Balduccio's methodical inclusion of angelic types on the *arca* of St. Peter Martyr in the Portinari Chapel, Sant'Eustorgio, Milan, is exceptional (Renata Cipriani, *La cappella Portinari in Sant'Eustorgio a Milano*, Milan, 1963, pls. I, XXXVIII, XXXIX). Only eight types are represented due to the rectangularity of the *arca*, but all are neatly labeled. Francesco di Giorgio enlists a variety of angels (Allen Weller [*Francesco di Giorgio, 1439–1501*, Chicago, 1943, 102] identifies all nine kinds) in a *Coronation* (Siena, Pinacoteca) notable for iconographic eccentricity.

24. Other notable examples are Perugino's frescoed altarpiece in the Sistine Chapel (later replaced by Michelangelo's *Last Judgment*, known through a drawn copy from Perugino's workshop (Leopold D. Ettlinger, *The Sistine Chapel before Michelangelo; Religious Imagery and Papal Primacy*, Oxford, 1965, pl. 34c) and Pintoricchio's fresco in S. Maria del Popolo (illustrated by Enzo Carli, *Il Pintoricchio*, Milan, 1960, pl. 64).

25. Fully corporeal angels may on occasion win proximity over seraphim. Examples are Mantegna's *Assumption* in the Ovetari Chapel and Nanni di Banco's Porta della Mandorla (figs. 54, 80). These artists illustrate the active nature of the Assumption by depicting angels who accompany the Virgin from earth—and who would for this reason be of a larger,"lowlier" order—as still clinging to her dress, though she is encircled already by the divine light of the seraphim-inhabited mandorla.

26. Of all the putti next to the Virgin, this angel alone has been noted as meaningful. As Fornari Schianchi has nicely observed (1981, 9),"il putto vicino (the feet of the Virgin) . . . inarca il sopracciglio schiacciato com'è dal peso corporeo della Vergine. . . ."

This idea is taken up again in the *Assumption* by Jacopo and Domenico Tintoretto in the Sala Terrena in the Scuola di San Rocco in Venice, where the action centers upon the tomb, the Virgin, and the athletic putto that gives her a palpable boost (illustrated by Rodolfo Pallucchini and Paola Rossi, *Tintoretto: Le opere sacre e profane*, Milan, 1982, vol. 2, pl. 566; vol. 1, 226, cat. 442).

27. Aurelia Stapert (*L'ange roman dans la pensée et dans l'art*, Paris, 1975, 129–31) provides a summary of Augustine's ideas on the knowledge of angels, with historical background on earlier Christian writers.

28. Tassi's identification (1968, 149) of one of the figures as Joseph is followed by von Simson (1983, 335) and Giuseppe Toscano (*Nuovi studi sul Correggio*, Parma, 1974, 202–203). A. C. Quintavalle and Alberto Bevilacqua (*L'Opera completa del Correggio*, Classici dell'arte, no. 41, Milan, 1970, 83) reproduce a detail of the head that emerges behind Joseph as "supposto autoritratto del Correggio." Concerning the general program of the figures behind the Virgin, all writers simply include them generically as part of the figural wreath. Gould (1976, 109) and von Simson (332) note the presence of New Testament characters as well as figures from the Old Testament but do not specify the location of each. Von Simson (335) is alone in offering a program for the blessed:"Alle genannten Gestalten weisen hin auf die Würde Mariä, auf ihre Jungfräulichkeit oder auf ihre Teilnahme am Erlösungswerk Christi."

29. Simeon's prophecy is the biblical impulse behind the late medieval devotion to the sorrows, which were often symbolized in book illustrations and broadsheets as swords. The actual number of sorrows remained flexible—usually five or seven—into the sixteenth century. See Carol M. Schuler,"The Sword of Compassion: Images of the Sorrowing Virgin in Late Medieval and Renaissance Art," Ph.D. diss., Columbia University, 1987, 124–35, who emphasizes the history of the cult in northern Europe, where it was most popular.

Chapter Five

1. Joseph A. Jungmann, *The Mass of the Roman Rite: Origins and Development*, trans. Francis A. Brunner, New York, 1951–55, vol. 2, 374.

2. Ibid., 364–65, 374. In the Middle Ages, the lay community did not take communion frequently but were more often satisfied by witnessing the communion of the priest.

3. A. C. Quintavalle 1974, 293–94, 347–50, and figs. xxxvii, xxxviii. Quintavalle has determined from textual and archaeological evidence that this central stair, which, supported by arches in the crypt below, must have met the presbytery floor at the present level, dated from a second building campaign of ca. 1170. In this argument the author convincingly negates the existence of a "pontile," or continuous front enclosure, between the nave and presbytery, which had previously been proposed by other architectural historians.

4. Shearman is the first to encourage an oblique viewpoint, and indeed, identifies the Byzantine and medieval origins of this tradition of viewing. It should be noted, however, that his specific observations with regard to the Cathedral fresco can be made more precise. He notes that "today the first and most natural viewpoint for the cupola is from the bottom of the steps up to the *presbyterium*, that is to say, not from the entrance to the crossing but at the beginning of the last bay of the nave" (1980, 290; and similarly, 1992, 186–87). Though he refers to Quintavalle's reconstruction, he does not take note of the crucial difference between the locations of the first steps of the present Renaissance stairs and the medieval arrangement of Correggio's time. The pre-1566 stairs would have protruded slightly more forward into the last nave bay, placing the worshiper farther west, with a correspondingly more limited view of the east face of the dome. At the foot of neither the old steps nor the new would one see, as Shearman supposes, the figure of Christ included in the visible composition (1980, 290; 1992, 186–87). Riccòmini (1983, 106) is also mistaken when he notes that "la porzione di cupola allora visibile da sotto il pontile è la stessa che si può vedere oggi stando ai piedi della scalea . . . [so that] la Vergine, protesa verso il bagliore del cielo, occupi l'esatto centro della composizione."

5. Martini 1865, 161: "ove la Donna del primo fallo, dovea vedersi nella pienezza del giubilo all'arrivo della Donna del perdono. . . ."

6. Ricci 1896, 261. Riccòmini (1983, 106), who emphasizes the geometric perfection of the arrangement, explains the iconological configuration, though he does not relate it to the significance of the position of the lay viewer: "i triangoli di cui il viso della Vergine è il vertice si rovesciano e s'aprono a loro volta ancora in un triangolo rettangolo inverso che trova gli altri due vertici nei volti di Adamo e d'Eva, quasi unendo in una simbolica triade i progenitori e colei che vinse gli effetti del peccato originale."

7. As Ernst Guldan observes, Adam and Eve came to be inserted in the Coronation in the fourteenth century at a time when confidence in the efficacy of the Virgin's conciliative power was increasing. Dante's Rose of Heaven, the image of the Virgin amid the celestial community of the blessed, includes Adam and Eve and is the background for depictions of the Coronation with first parents. Guldan credits Correggio as the founder of a visual tradition that will flourish in the seventeenth century. After Correggio's fresco, "kein prinzipieller Unterschied ist nunmehr zwischen den Bildern der Himmelfahrt und jenen der Krönung Marias im Beisein der erlösten Stammeltern zu verzeichnen"(*Eva und Maria: Eine Antithese als Bildmotiv*, Graz and Cologne, 1966, 83). But in Parma Cathedral the imagery of the Assumption has already merged with Coronation iconography. The inclusion of Adam and Eve in the cupola is novel yet natural, considering that the artist conceives the Assumption as a Coronation-in-the-making (see chap. 6 below). Fornari Schianchi (1981, 8) follows Guldan but perhaps overstresses the directness of Dante's influence, implying that the *Paradiso* is the text for the image.

8. "La piaga che Maria richiuse e unse,\ quella ch'è tanto bella da' suoi piedi\ è colei che l'aperse e che la punse," *Dante Alighieri: The Divine Comedy; Paradiso*, ed. and trans. Charles S. Singleton, Princeton, 1975, vol. I, 358–59.

9. *Sancti Bernardi, Opera*, ed. J. Leclerq and H. Rochais, Editiones Cistercienses, Rome, 1968, vol. 5 (Sermones II), 262, "Domenica infra Octavam Assumptionis":"Vehementer quidem nobis, dilectissimi, vir unus et mulier una nocuere; sed, gratias Deo, per unum nihilominus virum et mulierem unam omnia restaurantur, nec sine magno fenore gratiarum." In a fragment of a sermon once ascribed to St. Ambrose, the author methodically pairs the deeds and characteristics of Adam with Christ and Eve with Mary:"felix Eva, per quam natus est populus; felicior Maria, per quam natus est Christus" (Pseudo-Ambrose,"De primo Adamo et secundo," *PL*, XVII, col. 715).

10. John of Damascus,"In Dormitionem B. Mariae Virginis," *PG* XCVI, col. 734:"Tunc quidem, tum, inquam, Adam et Eva nostri generis auctores, exsultantibus labiis alte exclamerunt: Beata tu, filia, quae violati mandati poenas nobis sustulisti . . . Dolores solvisti; mortis fascias rupisti; ad verterem sedem nos post liminio revocasti. Nos paradisum clausimus, tu ligni vitae iter patefecisti."

11. The hooved leg of the demonic animal, known for its lustful predelication, extends with Eve's own. Variations of

the image can be found in Berenson, *Central Italian and North Italian Schools*, vol. 2, fig. 379 (figs. 350, 380, 381). Ghiberti depicts Eve in the goatskin on the Doors of Paradise; see Krautheimer (1956) 1982, 172, n. 7, pl. 122a. Guldan treats the image of Mary enthroned above a prostrate Eve, which he calls the "Lorenzetti-type" from a fresco attributed to Ambrogio in Montesiepi near Siena, ca. 1336 (1966, 128–36), see Eve Borsook, *Gli affreschi di Montesiepi*, Florence, 1969, 21–22, pls. 28, 42. An earlier instance of deliberate contrast between Mary and Eve ornaments the early-fourth-century sarcophagus of Cyriaca in the Museo Nazionale, Naples, where the Creation of Eve and the Temptation are pointedly placed next to the Adoration of the Magi; see K. Weitzmann, *Age of Spirituality*, exh. cat., Metropolitan Museum of Art, N.Y., Princeton, 1979, no. 411.

12. Guldan (1966, 84) points to Fra Filippo as a precedent, but the blessed that Lippi places behind Adam and Eve are different from those the first parents lead in the cupola in Parma. Other examples in which Adam and Eve appear with the Coronation occur in the frescoes in the apse of the church of S. Margherita in Casatenovo (by an anonymous Lombard artist, 1463; see Luisa Giordano in *L'arte dell'età romana al Rinascimento*, in *Storia di Monza e della Brianza*, vol. 4 [2], ed. A. Bosisio and G. Vismara, Milan, 1984, 407, fig. 151). Adam and Eve lead other patriarchs and prophets in Pietro di Domenico da Siena's *Assumption* in the Collegiata, Radicondoli, near Siena (fig. 92), and are included also in Sodoma's eccentric *Coronation* (ca. 1518) at the Oratorio di S. Bernardino, Siena (fig. 93). Sodoma, to illustrate connective contrast, includes a tiny putto who covers Adam's naked foot with the hem of Mary's bridal-white robe, as if to clothe the lowliest part of the first sinner with the Queen of Heaven's mantle of mercy.

13. Parmigianino's Adam and Eve are nude and still in Paradise, though on the verge of committing the damning act; the Eve of Anselmi's semidome is modestly concealed by her pose and hair (and lets Adam hold the apple), while Gatti's later depiction (below Christ's knee) shows Eve and Adam both attired in a whole hip-garland of leaves.

14. Pseudo-Jerome, col. 131: "Ac per hoc quidquid maledictionis infusum est per Evam, totum abstulit benedictio Mariae."

15. Bernard, vol. 5 (Sermones II), 263: "illa suggessit praevaricationem, haec ingessit redemptionem. Quid ad Mariam trepidet humana fragilitas?"

16. Fornari Schianchi (1981, 8) misinterprets nudity as sin: "Mela e nudità sono il simbolo della corruzione." A wonderfully clear demonstration of the sanctity of nudity in this context—and an example certainly well known to Correggio—occurs on the architrave of the Porta del Redentore of the Baptistery in Parma. In Antelami's *Last Judgment*, the resurrected blessed are heedless of their nakedness in their eagerness to worship Christ, while the damned are mindful of hiding their shameful bodies (reproduced in G. Duby, G. Romano, and C. Frugoni, *Il Battistero di Parma*, Parma, 1992, pl. 15).

17. Pseudo-Augustine, "De Assumptione Beatae Mariae Virginis," *PL*, XL, col. 1144: "gladius passionis Christi."

18. John of Damascus, col. 726: "Non enim amplius sumus nudi, et vestibus carentes, tamquam divinae imaginis splendore destituti, uberrimaque Spiritus gratia spoliati. Non jam veterem nuditatem deplorantes dicemus: 'Expoliavi me tunica mea, quomodo ea induar?' " (*Cant.* V:3).

19. For the drawing in the British Museum, London (fig. 95), see Popham 1957, 72 and 160, cat. 51. Popham and Ricci (1896, 267) attest to the authenticity of the drawing, which was in Lely's collection. The clearly preliminary relationship of the conception to the figure in the fresco (fig. 96), the delicate softness of the areas of darkest shadow, the play of reflected light, and the melting contours all substantiate Correggio's indisputable authorship. Correggio's drawings of Eve fall into two groups: they are either reflections of the sheet in the British Museum or studies for the pose in the fresco itself. A drawing in the Teylers Museum, Haarlem (Popham cat. 52; fig. 97) is "a tracing or in part a tracing" of the drawing in London. The drawings of Eve in the Louvre (cat. 53) and in Frankfurt (cat. 54; figs. 98, 99) resemble the figure in the painting.

20. Popham 1957, 72.

21. Ibid., 72.

Chapter Six

1. *Ordinarium*, 30: "Ut sacri dictant canones: Nunquam ullo tempore, et praesertim domino Episcopo praesente, aut ad altare, aut in sede episcopali existente, audeant laici, quando ante mensam caelestem Sacerdos astat immolaturus,

transcendere Sancta Sanctorum, ne ipsorum praesentiis et crebris quandoque discursibus per ecclesiam, mentem immolantis aliquatenus distrahi contingat." Barbieri annotates this passage with further references to conciliar decrees and medieval authorities concerning the prohibition of the laity from the *presbyterium* (30, n. 1).

2. A. C. Quintavalle 1974, 266, 268, n. 27, 346–49.

3. *Ordinarium*, 161: "Quibus omnibus de dicta processione ecclesiam ingressis, dominus Episcopus, astans in apice scalarum, per quas ascenditur chorum, ipsis benedictionem impertiatur pontificalem cum largitione veniae, quam largiri potest."

4. For instance, in the Augustinian devotional tract by Antonio Meli da Crema, *La scala dil paradiso*, Brescia, 1527, where the way to heaven is likened to a stair made up of the steps *Lectio*, *Meditatio*, *Oratio*, and *Contemplatio*. A woodcut illustration to this edition depicts the stages with four allegorical female figures, each of whom is seated upon a step. At the uppermost spiritual rung, a woman on a cloud, dressed in a loose gown, crowned, and in a prayerful attitude is touched by God. The scene is reminiscent of an Assumption. A woodcut frontispiece for the fourteenth-century text, the *Scala Coeli*, published in Strasbourg in 1483, depicts a worshiper who successfully ascends the allegorical steps to be rewarded with a garland crown by the Virgin, who in turn is crowned by Christ (Marie-Anne Polo de Beaulieu, *La Scala Coeli di Jean Gobi* [Sources d'histoire médiévale], Paris, 1991, frontispiece). For an overview of this durable and widespread devotional genre, see "Echelle spirituelle," *Dictionnaire de Spiritualité*, ed. Emile Bertraud and André Rayez, Paris, 1960, vol. 4, cols. 75–82.

5. Durandus, ed. Neale and Webb, 34–35. Durandus's treatise borrows heavily from Hugh of St. Victor's *Speculum de mysteriis ecclesiae* (PL, CLXXVII, col. 335 ff.), as the nineteenth-century English editors of the *Rationale* observe, but Durandus's text especially was still valid in the Cinquecento, as evidenced by a Venetian edition of 1519.

6. Ibid., 49.

7. Ricci (1896, 261–64), is the first to mention the figures by name, and he identifies Abraham, Isaac, Judith, and David. Tassi (1968, 150), Bottari ([1961] 1990, 36) von Simson (1983, 332 and 335), and Fornari Schianchi (1981, 8) also note and attempt to identify several of the most prominent figures, as does P. G. Toscano (*Il pensiero cristiano nell'arte*, Bergamo, 1960, vol. 2, 240–44).

8. Von Simson 1983, 335.

9. Tassi 1968, 150 and caption to fig. 76; repeated by von Simson 1983, 335.

10. Tassi (1968, 159–60, n. 42 and fig. 65) calls her "Maria di Betania" with "Martha" and argues, citing Mâle, that Mary and Martha are mentioned in the Assumption liturgy—but "Martha" is clearly Judith. St. Bernard (vol. 5, 231–44) does include discussion of Mary, Martha, and Lazarus in his Assumption sermon, but this Mary was traditionally pictured as Mary Magdalene. Besides the lack of attributes or correspondence, this sector of the cupola is given over consistently to figures from the Old Testament. Fornari Schianchi and von Simson agree with Tassi's assertion; the latter, however, sees Mary and Martha instead in the two women behind Eve, who at least form a pair. In addition, von Simson mentions Esther but does not clearly indicate the figure to which he refers—perhaps he means Judith's servant.

11. Some writers have offered some abstract associations for the individual figures, though not a unified program as such; for instance, Ricci (1896, 164): "Abraham symbolizes the obedience due from man to God, even to death. Judith bears witness that even a deed of violence may be sanctified by faith. David holding Goliath's hideous head by the hair reminds us that no human power can resist the arm of the Lord." Fornari Schianchi (1981, 8) refers to Toscano 1960, vol. 2, 244, who observes that David and Judith are "simboli ambedue di Maria trionfatrice sul demonio pel privilegio dell'Immacolato Concepimento."

12. Von Simson 1983, 335: "Alle genannten Gestalten weisen hin auf die Würde Mariä, auf ihre Jungfräulichkeit oder auf ihre Teilnahme am Erlösungswerk Christi." Martini (1865, 161), who does not bother to identify the figures individually, calls the multitude of figures "l'altre famose nella storia del popolo eletto; ov'erano a vedersi, distinti dagli altri, i patriarchi, e gl'inspirati saggi che prenunziarono le virtù e le glorie dell'assunta Regina."

13. Tassi (1968) enigmatically reverses the identities of David and Judith (150, figs. 65, 66, 68). Perhaps he read David's foreshortened chest as a breast, when the glimpse of beard may have been less visible before restoration.

14. See n. 11.

15. Augustine, *City of God against the Pagans*, ed. and trans. Philip Levine (Loeb Classical Library), Cambridge, Mass., and London, 1966, vol. 5, 152–53 (XVI:32).

16. Sheba and Esther are types for Mary crowned in Bonaventura, "De Assumtione B. Virginis Mariae (15 Augusti)," Sermons III and IV, *Opera Omnia*, vol. 9, Florence, 1901, 693–95. See also Bernard, vol. 5 (Sermones II), 266. In the *Biblia Pauperum*, Mary sits crowned and enthroned between Sheba and Esther; a good example is the fifteenth-century woodcut reproduced in *Biblia Pauperum Unicum der Heidelberger Universität*, ed. P. Kristeller, Berlin, 1906, pl. XXXIV. Fra Filippo includes, with Eve and Judith, the figures of Esther, Rachel, Leah, Bathsheba, and the Erithrean Sibyl.

17. Augustine, Sermon VIII, "De puero Abraham," *PL*, XXXIX, col. 1754, in section 3: "Abraham et servus ipsius, quorum figurae. Rebecca desponsata Isaac figura Ecclesiae": "quia miserat Deus Pater propheticum verbum per universam terram, ut quaereret Ecclesiam catholicam sponsam Unigenito suo. Et quomodo per puerum Abrahae beato Isaac sponsa adducitur, . . . ita per Verbum propheticum Ecclesia Gentium ad verum sponsum Christum de longinquis regionibus invitatur."

18. Ambrose, "Isaac, or the Soul," in *Seven Exegetical Works*, trans. Michael P. McHugh, Fathers of the Church, no. 65, Washington, D.C., 1972, vol. 1 (2), 11, continues, vol. 3 (7), 14: "it was rightly said to her, 'may you become thousands of myriads and may your seed possess the cities of their enemies.' Therefore the church is beautiful, for she has acquired sons from hostile nations. But this passage can be interpreted in reference to the soul. . . .'"

19. Bonaventura, "De Assumtione B.V.M.," Sermon IV, 697.

20. Along with Rachel, and of course Beatrice: *Paradiso*, Canto 32.

21. It is a challenging problem of visual representation, if these figures are to have forsaken their material accessories to win a place in heaven (see chap. 5, Eve's nudity, and below, Rebecca's mantle) and yet be recognizable. We do not expect to find camels in heaven, but gold earrings and bracelets, Eliezar's gift to Isaac's betrothed, would make identification more secure.

22. Clement of Alexandria, *Christ the Educator*, trans. Simon P. Wood, in Fathers of the Church, no. 23, New York, 1954, 22. Ambrose calls Rebecca "patience" ("Isaac," vol. 1 [1], 11; vol. 4 [18]; see *Seven Exegetical Works*, 11, n. 9).

23. Ambrose, "Isaac," vol. 6 (55), 45; also vol. 7 (58), 48. The mantle of the soul or bride "is not taken from her without purpose, but so that she, uncovered and bare, might be resplendent in her merits."

24. Augustine, *City of God*, Book XVI:31. Genesis 18:12–15, 21:6.

25. Augustine, Sermo VIII, "De puero Abraham," cols. 1754–55: "Synagoga per Saram, Ecclesia per Rebeccam adumbrata": "*Accepit*' ergo Isaac Rebeccam, et 'intromisit eam in tabernaculum matris suae': accepit Christus Ecclesiam, et eam in loco constituit Synagogae . . . Moritur ergo Sara, et in loco ejus Rebecca ducitur: Synagoga repudiatur, ut introducatur Ecclesia." The vulgate Old Testament specifies that the tent was Sarah's, a detail omitted in modern Bibles (Gen. 24:67).

26. We see again the developing optimism of Correggio's thinking, already encountered in the evolution of his portrayal of Eve. The drawing in Frankfurt, which must represent a fairly advanced point in the planning of the composition, does not yet include the figure between Eve and Rebecca (fig. 99).

27. Augustine, Sermo XXXVII, "De David et Isai," *PL*, XXXIX, col. 1820, in section 7: "David cum baculo contra Goliam, Christus cum cruce contra diabolum": "Venit enim verus David Christus, qui contra spiritualem Goliam, id est, contra diabolum pugnaturus crucem suam ipse portavit."

28. Hugh of St. Victor, *Exegetica dubia*, Book IX, Chapter III, "De mysteriis quae continentur in libro Judith," *PL*, CLXXV, col. 744.

29. Ibid., col. 748: "Persecutores Ecclesiae, integritatem ejus concupiscunt corrumpere. Judith, in castris Holophernis non est polluta escis gentilibus, et sancta Ecclesia inter paganos habitans non contaminatur idolorum sordibus. 'Judith gladio Holophernis caput illius abscidit,' et sancta Ecclesia hostes suos per propriam eoram malitiam perimit. Judith, post victoriam cum suis celebravit laetitiam, et Ecclesia sancta superatis vitiis cum hostibus suis, laetitiam celebrabit eum angelis."

30. Ibid., col. 747: Judith "quae interpretatur *confitens* vel *laudans*, Ecclesiam significat. . . ."

31. A number of altarpieces of the Assumption share a similar format and adhere to this iconography: for instance, Lorenzo di Pietro's (Vecchietta) of 1461–62 in Pienza Cathedral (Berenson, *Central Italian and North Italian Schools*, vol. 2, 805); Benvenuto di Giovanni's of 1498, once in the Metropolitan Museum, New York (ibid., 852); and Giovanni di

Paolo's, in Ascanio (Venturi 1926, vol. 7 [1], fig. 279). Slightly later examples testify to the persistence of the type: a painting by Signorelli and assistants in the Museo Diocesano, Cortona (Toscano 1960, II, 180), and an *Assumption with St. Thomas* by the "Master of the Lathrop Tondo," a follower of Filippino, in the Ringling Museum, Sarasota (Berenson, *Central Italian and North Italian Schools*, vol. 2, 1177). John the Baptist may be included, and even on occasion Adam and Eve make an appearance, as in Pietro di Domenico da Siena's painting in Radicondoli (fig. 92), though this—indeed, the inclusion of any female figures—is unusual.

It may be noted that in a study of the iconography of the Assumption in Italy, reference to Sienese examples is inescapable due to the combination of an early and complex artistic tradition in a city that also claimed the Virgin as its primary patron; for Sienese Marian imagery in the Trecento, especially, see Henk van Os, *Marias Demut und Verherrlichung*, 's Gravenhage, 1969, 147–76. A Lombard elaboration, which includes doctors of the church and saints as well as a mandorla full of prophets is an *Assumption* from the circle of Benedetto Bembo in the Accademia Carrara, Bergamo (fig. 103). Michelangelo's prophets and sibyls, which surround the Assumption chapel of the Sistine with Perugino's altarpiece, are a later variant on the tradition.

32. For Fra Angelico's altarpiece, from S. Domenico in Fiesole, see Pope-Hennessy (1952) 1974, 215–16; pl. 42, figs. 127, 129. The representation of the Coronation of the Virgin surrounded by ranks of the blessed of both sexes is widespread in the fifteenth and the early sixteenth centuries, as the following Tuscan, Lombard, and Venetian examples attest: Lorenzo Monaco, Uffizi, Florence (Berenson, *Florentine School*, vol. 1, fig. 448); Francesco di Giorgio, Pinacoteca, Siena (Piero Torriti, *La Pinacoteca Nazionale di Siena*, vol. 1, *I dipinti dal XII al XV secolo*, Genoa, 1980, figs. 477–78, no. 440); Bergognone, fresco in S. Simpliciano, Milan (Venturi 1926, vol. 7 [4], figs. 605–7); Michele Giambono and Jacobello del Fiore, both paintings in the Accademia, Venice (*La pittura del Veneto*, M. Lucca et al., vol. 1, 58, fig. 67; 117, fig. 150). Lodovico Brea's elaborate *Paradiso* in S. Maria di Castello, Genoa, elaborates upon the theme and emphasizes the mediational importance of the crowning of Mary, here performed in the presence of the Trinity and accompanied by a vast crowd of saints, some of whom extend helping hands to the earthly worshipers depicted below (Berenson, *Central Italian and North Italian Schools*, vol. 3, fig. 1209). The subject of the Coronation amid numerous, though less geometrically organized, ranks of saints persists into the sixteenth century, as, for instance, in Correggio's own apse painting in S. Giovanni Evangelista or Anselmi's (fig. 91) in the Steccata.

Chapter Seven

1. Chapter XII of the *Ordinarium*, entitled "De sedilibus dominorum Canonicorum et supra scriptorum Officialium" (86–88), lists all the persons seated in the upper and lower choirs. Barbieri, in his notes to this section (1886, 86, n. 2), states: "il quale clero si divideva così in due cori . . . L'uno allogato innanzi l'altare (*chorus superior, primus*), che comprendeva la scuola de' cantori (*chorus psallentium*) secondo la tradizione . . . l'altro, situato dopo l'altare (*chorus inferior, posterior, secondus*), composto del clero maggiore. . . . E dunque naturale che nel primo coro v'avesse il leggio (*letterile*) coi libri di canto . . . che vi stesse, in faccia all'altare, il Maestro delle scuole (*chori episcopus*)." Barbieri bases his explication on the authority of Durandus and Isidorus.

2. Shearman (1980, 289, and 1992, 187) states that Christ "hovers," awaiting the Virgin's ascent. Correggio is especially extravagant with his drapery effects just in order to show that Christ is descending, as Ricci observes (1896, 264, n. 1).

3. Riccòmini (1984, 109) and von Simson (1983, 332) agree that the figure is Christ, while Morel (1984, 10) follows A. C. Quintavalle (1970, 105) in calling the figure an angel.

4. Vasari must surely have seen the entire composition, since he mentions the figures in all four squinches, yet he neglects to mention Christ. The omission might be due to the generality of his manner of description, but the possibility should not be overruled that he was simply puzzled or offended by the central figure. Twentieth-century critics, writing in a more loquacious style, have also evaded the issue by merely failing to mention the controversial figure, thereby avoiding a decision as to his identity. The best instance of this is Selwyn Brinton's description in *Correggio* (London, 1907, 84–96), where, in the course of ten pages of text on the Duomo, not one mention is made of the figure. A more recent example is Ceschi Lavagetto (1980, 22–33), who in an article dealing with the iconography of the dome fresco also omits discussion of the figure. The only open avowal of the problem, to my knowledge, is in W. Luebke and M. Semrau's *Die Kunst der Renais-*

sance in Italien und im Norden, Esslingen, 1912, 322: "In der Kuppel wölbung aber fährt, inmitten eines unentwirrbaren Gedränges schwebender Begleiter, Maria mit ekstatischer Bewegung zur himmlischen Helle empor, aus welcher eine einzelne Gestalt—Christus selbst oder ein Engel?—sich loslöst, um ihr bewillkommnend entgegenzustürzen."

5. Mengs (1780) 1787, 176.

6. Burckhardt 1955, 310: "Im Zentrum (jetzt sehr verdorben) stürzt sich Christus . . ."; Martini 1865, 160; and Meyer 1871, 181, and London, 1876, 166.

7. Venturi (1926, vol. 9 [2], 572) is an exception to the trend. These writers call the figure by a variety of names: he is "the angel Gabriel" (Popham 1957, 70); the "unedeln Erzengel," or "göttlicher Sendbote" (Gronau 1909, xxx); "a messenger of God" (Ricci 1896, 264); "l'angelo alato" (Bodmer 1943, 18); and even "der Engel, welcher ihr einst die Botshaft von Himmel gebracht" (Thode 1898, 76).

8. Gould 1976, 108–9, 111; Shearman 1980, 289, and 1992, 187; Fornari Schianchi 1981, 6; and others. Toscano (1960, vol. 2, 244), concerned with Marian iconography rather than Correggio's oeuvre *per se*, had already considered the figure to be Christ: "Nel centro, in un scorcio mirabile, v'è il Cristo che scende verso la Madre sua con uno slancio ed una effusione non minore allo slancio e all'anelito posto dalla Madre nel salire verso il Figlio suo."

9. Morel 1984, 10.

10. Testi 1923, 42, n.1: "Qualcuno volle vedere in questa figura Gesù che scende ad incontrare la Madre. Per noi si tratta d'errore manifesto." Ricci (1896, 255, 264) describes the "youthful angel" who "flings himself forward to meet her [Mary]."

11. Gould 1976, 111.

12. Morel (1984, 10) notes the beardlessness of the figure, which may have influenced his decision to name him an angel.

13. Gronau 1909, xxx: "man möchte sagen: geschwebt, aber seine hastige Bewegung, die von Armen und Beinen mitgemacht wird, ist eher die des Sturzes als des Fluges . . . so ist der Eindruck dieser Figur peinlich und unangenehm, weil die Sucht nach kühner Wahrheit ihr jegliche Hoheit genommen hat."

14. This objection—a quite reasonable one—was first posed to me by Dr. Charles Minott.

15. The Sienese painter Pietro di Francesco Orioli depicts Christ beardless in his *Ascension*, ca. 1480, in the Pinacoteca, Siena (reattributed from Giacomo Pacchiotto; see A. Angelini in *Francesco di Giorgio e il Rinascimento a Siena, 1450–1500*, ed. Luciano Bellosi, exh. cat. Siena, Chiesa di Sant'Agostino, Milan, 1993, 456–57, cat. 101); also in the *Baptism* and *Resurrection* (Cambridge, Fitzwilliam Museum), and at the *Coronation* (S. Casciano dei Bagni, S. Leonardo). For illustrations, see Berenson, *Central Italian and North Italian Schools*, vol. 2, 926, 924, 925, and 914 (as Pacchiotto). So many examples in one artistic circle might be ascribed to a workshop model rather than any deeper significance except that additional examples, especially in which the theme is linked with Christ's corporeal integrity, suggest otherwise: for instance, the *Flagellation* of the Umbrian School in the National Gallery in Washington (ca. 1505; F. R. Shapley, *Catalogue of the Italian Paintings, National Gallery of Art*, Washington, D.C., 1979, vol. 2, pl. 359, no. 1160) and the unusual *Disrobing of Christ* by Pietro di Domenico da Siena (Berenson, *Central Italian and North Italian Schools*, vol. 2, 913).

16. A handsome, clean-shaven Christ with loose blond hair becomes the husband of St. Catherine in Giovanni dal Ponte's *Mystic Marriage with Donors* in Budapest (Berenson, *Florentine School*, vol. 1, 492). He is similarly portrayed in a number of late Trecento treatments of the same subject, such as the *Mystic Marriage* by Giovanni del Biondo in the Allentown Museum (*The Samuel H. Kress Memorial Collection*, catalogue, Allentown, Pa., 1960, 45). The occurrence of the beardless Christ in the Mystic Marriage of St. Catherine is consistent with his role, as in the Coronation, as bridegroom. And Botticelli, in the *Pietà* in Munich, heightens the reverent eroticism of the Magdalen's love for Christ by depicting the dead Savior as a beautiful and beardless young man.

17. Pope-Hennessy 1952, 223. Another instance of the beardless Christ crowning Mary is a French tondo of the Coronation (ca. 1400–10): Schiller 1980, vol. 4 (2), fig. 734.

18. Jacobus de Voragine, ed. Ryan and Ripperger, 454; Graesse, 509: "Statimque anima ad Mariae accessit corpusculum et de tumulo prodiit gloriosum sicque ad aethereum assumitur thalamum comitante secum multitudine angelorum." Similarly, in the *Liber Responsalis*, the Virgin ascends "ad aethereum thalamum" (*PL*, LXXVIII, col. 799).

19. Graesse, 507: "veni de Libano, sponsa, veni de Libano, coronaberis" (and Ryan and Ripperger, 451). Derived directly from Pseudo-Jerome, *PL*, XXX, col. 131, and thence from *Cant*. IV: 6, 8.

20. Bernard, vol. 5, 230–31: "Felicia prorsus oscula labiis impressa lactentis, cui virgineo mater applaudebat in gremio! Verum numquid non feliciora censebimus, quae ab ore sedentis in dexteram Patris hodie in beata salutatione suscepit, cum ascenderet ad thronum gloriae, epithalamium canens et dicens: 'Osculetur me osculo oris sui?'"

21. "Così l'anima sua del desir toccha/ Volò in braccio al figliol: e al corpo occiso/ Lui serò gli occhi: e la basiò per boccha" (Cornazzano, 27r). The peculiarity of this passage is that it takes place at the *Transito* proper, and the author, in order to realize an erotic and very corporeal exchange between Christ and his mother's soul, blurs the distinction between her spiritual and corporeal ascent. Anna Ceruti Burgio offers a judicious assessment of the cultural value of the poem and a comparison between the corresponding passages—often very close—of Cornazzano's account of the Virgin's death and Assumption and those of Jacobus de Voragine ("Due poemetti sacri quattrocenteschi: Le 'Vite' della Vergine e di Cristo di Antonio Cornazzano," *Rivista di storia e letteratura religiosa* 10, 1974, 319–21, 326–27).

22. Christ's tender invitation to the Virgin to rise from the bier portrayed in Taddeo di Bartolo's fresco in the Palazzo Pubblico in Siena, ca. 1407, may be explained in this way (fig. 109); the mutually responding curves of their bodies express physically the words of Solomon, while the puzzled amazement of the apostles demonstrates Mary's corporeal removal from the tomb. Similarly, Christ is the affectionate Bridegroom and Mary the Bride in manuscript illuminations, such as Don Simone's illuminated *Assumption* in the Museo Civico, Bologna, where he affectionately strokes her chin and adjusts her crown (Boskovits 1975, fig. 377).

23. Nor did Michelangelo paint the wounds on Christ in the *Entombment* in the National Gallery in London.

24. Examples of Christ woundless at the Coronation are too numerous to list; important examples are Fra Angelico's panel in the Louvre (see chap. 6, n. 32) and the Monteluce altarpiece, designed by Raphael, in the Vatican (Mancinelli 1990, fig. 173).

25. Schiller 1976, vol. 4 (1), 103.

26. Ambrose, "Isaac, or the Soul," 28–29.

27. *The Sexuality of Christ in Renaissance Art and in Modern Oblivion*, New York, 1983. A remarkable image from later in the century offers further evidence, if after the fact, that Christ may be depicted with startling corporeality in the Assumption. In Tintoretto's altarpiece in Bamberg Cathedral (ca. 1562), the Savior hurtles impetuously toward his mother in a pose very like St. Mark's in the *Miracle of the Slave*. His emergence from the upper left foreground gives us a feet-first spectacle of his foreshortened body, including much of his muscular legs and the wound-marked sole of one foot (W. R. Rearick, "Tintoretto's Bamberg *Assunta*," in *Art the Ape of Nature; Studies in Honor of H.W. Janson*, New York, 1981, 367–73; a good post-restoration reproduction is included in *Die Bamberger 'Himmelfahrt Mariae' von Jacopo Tintoretto, Internationales Kolloquium in München, 1981, und Restaurierungsbericht*, Munich, 1988, foldout).

28. John of Damascus, col. 742: "ut ipse ad eam descenderat, sic eam ad majus praestantiusque tabernaculum, hoc est, ad ipsum coelum deferri. Oportebat, inquam, ut quae Deum Verbum ventris sui hospitio exceperat, in divinis Filii sui tabernaculis collocaretur."

29. Bernard, vol. 5, 245: "Quid mirantur de terra deserta Mariam ascendere deliciis affluentem? Mirentur potius pauperem Christum de caelestis regni plenitudine descendentem."

30. Jacobus de Voragine, ed. Ryan and Ripperger, 449–50; Graesse, 505. Duccio illustrates this reciprocity when he depicts the Annunciation of the Death of the Virgin in a composition so similar to the customary representation of the Annunciation itself that only the palm branch betrays the true subject; and John White points out that the placement of the two scenes on the same vertical axis of the front of the *Maestà* emphasizes the linkage (*Duccio: Tuscan Art and the Medieval Workshop*, London, 1979, 120).

31. Ibid., 455, 510.

32. Ibid., 457, 512.

33. Von Simpson 1983, 336. Examples exist in medieval manuscript illumination, for example, Schiller 1980, vol. 4 (2), fig. 608.

34. Testi 1934, 123.

35. Popham (1957, 117) refers to this appellation but finds it untraceable before Testi (*Sta. Maria della Steccata*, Florence, 1922, 269). See also DeGrazia 1984, 271–72. Gatti's reputation as a student of Correggio begins with Alessandro Lamo (*Discorso intorno alla scoltura et pittura*, Cremona) and G. P. Lomazzo (*Trattato*, Milan), both published in 1584. Popham resurrected this theory in an argument that Gatti was in Parma in the 1520s as a young man and therefore had access to all the artistic developments of those years. It makes sense that, arriving in Parma to paint an Assumption in

the church of the Steccata, he strolled over to the Cathedral to see the renowned painting. The Cathedral frescoes became an inescapable point of departure and of continuous comparison as Correggio's work never seems to have been in Gatti's oeuvre before.

36. The pose of Gatti's Christ is also reminiscent of Pordenone's *God the Father* in the dome of the Madonna di Campagna, Piacenza (fig. 112), but again, as a spatially timid reflection. Gatti had been employed at the church of S. Maria di Campagna, in Piacenza, and would have been well acquainted with Pordenone's frescoes there, which in themselves show a deep awareness of Correggio's *Assumption*.

37. Affò (1796) 1972, 25; see Introduction, p. 11 and n. 50.

38. Bernard, vol. 5, 262: "Sic nimirum prudentissimus artifex, quod quassatum fuerat, non confregit, sed utilius omnino refecit, ut videlicet novum nobis Adam formaret ex veteri et Evam transfunderet in Mariam."

39. Jan van Eyck's Ghent altarpiece and the frescoes in the Brancacci Chapel (Masaccio's Christ in the *Tribute Money* and Masolino's Adam in the *Temptation*) are others.

40. Tassi notes the complementary nature of the two poses (1968, 149) and von Simson observes that both figures lift their arms in similar fashion (1983, 332).

41. Joseph Meder, *Die Handzeichnung; Ihre Technik und Entwicklung*, Vienna, 1919, 411, 553, figs. 170, 258.

42. The resemblance of mother and son is the theme of Gaudenzio Ferrari's painting of the Madonna and Child in the Accademia Carrara in Bergamo, from S. Chiara, Milan. Mother and son look out at the viewer, their faces side by side in order to stress the closeness of their features. The resemblance in this case goes beyond that of stylistic consistency (Luigi Mallé, *Incontri con Gaudenzio: raccolta di studi e note su problemi gaudenziani*, Turin, 1969, fig. 234).

43. Pseudo-Augustine, col. 1145: "Caro enim Jesu caro est Mariae. . . . Si igitur natura matris est filius, conveniens est ut si et filii mater, . . . non ad unitatem personae, sed ad unitatem corporalis naturae et substantiae."

44. Ibid., cols. 1142–43: "ab ea naturam sumens, non originem . . . ; humilitatis naturam de sanctificato corpore sumens sanctam, et immaculatam de immaculato."

45. Bernard, vol. 5, 242: "Annon formosa, quae, revelata facie gloriam Domini speculando, in eamdem imaginem transformatur de claritate in claritatem, tamquam a Domini spiritu?" Moses' face was veiled when he came from God to the Israelites, but hers is unveiled (Cor. II:3:18). The comparison is a reminder of the contrast between the Synagogue and the Church.

Chapter Eight

1. Riccòmini 1983, 109.

2. Ibid.: "In quella posizione la visione totale dell'affresco nella sua centralità è privilegio del sacerdote che, nell'alzare le sacre speci, fissa gli occhi proprio al centro della cupola, che è posto in un punto esattamente mediano tra la testa della Vergine e quella del Figlio che le si fa incontro."

3. Riccòmini, 1980, 37: "Nella grande cupola di Parma, ormai al culmine del proprio percorso, il Correggio sembra rapprendere i dati formali, fenomenici di quelle intuizioni; e rimescolarli in un gigantesco mulinello ottico, in un caleidoscopio rotante, ove il moto accelera e scompone ogni presupposto d'armonia e d'equilibrio."

4. Shearman 1980, 289.

5. Gronau 1907, xxviii.

6. An extreme example of a Coronation in which Christ is dominant occurs in the Romanesque relief of an altar frontal in the parish church of Bardone, a mountain town west of Parma. Within a conventional representation of Christ in Judgment with symbols of the four Evangelists, the Antelamian sculptor has inserted a smaller figure of the Virgin, kneeling to her son's right in profile, awaiting her Coronation. As he blesses with his left hand, he takes the crown from an angel with his right. The conflation alludes also to Mary's death, since two pairs of angels with censers and candles also accompany the scene (illustrated in Schiller 1980, vol. 4 [2], fig. 638).

7. Tassi 1968, 156: "Su questa opera però non si è mai esercitata l'intelligenza interpretativa degli studiosi, poichè vi sono respettate le regole iconografiche nel modo più semplice, non presentando le ragioni della lettera alcuna difficoltà." His conclusion, if unspecific, is not inaccurate: "Qui è una suprema composizione di eros e logos. . . ."

8. Shearman 1992, 188; compare with Shearman 1980, 291: "in the Duomo the theological sources are of the most

'popular' kind—in fact this is the most perfect illustration I know of the 'Assunta' as it is described in the *Golden Legend*. . . . The rapturous joy of the angels, their music-making, and the intense light in Paradise on the Virgin's arrival are represented exactly in the spirit of the *Golden Legend*." (See above, Introduction, p. 4 and n. 8.)

9. Von Simson 1983, 332.

10. Ibid., 338; Jacobus de Voragine, ed. Ryan and Ripperger, 457.

11. In the *Golden Legend*, Pseudo-Augustine gives as the second of three reasons for the Assumption that Mary's body should be treated with dignity as the "throne of God, bridechamber of the Lord, [and] the tabernacle of Christ." Jacobus also quotes John of Damascus, who calls the Virgin the "sacred and living ark, which bore within itself the One who builded it . . ." (Jacobus de Voragine, ed. Ryan and Ripperger, 456, 463). In the narrative, Peter orders the offending rabbi to state his belief in Christ, borne by the Virgin; Christ declares his mother, at her tomb, to be the "tabernacle of glory, [and] vessel of life" (ibid., 453–54). Each of these references to the Annunciation is cited in passing and in the manner of epithets. Jacobus never offers any discourse on the theological relationship of the Incarnation to the Assumption, although it is the very basis of other writers' discussions.

12. *Apocryphal Gospels, Acts, and Revelations*, trans. Alexander Walker, Edinburgh, 1870, 516 ("The Passing of Mary, first Latin form"). An alternative manuscript has the Virgin reply with the words of the Magnificat (516, n. 1).

13. Bernard, vol. 5: "Ut quid enim ea hodie in ecclesiis Christi lectio evangelica recitatur, in qua mulier benedicta in mulieribus excepisse intelligentur Salvatorem? Credo ut haec quam celebramus, ex illa susceptione aliquatenus aestimetur, immo ut, iuxta illius inaestimabilem gloriam, inaestimabilis cognoscatur et ista."

14. Ibid.: "Felix nimitum utraque susceptio, ineffabilis utraque, quia utraque in excogitabilis est."

15. S. Bernardino da Siena, *Le prediche volgari*, ed. Piero Bargellini, I Classici Rizzoli, Milan and Rome, 1936, 35–36.

16. One figure stands out among the commissioners, for his prominence both in the presiding committee and in local intellectual circles, but the substance of his accomplishments remains a mystery. The head of the *fabbricieri*, the canon Pascasio Belliardi, was a learned churchman and humanist with experience in Rome and intimacy with the major literary figures of the period in Parma (such as Ugoleto, Grapaldus, and Giorgio Anselmi). After beginning a promising career in the Roman curia as secretary to Pius III and being well on his way to earning advancement (even perhaps a cardinalship), he was left by the sudden demise of his papal sponsor to return, disappointed, to Parma. There is evidence from the dedications and epitaphs of his contemporaries that he was a notable Latinist and poet, but no texts by him survive. At his death in 1528, perhaps from plague, he was buried in the Cathedral. See I. Affò, *Memorie degli scrittori e letterati parmigiani*, Parma, vol. 3, 1791, 264–66.

17. Krautheimer, preface to 3rd edition, 1982, xxxiv.

18. The *biblioteca capitolare* or *canonica* included works collected from the ninth century on; the holdings appear to have been dispersed by the end of the sixteenth century. The largest monastic library in Parma was probably that of the Minori Osservanti at the former church of SS. Annunziata (Celestino Piana, "L'università di Parma nel Quattrocento," in *Parma e l'umanesimo italiano, Atti del Convegno internazionale di studi umanistici* [Parma, 1984], ed. Paola Medioli Masotti, Padua, 1986, 119).

19. Del Prato 1904, 14–15, and app. 38–54. The *fabbricieri* were the canons Floriano Zampironi and Lattanzio Lalatta, as well as the lay member of the administration of the Fabbrica, Bartolomeo Tagliavini.

20. Ibid., 15. The Commune was also involved in the decision to unify and to move the Chapter library, split between the sacristy and the episcopal palace, to a separate, enlarged building in 1514, since the library was public. Also discussed by Ceschi Lavagetto 1980, 25.

21. On the medieval practice of suspending the host within a baldachin over the altar, see Jacques-Paul Migne, *Encyclopédie Theologique*, vol. 8, *Liturgie*, Paris, 1844, col. 115; also Joseph Braun, *Der christliche Altar in seiner geschichtlichen Entwicklung*, Munich, 1924, vol. 2, 185–237. Testi (1934, 96) hypothesizes that the medieval altar in Parma Cathedral—at least very early in its history—possessed such a ciborium.

Chapter Nine

1. Riccòmini 1983, 110: "il senso dell'affresco non si capisce, perchè ovviamente non si scorge la figura della Vergine."

2. For a description of the furnishings of the apse, see Testi 1934, 100–104; the contract of 1469 even specifies that

portraits of the canons and other dignitaries be placed above the stalls. For the placement of the bishop's throne, see also Allodi 1856, vol. 2, 23.

3. The arrangement of the clergy is given in *Ordinarium*, 86–88, Part II, Chapter XII, "De sedibus dominorum Canonicorum et supra scriptorum Officialium." The clergy is split into two equal groups, in front of and behind the altar.

4. Quoted by Barbieri in his notes to the *Ordinarium*, p. 86, n. 2: "Majores in choro posteriores sunt, quia salus fit descendenti." G. Durandus, *Rational ou Manuel des Divins offices*, trans. Charles Barthélemy, Paris, 1954 (I: XVIII), vol. 1, 21; in *Guglielmus Durantis, The Symbolism of Churches and Church Ornaments*, eds. J. M. Neale and B. Webb (Leeds, 1843), New York, 1973, 156, cited from Hugh of St. Victor, *Speculum de Mysteriis ecclesiae*, who refers to Eccl. III:18: "The greater thou art the more humble thyself."

5. *Ordinarium*, 86–87.

6. At the death of his predecessor, Gianantonio Sangiorgio, Alessandro was created perpetual administrator of the church of Parma on March 28, 1509. The Consorzio approved him bishop on November 7 of the same year. He was in Parma for the synods of 1516 and 1519, as well as in 1518.

7. Clemente Ruta, *Guida ed esatta notizia . . . della città di Parma* (Parma, 1739), Milan, 1780, 43; Mengs (1780) 1787, 177. Both name him "protettore" of Parma.

8. Popham 1957, 64, n. 7.

9. Riccòmini 1983, 51, 56: "Come s'è visto, è più che probabile che l'occasione prima e immediata che spinse i committenti a far dipingere la cupola, e ad effigiarvi quel tema dei cinque protettori della città (i quattro santi, più la Vergine), sia stata l'insperata vittoria del giorno di San Tommaso." It should be noted, however, that even by 1524 the victory was attributed by the somewhat fickle Parmesans to the miraculous Madonna della Steccata (del Prato 1903, 24; David Ekserdjian, "Correggio in Parma Cathedral: Not Thomas but Joseph," *Burlington Magazine* 128, June 1986, 415, n. 15).

10. Vasari-Milanesi, vol. 6, 471–72. So sure is he of this appellation that he puts Joseph first, in a list clearly arranged in order of certainty of identification. See above, chap. 2, n. 1 for a reading of Vasari's list of figures in the squinch.

11. Ekserdjian 1986, 412–15. I had also reached this conclusion independently and presented in lecture a summary of the argument that follows ("Correggio's 'Joseph' in Parma Cathedral," Frick Collection–Institute of Fine Arts Symposium for Graduate Students in the History of Art, New York, April 1986). I agree with Ekserdjian's general conclusion, except on one point. Ekserdjian posits that Correggio initially planned to depict St. Thomas in the squinch, but when Joseph was so favored in 1528, the program was altered. Instead, it is argued here that the absence of any evidence for St. Thomas ever being considered for the squinch subject and the long-standing tradition behind the veneration of Joseph in Parma even preceding the 1520s make Joseph a quite natural initial choice for the fresco project. For reference to the document, known to me through secondary sources, see n. 29 below.

12. Correggio includes the figure of St. Joseph in the following works: *Nativity with Saint Elizabeth and the Infant Baptist* (Brera), *Holy Family with Infant Baptist* (Orleans), *Rest on the Flight with St. Francis* (Uffizi), *Adoration of the Magi* (Brera), *Holy Family with Saint* (Hampton Court), *"Madonna della Cesta"* (National Gallery, London), *Adoration of the Shepherds* or *"La Notte"* (Dresden; fig. 38), and the *Rest on the Flight* or *"Madonna della Scodella"* (National Gallery, Parma; fig. 84), as well as in numerous disputed and attributed paintings that may still reflect the artist's designs or influence.

13. This consistency is surely deliberate, and the apostles in the cupola of S. Giovanni Evangelista demonstrate with how much individuality Correggio can invest his portrayals of elderly men (fig. 58).

14. In the Quattrocento, the portrayal of Joseph as guardian of the Holy Family in Egypt usually took the form of a narrative painting of the Flight, most frequently in *predelle* or in infancy series. Fra Angelico's panel for the silver chest in SS. Annunziata, Florence (now in the Museo di S. Marco) includes a scene of the Flight in which the Virgin's husband, dressed in cloak and leggings and carrying a pail, drinking bowl, and crooked stick, follows the donkey and Holy Family (Pope-Hennessy 1974, pl. 133). In the Cinquecento, the subject is more frequently self-sufficient. Andrea del Sarto's fresco, the *Madonna del Sacco*, also in the Servite church of SS. Annunziata, may be interpreted as a Rest reduced to its essential components (Freedberg 1963, vol. 1, fig. 154). In northern Italy, paintings of the Holy Family on the sojourn from Palestine in which Joseph receives special emphasis become more common, perhaps partly due to northern European influence—for instance, Gaudenzio Ferrari's altarpiece for Como Cathedral of the 1530s (Mallé 1969, fig. 231).

15. David Alan Brown, *Andrea Solario*, Milan, 1987, 283, cat. 67. The original location of the painting is unknown.

16. In the *Holy Family at the Fountain* (British Museum, London); reproduced in *The Illustrated Bartsch*, ed. Robert E. Koch, vol. 14: *Early German Masters*, 165, 59 (80).

17. Maria Letizia Casanova, "Giuseppe," in *Bibliotheca Sanctorum*, Rome, 1966, vol. 6, 1258. For Augustinian references and a summary of Josephological commentary relating to the Flight, see Sheila Schwartz, "Symbolic Allusions in a Twelfth-Century Ivory," *Marsyas* 16, 1972–73, 38ff.

18. Quoted by Schwartz (1972–73, 38) from Bernard's second Homily in "In laudibus Virginis Matris." See Bernard, vol. 4, 29. The more fanciful overtones of this notion, that the espousal of the Virgin conceals Mary's virginal conception and thereby tricks the devil, are discussed by Meyer Schapiro, "'Muscipula Diaboli': The Symbolism of the Merode Altarpiece," *Art Bulletin* 27, 1945, 182–87, and by Charles Minott, "The Theme of the Merode Altarpiece," *Art Bulletin* 51, 1969, 268.

19. Testi (1934, 76–77) discusses the history of the dedication of this chapel. He notes that in the Renaissance the chapel was usually indicated as dedicated to both St. Michael and the Annunciation. Also see the *Ordinarium*, prologue, 1; discussing the relics in Parma Cathedral, the *Ordinarium* notes, "in altare Annuntiatae, in cornu dextero ecclesiae, iacet corpus sancti Ioannis Calybitae confessoris."

20. Non-Tuscan representations of the Virgin's Assumption which include Thomas's reception of the girdle are numerous. A few examples in which the apostle's role is even stressed include: Jacopo Bellini's drawing of the *Madonna della Cintola* in the British Museum sketchbook (Colin Eisler, *The Genius of Jacopo Bellini*, New York, 1988, 377, pl. 236); Palma Vecchio's *Assumption* for the Scuola di S. Maria Maggiore, ca. 1513, now in the Accademia, Venice (Rylands 1992, 155, cat. 11); Pseudo-Boccaccino, attributed, *Assumption* in the Pinacoteca Ambrosiana, Milan (*La Pinacoteca Ambrosiana*, ed. Antonia Falchetti, Cataloghi di raccolte d'arte 10, Vicenza, 1969, 67, cat. 17). The image also circulated throughout Italy in the form of woodcut book illustrations: for instance, in *La vita gloriosa della Vergine Maria con alcuni soi Miracoli devotissimi*, Venice, 1505, a depiction of the death of the Virgin is paired with an illustration of three disciples, among whom appears Thomas in the foreground receiving the girdle from Mary in heaven.

21. Ricci (1896, p. 257, and 1930, 105) calls the staff the lance of St. Thomas, that is, the instrument of the apostle's martyrdom.

22. Pietro Perfetti passed his own enigma to the viewer by depicting the problematic cluster as an inexplicable metallic orb with surrounding knobs. On Perfetti, who, concerned by the poor condition of the frescoes, began his series of drawn, watercolor and print copies in 1760, see Fornari Schianchi 1983, 149, 151, 168, 171, nos. 22–27. Tassi (1968, 128) calls the figs, which are especially irrelevant to Thomas, "una maschera."

23. Casanova 1966, 1268; da Mareto 1978, 156–57; and M. Lopez, *Il Battistero di Parma descritto*, Parma, 1864, 39. This structure was no longer present in the Renaissance but had been replaced in devotional function by another in a nearby parish, which boasted an unusual late Trecento fresco cycle of the life of Joseph. This oratory is no longer in existence either, though it remained open for devotion until the eighteenth century and was still standing in 1847. The scenes in the fresco cycle, like the apocryphal stories concerning Joseph, are mostly drawn from incidents of the life of Mary and the infancy of Christ (but include also the Coronation of the Virgin). The frescoes no longer survive, but the Biblioteca Palatina possesses early-nineteenth-century line drawings copied after the compositions by Carlo Martini (some of which are reproduced by da Mareto, figs. 218–24). The oratory was in 1456 ceded to the Augustinians, who also later possessed the "new" and present oratory of St. Joseph built on the other side of the Torrente in the Seicento.

24. The cult of Joseph was relatively unknown in the medieval period (see C.A., "Le développement historique du culte de St. Joseph," *Revue Bénédictine* 16, 1897, 105; this three-part article is an excellent review of the history of Josephine devotion). Jean Gerson, Chancellor of the University of Paris, effected the most persistent efforts of the early fifteenth century to encourage devotion to the saint; he wrote an office to Joseph, a long poem entitled the *Josephina*, and a sermon delivered at the Council of Constance urging worship of the saint (ibid., 146; also see Casanova 1966, 1259). Especially dedicated to the promotion of devotion to Joseph were the Franciscans: Bonaventura, Bernardino da Siena, and Bernardino da Busto, all authors of sermons in his honor (*Rev. Bénéd.*, 152; Casanova, 1273).

The Servites and Carmelites were similarly active (*Rev. Bénéd.*, 151; Casanova, 1273; see, for two Servite commissions, n. 14). It may be no coincidence that Correggio depicted the *Rest on the Flight* for the Franciscans at S. Francesco, Cor-

reggio (now in the Uffizi), nor that Anselmi's altarpiece for the Carmine in Parma (1529–30, now in the National Gallery, Parma) includes Joseph in a *sacra conversazione* in which he holds the Christ child with an intimacy unusual for this period (reproduction in A. G. Quintavalle 1960, fig. 76).

The Dominicans' enthusiasm was late but fervid, and they did not petition for a Josephine office until the sixteenth century (1517) under their general Tommaso Cajetano (*Acta SS.*, III, Mart., 8). At about the same time, this order produced Isidoro da Isolani's *Summa de donis S. Josephi*, published in 1522, the most thoroughgoing tract of that time on the saint. The treatise was offered to Hadrian VI in the hope of elevating Joseph's day, March 19, to official status as an obligatory church festival (*Rev. Bénéd.*, 151). Both Isidoro and Giovanni da Fano, the Cappuchine author of another work, *Historia de Josepho et de eius intercessione*, which proposes devotion to the seven joys and sorrows of St. Joseph (Casanova, 1280), were writers as well of anti-Lutheran books: Isolani's *Revocatio Martini Lutherii Augustiniani ad Sanctam Sedem* (Cremona, 1520) and da Fano's *Opera utilissima vulgare contra le pernitiosissime heresie Lutherane per li simplici* (Bologna, 1532). To the list of treatises on Joseph may be added the *Tractatus de S. Josepho, nutricio Christi ac intem. Virg. Mariae* by the German Domenican Bernard Lutzenburg, published in Cologne in 1510. Though I have discovered no discussion of the historical development of Josephology in the time Correggio was painting, the promotion of an office and cult of Joseph, active especially in northern Italy and at the moment just before the Counter-Reformation, could perhaps be seen as a counterattack on the Protestant rejection of the cult of the saints. The theological significance of Joseph as spouse of *Ecclesia*, and therefore as *typus apostolorum* and priest (see below), could reflect, if obliquely, a defensive maneuver on the part of church authority. In this way, the inclusion of Joseph in the squinch in Parma Cathedral may perhaps be counted as part of the subtley ecclesiological, even precociously Counter-Reformatory fabric of the canons' project.

The worship of Joseph received official sanction on at least four occasions during the papacy of Paul III (in his pre-papal career, Bishop of Parma, *Rev. Bénéd.*, 146, 152; *Acta SS.*, III, Mart., 7; and Casanova, 1279). Joseph's feast day was declared by the church in 1870, when he was made Patron Saint of the Universal Church.

25. Individual instances of Josephine devotion occur in Parma from the fourteenth century on, including bequests of benefices (*Rev. Bénéd.*, 114; da Mareto 1978, 156) and artistic commissions like Correggio's for S. Sepolcro and Anselmi's for the Carmelites. A Confraternity of St. Joseph held rights to an altar in the Cathedral, for which they commissioned Araldi's *Marriage of the Virgin* in 1519 (Testi 1934, 125); it is now in the Cathedral crypt.

26. *Rev. Bénéd.*, 148; Casanova 1966, 1268. St. Ambrose's attention to Joseph's role in Christian history may also have stimulated a particular attachment to the saint in Milan. Isidoro da Isolani, author of the *Summa de donis S. Josephi*, was Milanese.

27. In the churches of S. Domenico and S. Giuseppe del Mercato; Casanova 1966, 1268, 1281.

28. For reproductions, Varese 1967, pl. 32; Freedberg 1975, fig. 175.

29. Ekserdjian 1986, 415. The document, in the Archivio del Comune, Archivio di Stato, Parma, was published in part by del Prato 1903, 19, and referred to also by da Mareto 1978, 156.

30. Del Prato 1903, 18.

31. Ekserdjian 1986, 415; Gould 1976, 264–65.

32. Schwarz 1972–73, 40–41; St. Ambrose, *Opere esegetiche IX/I; Esposizione del Vangelo Secondo Luca*, ed. Giovanni Coppa, Milan and Rome, 1978, vol. 1, 150–51, for *In Luc.* II, 7: "Et ideo fortasse sancta Maria alii nupta, ab alio repleta, quia et singulae ecclesia spiritu quidem replentur et gratia, iungantur tamen ad temporalis speciem sacerdotis."

33. Also, Bede (Hom. lib. I, 9, *SS. Innocentium*): "So it happened that the Gentiles, represented by Egypt, who had lived in darkness because of their sins, received the light of the Word. That Joseph led the Child Jesus and his mother to Egypt signifies that the faith in the Incarnation of the Lord and the community of the Church were carried to the Gentiles by the holy doctors" (quoted by Schwarz 1972–73, 41–42).

34. Morel observes incorrectly when he states that "San Bernardo sembra guardare in direzione della Virgine, ma punta l'indice verso l'altar maggiore e non verso i fedeli" (1984, 10). Those gathered in the presbytery surely must be counted among the faithful.

35. Ricci calls this figure female; the grace of these angels inspired him to describe them with particular care and to chide them for their mirth (1896, 257; 1930, 105).

36. A. C. Quintavalle (1974, 233–38) quotes extensively from the *Vite*; the second *Vita*, which is the one more likely

accessible in sixteenth-century Parma, is transcribed in Latin and Italian by Luigi Barbieri, *Chronica Parmensia a Sec. VI ad Exitum Sec. XIV*, in *Monumenta historica ad provincias parmensem et placentinam pertinentia*, III, fasc. 7, Parma, 1858. A modern biography can be found in Raffaello Volpini, "S. Bernardo da Parma," *Bibliotheca Sanctorum*, Rome, 1963, vol. 3, 49–57.

37. We cannot know exactly how the Renaissance Parmesans would have conceived of the bishop's part in the architectural history of the Cathedral, but the dedication under Pope Pascal was known. The exact chronology of the church structure is still open to debate; see A. C. Quintavalle, "La recinzione presbiteriale di Nicolò alla cattedrale di Parma," in *Scritti di storia dell'arte in onore di Roberto Salvini*, Florence, 1984, 63–65.

38. The major events of Bernardo's life were depicted in a fourteenth-century cycle now in the castle at Vincigliata, originally in the church of S. Martino in Via della Scala, Florence (George Kaftal, *Saints in Italian Art: Iconography of the Saints in Tuscan Painting*, Florence, 1952, 184–90, figs. 192–204). Even in Tuscan art there is no consistent pattern of portrayal; for instance, Andrea del Sarto depicts him as a stalwart young saint in the altarpiece for Vallombrosa (Uffizi, Florence) but as a gray-bearded elder in the tondo in the church of S. Salvi (Freedberg 1963, vol. 1, figs. 201, 26). The two patron saints of the order, St. John Gualbert and S. Bernardo, frequently accompany the Assumption of the Virgin, patroness of Vallombrosa: Perugino's *Assumption* of 1500 in the Uffizi, from Vallombrosa (Venturi 1926, vol. 7 [2], fig. 424); Granacci's *Assumption* in the Accademia, Florence (Berenson, *Florentine School*, vol. 2, fig. 1275); and, the most strikingly individualized depiction, Baldassare Carrari's *Coronation with Saints* (1512), once in S. Mercuriale, Forlì (Giordano Viroli, *La Pinacoteca Civica di Forlì*, Forlì, 1980, 93).

39. Affò (*Vita di San Bernardo degli Uberti*, Parma, 1788, 83, 174–77) asserts that Bernardo was a patron saint of the city from the thirteenth century (del Prato 1903, 30). Ekserdjian (1986, 412, n. 9) follows Affò; Testi (1934, 40, n. 1) must be reading del Prato when he remarks: "La sua elezione (Bernardo's) è quindi posteriore al pennachio dove è glorificato." The document relative to the translation is in the Archivio Notarile, Parma, no. 1669, July 7 1548, not. Cristoforo della Torre.

40. *Ordinarium*, 95.

41. Ekserdjian 1986, 412, n. 8.

42. In 1518, according to Francesco Cherbi (*Le Grande Epoche, sacre, dipolomatiche, chronologiche, critiche, della chiesa vescovile di Parma*, Parma, 1835, vol. 3, 14), Alessandro "avendo fatto la visita di tutta la Diocesi preparava le cose per la sinodia futuro." The commission of the tomb occurred on February 24 of the next year. The synod was opened by the bishop himself on the Feast of All Saints, 1519. On this occasion, the bishop was first given his full title, "Alexander Miseratione divina Episcopus Tusculanus ac Sanctae Romanae Ecclesiae, Parmensis perpetuus administrator" (ibid, 15; also Benassi 1899–1906, vol. 3, 36, n. 1). The event was thus important for Alessandro's personal position as well as for the reform of the Parmesan church. Though it must remain a speculation, it is possible that this first plan for the tomb was both a tribute to the medieval founder of the Cathedral structure and a part of the preparations for Alessandro's appearance in Parma.

43. *Chronica*, 506: "A quali tempi Henrico nefando imperatore entro in Roma, et domenticato de l'honore de Dio, spoliando il clero, fece pergione il Papa cun molti cardinali, vescovi e prelate."

44. The manuscript may date from Correggio's lifetime or later. This is the version transcribed by Barbieri. See n. 36 above.

45. *Chronica*, 502: upon receiving the pope's letter of invitation, Bernardo, "fugeva le dignitade temporale, humilmente se excuso da tal viagio. Ma il summo Pontifice savendo bene che il sancto homo non se era excusato per spirito de superbia ma per profunda humilita et sancta intentione, li mando la seconda volta et tertia volta, et, non andando anchora Bernardo, finalmente lo costrinse in virtu de sancta obedientia."

46. Ibid., 502, 504.

47. Jacobus de Voragine, ed. Ryan and Ripperger, 454; ed. Graesse, 529. Walker 1870, 529. In the "second Latin form" edited by Walker, sight is linked with belief: in a passage prior to the Virgin's ascent, Peter sends the converted Jew to place a palm on the eyes of his fellow unbelievers, now blinded for their spiritual resistance. Those who believe have their sight restored, the others die.

48. Walker 1870, 519. The light that overwhelms the apostles' power of sight at the *Transito* in this version (the "first Latin form") is compared to that of Christ's Transfiguration on Mt. Tabor.

49. Fornari Schianchi 1981, 5: a putto "con la testa dentro le nubi."

50. Tassi 1968, 150.

51. Ricci 1896, 261; also 1930, 108.

52. Gronau 1907, xxx: "Betrachtet man dann Figuren, wie den unedeln Erzengel in der Mitte der Komposition oder gar die Gestalt gerade über ihm in den Wolken, wo uns, durch keinen gnädigen Gewandfetzen verhüllt, die peinlichste Untenansicht eines Menschenleibes gezeigt wird."

53. Riccòmini 1983, 109–10: "si può immaginare . . . infine che il Correggio si sia riservato . . . un terzo punto di vista destinato al capitolo, o meglio al membro più importante di esso, visto che il vescovo in quegli anni a Parma non c'era mai. Per averne la prova (e per avere la certezza che la cosa è stata studiata, e non avviene a caso) basta mettersi al centro dell'emiciclo del coro, proprio ove gli stalli s'interrompono per dare accesso alla cattedra antelamica. Quel punto è esattamente simmetrico a quello da cui, nella navata centrale e ai piedi della scalea, si contempla l'ascesa della Vergine. . . . A chi personalmente questo scherzo fosse diretto, non sappiamo; e non sappiamo neppure, propriamente, se sia uno scherzo o che altro. Ma esso serve, egualmente, a introdurre una nota di sorriso nel tono 'alto' e sostenuto dell'intera rappresentazione. . . ."

54. Emil Schneweis, "Angels and Demons According to Lactantius," Ph. D. diss., Catholic University of America, Washington, D.C., Washington, 1944, 30. Lactantius, in *De Divines Institutionibus*, vol. 4, 6, 1–2, states that God created many spirits, who are the angels, but the first and greatest of them he made omnipotent and worthy of being his Son; the troublesome aspect of this seems to have occurred to the early writer himself, who several passages later emphasizes the distinction between the angels and the Word *Lactantius, Institutionis Divinis*, ed. Pierre Monat, Sources chrétiennes, no. 377, Paris, 1992, 62, 76.

55. Stapert 1975, 115.

56. For a complete discussion of the theological implications of Christ's sexuality in Renaissance art, see Steinberg 1983.

Conclusion

1. Quoted by Henri de Lubac, *The Splendour of the Church*, trans. Michael Mason, New York, 1956, 243. Lubac discusses the equation Maria-Ecclesia, providing many references to the development and usage of the concept from the Fathers to the modern period in Chapter IX, "The Church and Our Lady." See Honorius of Autun, "Expositio in Cantica Canticorum," *PL*, CLXXII, 494.

2. Ibid., 494: "Omnia, quae de Ecclesia dicta sunt, possunt etiam de ipsa Virgine, sponsa et matre sponsi intelligi."

3. Lubac 1956, 238, 268. Luther's statement concerning the exclusivity of divine grace for justification occurs as early as his doctoral lectures, the *Dictata Super Psalterium*, of ca. 1513–15; see *Luther's Works*, vol. 10, *First Lectures on the Psalms*, vol. 1, eds. Jaroslav Pelikan and Hilton C. Oswald, St. Louis, 1974, "Psalm 72," 410. His interpretation of the Song of Songs, delivered later in 1530–31 and published in 1539, does not even acknowledge the long-venerated tradition of Marian exegesis (Ibid., vol. 15, *Lectures on the Song of Songs*, 191ff).

4. See Introduction, n. 53.

5. As noted by Milstein 1978, 95–96.

6. Vasari-Milanesi, vol. 4, 111: "una moltitudine grandissima di figure lavorate in fresco e ben finite . . . nelle quali scorta *le vedute* al di sotto in su." In the *Life* of Correggio in both editions, Vasari nonchalantly locates the *Assumption* in S. Giovanni (vol. 4, 112) but corrects himself in the *Life* of Girolamo da Carpi (vol. 6, 471).

7. G. P. Lomazzo, *Scritti sulle arti*, ed. R. P. Ciardi, Florence, 1973, II, 235–36: "ci fa vedere a suoi luoghi gli scorti obliqui, cioè quelli che nelle volte delle capelle si possono fare, non ne i quadri, ma ne i semicircoli e simili; come sono i tiburij, o le truine."

8. Dall'Acqua 1984, 49.

9. The letter is transcribed in *Vita religiosa a Cremona nel Cinquecento: Mostra di documenti e arredi sacri* (Archivio di Stato di Cremona, Archivio della Curia Vescovile di Cremona), Palazzo Vescovile, Cremona, 1985, 48.

10. Riccòmini (1983, 49–50), offers the most recent discussion of Correggio's use of the Sistine Ceiling; also see A.

Foratti, "Impressioni Michelangelesche sul Correggio," in *Manifestazioni parmensi nel IV centenario della morte del Correggio*, Parma, 1936.

11. Popham 1957, 66; but Popham equates these figures only with the *ignudi*, not with seers; the frieze of S. Giovanni Evangelista also connects with the Ashmolean drawing.

12. Though some of Michelangelo's figural motifs are perceptible in the Cathedral; for instance, the pose of the angel over the southeast oculus recalls that of the *ignudo* to the upper right of the *Creation of Eve* in the Sistine Ceiling.

13. Shearman 1980, 290; 1992, 180. Shearman first postulates an *Assumption* altarpiece for the Chigi Chapel which would have related to the image of God the Father in the dome in "The Chigi Chapel in Sta. Maria del Popolo," *Journal of the Warburg and Courtauld Institutes* 24, 1961, 143–44.

14. Morel (1984, 10–11) argues against Riccòmini that Correggio's dome, like Raphael's, is still Renaissance because both exhibit a basic "concentricity" that he deems a consistent feature in all Renaissance decorations.

15. Shearman 1980, 284–85, 288, 289.

16. Longhi (1934) 1968, 67–73.

17. David Rosand, "Titian in the Frari," *Art Bulletin* 53, 1971, 200.

18. Johannes Wilde, "The Decoration of the Sistine Chapel," *Proceedings of the British Academy* 44, 1958, 69–70; Shearman 1972, 28, n. 36.

19. For a general treatment of Pordenone's major fresco cycles, see Juergen Schultz, "Pordenone's Cupolas," in *Studies in Renaissance and Baroque Art Presented to Anthony Blunt on his 60th Birthday*, London, 1967, 44–55; also specific entries in Furlan 1988, 92–97, 174–81, 185–99.

20. All recent scholars, writing after the bombing of the chapel which destroyed Pordenone's first and perhaps most eccentric exercise in dome illusion, assume that God the Father descends to the altarpiece of the *Annunciation*, while an attentive reading of prewar photographs and descriptions makes clear that the dome figuration is directed toward the *Adoration of the Magi* on the north or left wall. This phenomenon, a result of local political ecclesiastical squabbles that culminated in the vandalism of Titian's altarpiece for the chapel, is the subject of my forthcoming study.

21. Freedberg (1971) 1975, 301. The situation is further complicated by the existence of ribs in the central dome.

22. See Morassi, "Gli affreschi del Lotto in San Michele del Pozzo Bianco a Bergamo," *Bollettino d'arte* 26, 4, 1932–33, 160–72; and Costanza Barbieri, "La *Nascita della Vergine* di Lorenzo Lotto in S. Michele al Pozzo Bianco a Bergamo," *Venezia Cinquecento: Studi di storia dell'arte e della cultura* 1, 1991, 63–100.

23. On this connection, see Michelangelo Muraro, "Giovanni Antonio de Pordenone e il periodo parmense dell'episcopato trevignano," in *Giornata di studio per il Pordenone*, ed. Paola Ceschi Lavagetto, Parma, 1972, 72–85. Moreover, Bishop de Rossi's tomb was once located at the center of the crossing in Parma Cathedral (Allodi 1856, vol. 2, 32).

24. For the viewer in the west, the right foot of the apostle to the right in the pair in the southeast projects enough to make a shadow on the molding; for the viewer in the east, a similar overlap occurs with the foot of the single apostle to the north of the west oculus.

Bibliography

Published Editions and Secondary Sources

Adorni, Bruno, ed. *L'abbazia benedettina di S. Giovanni Evangelista a Parma*. Parma, 1979.

————. *Sta. Maria della Steccata a Parma*. Parma, 1982.

Affò, Ireneo. *Vita di San Bernardo degli Uberti*. Parma, 1788.

————. *Memorie degli scrittori e letterati parmigiani*. Parma, 1791.

————. *Storia della città di Parma*. 4 vols. Parma, 1792–95.

————. *Il Parmigiano, servitor di piazza*. Parma (1794), 1972.

Alberti, Leon Battista. *"On Painting" and "On Sculpture."* Ed. Cecil Grayson. London, 1972.

————. *Leon Battista Alberti: "On Painting."* Ed. John R. Spencer. London and New Haven, 1966.

Allentown Museum of Art, Samuel Kress Memorial Collection. Catalogue. Allentown, Penn., 1960.

Allodi, Giovanni M. *Serie cronologica dei vescovi di Parma, con alcuni cenni sui principali avvenimenti civili*. 2 vols. Parma, 1856.

Ambrose, St. *Opere esegetiche IX/I: Esposizione del Vangelo secondo Luca*. Ed. Giovanni Coppa. 2 vols. Milan and Rome, 1978.

————. *Seven Exegetical Works*. Trans. Michael P. McHugh. Fathers of the Church, no. 65. Washington, D.C., 1972.

Anonymous. *La vita gloriosa della Vergine Maria con alcuni soi miracoli devotissimi*. Venice, 1505.

Antonio Meli da Crema. *La scala dil paradiso*. Brescia, 1527.

Apocryphal Gospels, Acts, and Revelations. Ed. Alexander Walker. Edinburgh, 1870.

Apocryphal New Testament. Ed. Montagu Rhodes James. Oxford (1924), 1953.

Arisi, Francesco, et al. *Il Duomo di Piacenza (1120–1972): Atti del convegno di studi storici in occasione dell'8500 anniversario della fondazione della Cattedrale di Piacenza*. Piacenza, 1975.

Arisi, Raffaella. *La chiesa e il monastero di S. Sisto a Piacenza*. Piacenza, 1977.

Armstrong, Lilian. *Renaissance Miniature Painters: The Master of the Putti and His Venetian Workshop*. London, 1981.

Augustine, St. *City of God*. Ed. and trans. Philip Levine. Loeb Classical Library. 7 vols. Cambridge, Mass., and London, 1966.

————. Sermo VIII, "De puero Abraham, qui missus est ad Rebeccam." *PL*, ser. 1, XXXIX, 1853–55.

————. Sermo XXXVII, "De David et Isai," *PL*, ser. 1, XXXIX, 1818–21.

Banzola, Maria Ortensia. *L'Ospedale Vecchio di Parma*. Parma, 1980.

Barbieri, Costanza. "La *Nascita della Vergine* di Lorenzo Lotto in S. Michele al Pozzo Bianco a Bergamo." *Venezia Cinquecento, Studi di storia dell'arte e della cultura* 1 (1991): 63–100.

Barbieri, Luigi. See *Ordinarium*.

Battisti, Eugenio. "Il Correggio e il Parmigianino." In Adorni, ed., *L'abbazia benedettina di S. Giovanni Evangelista a Parma*, 106–45.

————. *Cicli pittorici, storie profane*. Milan, 1981.

Beaulieu, Marie-Anne Polo de. *La Scala Coeli di Jean Gobi*. Sources d'histoire médiévale. Paris, 1991.

Begni Redona, P. V. and Giovanni Vezzoli. *Lattanzio Gambara, pittore*. Brescia, 1978.

Belloni, Gian Guido. *Il Castello Sforzesco di Milano*. Milan, 1966.

Bellosi, Luciano di, ed. *Francesco di Giorgio e il Rinascimento a Siena, 1450–1500*. Exh. cat., Siena, Chiesa di Sant'Agostino. Milan, 1993.

Beltrami, Luca. *Luini, 1412–1532: Materiali di studio raccolto a cura di L. Beltrami*. Milan, 1911.

Benassi, Umberto. *Storia di Parma*. 5 vols. Bologna, 1899–1906.

Berenson, Bernard. *Italian Pictures of the Renaissance: Venetian School*. 2 vols. London, 1957.

———. *Italian Pictures of the Renaissance: Florentine School*. 2 vols. London, 1963.

———. *Italian Pictures of the Renaissance: Central Italian and North Italian Schools*. 3 vols. London, 1968.

Bergstein, Mary Ellen. "The Sculpture of Nanni di Banco." Ph.D. diss., Columbia University, 1987.

Bernard, St. *Opera*. Vol. 5. Eds. J. Leclerq and H. Rochais. Editiones Cistercienses. Rome, 1968.

Bernardino da Siena, St. *Le prediche volgari*. Ed. Piero Bargellini. I Classici Rizzoli. Milan and Rome, 1936.

Bertraud, Emile, and André Tayez, eds. *Dictionnaire de Spiritualité*. Paris, 1960, s. v. "Echelle spirituelle."

Biblia Pauperum Unicum der Heidelberger Universität. Ed. Paul Kristeller. Berlin, 1906.

Bober, Phyllis Pray, and Ruth Rubenstein. *Renaissance Artists and Antique Sculpture: A Handbook of Sources*. Oxford, 1986.

Bodmer, Heinrich. *Correggio e i Emiliani*. Novara, 1943.

Bologna, Giulia. *Il castello di Milano: da fortezza a centro di cultura*. Milan, 1986.

Bonaventura, St. Sermons III and IV, "De Assumtione B. Virginis Mariae (15 Augusti)." *Opera Omnia*, vol. 9. Florence, 1901.

Borsook, Eve. *Gli affreschi di Montesiepi*. Florence, 1969.

Boschini, M. *La carta del navegar pittoresco*. (Venice, 1660.) Ed. A. Pallucchini. Venice, 1966.

Bosisio, A., and F. Vismara, eds. *Storia di Monza e della Brianza: L'arte dell'età romana al Rinascimento*. Vol. 2, pt. 2. Milan, 1984.

Boskovits, Miklòs. *La pittura fiorentina alla vigilia del Rinascimento*. Florence, 1975.

Bottari, Stefano. *Correggio*. Milan, 1961.

———. *Il Correggio*. Novara, 1990.

Braun, Joseph. *Der christliche Altar in seiner geschichtlichen Entwicklung*. Munich, 1924.

———. *Die liturgischen Paramente in Gegenwart und Vergangenheit*. Freiburg, 1924.

Brescia, Pinacoteca Comunale Tosio-Martinengo. *La pittura bresciana del Rinascimento*. Exh. cat. Bergamo, 1939.

Brinton, Selwyn. *Correggio*. London, 1907.

Brown, David Alan. *Andrea Solario*. Milan, 1987.

Burckhardt, Jacob. *The Cicerone: An Art Guide to Paintings in Italy*. (London, 1918.) Reprint, New York and London, 1979.

———. *Der Cicerone: Eine Anleitung zum Genuss der Kunstwerke italiens*. Vol. 2. *Gesammelte Werke*. Vol. 10. Basel, 1955.

Burgio, Anna Ceruti. "Due poemetti sacri quattrocenteschi: le 'vite' della Vergine e di Cristo di Antonio Cornazzano." *Rivista di storia e letteratura religiosa* 10 (1974): 56–71.

Buscaroli, Rezio. *La pittura romagnola nella seconda età del Quattrocento*. Faenza, 1931.

———. "Opere inedite di influsso melozziano in Romagna." *Melozzo da Forlì* 6 (1939): 286–94.

———. *Melozzo e il melozzismo*. Bologna, 1955.

Busmanti, Eugenio. "Alcune trascrizioni della cupola del Duomo." In Riccòmini, ed., *"La più bella di tutte,"* 177–88.

Buttell, Sister Mary Frances. *The Rhetoric of St. Hilary of Poitiers*. Patristic Studies, 38. Washington, D.C., 1933.

Calepino, Ambrogio. *Ditionarium linguarum septem*. Reggio, 1502, and Basel, 1575.

Carli, Enzo. *Il Pintoricchio*. Milan, 1960.

Carminati, Marco. *Cesare da Sesto, 1477–1523*. Milan, 1994.

Caroli, Flavio. *Lorenzo Lotto e la nascita della psicologia moderna*. Milan, 1980.

Casanova, Maria Letizia. "Giuseppe." In *Bibliotheca Sanctorum*, vol. 6, 1251–92. Rome, 1966.

Ceschi Lavagetto, Paola. "La cupola del Duomo: tracci per una ricerca storica e iconografica." In *Correggio: gli affreschi nella cupola del Duomo di Parma*, 22–33. Parma, 1980.

Chastel, André. "Note sur le sphinx à la Renaissance." In *Umanesimo e simbolismo: Atti del IV convegno internazionale di studi umanistici*. Venice, 1958, ed. Enrico Castelli, 179–82. Padua, 1959.

Cherbi, Francesco. *Le Grande Epoche: sacre, diplomatiche, chronologiche, critiche, della chiesa vescovile di Parma*. Parma, 1835.

Chronica Parmensia a sec. VI ad exitum sec. XIV. Ed. Luigi Barbieri. In *Monumenta historica ad provincias parmensem et placentinam pertinentia*, vol. 3, fasc. 7. Parma, 1858.

Cipriani, Renata. *La Cappella Portinari in Sant'Eustorgio a Milano*. Milan, 1963.

Clement of Alexandria. *Christ the Educator*. Trans. Simon P. Wood. Fathers of the Church, no. 23. New York, 1954.

———. *The Miscellanies, or Stromata*. Trans. William Wilson. *Clement of Alexandria*, pt. 4, vol. 1. The Ante-Nicene Christian Library. Edinburgh, 1869.

Conti, Alessandro. "Diario correggesco." *Ricerche di storia dell'arte* 13–14 (1981): 105–10.

Copertini, Giovanni. "Quesiti e precisazioni sul Parmigianino." *Archivio storico per le province parmensi*. series 3, 5 (1940): 17–27.

Cornazzano, Antonio. *Vita della Gloriosa Vergine Maria*. Venice, 1517.

Corpus Nummorum Italicorum. Vol. 9, Emilia (part 1). Reale Accademia dei Lincei. Rome, 1910.

Correggio: Gli affreschi nella cupola del Duomo di Parma. Produced by the Ministero per i Beni Culturali e Ambientali and the Soprintendenza ai Beni Storici e Artistici di Parma e Piacenza. With contributions by Paolo Ceschi Lavagetto et al. Parma, 1980.

Corsi, Maria Luisa, Andrea Foglia, and Massimo Marcocchi (Cremona, Archivio di Stato and Archivio della Curia Vescovile). *Vita religiosa a Cremona nel Cinquecento: Mostra di documenti e arredi sacri*. Exh. cat., Palazzo Vescovile. Cremona, 1985.

Coustant, Pierre. "Vita S. Hilarii ex ejus scriptis potissimum collecta." *PL*, IX, 125–84.

Cumont, Franz. *Recherches sur le symbolisme funéraire des romains*. Paris, 1942.

Cuttler, Charles. *Northern Painting from Pucelle to Breugel*. New York, 1968.

Dall'Acqua, Marzio. *Correggio e il suo tempo*. Exh. cat., Archivio di Stato di Parma. Parma, 1984.

Dante Alighieri. *The Divine Comedy: Paradiso*. Ed. Charles S. Singleton. Vol. 1. Princeton, 1975.

D. C. A. "Le développement historique du culte de Saint Joseph." *Revue Bénédictine* 14 (1897). Reprint, 1964, 104–209.

DeGrazia, Diane, ed. *Correggio and His Legacy: Sixteenth-Century Emilian Drawings*. Exh. cat., National Gallery of Art. Washington, D.C., 1984.

Demisch, Heinz. *Die Sphinx: Geschichte ihrer Darstellung von den Anfängen bis zur Gegenwart*. Stuttgart, 1977.

Demus, Otto. *The Mosaics of S. Marco in Venice: The 11th and 12th Centuries*. 2 vols. Chicago and London, 1984.

Dickens, Charles. *Pictures from Italy*. (1846), New York, 1973.

Duby, George, G. Romano, and C. Frugoni. *Il Battistero di Parma*. Parma, 1992.

Durandus, G. (Guillaume Durand). *Rationale divinorum officiorum*. Venice, 1519.

———. *Rational ou Manuel des Divins Offices*. Trans. Charles Barthélemy. Paris, 1854.

———. *Guglielmus Durantis, The Symbolism of Churches and Church Ornaments: A Translation of the First Book of the Rationale Divinorum Officiorum*. Eds. John Mason Neale and Benjamin Webb. (Leeds, 1843.) Reprint, New York, 1973.

Eichler, Fritz, and Ernst Kris. *Die Kameen im Kunsthistorischen Museum*. Vienna, 1927.

Eisler, Colin. *The Genius of Jacopo Bellini*. New York, 1988.

Ekserdjian, David. "Correggio in Parma Cathedral: Not Thomas but Joseph." *Burlington Magazine* 128 (1986): 412–15.

Emiliani, Andrea, ed. *Ludovico Carracci*. Exh. cat., Pinacoteca Nazionale, Bologna, and Kimbell Art Museum, Fort Worth, Texas. Bologna, 1993.

Ercoli, Giuliano. *Arte e fortuna del Correggio*. Modena, 1982.

Ettlinger, Leopold D. *The Sistine Chapel before Michelangelo: Religious Imagery and Papal Primacy*. Oxford, 1965.

Falchetti, Antonia, ed. *La Pinacoteca Ambrosiana*. Cataloghi di raccolte d'arte, no. 10. Vicenza, 1969.

Ferrara. *Catalogo della Esposizione della pittura Ferrarese del Rinascimento*. 1933.

Fiocco, Giuseppe. "Le architetture di Giovanni Maria Falconetto." *Dedalo* 15 (1930–31): 1204–41.

———. *Giovanni Antonio Pordenone*. Padua, 1943.

———. *The Frescoes of Mantegna in the Eremitani Church, Padua*. (1947.) Reprint, Oxford and New York, 1978.

Fischer, Chris. *Fra Bartolommeo, Master Draughtsman of the High Renaissance*. Exh. cat., Museum Boymans-van Beuningen. Rotterdam, 1990.

Foratti, Aldo. "Impressioni Michelangelesche sul Correggio." In *Manifestazioni parmensi nel IV centenario della morte del Correggio*. Parma, 1935, 121–25. Parma 1936.

Fornari Schianchi, Lucia. "Dal umano al celeste; le tre cupole del Correggio a Parma." In *Correggio: gli affreschi nella cupola del Duomo di Parma*, 9–21, Parma, 1980.

———. "Come si fabbrica un paradiso." In *Rivedendo Correggio: L'Assunzione del Duomo di Parma*, eds. Lucia Fornari Schianchi and Eugenio Battisti, 5–13. Milan, 1981.

———. "La cupola del Duomo nella grafica di riproduzione." In Riccòmini, ed., *"La più bella di tutte,"* 141–76. Parma, 1983.

Francovich, Geza. *Benedetto Antelami: Architetto e scultore e l'arte del suo tempo.* Milan and Florence, 1952.

Frattini, Andriano. "Documenti per la committenza nella chiesa di S. Pietro in Gessate." *Arte Lombarda*, n. s. 65 (1983): 27–48.

Freedberg, Sidney J. *Parmigianino: His Works in Painting.* Cambridge, Mass., 1950.

———. *Andrea del Sarto.* 2 vols. Cambridge, Mass., 1963.

———. *Painting in Italy: 1500–1600.* Harmondsworth (1971), 1975.

Furlan, Caterina. *Il Pordenone.* Milan, 1988.

Gazeau, R. "Contribution à l'étude de l'histoire de la diffusion du culte de saint Hilaire." In *Hilaire et son temps, Actes du Colloque de Poitiers, XVI Centenaire de la mort du saint.* Études augustiniennes. Paris, 1969.

Gauricus, Pomponius. *De Sculptura.* 1504. Eds. and trans. André Chastel and Robert Klein. Geneva, 1969.

Giampaolo, Mario di, and Andrea Muzzi. *Correggio: I disegni.* Turin, 1988.

Gilbert, Creighton. "Some Findings on the Early Works of Titian." Art Bulletin 52 (1980): 36–75.

Glasser, Hannelore. *Artists' Contracts of the Early Renaissance.* Ph.D. diss., Columbia University, 1965. New York and London, 1977.

Golzio, Vincenzo. "Il Correggio nella critica d'arte del secolo XIX." In *Manifestazioni parmensi nel IV centenario della morte del Correggio*, Parma, 1935, 255–60. Parma, 1936.

Gould, Cecil. *The "School of Love" and Correggio's Mythologies.* London, 1970.

———. *The Paintings of Correggio.* Ithaca, N.Y., 1976.

Grabar, André. *Les Ampoules de Terre Sainte: Monza et Bobbio.* Paris, 1958.

———. *Early Christian Art.* Trans. S. Gilbert and J. Emmons. New York. 1968.

Grapaldi, Francesco M. *De partibus aedium: Lexicon utilissimum.* (1494.) Reprint, Basel, 1533.

Grazzi, Luigi. *Parma romana.* Parma, 1972.

Gronau, Georg. *Correggio. Klassiker der Kunst; Des Meisters Gemälde.* Stuttgart and Leipzig, 1907.

Guarisco, Gabriella. *Il Duomo di Parma: materiali per un'altra storia.* Florence, 1992.

Guldan, Ernst. *Eva und Maria: Eine Antithese als Bildmotiv.* Graz and Cologne, 1966.

Hartt, Frederick. *Giulio Romano.* (1958.) Reprint, New York, 1981.

Hatfield, Rab. *Botticelli's Uffizi "Adoration": A Study in Pictorial Content.* Princeton, 1976.

Heaton, Mrs. Charles. *Correggio.* London, ca. 1907.

Herzog zu Mecklenburg, Carl Gregor. *Correggio in der deutschen Kunstanschauung in der Zeit von 1750–1850.* Baden-Baden and Strasbourg, 1970.

Hilary of Poitiers, St. *Sur Matthieu.* Ed. and trans. Jean Doignon. Sources chrétiennes, no. 254. 2 vols. Paris, 1971.

———. *The Trinity.* Trans. Stephen McKenna. Fathers of the Church, no. 25. New York, 1954.

———. *Traitée des mystères.* Ed. and trans. Jean-Paul Brisson. Sources chrétiennes, no. 19. Paris, 1947.

Hill, Dorothy Kent. "Ancient Representations of Herakles as a Baby." *Gazette des Beaux-Arts.* ser. 6, 33 (1948): 193–200.

Hirst, Michael. *Sebastiano del Piombo.* Oxford, 1981.

Holland, R. "A Note on 'La Vierge aux Rochers'." *Burlington Magazine* 94 (1952): 285–86.

Honorius of Autun. "Expositio in Cantica Canticorum." *PL*, CLXXII, 347–496.

Hugh of St. Victor. "De mysteriis quae continentur in libro Judith," *Exegetica dubia*, IX (II). *PL*, CLXXV, 744–48.

———. "Speculum de mysteriis ecclesiae." *PL*, CLXXVII, 335–80.

Hülsen, Christian, and Hermann Egger. *Die römischen Skizzenbücher von Marten van Heemskerck im Königlichen Kupferstichkabinett zu Berlin.* 2 vols. Berlin, 1916.

Humphrey, Peter. "Cima da Conegliano a Parma." *Saggi e memorie di storia dell'arte* 13 (1982): 35–46.

Jacob, Henriette s'. *Idealism and Realism: A Study of Sepulchral Symbolism.* Leiden, 1954.

Jacobus de Voragine. *Legenda Aurea: Vulgo Historia Lombardica Dicta.* Ed. Johann G. T. Graesse. Dresden and Leipzig, 1876.

————. *The Golden Legend.* Trans. and adapted by G. Ryan and H. Ripperger. New York and London, 1969.

Jacoubet, H., et al. "Le Corrège vu par quelques Français." *Etudes italiennes* 4 (1934): 211–46.

Janson, H. W. *The Sculpture of Donatello.* 2 vols. Princeton, 1957.

John of Damascus. "In dormitionem B. Mariae Virginis." *PG,* ser. 2, XCVI, 699–762.

————. *Homélies sur la Nativité et la Dormition.* Ed. and trans. Pierre Voulet. Sources chrétiennes, no. 80. Paris, 1961.

Jones, H. Stuart. *A Catalogue of the Ancient Sculptures Preserved in the Municipal Collections of Rome.* Vol. 1, *The Sculptures of the Museo Capitolino.* Oxford, 1912.

Jungmann, Josef A. *The Mass of the Roman Rite: Origins and Development.* Trans. Francis A. Brunner. 2 vols. New York, ca. 1951–55.

Kaftal, George. *Saints in Italian Art: Iconography of the Saints in Tuscan Painting.* Florence, 1952.

Knab, E., E. Mitsch, and K. Oberhuber. *Raffaello: I Disegni.* Florence, 1984.

Koch, Guntram, and Hellmut Sichtermann. *Römische Sarkophage.* Munich, 1982.

Koch, Robert E., ed. *The Illustrated Bartsch: Early German Masters.* Vol. 14. New York, 1980.

Krautheimer, Richard, and Trude Krautheimer-Hess. *Lorenzo Ghiberti.* Princeton (1956), 1982.

Kreytenburg, Gert. *Andrea Pisano und der toskanische Skulptur des 14 Jahrhunderts.* Munich, 1984.

Lactantius. Institutionis Divinis. Ed. and trans. Pierre Monat. Sources chrétiennes no. 377. Paris, 1992.

Lamo, Alessandro. *Discorso intorno alla scoltura et pittura dove ragiona della vita, e opere in molti luoghi, e à diversi prencipi, e personaggi fatte dall'Eccell. e Nobile M. Bernardino Campo, pittore cremonese.* Cremona, 1584.

Lasareff, Victor. "Studies in the Iconography of the Virgin." *Art Bulletin* 20 (1938): 26–65.

LeBachelet, X. M. "Hilaire." In *Dictionnaire de théologie catholique.* Paris, 1920, s.v.

Lightbown, R. W. "Correggio and Begarelli: A Study in Correggio Criticism." *Art Bulletin* 46 (1964): 7–21.

————. *Mantegna.* Berkeley and Los Angeles, 1986.

Liturgische Gerate der Christlichen Kirchen. Strasbourg, 1972.

Lomazzo, G. P. *Scritti sulle arti.* Ed. R. P. Ciardi. Florence, 1973.

Longhi, Roberto. "Risarcimento di un Mantegna" (1934). In *"Me pinxit" e Quesiti Caravaggeschi. 1928–34. Edizione delle opere complete di R. Longhi,* vol. 4, 67–73. Florence, 1968.

Lopez, M. *Il Battistero di Parma descritto.* Parma, 1865.

Lubac, Henri de. *The Splendour of the Church.* Trans. Michael Mason. New York, 1956.

Lucco, Mauro, et al. *La pittura del Veneto: Il Quattrocento.* Milan, 1989.

Luebke, W., and M. Semrau. *Die Kunst der Renaissance in Italien und im Norden.* Esslingen, 1912.

Luther, Martin. *Luther's Works.* Vol. 10, *First Lectures on the Psalms.* Eds. Jaroslav Pelikan and Hilton C. Oswald. St. Louis, 1974.

Malaguzzi Valeri, Francesco. *La corte di Lodovico il Moro.* Vol. 2, *Bramante e Leonardo.* Milan, 1915.

Malaspina, Carlo. *Vocabulario Parmigiano-Italiano.* (Parma, 1859.) Reprint, Bologna, 1970.

Mallé, Luigi. *Incontri con Gaudenzio: Raccolta di studi e note su problemi gaudenziani.* Turin, 1969.

Manca, Joseph. "Stylistic Intentions in Correggio's *Assunta.*" *Source: Notes in the History of Art* 7 (1987): 14–20.

Mancinelli, Fabrizio. "La *Trasfigurazione* e la Pala di Monteluce: considerazioni sulla loro tecnica esecutiva alla luce dei recenti restauri." In *The Princeton Raphael Symposium,* 149–60. Princeton, 1990.

Mareto, F. da. *Chiese e conventi di Parma.* Parma, 1978.

Martindale, Andrew. *"The Triumphs of Caesar" by Andrea Mantegna.* London, 1979.

Martineau, Jane, ed. *Andrea Mantegna.* Exh. cat., Royal Academy of Arts, London, and Metropolitan Museum of Art, New York. London and New York, 1992.

Martini, Pietro. *Studi intorno il Correggio.* Parma, 1865.

Massing, J. M. *Du texte à l'image: La calomnie d'Apelle et son iconographie.* Strasbourg, 1990.

Meder, Joseph. *Die Handzeichnung: Ihre Technik und Entwicklung.* Vienna, 1919.

Meiss, Millard. "A Dugento Altarpiece at Antwerp," *Burlington Magazine* 71 (1937): 14–25.

Mengs, Anton Raphael. "Memorie sopra il Correggio." In *Opere*. (Parma, 1780.) Eds. Giuseppe Niccola D'Azara and Carlo Fea. Rome, 1787.

Meyer, Julius. *Correggio*. Leipzig, 1871.

———. *Antonio Allegri da Correggio*. Trans. and ed. Mrs. Charles Heaton. London and New York, 1876.

Michel, A. *Dictionnaire de théologie catholique*. Paris, 1925, s. v. "St. Joseph."

Migne, J.-P. *Encyclopédie théologique*. Vol. 8, *Liturgie*. Paris, 1844.

Milstein, Ann Rebecca. *The Paintings of Girolamo Mazzola Bedoli*. Ph.D. diss., Harvard University, 1977. New York and London, 1978.

Minott, Charles. "The Theme of the Merode Altarpiece." *Art Bulletin* 51 (1969): 267–71.

Morassi, Antonio. "Gli affreschi del Lotto in San Michele del Pozzo Bianco a Bergamo." *Bollettino d'arte*, 26, 4 (1932–33): 160–72.

Morel, Philippe. "Morfologia delle cupole dipinte da Correggio a Lanfranco." *Bollettino d'arte* ser. 6, 23 (1984): 1–34.

Muraro, Michelangelo. "Giovanni Antonio da Pordenone e il periodo parmense dell'episcopato trevigiano." In *Giornata di studio per il Pordenone*, Piacenza, Sta. Maria di Campagna, 1981, ed. Paola Ceschi Lavagetto, 72–85. Parma, 1982.

Negri, Gaetano, and Antonio Barbieri. *Cenni intorno la vita di S. Ilario*. Parma, 1846.

Neilson, Nancy Ward. *Camillo Procaccini: Paintings and Drawings*. Ph.D. diss., Harvard University, 1975; rev., New York and London, 1979.

Norden, Eduard. *Die Antike Kunstprosa vom VI Jahrhundert vor Christ bis in die Zeit der Renaissance*. Vol. 2. Stuttgart, 1958.

Oderici, Federico. *La Cattedrale di Parma, ricerche storico-artistiche*. Milan, 1864.

Olin, John C. *Six Essays on Erasmus and a Translation of Erasmus' Letter to Carondelet, 1523*. New York, 1979.

Ordinarium Ecclesiae Parmensis (1417). Ed. Luigi Barbieri. In *Monumenta historica ad provincias parmensem et placentinam pertinentia*. Parma, 1866.

Os, Henk van. *Marias Demut und Verherrlichung in der sienesischen Malerei, 1300–1500*. s'Gravenhage, 1969.

Osborne, John. *Early Mediaeval Wall-Paintings in the Lower Church of San Clemente Rome*. Ph.D. diss., Courtauld Institute, 1979. New York and London, 1984.

Ottonelli, Giovanni Domenico, and P. Berrettini. *Trattato della pittura e scultura, uso et abuso loro*. (Florence, 1652.) Ed. Vittorio Casale. Treviso, 1973.

Paccagnini, G., ed. *Andrea Mantegna*. Exh. cat., Palazzo Ducale, Mantua. Venice, 1961.

Pallucchini, Rodolfo. *I dipinti della Galleria Estense*. Rome, 1945.

Pallucchini, Rodolfo, and Paola Rossi. *Tintoretto: le opere sacre e profane*. 2 vols. Milan, 1982.

Panofsky, Erwin. *Early Netherlandish Painting*. New York (1953), 1971.

———. *The Iconography of Correggio's Camera di San Paolo*. London, 1961.

Pasini, Pier Giorgio, ed. *Carlo Francesco Marcheselli, Pitture delle chiese di Rimini 1754*. Fonti e studi per la storia di Bologna e delle province emiliane e romagnole, no. 4. Bologna, 1972.

Paulinus of Nola. *The Poems*. Trans. and ed. P. G. Walsh. Ancient Christian Writers: The Works of the Fathers in Translation, no. 40. New York and Ramsay, N.J., 1975.

Pax, E. In *Lexikon für Theologie und Kirche*. Freiburg, 1965, s. v. "Weihrauch."

Pecchiai, Pio, et al. *Roma cristiana*. Vol. 12, *Riti, ceremonie, feste e vita di popolo nella Roma dei Papi*. Bologna, 1970.

Peter Damian. Sermo II, "De Translatione S. Hilarii Episcopi Pictaviensis et Confessoris (XIV Jan.)." *PL*, CXLIV, 514–17.

Pezzana, Angelo. *Storia della città di Parma*. 5 vols. Parma, 1837–59.

PG = Patrologiae Cursus Completus, Series Graeca. Ed. J.-P. Migne. Paris, 1857–66.

Piana, Celestino. "L'università di Parma nel Quattrocento." In *Parma e l'umanesimo italiano: Atti del convegno internazionale di studi umanistici*. Parma, 1984, ed. Paola Medioli Masotti, 119–25. Padua, 1986.

Pico della Mirandola. *De rerum praenotione libri novem, pro veritate religionis, contra superstitiosas vanitates*. Florence, 1506–7.

Pincus, Debra. "The Venetian Ducal Tomb: Issues of Methodology and a Note on Titian's *Assunta*." In *Verrocchio and Late Quattrocento Italian Sculpture*, eds. S. Bule, Alan Phipps Dart, and Fiorella Superbi Gioffredi, 349–53. Florence, 1992.

PL = Patrologiae Cursus Completus, Series Latina. Ed. J.-P. Migne. Paris, 1844–80.

Plutarch. *Diatriba Isiaca e Dialoghi Delfici*. Ed. Vincenzo Cilento. Classici della storia antica. Florence, 1962.

Pope-Hennessy, John. *Fra Angelico*. London (1952), 1974.

——. *Italian Renaissance Sculpture*. (London, 1958.) Reprint, New York, 1985.

——. *Italian High Renaissance and Baroque Sculpture*. (London, 1963.) Reprint, New York, 1985.

Popham, A. E. "On a Drawing Attributed to Correggio." *Critica d'arte* 7 (1949): 246–88.

——. *Correggio's Drawings*. London, 1957.

Prato, Alberto del. *I santi prottetori di Parma*. Parma, 1903.

——. "Librai e biblioteche parmensi del secolo XV." *Archivio storico per le province parmense* n. s. 4 (1904): 1–56.

Pseudo-Ambrose. Sermo XLV, "De primo Adamo et secundo." *PL*, XVII, 715–16.

Pseudo-Augustine. "De Assumptione Beatae Mariae Virginis." *PL*, XL, 1141–48.

Pseudo-Dionysius the Areopagite. "La Hierarchie céleste." In *Oeuvres Complètes*, ed. Maurice de Gandillac. Paris, 1943.

Pseudo-Gregory. "Responsoria sive Antiphonae de Assumptione sanctae Mariae." *PL*, LXXVIII, 798–800.

Pseudo-Jerome. "Epistola IX ad Paulam et Eustochium." *PL*, XXX, 122–45.

Puerari, Alfredo. *La Pinacoteca di Cremona*. Florence, 1951.

Pungileoni, Luigi. *Memorie istoriche di Antonio Allegri detto il Correggio*. 3 vols. Parma, 1817–21.

Quintavalle, Arturo Carlo. "Correggio: le scelte critiche." *Arte come comunicazione visiva*. Quaderni di storia dell'arte, no. 5, Parma, 1969.

——. *La Cattedrale di Parma e il romanico europeo*. Parma, 1974.

——. "La recinzione presbiteriale di Nicolò alla cattedrale di Parma." In *Scritti di storia dell'arte in onore di Roberto Salvini*, 63–76. Florence, 1984.

Quintavalle, Arturo Carlo, and Alberto Bevilacqua. *L'Opera completa del Correggio*. Classici dell'arte, no. 41. Milan, 1970.

Quintavalle, Augusta Ghidiglia. *Michelangelo Anselmi*. Parma, 1960.

——. *Correggio: The Frescoes in San Giovanni Evangelista in Parma*. Trans. Olga Ragusa. New York, n.d.

Quintavalle, Armando Ottaviano, with Cesare Brandi, Giovanni Copertini, Giovanni Masi. *Mostra del Correggio*. Exh. cat., Palazzo della Pilotta. Parma, 1935.

Quintavalle, A. O. "Nuovi affreschi di Parmigianino." *Le arti* 2, fasc. 5–6 (1940): 308–18.

Razzetti, Fausto. "Antologia di viaggiatori e di scrittori antichi." In *Correggio: gli affreschi nella cupola del Duomo di Parma*, 60–64. Parma, 1980.

Rearick, W. R. "Tintoretto's Bamberg *Assunta*." In *Art the Ape of Nature; Studies in Honor of H. W. Janson*, 367–73. New York, 1981.

Resta, Padre Sebastiano. *Correggio in Roma*. Ed. A. E. Popham. Archivio storico per le province parmensi, no. 9, supplement. Parma, 1958.

Ricci, Corrado. *Antonio Allegri da Correggio: His Life, His Friends, and His Time*. Trans. Florence Simmonds. New York, 1896.

——. *Correggio*. Valori Plastici. Rome, 1930.

——. *Correggio*. London and New York, 1930.

Riccòmini, Eugenio. "I nipotini del Correggio." In *Correggio: gli affreschi nella cupola del Duomo di Parma*, 34–53 Parma, 1980.

——. "La più bella di tutte.'" In Riccòmini, ed., *"La più bella di tutte,"* 9–139.

Riccòmini, Eugenio, ed. *"La più bella di tutte": La cupola del Correggio nel Duomo di Parma*. Parma, 1983.

Riccòmini, Eugenio, and Lucia Fornari Schianchi. "La vicenda della conservazione." In Riccòmini, ed., *"La più bella di tutte,"* 189–212.

Rosand, David. "Titian in the Frari," *Art Bulletin* 53 (1971): 198–213.

Ruta, Clemente. *Guida ed esatta notizia à forestieri della più eccellenti Pitture che sono in molte chiese della città di Parma*. (1739.) Milan, 1780.

Rylands, Philip. *Palma Vecchio*. Cambridge, 1992.

Scannelli, Francesco. *Il microcosmo della pittura*. (Cesena, 1657.) Eds. A. Ottina della Chiesa and B. della Chiesa. Milan, 1966.

Scaramuccia, Luigi. *Le finezze de' pennelli italiani ammirate e studiate da Girupeno sotto la scorta e disciplina del genio di Raffaello d'Urbino*. (1674.) Ed. Guido Giubbini. Milan, 1965.

Schapiro, Meyer. "'Muscipula Diaboli': The Symbolism of the Merode Altarpiece." *Art Bulletin* 27 (1945): 182–87.

Seymour, Charles. *Sculpture in Italy: 1400–1500*. Harmondsworth, 1966.

Schiller, Gertrude. *Ikonographie der christlichen Kunst*. Vol. 3, *Die Auferstehung und Erhöhung Christi*, 1971; vol. 4, pt. 1, *Die Kirche*, 1976; vol. 4, pt. 2, *Maria*, 1980. Gütersloh.

Schmidt, Hans Martin. *Der Meister des Marienlebens und sein Kreis*. Dusseldorf, 1978.

Schneweis, Emil. "Angels and Demons According to Lactantius." Ph.D. diss., Catholic University of America, Washington, D.C., 1944.

Schrade, Hubert. "Uber Mantegnas 'Cristo in scurto' und verwandte Darstellungen: Ein Beitrag zur Symbolik der Perspektive." *Neue Heidelberger Jahrbucher* (1930): 75–111.

Schuler, Carol M. "The Sword of Compassion: Images of the Sorrowing Virgin in Late Medieval and Renaissance Art." Ph.D. diss., Columbia University, 1987.

Schultz, Juergen. "Pordenone's Cupolas." In *Studies in Renaissance and Baroque Art Presented to Anthony Blunt on his 60th Birthday*, 44–55. London, 1967.

Schwartz, Sheila. "The Iconography of the Rest on the Flight into Egypt." Ph.D. diss., New York University, 1975.

———. "Symbolic Allusions in a Twelfth-Century Ivory." *Marsyas* 16 (1972–73): 35–42.

Sedini, Domenico. *Marco d'Oggiono: Tradizione e rinnovamento in Lombardia tra Quattrocento e Cinquecento*. Milan and Rome, 1989.

Shapley, Fern Rusk. *Catalogue of the Italian Paintings, National Gallery of Art*. 2 vols. Washington, D.C., 1979.

Shearman, John. "The Chigi Chapel in Sta. Maria del Popolo." *Journal of the Warburg and Courtauld Institutes* 24 (1961): 129–85.

———. *Raphael's Cartoons in the Collection of Her Majesty the Queen: The Tapestries for the Sistine Chapel*. London, 1972.

———. "Correggio and the Connoisseurs." Review of Gould, *Correggio. Times Literary Supplement*, London, March 18, 1977.

———. "Correggio's Illusionism." In *La prospettiva rinascimentale, codificazioni e trasgressioni*, ed. M. Dalai Emiliani, 281–94. Florence, 1980.

———. "Correggio's Pendentives and Travels." Lecture, Institute of Fine Arts, New York University, December 1982.

———. "Raphael's Clouds, and Correggio's." In *Studi su Raffaello: Atti del congresso internazionale di studi*, Urbino and Florence, 1984, eds. Micaela Sambucco Hamoud and Maria Letizia Strocchi, 657–68. Urbino, 1987.

———. *Only Connect: Art and the Spectator in the Italian Renaissance*. The A.W. Mellon Lectures in the Fine Arts, 1988. Princeton, 1992.

Simson, Otto von. "Correggios *Assunta* in der Domkuppel zu Parma." *Römisches Jahrbuch für Kunstgeschichte* 20 (1983): 329–43.

Smyth, Carolyn. "Foreshortening as Meaning in Michelangelo's *Jonah*." Unpublished paper, 1984.

———. "Correggio's 'Joseph' in Parma Cathedral." Lecture, Frick Collection–Institute of Fine Arts Symposium for Graduate Students in the History of Art, New York, April 11, 1986.

———. Review of E. Riccòmini et al., *"La più bella di tutte": La cupola del Correggio nel Duomo di Parma. Art Bulletin* 70 (1988): 150–54.

Solberg, Gail. "Taddeo di Bartolo; His Life and Work." Ph.D. diss., New York University, 1991.

Stapert, Aurelia. *L'ange roman dans la pensée et dans l'art*. Paris, 1975.

Stebbins, Eunice Burr. *The Dolphin in the Literature and Art of Greece and Rome*. Ph. D. diss., Johns Hopkins University, 1927. Menasha, Wis., 1929.

Steinberg, Leo. "The Sexuality of Christ in Renaissance Art and in Modern Oblivion." *October* 25 (1983); also, book of the same title, New York, 1983.

Strzygowski, Josef. *Des Werden des Barock bei Raphael und Correggio*. Strasbourg, 1898.

Stubblebine, James H. "Cimabue's Frescoes of the Virgin at Assisi." *Art Bulletin* 49 (1967): 330–33.

———. *Duccio di Buoninsegna and His School*. Princeton, 1979.

Suida, Wilhelm. *Leonardo und sein Kreis*. Munich, 1929.

Sulpicius Severus. *Chronica II*. Ed. C. Halm. In *Corpus scriptorum ecclesiasticorum latinorum*. Vol. I. Vienna, 1866.

Summers, David. "Maniera and Movement: The 'Figura Serpentinata'." *Art Quarterly* 35 (1972): 269–301.

Symeonides, Sibilla. *Taddeo di Bartolo*. Siena, 1965.

Tanzi, Marco. "Francesco Prata da Caravaggio: aggiunte e verifiche." *Bollettino d'arte* 72 (1987): 141–56.

Tassi, Roberto. *La cupola del Correggio nel Duomo di Parma.* Milan, 1968.

Testi, Laudadeo. *Sta. Maria della Steccata.* Florence, 1922.

———. *La cupola del Duomo di Parma.* Rome, discontinued in 1923.

———. *La Cattedrale di Parma.* Bergamo, 1934.

Theokritos. *The Idylls.* Trans. Barriss Mills. West Lafayette, Ind., 1968.

Thode, Henry. *Correggio.* Künstler Monographien, no. 30. Bielefeld and Leipzig, 1898.

Tiraboschi, Girolamo. *Notizie de' pittori, scultori, incisori e architetti natii degli stati del Serenissimo Duca di Modena.* Modena, 1786.

Toesca, Pietro. *Il Battistero di Parma.* Milan, 1960.

Torriti, Piero. *La Pinacoteca nazionale di Siena: I dipinti dal XII al XV secolo.* Genoa, 1980.

Toscano, Giuseppe. *Nuovi studi sul Correggio.* Parma, 1974.

———. *Il pensiero cristiano nell'arte.* 3 vols. Bergamo, 1960.

Varese, Ranieri. *Lorenzo Costa.* Milan, 1967.

Vasari, Giorgio. *Le vite de' più eccellenti pittori, scultori ed architetti.* Ed. Gaetano Milanesi. 9 vols. Florence, 1878–85.

Vedriani, Ludovico. *Raccolta de' pittori, scultori, et architetti modenesi più celebri* (Modena, 1662.) Bologna, 1970.

Venantius Fortunatus. *Vita Sancti Hilarii.* Ed. B. Krusch. In *Monumenta Germaniae Historica.* Vol. 4, pt. 1. Berlin, 1885.

Venturi, Adolfo. *Storia dell'arte italiana.* Vol. 7, *La pittura del Quattrocento.* Part 3. Milan, 1914.

———. *Storia dell'arte italiana.* Vol. 9, *La pittura del Cinquecento.* Part 2. Milan, 1926.

Vignali, A. *La Basilica Cattedrale di Parma ed il XVII cinquantenario della sua consacrazione.* Fidenza, 1956.

Virgil. *The Aeneid.* Trans. Allen Mandelbaum. New York, 1972.

Vito Battaglia, Silvia de. *Correggio bibliografia.* Rome, 1934.

Volpini, Raffaello. "S. Bernardo da Parma." In *Bibliotheca Sanctorum,* vol. 3, 49–57. Rome, 1963.

Wackernagel, Martin. *The World of the Florentine Renaissance Artist: Projects and Patrons, Workshop and Art Market.* (Leipzig, 1934.) Trans. A. Luchs. Princeton, 1981.

Weitzmann, Kurt. *The Age of Spirituality.* Exh. cat., Metropolitan Museum of Art, New York. New York and Princeton, 1979.

Weller, Allen. *Francesco di Giorgio, 1439–1501.* Chicago, 1943.

Wilde, Johannes. "The Decoration of the Sistine Chapel." *Proceedings of the British Academy* 44 (1958): 61–86.

Wind, Edgar. *Pagan Mysteries of the Renaissance.* (1958.) Reprint, New York, 1968.

Wind, Geraldine D. "The Benedictine Program of S. Giovanni Evangelista in Parma." *Art Bulletin* 58 (1976): 121–27.

Wölfflin, Heinrich. *Classic Art.* (1889.) Reprint, London and New York, 1968.

Wolters, Christian. "Ein Selbstbildnis des Taddeo di Bartolo." *Mitteilungen des Kunsthistorischen Institutes in Florenz* 7 (1953): 70–72.

Zama, Raffaella. *Vecchie e nuove conoscenze nella Cappella Sforzesca restaurata.* Cotignola, 1990.

Manuscripts

Callegari, Carlo. *Istrumenti in copia autentica delle convenzioni fatte nel secolo XVI tra la congregazione della fabbrica della Cattedrale di Parma e li celebratissimi pittori Antonio Allegri . . . ,* Manoscritto della Biblioteca No. 45, 1803. Archivio di Stato, Parma.

Rog. Stefano Dodi. Contract, Correggio, Nov. 3, 1522. No. 816, Archivio Notaio, Archivio di Stato, Parma.

Rog. Galeazzo Piazza. Contracts, Parmigianino, Rondani, Anselmi, Nov. 21, 1522. No. 939, Archivio Notaio, Archivio di Stato, Parma.

Rog. Benedetto del Bono. Contracts, Giorgio Gandini, May 19, 1536; Mazzola Bedoli, April 5, 1538. Archivio Notaio, Archivio di Stato, Parma.

Scarabelli-Zunti, E. *Documenti e memorie di Belle Arti parmigiane.* Vol. 3. MS. 19th century. Soprintendenza, Parma.

Index

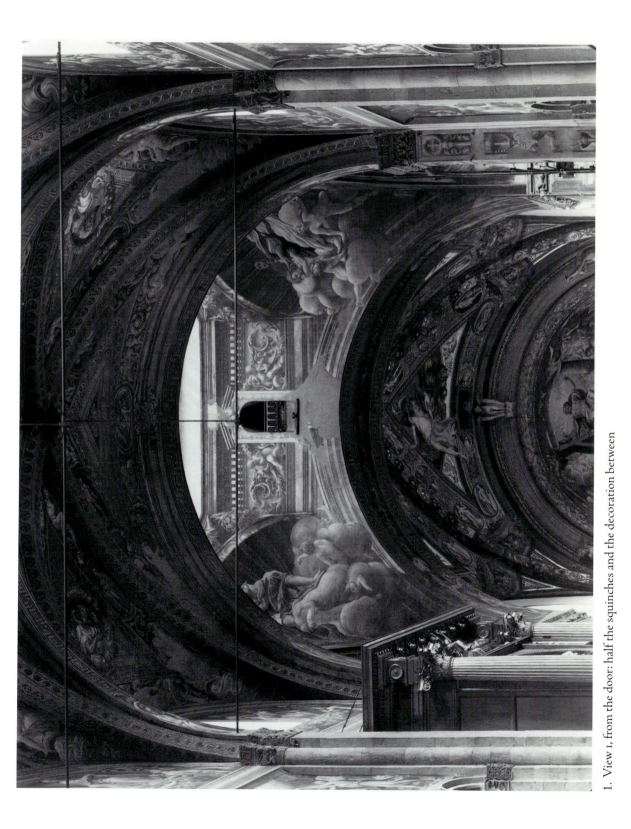

1. View 1, from the door: half the squinches and the decoration between

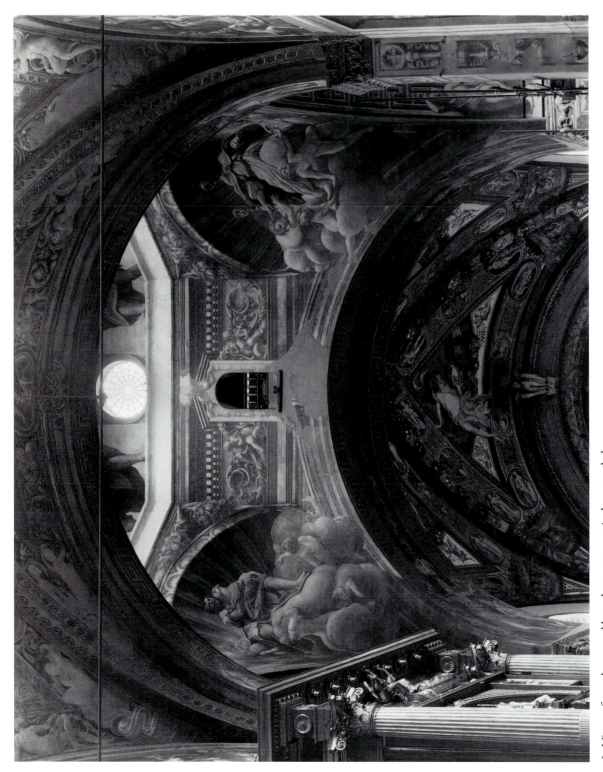

2. View 2, from the second bay: the eastern squinches revealed

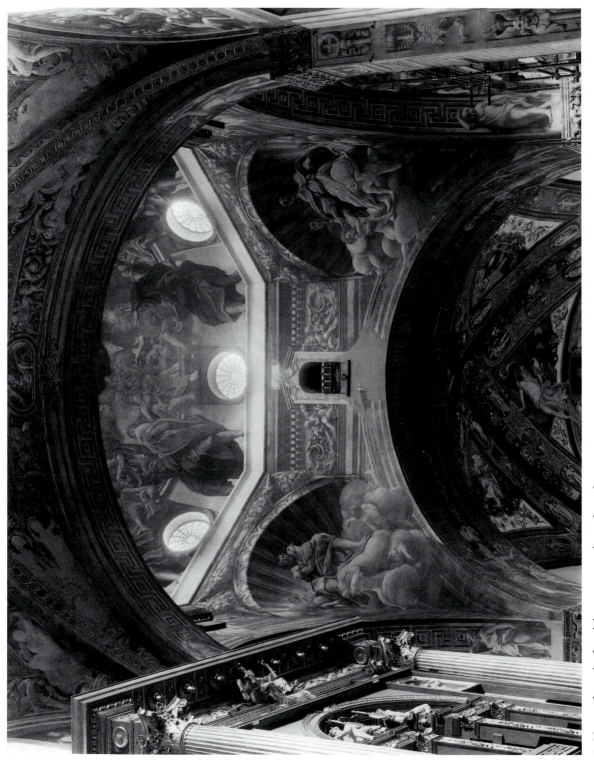

3. View 3, from the fourth bay: two apostles and angels

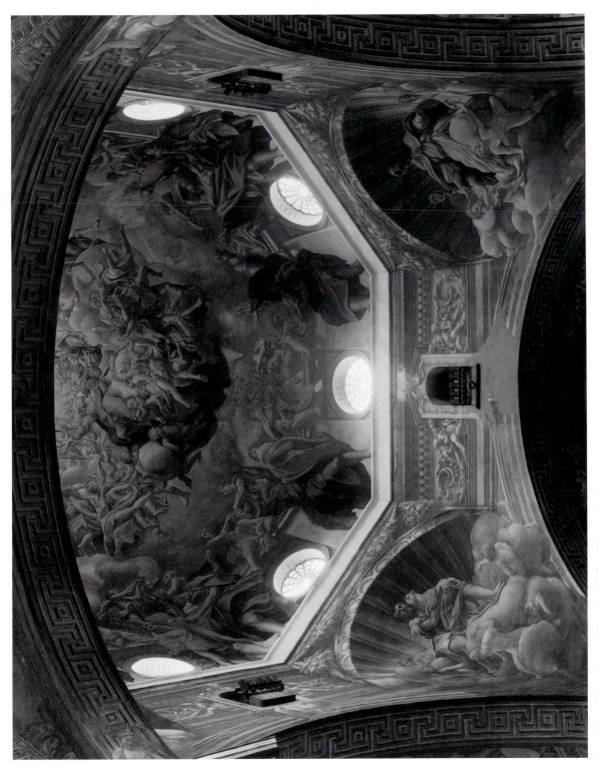

4. View 4, from the sixth bay (west): the Virgin appears

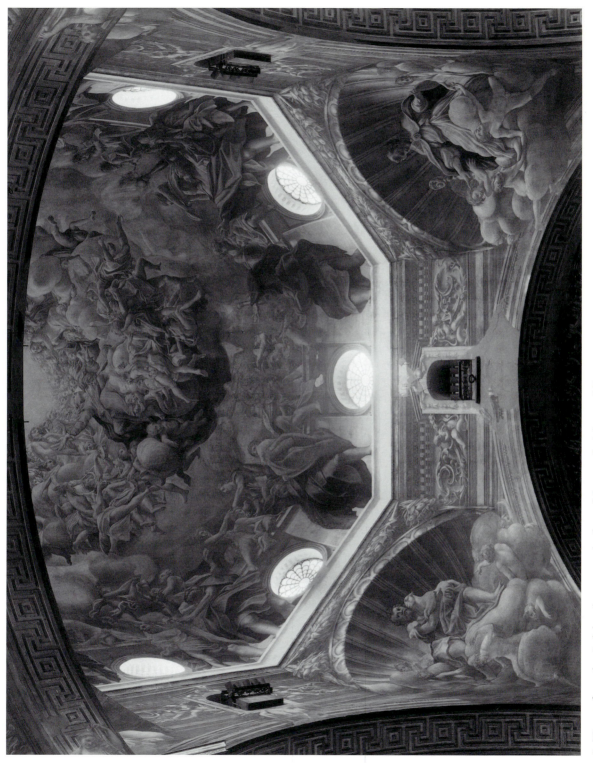

5. View 5, from the sixth bay (east; once the foot of the stairs): Adam and Eve

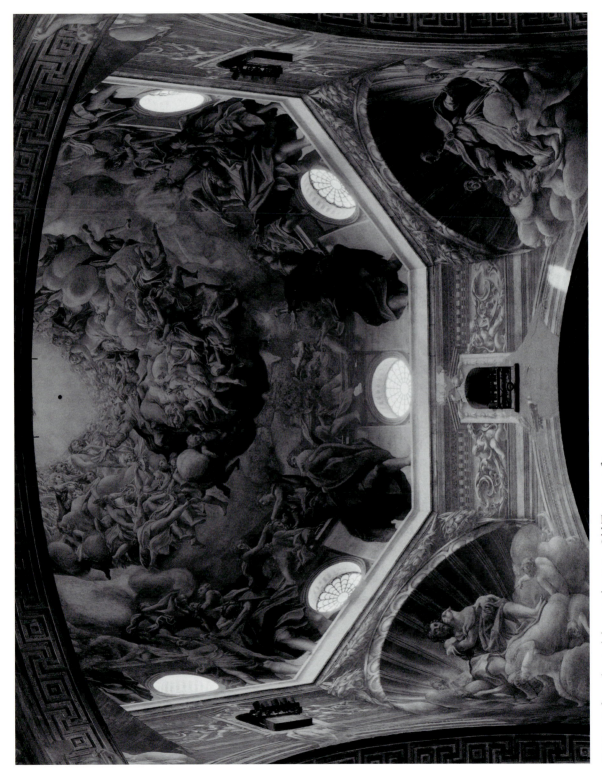

6. View 6, from the sixth bay, on the stairs: Old Testament figures

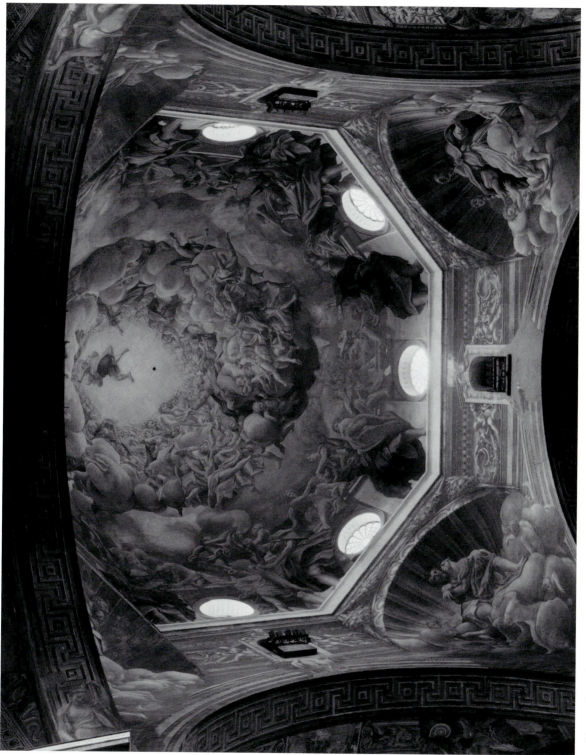

7. View 7, from the seventh bay, on the stairs: Christ appears

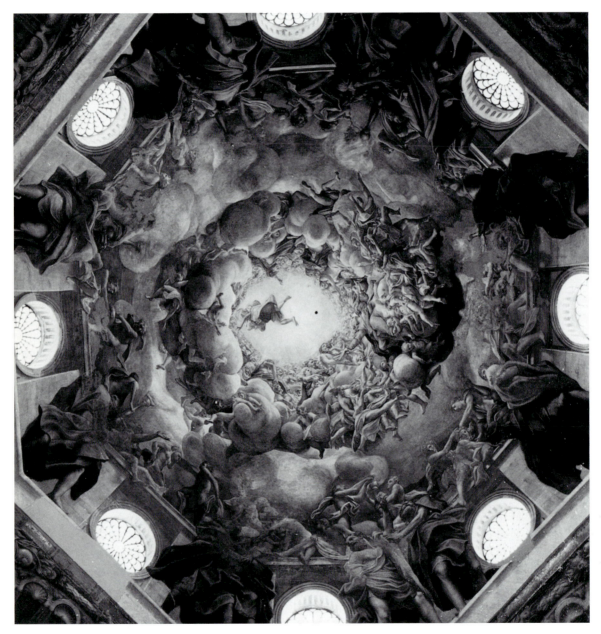

8. View 8, the central view

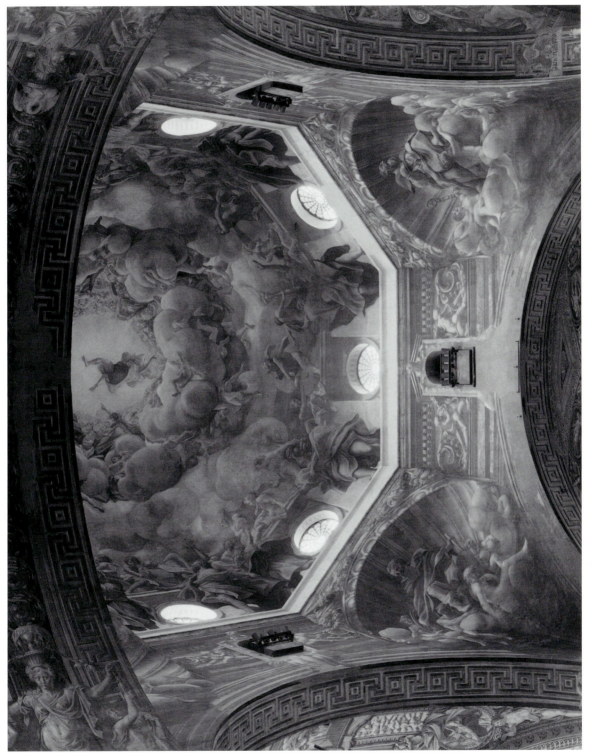

9. View 9: the eastern view, from the lower choir

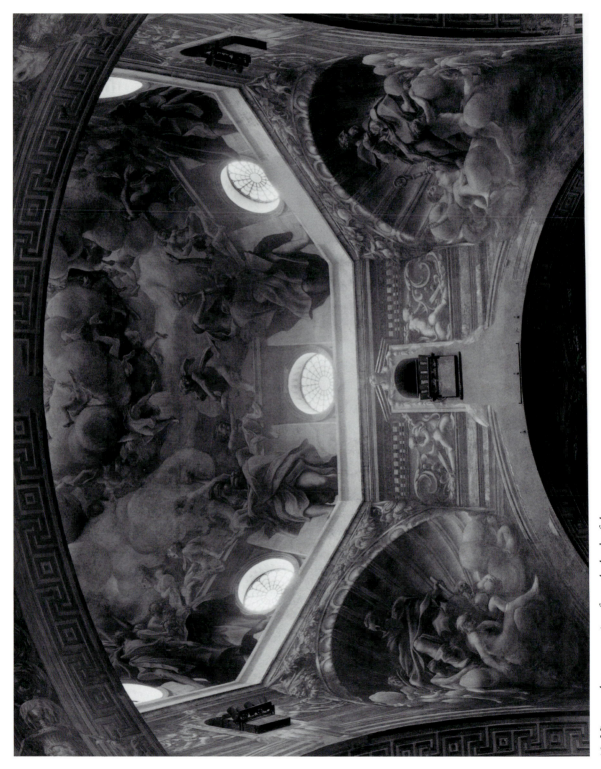

10. View 10: the eastern view, from the back of the apse

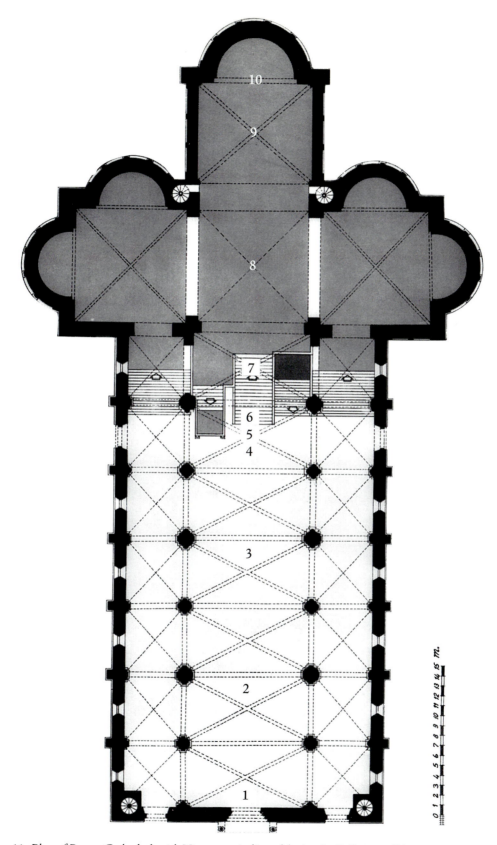

11. Plan of Parma Cathedral, with Views 1–10 indicated (using A. C. Quintavalle's reconstruction of the architecture as it appeared before 1566)

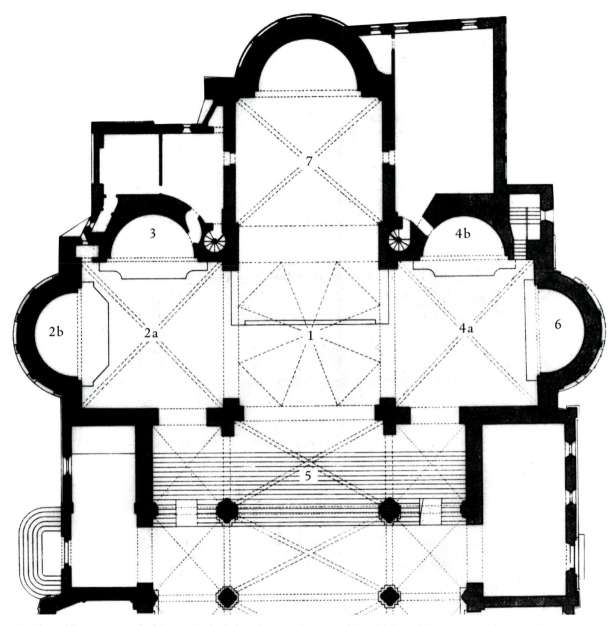

12. Plan of the eastern end of Parma Cathedral, with commissions indicated (plan of the present architecture)

1. Correggio
2. (a and b) Parmigianino
3. Rondani
4. (a and b) Anselmi
5. Araldi
6. Caselli (earlier work: Montini Chapel)
7. Correggio

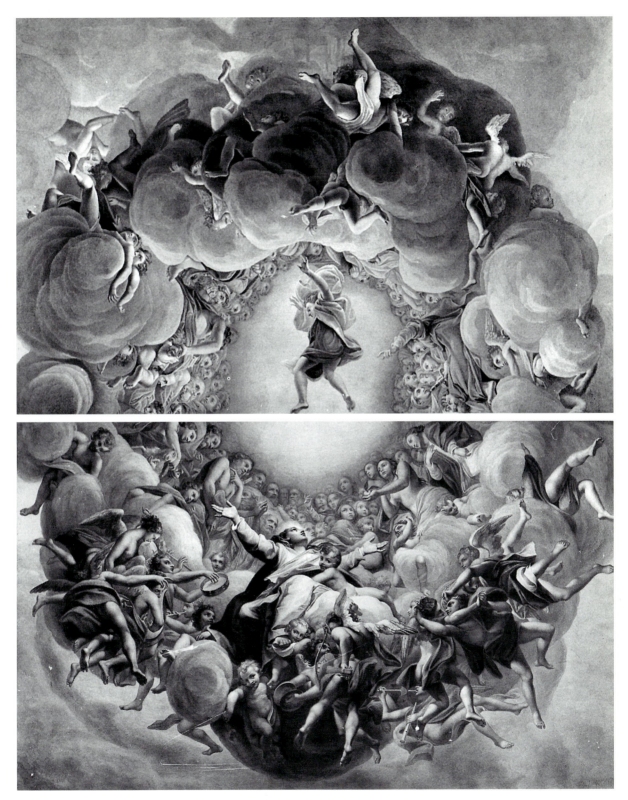

13. P. Toschi and C. Raimondi, copy of Correggio's *Assumption of the Virgin*, Parma Cathedral. View of the cupola, mid-19th century. Galleria Nazionale, Parma

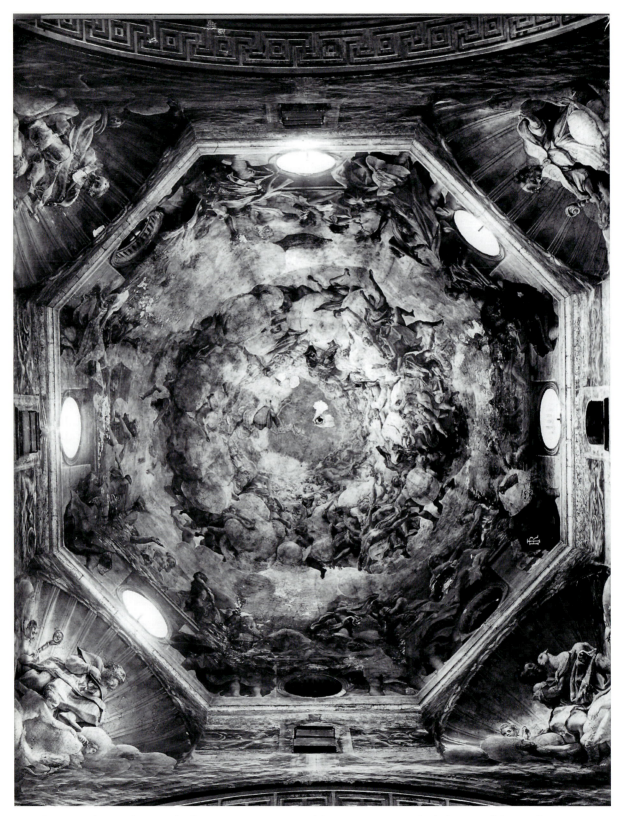

14. Alinari/Anderson photograph of Correggio's *Assumption of the Virgin*, Parma Cathedral. View of the cupola

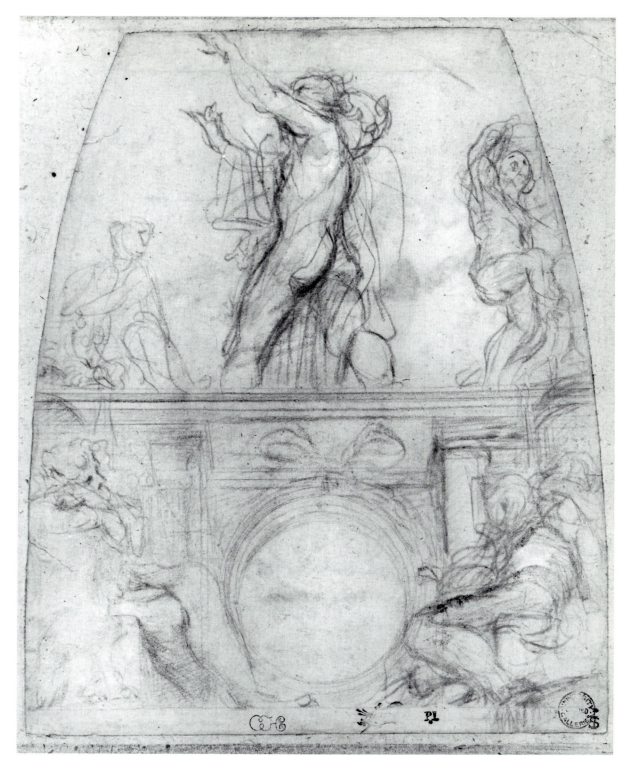

15. Correggio, project for lower part of the Cathedral dome decoration, drawing, red chalk, recto. Ashmolean Museum, Oxford (Popham 50r)

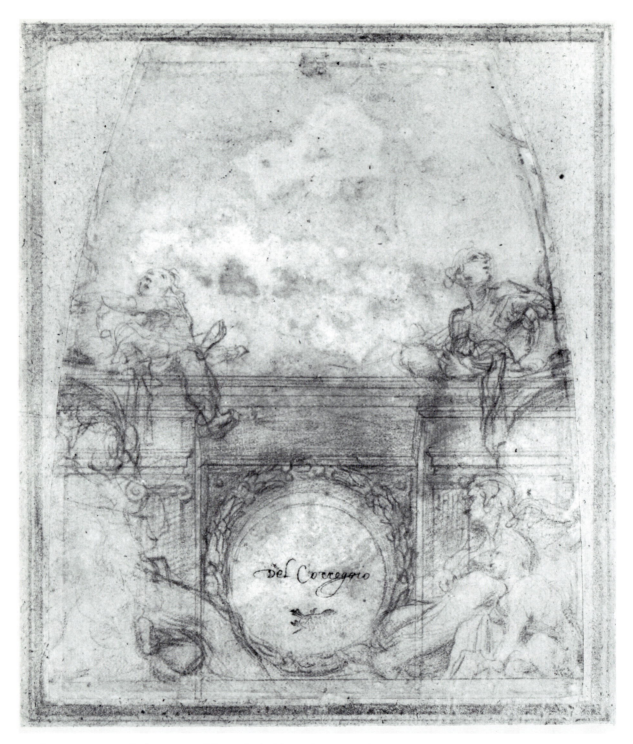

16. Correggio, project for lower part of the Cathedral dome decoration, drawing, red chalk, verso. Ashmolean Museum, Oxford (Popham 50v)

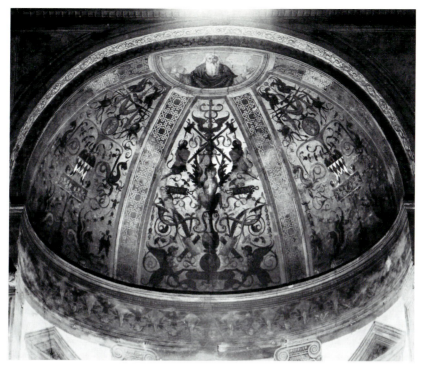

17. Cristoforo Caselli, *God the Father and Grotesque Decoration*, frescoed lunette, Montini Chapel, Parma Cathedral, 1505–7

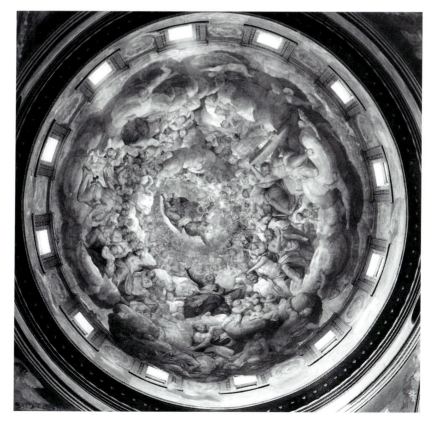

18. Bernardino Gatti, *Assumption of the Virgin*, fresco, cupola, S. Maria della Steccata, Parma, 1560–72

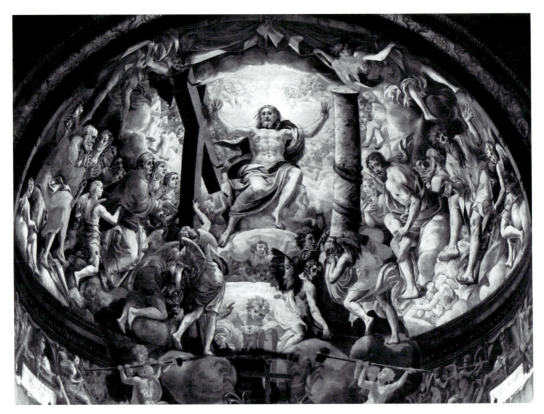

19. Girolamo Mazzola Bedoli, *Resurrection*, fresco, apse of Parma Cathedral, 1538–44

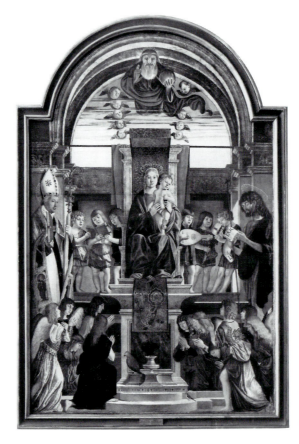

20. Cristoforo Caselli,
*Madonna and Child Enthroned
with Saints John the Baptist and
Hilary of Poitiers*, 1496–99.
Galleria Nazionale, Parma

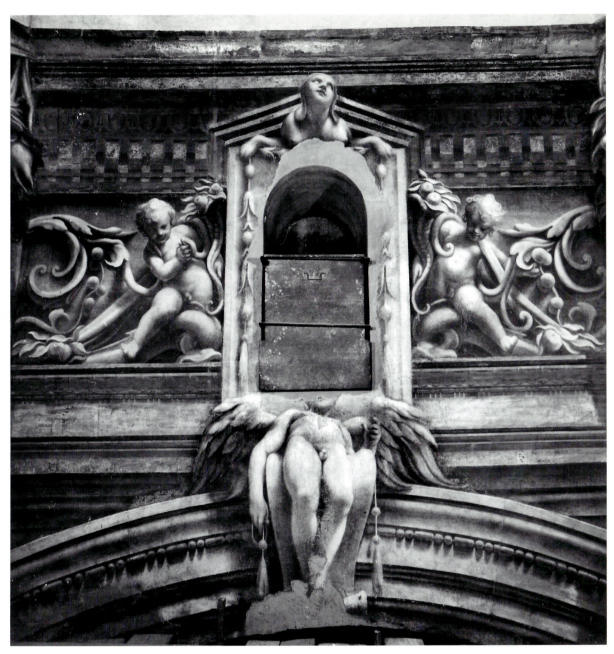

21. Fictive relief to either side of the north window below the dome

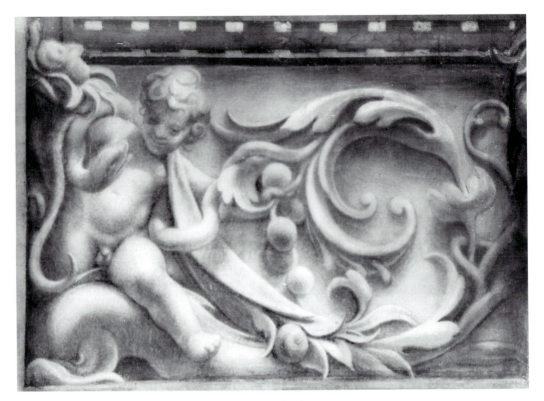

22. Fictive relief to the right of the east window below the dome

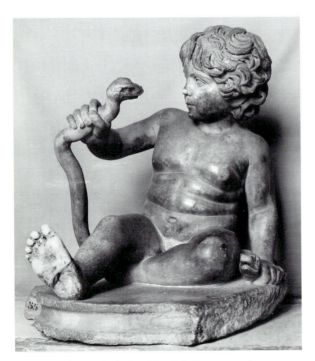

23. *Boy with a Snake* (*Infant Hercules*), Roman, 2nd century
A.D. Museo Capitolino, Rome

24. Correggio, Camera di S. Paolo, Parma, detail of vault
fresco, ca. 1519

25. Winged female figure, monochrome fresco, over south crossing arch

26. P. Toschi, C. Raimondi, and L. Bigola, reconstruction of fresco surrounding drum window, watercolor, mid-19th century. Biblioteca Palatina, Parma

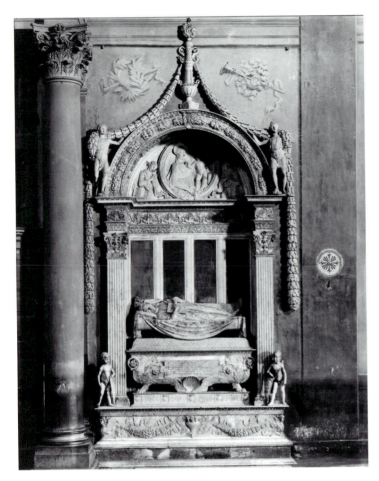

27. Desiderio da Settignano, tomb of Carlo
Marsuppini, S. Croce, Florence, begun 1453

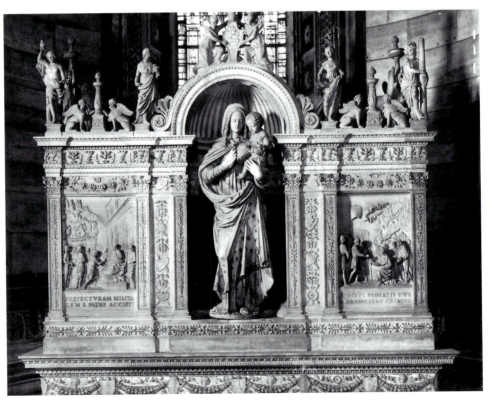

28. Gian Cristoforo
Romano, tomb of
Gian Galeazzo
Visconti, Certosa
di Pavia, 1497

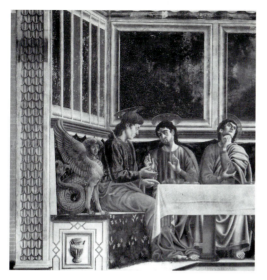

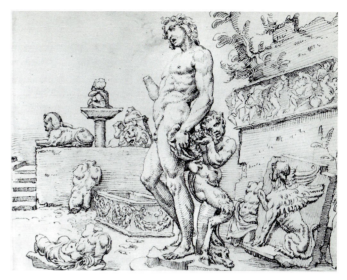

29. Andrea del Castagno, detail of *Last Supper*, fresco, Sant'Apollonia, Florence, ca. 1445–50

30. Maerten van Heemskerck, *Jacopo Galli's Sculpture Garden*, drawing, 1532–35. Kupferstichkabinett, Staatliche Museen, Berlin

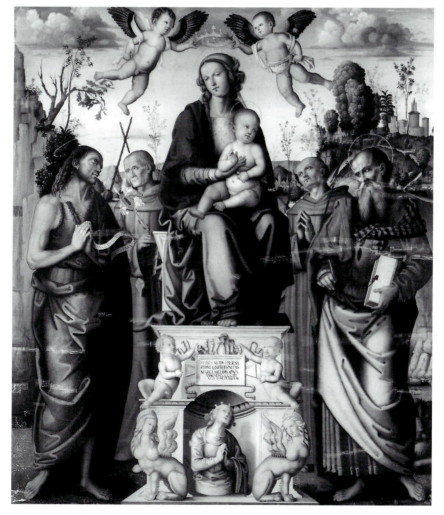

31. Marco Meloni, *Madonna and Child Enthroned with Saints*, 1504. Galleria Estense, Modena

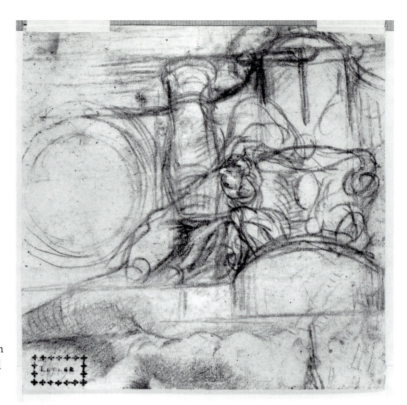

32. Correggio, design for fictive architecture and figures framing oculus in lower area of the dome, drawing, pen and ink over red chalk. Teylers Museum, Haarlem (Popham 52v)

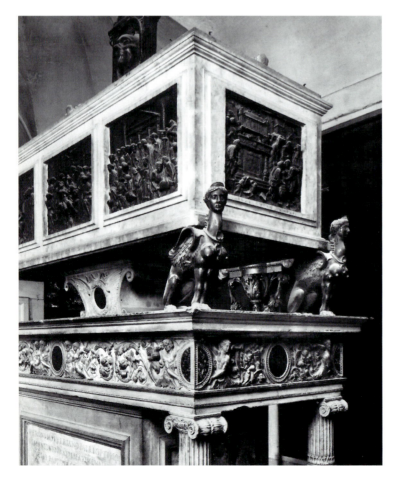

33. Andrea Riccio, Torriani tomb, S. Fermo Maggiore, Verona, before 1532

34. St. Hilary of Poitiers, southeast squinch

35. Michelangelo Anselmi, *Madonna and Child with Saints Sebastian, Roche, Biagio, and Hilary*, Parma Cathedral, completed 1526

36. Taddeo di Bartolo, Thaddeus, detail from *Assumption*, Duomo, Montepulciano, 1401

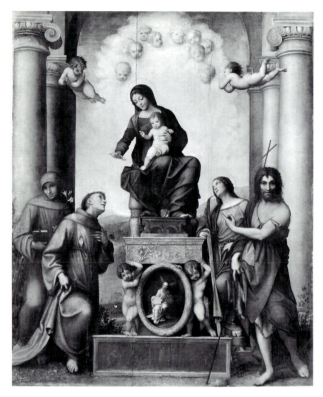

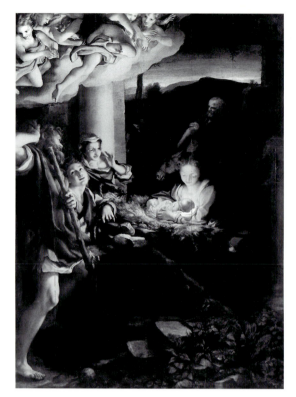

37. Correggio, *Madonna and Child Enthroned with Saints*, 1514–15. Staatliche Kunstsammlungen, Dresden

38. Correggio, *Adoration of the Shepherds*, commissioned 1522, completed by 1530. Staatliche Kunstsammlungen, Dresden

39. A. C. Quintavalle's reconstruction of the eastern termination of the nave of Parma Cathedral before the mid-16th-century rearrangement

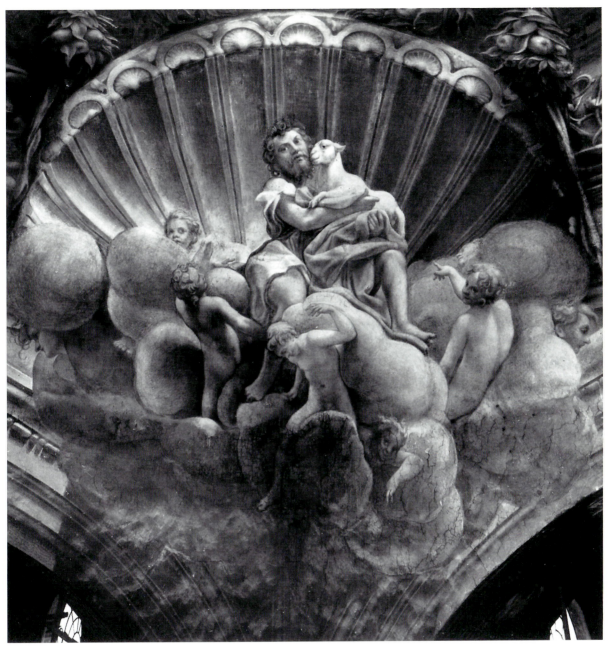

40. St. John the Baptist, northeast squinch

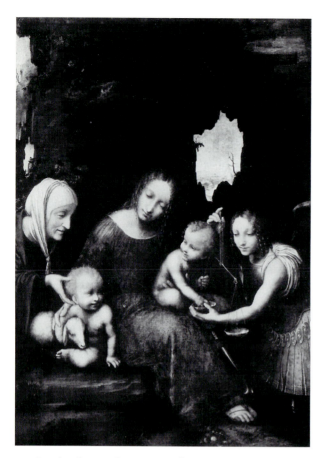

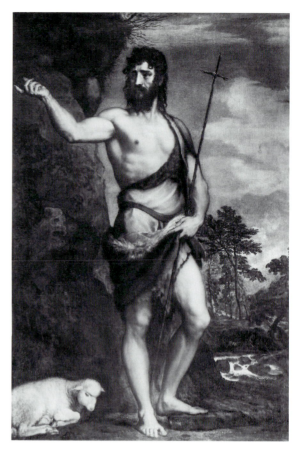

41. Lombard artist, *"Vierge aux Balances,"* 16th century. Musée du Louvre, Paris

42. Titian, *St. John the Baptist*, ca. 1531. Galleria dell'Accademia, Venice

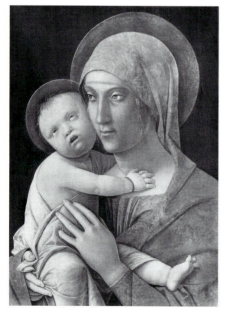

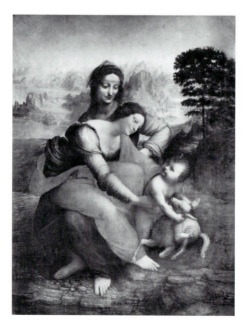

a

b

43. Andrea Mantegna, *Madonna and Child*, 1485–95(?). Accademia Carrara, Bergamo

44. Leonardo, *Madonna and Child with St. Anne*, 1508–13(?). Musée du Louvre, Paris

45a, b. Coin of Parma: *Coronation of the Virgin* (recto), *Saints John the Baptist and Hilary* (verso), papacy of Hadrian VI, 1522

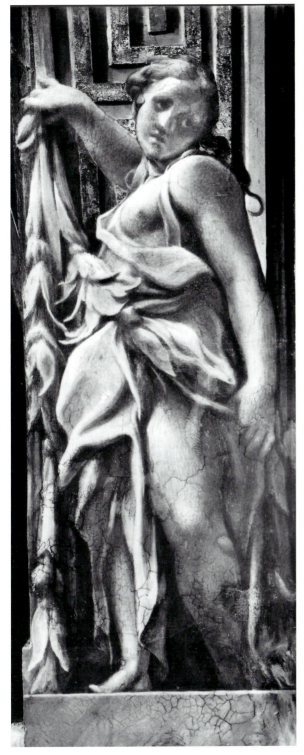

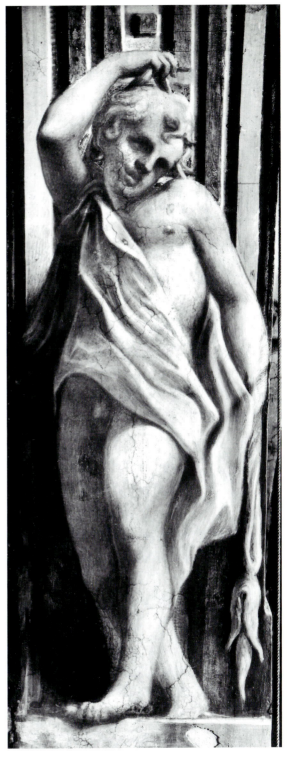

46. Grisaille figure on crossing arch, fresco, facing the nave over northeast pier

47. Grisaille figure on crossing arch, fresco, facing the nave over southeast pier

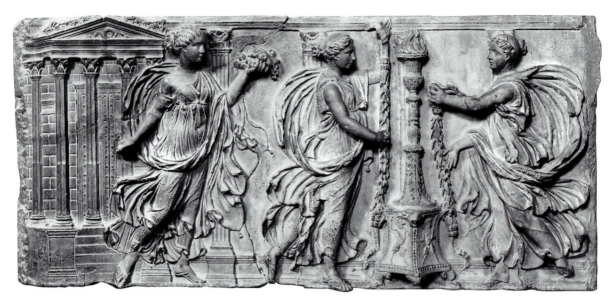

48. Roman neo-Attic relief, *Maidens Decorating a Candelabrum* (mate of the *"Borghese Dancers"*), 1st century B.C.–1st century A.D. Musée du Louvre, Paris

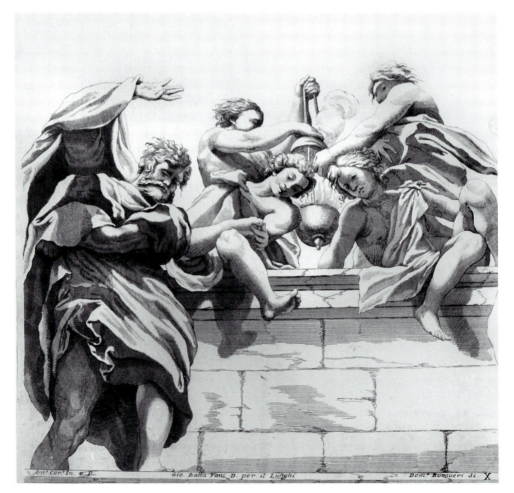

49. Domenico Boniveri, etching of 1697 after drawing by G. B. Vanni of 1642, after Correggio: eastern group of censer-tending angels. Biblioteca Palatina, Parma

50. Apostle, left of east oculus

51. Apostle, right of east oculus

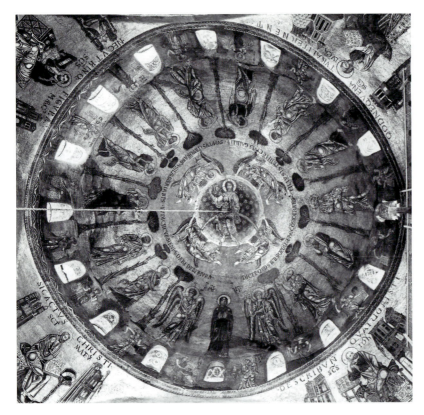

52. *Ascension*, dome mosaic, S. Marco, Venice, late 12th century

53. Giacomo and Giulio Francia, *Assumption*, ca. 1513. Galleria Estense, Modena

54. Andrea Mantegna, *Assumption*, fresco, Cappella
Ovetari, Church of the Eremitani, Padua, 1453–57

55. Titian, *Assumption*, S. Maria Gloriosa dei Frari, Venice,
1516–18

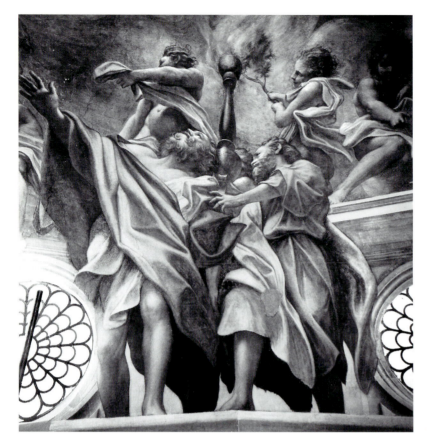

56. Pair of apostles left of south oculus, including attendant angel with bough of cypress

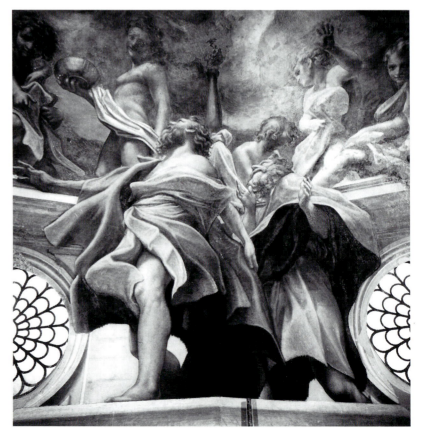

57. Pair of apostles right of south oculus, including attendant angels

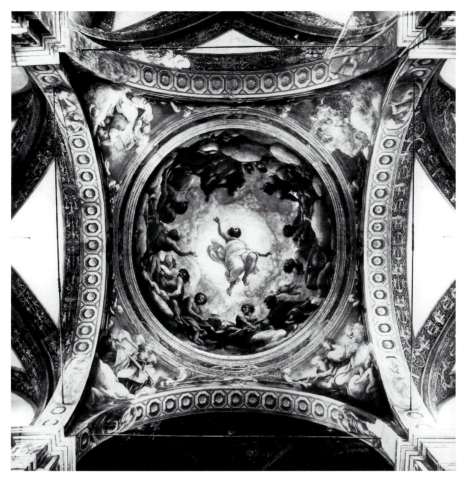

58. Correggio, dome fresco, S. Giovanni Evangelista, Parma, 1522–24

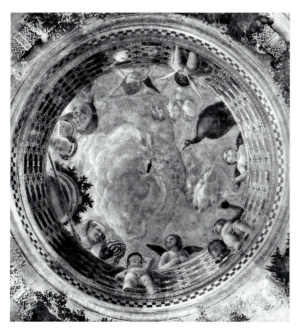

59. Andrea Mantegna, vault fresco, Camera degli Sposi, Palazzo Ducale, Mantua, 1465–74

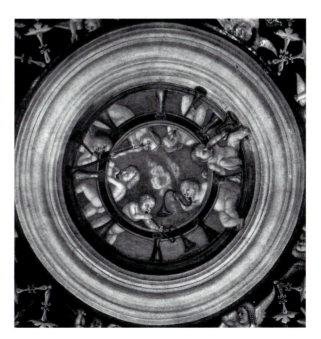

60. Alessandro Araldi, vault fresco, Convento di S. Paolo, Parma, 1514

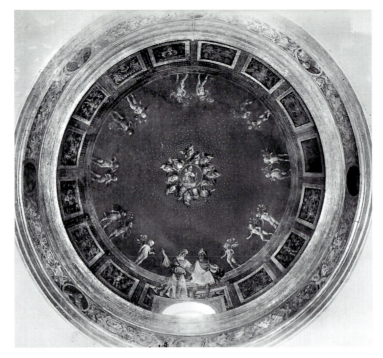

61. Marco Palmezzano, *Vision of Augustus*, dome fresco, Cappella Acconci, S. Biagio, Forlì, ca. 1500 (destroyed)

62. Bernardino and Francesco Zaganelli, dome fresco, Cappella Sforza, S. Francesco, Cotignola, ca. 1500

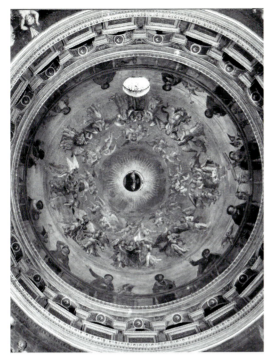

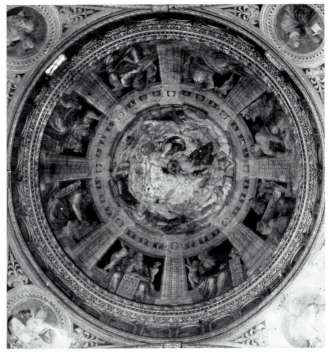

63. Francesco Prata da Caravaggio, dome fresco,
Cappella del Sacramento, SS. Fermo e Rustico,
Caravaggio, ca. 1525–26

64. Bernardino Zacchetti, *Christ with Prophets*, fresco in dome of
first nave bay, S. Sisto, Piacenza, 1517

65. Attendant angels with incense boat, group over northeast oculus

66. Attendant angels with censer (ruined section), group over east oculus

67. Attendant angels with large basin, group over southeast oculus

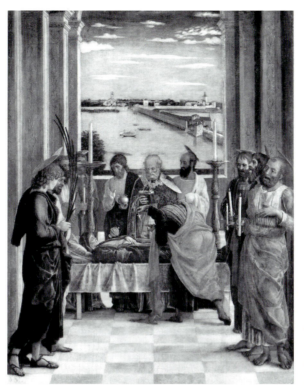

68. Andrea Mantegna, *Death of the Virgin*, early 1460s. Museo del Prado, Madrid

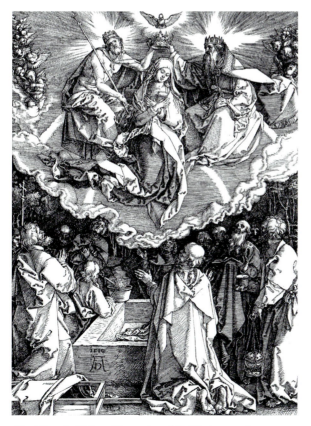

69. Albrecht Dürer, *Coronation of the Virgin*, woodcut, 1510, series of the *Life of the Virgin*. The Metropolitan Museum of Art, New York

70. Giotto school, detail of *Death of the Virgin*, 1315–20. Gemäldegalerie, Berlin

71. Baldassare d'Este(?), *Death of the Virgin*, before 1502(?). Pinacoteca Ambrosiana, Milan

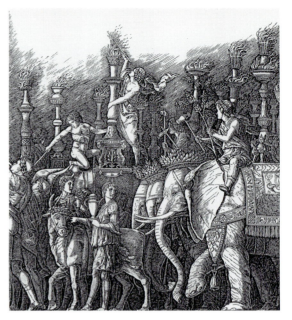

72. Giovanni Antonio da Brescia, engraving after Mantegna, *Triumph with Elephants*, ca. 1500. Petit Palais, Paris

73. Pair of apostles with group of attendant angels dropping incense and lighting flame, right of the north oculus

74. Virgin ascending

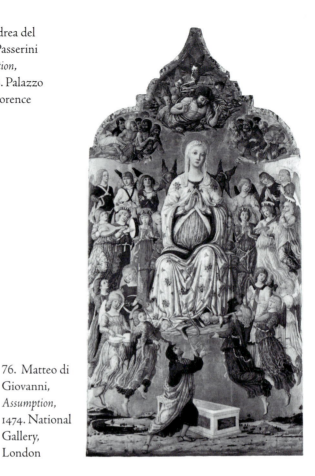

75. Andrea del Sarto, Passerini *Assumption*, 1526–28. Palazzo Pitti, Florence

76. Matteo di Giovanni, *Assumption*, 1474. National Gallery, London

77. Lorenzo Costa, *Assumption*, S. Martino Maggiore, Bologna, 1506

78. Simeone and Machilone of Spoleto, *Assumption*, detail from altarpiece of the *Virgin Enthroned with Scenes from Her Life*, 1250–55. Museum Mayer Van den Bergh, Antwerp

79. Correggio (attributed), *Virgin*, red chalk drawing with traces of white heightening. British Museum, London (Popham 57)

80. Nanni di Banco, *Madonna della Mandorla* (*Assumption*), Porta della Mandorla, Duomo, Florence

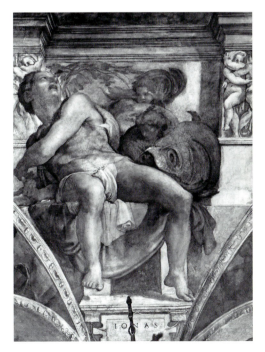

81. Michelangelo, *Jonah*, fresco, vault over altar end of Sistine Chapel, Vatican, 1508–12

82. Master of the Life of Mary, *Assumption*, ca. 1465. Altepinakothek,
Bayerische Staatsgemäldesammlungen, Munich

83. Marco d'Oggiono, *Assumption*, 1522–24. Brera, Milan

84. Correggio, *Madonna della Scodella (Rest on the Flight)*,
mid-1520s, before 1530. Galleria Nazionale, Parma

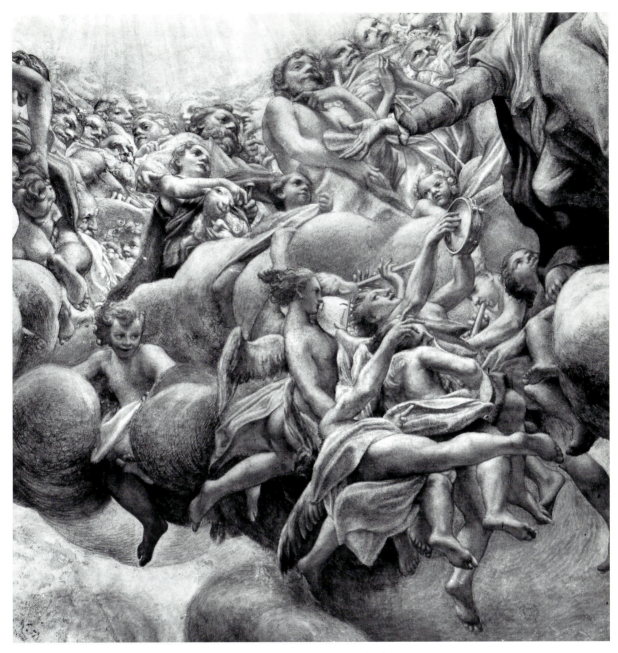

85. Music-making angels and Old Testament figures below and to the left of the Virgin

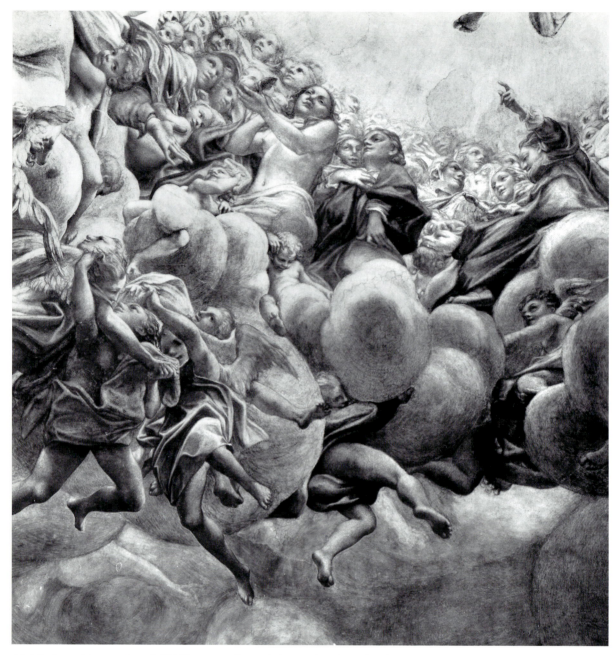

86. Music-making angels and Old Testament figures below and to the right of the Virgin

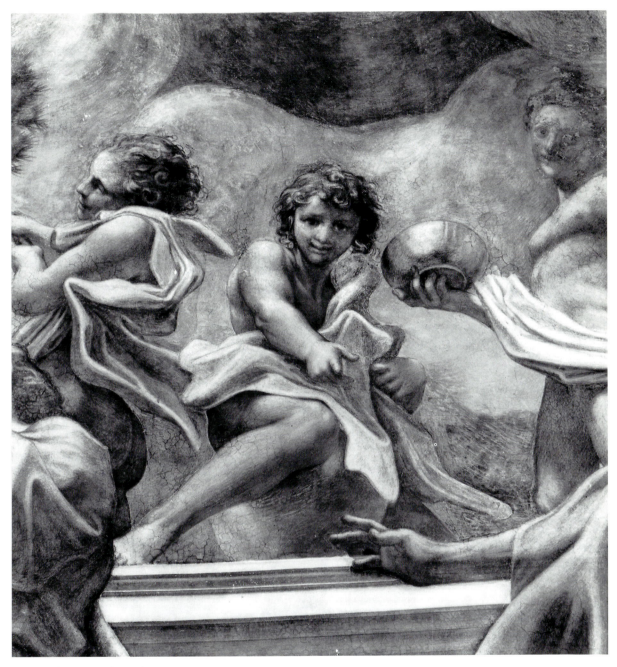

87. "Confrontational" angel

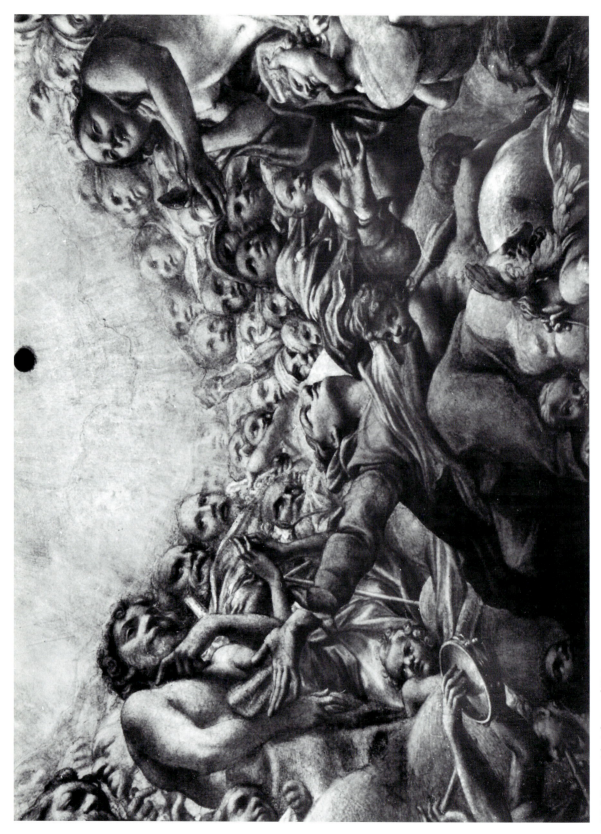

88. *Virgin with Adam and Eve*

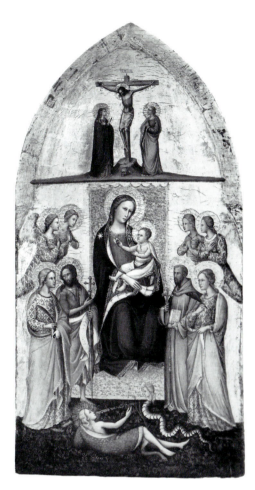

89. Giuliano di Simone da Lucca, *Madonna Enthroned with Eve below*, 14th century. Galleria Nazionale, Parma

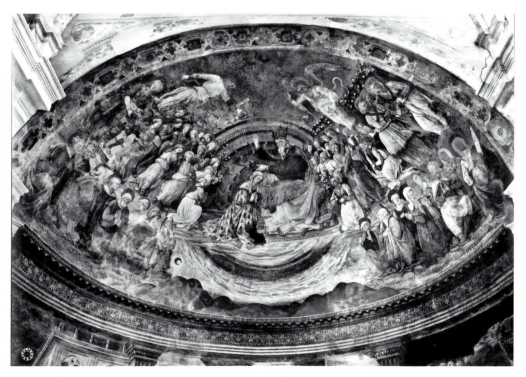

90. Fra Filippo Lippi (with assistants), *Coronation*, apse fresco, Duomo, Spoleto, 1467–69

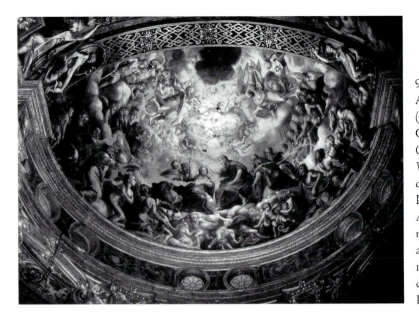

91. Michelangelo
Anselmi
(designed by
Giulio Romano),
*Coronation of the
Virgin*, apse fresco,
ca. 1540–42;
Parmigianino,
Adam and *Eve*,
monochrome
arch frescoes, ca.
1538–39; S. Maria
della Steccata,
Parma

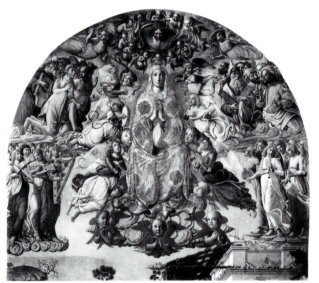

92. Pietro di Domenico da
Siena, *Assumption*, after 1498.
Collegiata, Radicondoli
(near Siena)

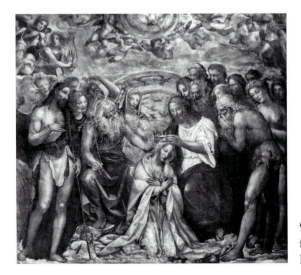

93. Sodoma, *Coronation*,
fresco, Oratorio di S.
Bernardino, Siena, 1518

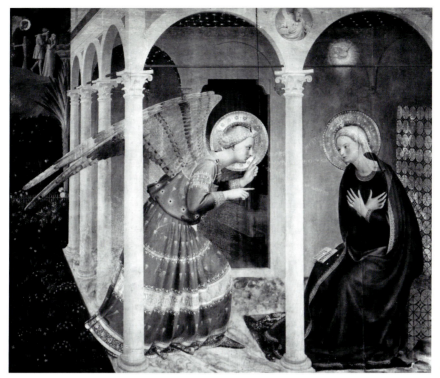

94. Fra
Angelico,
Annunciation,
1432–33.
Museo
Diocesano,
Cortona

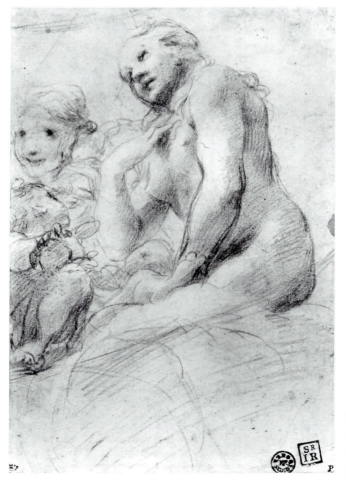

95. Correggio, *Eve*, red
chalk drawing. British
Museum, London
(Popham 51r)

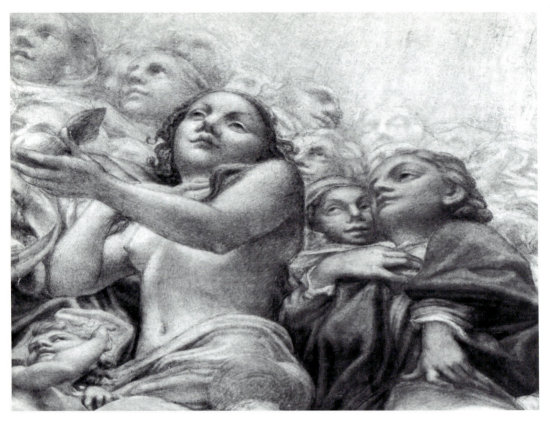

96. Eve and Old Testament Women (Sarah and Rebecca)

97. Correggio, *Eve*, drawing, pen and ink over red chalk. Teylers Museum, Haarlem (Popham 52r)

98. Correggio, *Eve*, red chalk drawing heightened with white. Musée du Louvre, Paris (Popham 53)

99. Correggio, *Eve and Other Old Testament Figures*, squared red chalk drawing. Städelsches Kunstinstitut, Frankfurt (Popham 54)

100. Adam

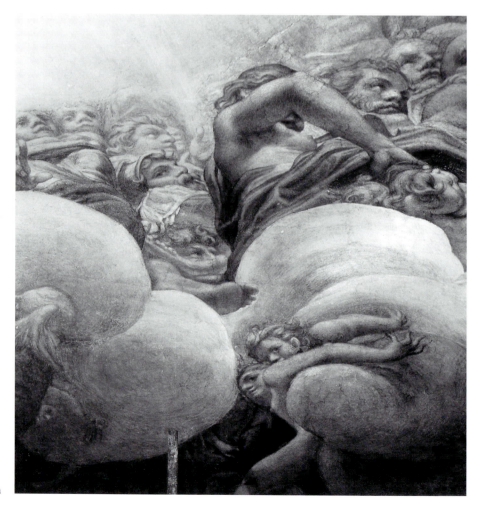

101. David and Goliath

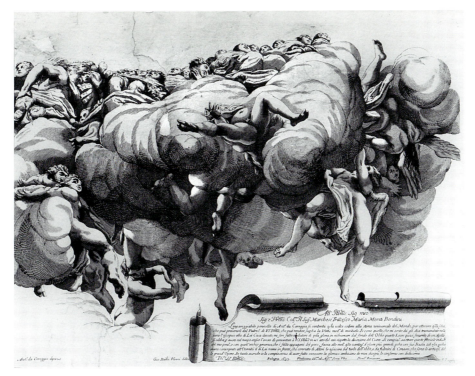

102. Domenico Boniveri, etching of 1697 after drawing by G. B. Vanni of 1642, after Correggio: west face of dome. Biblioteca Palatina, Parma

103. Circle of Benedetto Bembo, *Detail of Assumption*, second half of 15th century. Accademia Carrara, Bergamo

104. Antonio Vivarini and Giovanni d'Alemagna, *Coronation*, Cappella di S. Chiodo, S. Pantaleone, Venice, 1444

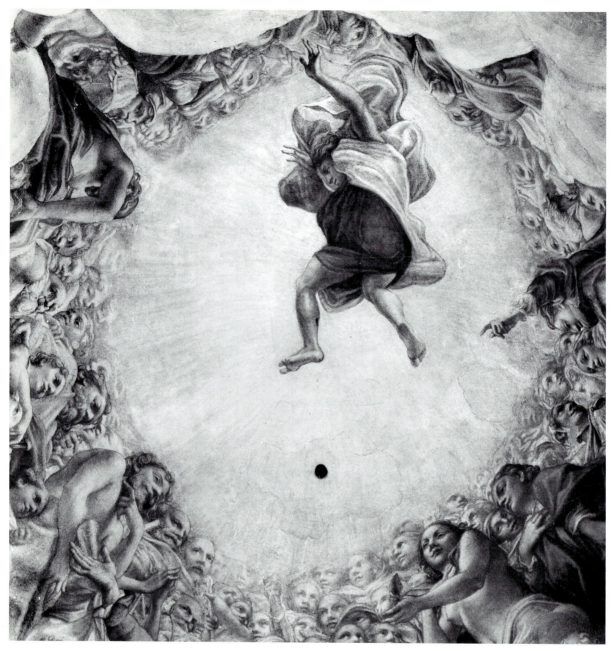

105. Christ

106. Andrea del Castagno, detail of *Resurrection*, fresco, S. Apollonia, Florence, ca. 1445–55

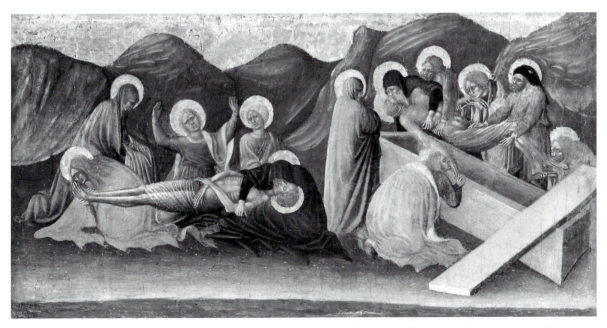

107. Bartolomeo di Tommaso da Foligno, *Entombment/Lamentation*, 15th century. The Metropolitan Museum of Art, New York

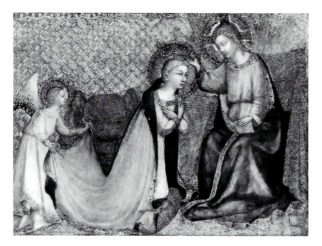

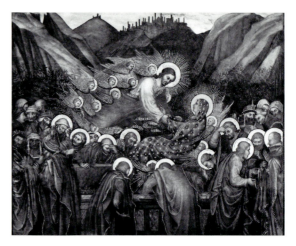

108. Follower of Arcangelo di Cola da Camerino, *Coronation*, 1420s(?). Cleveland Museum of Art, Cleveland, Ohio

109. Taddeo di Bartolo, *Assumption*, fresco, Palazzo Pubblico, Siena, ca. 1407

110. Correggio, *Coronation*, fragment of apse fresco from S. Giovanni Evangelista, 1520–22. Galleria Nazionale, Parma

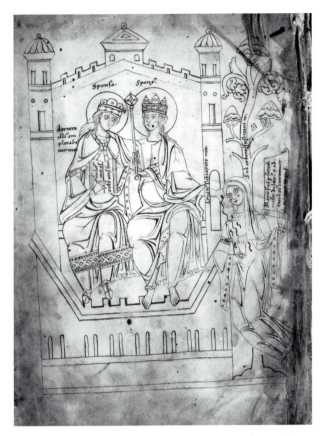

111. *Sponsa-Sponsum*, frontispiece to Honorius of Autun's
Commentary on the *Song of Songs*, manuscript illustration,
Cod. Lat. 4550, fol. IV, 12th century. Bayerische
Staatsbibliothek, Munich

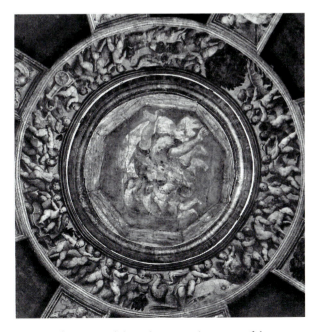

112. Pordenone, *God the Father*, central portion of dome
fresco, Madonna di Campagna, Piacenza, ca. 1530–32

113. Anonymous. *Christ Blessing*, vault fresco, S. Francesco
al Prato, Parma, 15th century

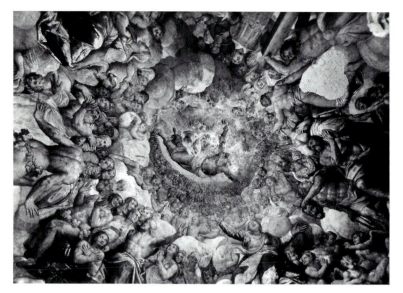

114. Bernardino Gatti, *Christ*, detail of dome fresco, S. Maria della Steccata, Parma

115. Lay figures representing poses of Christ and the Virgin in Correggio's *Assumption* in Parma Cathedral

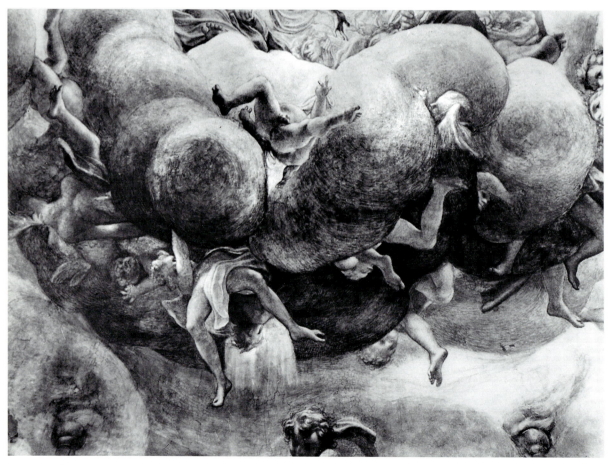

116. West wall of dome with angels in clouds

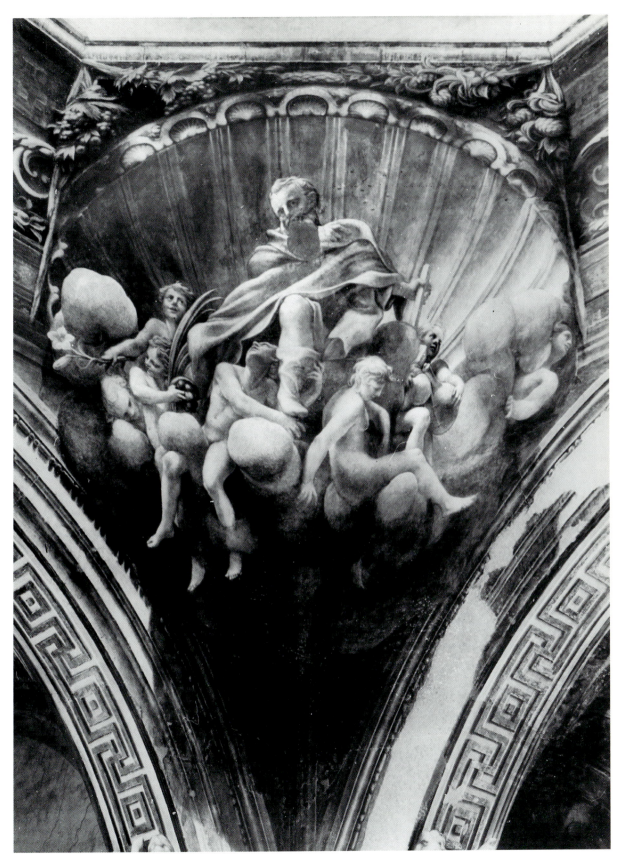

117. Joseph, southwest squinch

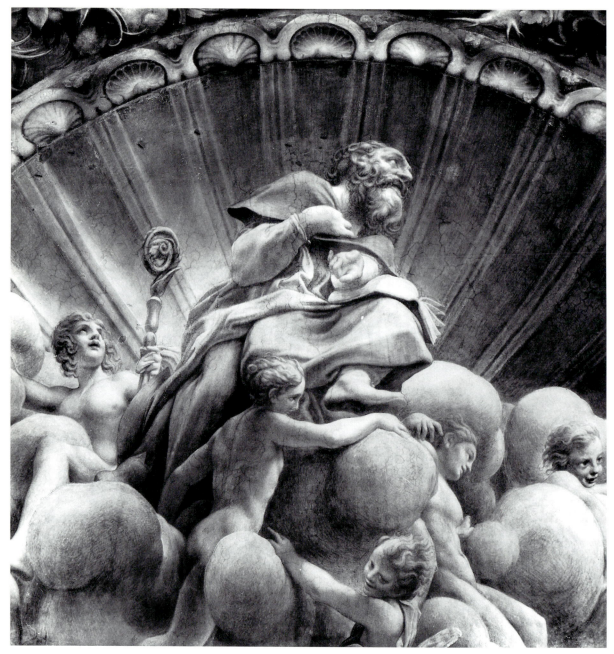

118. S. Bernardo degli Uberti, northwest squinch

119. Joseph, detail: pack, cask

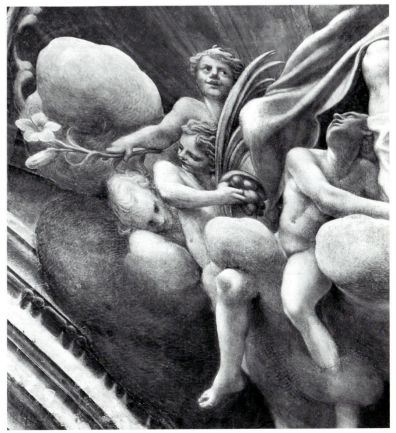

120. Joseph, detail: dates, lily

121. Andrea Solario, *Rest on the Flight into Egypt*, 1515. Museo Poldi-Pezzoli, Milan

122. Albrecht Dürer, *Flight into Egypt*, woodcut, ca. 1503, series of the *Life of the Virgin*. The Metropolitan Museum of Art, New York

123. Francesco Solimena, *St. Theresa, Vision of St. Joseph*, Convent of the Theresians, Piacenza, ca. 1700

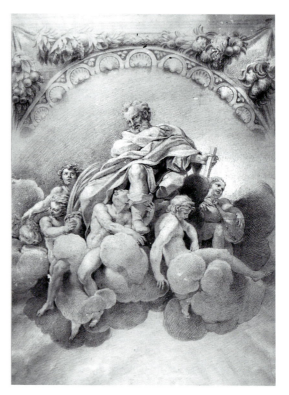

124. Pietro Perfetti, *Joseph*, pencil drawing, copy after Correggio, after 1760. Palazzo Vescovile, Parma

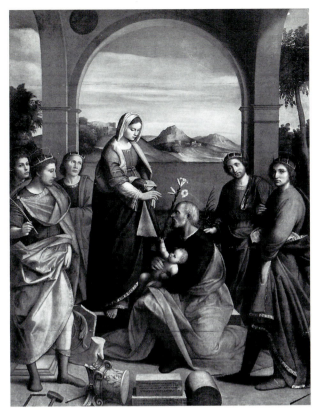

125. Niccolò Pisano, *Holy Family with Saints*, 1520.
Worcester Art Museum, Worcester, Mass.

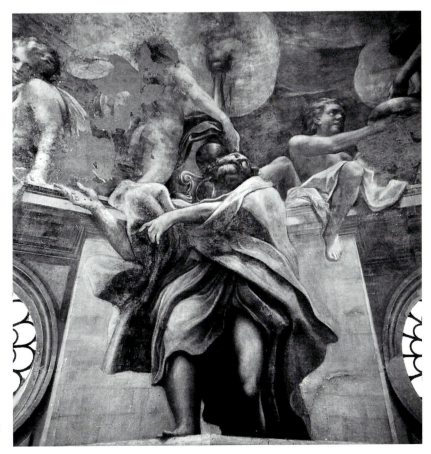

126. Apostle to the left of the west
oculus

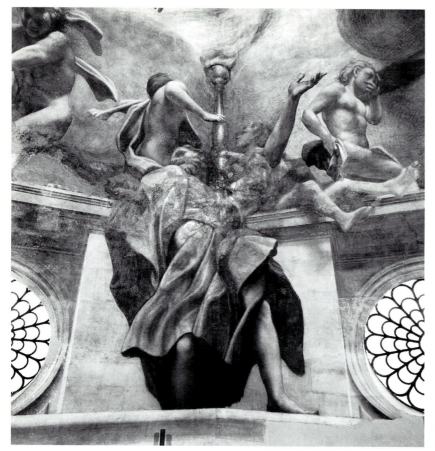

127. Apostle to the right of the west oculus

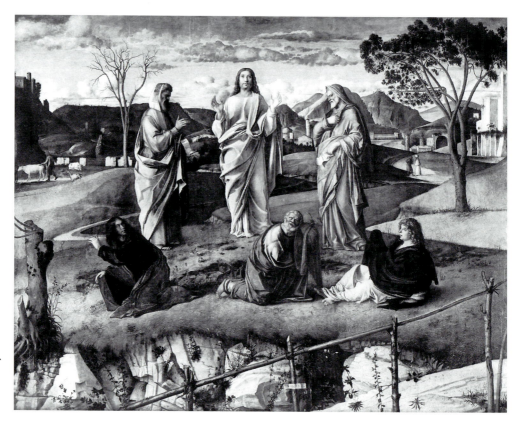

128. Giovanni Bellini, *Transfiguration*, ca. 1487. Museo del Capodimonte, Naples

129. Two attendant angels, group over west oculus

130. Attendant angel, over northwest oculus

131. Two "distracted" angels, over southwest oculus

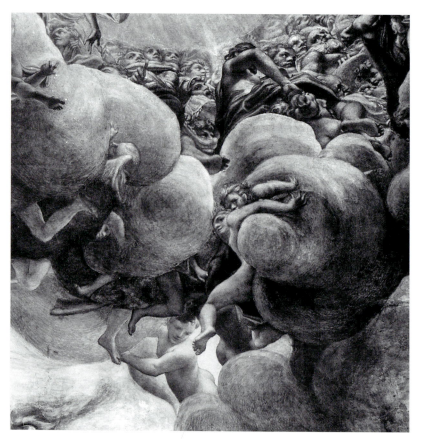

132. "Peeking" angel, through gap in clouds, west face of the dome

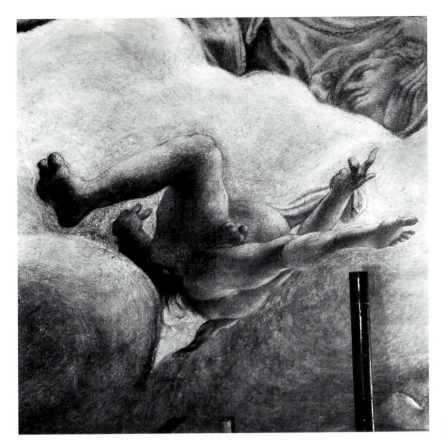

133. "Putto with head in the clouds"

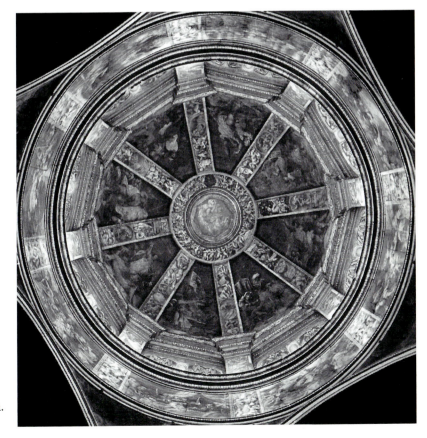

134. Pordenone, *God the Father and Prophets*, fresco, central dome, Madonna di Campagna, Piacenza, ca. 1530–32

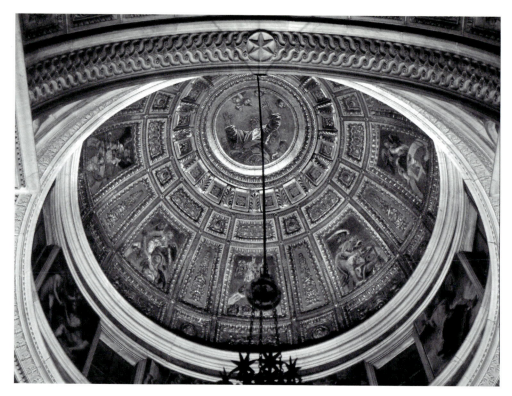

135. Raphael, view of mosaic dome of the Cappella Chigi, S. Maria del Popolo, Rome, designed 1516

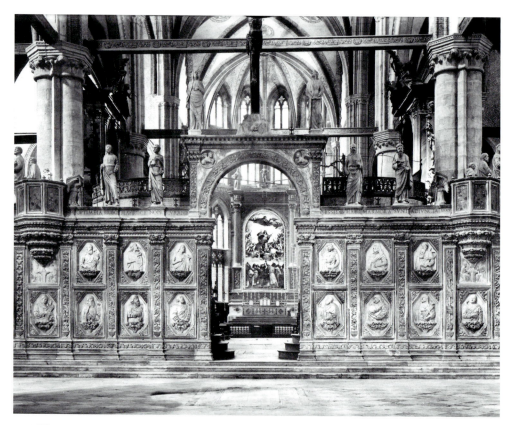

136. Titian, *Assumption*, S. Maria Gloriosa dei Frari, Venice

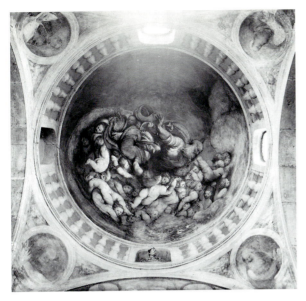

137. Pordenone, *God the Father*, dome fresco (destroyed),
Cappella Malchiostro, Duomo, Treviso, 1520

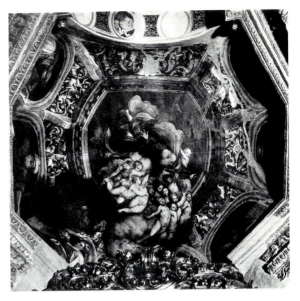

138. Pordenone, Chapel of the Immaculate Conception,
Cortemaggiore, ca. 1529–30

139. Lorenzo Lotto, Chapel of the Virgin, S. Michele al Pozzo Bianco, Bergamo, 1525

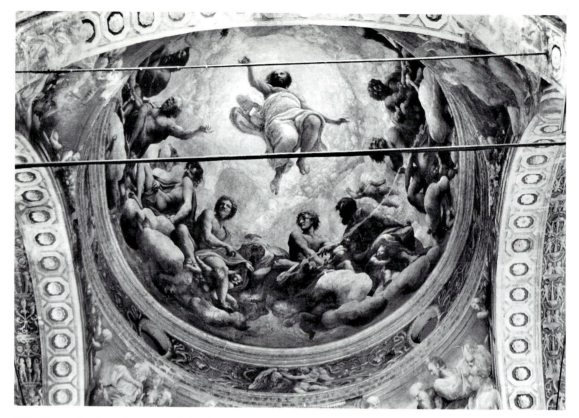

140. Correggio, dome fresco seen from the west, S. Giovanni Evangelista, Parma

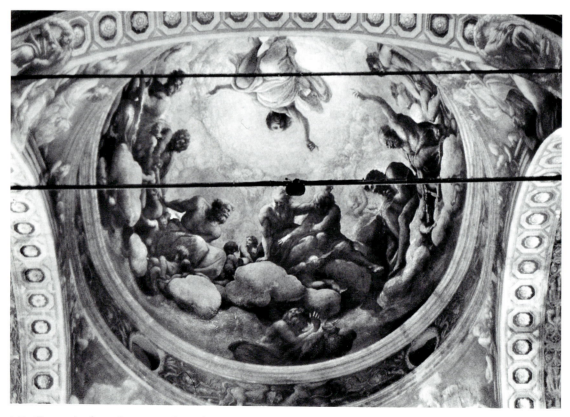

141. Correggio, dome fresco seen from the east, S. Giovanni Evangelista, Parma